D1499771

BRIGHT EARTH

BRIGHT EARTH

ART AND THE INVENTION

OF COLOR

PHILIP BALL

FARRAR, STRAUS AND GIROUX

NEW YORK

Farrar, Straus and Giroux
19 Union Square West, New York 10003

Copyright © 2001 by Philip Ball
All rights reserved
Distributed in Canada by Douglas & McIntyre Ltd.
Originally published in 2001 by Penguin, Great Britain
Published in the United States by Farrar, Straus and Giroux
First American edition, 2002

Owing to limitations of space, all acknowledgments for permission to reprint previously published material can be found on pages 383–384.

Library of Congress Cataloging-in-Publication Data
Ball, Philip, 1962–
 Bright earth : art and the invention of color / Philip Ball.— 1st American ed.
 p. cm.
 Includes bibliographical references and index.
 ISBN 0-374-11679-2 (hc : alk. paper)
 1. Color in art. 2. Coloring matter—History. 3. Dyes and
dyeing—Chemistry. 4. Art and industry. I. Title.
 N7432.7 .B35 2002
 701'.85—dc21

 2001041820

Designed by Jonathan D. Lippincott

www.fsgbooks.com

1 3 5 7 9 10 8 6 4 2

CONTENTS

PREFACE

For the past two years I have been learning to speak a new language. Or rather, not so much to speak it as to think it, for painterly color is a language that words struggle to convey. Here, for example, is German art critic Lorenz Dittmann on Jean-François Millet's *The Gleaners* (1857):

> The unusually restrained colors . . . follow a closely stepped sequence: reddish tones in the central figure, based around copper-reddish, brownish, and bright carmine; delicate nuances of colorful grays in the standing figure to the right: silvery bright blue-gray, dove-gray, blue and turquoise grays . . . The barely definable, shimmering brownish tone of the field in the middle distance takes on a slender pink-violet tone against the gray-scale of the figure at the back, which is echoed again in the slightly darkened foreground.[1]

Do you see the image? Of course not, although the words begin to paint a picture of their own. Color, like music, takes a shortcut to our senses and our emotions. The Church understood this in the Middle Ages; so have the greatest painters, as well as propagandists, advertisers, and designers. No wonder philosophers and linguists so love to debate color—it tempts, teases, and eludes them at the same time that it promises wonders and deep secrets.

Well, then, where does one start to learn this language? I am quite sure that there is no best answer. I have approached it through the *substance* of

color; and if that is partly because I have been trained as a chemist, it is also because I relish paint and pigments as materials, with appearances, smells, textures, and names that entice and intoxicate. Here is one language of color that I can interpret already: phthalocyanine speaks to me of chlorophyll and blood, vermilion conjures up the sulfur and mercury of the alchemists. Yet the painter's use of color has not only its unique chemistry but also its historical traditions, its psychology, its prejudices, its religiosity and mysticism.

I imagine that were I ever to acquire fluency in a foreign language, I would, on entering the country where the language was spoken, experience something of what I felt after revisiting the National Gallery several months into this project. Through the agency of color I could begin to understand, or at least to catch fragments of, what was being said on the walls all around. Where before there were two-dimensional images in gilded frames, there was now a living world. Each picture seemed as though it had just left the artist's workshop or studio, the paint's transition from palette to panel or canvas almost visible in the brush marks. Of course, time, too, has left its mark: paintings often need more decoding than the artist intended, as greens darken to black and reds fade to pink. In the end, learning the language of color is really about learning to see.

I have been deeply fortunate to benefit, in this learning process, from the advice of people who have far greater fluency in the language than I shall ever attain. My thanks go to Tom Learner at the Tate Gallery, Jo Kirby at the National Gallery, John Gage at the University of Cambridge, Martin Kemp at the University of Oxford, Helen Skelton and David Lewis at the University of Leeds, and most of all Joyce Townsend at the Tate, who not only helped with materials and information but read the entire draft manuscript diligently. I am indebted to the Royal College of Art for the use of its splendid Colour Reference Library and to my editors, Andrew Kidd and John Glusman, for helping the book find its shape. The sustaining interest and enthusiasm of many friends and colleagues is, of course, the nutrition that every writer needs and can never adequately acknowledge.

<div style="text-align: right">

Philip Ball
London, 2001

</div>

Note: I have often used the masculine third person to denote a generic painter until the twentieth century. This is simply an attempt to be consis-

tent with the historical record: female painters were usually such rare exceptions that "his or her" would jar within the context. We can deplore the inequities of earlier ages without trying to deny them. But as you will see, some women were able to become painters even in the most chauvinistic of times.

BRIGHT EARTH

THE EYE OF
THE BEHOLDER

THE SCIENTIST IN THE STUDIO

"The starting point is the study of color and its effects on men."
—Wassily Kandinsky (1912), *Concerning the Spiritual in Art*

"Then the man in the blue suit reaches into his pocket and takes out a large sheet of paper, which he carefully unfolds and hands to me. It is covered with Picasso's handwriting—less spasmodic, more studied than usual. At first sight, it resembles a poem. Twenty or so verses are assembled in a column, surrounded by broad white margins. Each verse is prolonged with a dash, occasionally a very long one. But it is not a poem; it is Picasso's most recent order for colors . . .

"For once, all the anonymous heroes of Picasso's palette trooped forth from the shadows, with Permanent White at their head. Each had distinguished himself in some great battle—the blue period, the rose period, cubism, 'Guernica' . . . Each could say: 'I too, I was there . . .' And Picasso, reviewing his old comrades-in-arms, gives to each of them a sweep of his pen, a long dash that seems a fraternal salute: 'Welcome Persian red! Welcome emerald green! Cerulean blue, ivory black, cobalt violet, clear and deep, welcome! Welcome!' "
—Brassaï (1964), *Picasso and Company*

I believe that in the future, people will start painting pictures in one single color, and nothing else but color." The French artist Yves Klein made this remark in 1954, before embarking on a "monochrome" pe-

riod in which each work was composed from just a single glorious hue. This adventure culminated in Klein's collaboration with Paris paint retailer Édouard Adam in 1955 to make a new blue paint of unnerving vibrancy. In 1957 Klein launched his manifesto with an exhibition, "Proclamation of the Blue Epoch," that contained eleven paintings in his new blue.

By saying that Yves Klein's monochrome art was the offspring of chemical technology, I mean something more than that his paint was a modern chemical product. The very *concept* of this art was technologically inspired. Klein did not just want to show us pure color; he wanted to display the glory of *new* color, to revel in its materiality. His striking oranges and yellows are synthetic colors, inventions of the twentieth century. Klein's blue was ultramarine, but not the natural, mineral-based ultramarine of the Middle Ages: it was a product of the chemical industry, and Klein and Adam experimented for a year to turn it into a paint with the mesmerizing quality the artist was seeking. By patenting this new color, Klein was not simply protecting his commercial interests but also hallmarking the authenticity of a creative idea. One could say that the patent was a part of his art.

Yves Klein's use of color became possible only when chemical technology had reached a certain level of maturity. But this was nothing new. For as long as painters have fashioned their visions and dreams into images, they have relied on technical knowledge and skill to supply their materials. With the blossoming of the chemical sciences in the early nineteenth century it became impossible to overlook this fact: chemistry was laid out there on the artist's palette. And the artist rejoiced in it: "Praise be to the palette for the delights it offers . . . It is itself a 'work,' more beautiful, indeed, than many a work," said Wassily Kandinsky in 1913. The Impressionist Camille Pissarro made the point forcefully in his *Palette with a Landscape* (1878), a pastoral scene constructed directly on his palette by pulling down the bright colors dotted around its edges.

The Impressionists and their descendants—van Gogh, Matisse, Gauguin, Kandinsky—explored the new chromatic dimensions opened up by chemistry with a vitality that has arguably not been equaled since. Their audiences were shocked not only by the breaking of the rules—the deviation from "naturalistic" coloration—but by the sight of colors never before seen on canvas: glowing oranges, velvety purples, vibrant new greens. Van Gogh dispatched his brother to acquire some of the brightest, most striking of the new pigments available and wrought them into disturbing compositions whose strident tones are almost painful to behold. Many people were

dumbfounded or outraged by this new visual language: the conservative French painter Jean-Georges Vibert rebuked the Impressionists for painting "only with intense colors."

It was a complaint that echoes back through the ages, to be heard whenever chemistry (or foreign trade, which also broadens a culture's repertoire of materials) has made new or superior colors available to painters. When Titian, Henry James's "prince of colorists," took advantage of having the first pick of the pigments brought to the thriving ports of Venice to cover his canvases with sumptuous reds, blues, pinks, and violets, Michelangelo remarked sniffily that it was a pity the Venetians were not taught to draw better. Pliny bemoaned the influx of bright new pigments from the East to corrupt the austere coloring scheme that Rome inherited from classical Greece: "Now India contributes the ooze of her rivers and the blood of dragons and of elephants."

That the invention and availability of new chemical pigments influenced the use of color in art is indisputable. As art historian Ernst Gombrich says, the artist "cannot transcribe what he sees; he can only translate it into the terms of his medium. He, too, is strictly tied to the range of tones which his medium will yield."[1]

So it is surprising that little attention has been given to the matter of how artists obtained their colors, as opposed to how they used them. This neglect of the material aspect of the artist's craft is perhaps a consequence of a cultural tendency in the West to separate inspiration from substance. Art historian John Gage confesses that "one of the least studied aspects of the history of art is art's tools." Anthea Callen, a specialist on the techniques of the Impressionists, makes a stronger criticism:

> Ironically, people who write on art frequently overlook the practical side of their craft, often concentrating solely on stylistic, literary or formal qualities in their discussion of painting. As a result, unnecessary errors and misunderstandings have grown up in art history, only to be reiterated by succeeding generations of writers. Any work of art is determined first and foremost by the materials available to the artist, and by the artist's ability to manipulate those materials. Thus only when the limitations imposed by artists' materials and social conditions are taken fully into account can aesthetic preoccupations, and the place of art in history, be adequately understood.[2]

One might expect the "craft" aspects of art to suffer less neglect when the use of color is under discussion, for surely the nature of materials

should then come naturally to the fore. But it is not always so. Faber Birren admits in his classic *History of Color in Painting* that "the choice of colors for a palette or palettes is not in any way concerned with chemistry, or with permanence, transparency, opacity, or any of the *material* aspects of art." This extraordinary omission of the substantial dimension of color is surely the precondition for such absurdities as Birren's assigning cobalt blue to the palette of Rubens and his contemporaries almost two centuries before its invention.[3] In view of the attention that Birren gives to the hues required for a "balanced palette," it is indeed odd how little concerned he is with whether artists of different eras had access to them.

PAINT AND THE PAINTER

Every painter must confront the question: What is color *for*? Bridget Riley, one of the modern artists most concerned with color relationships, has expressed the dilemma very clearly:

> For painters, colour is not only all those things which we all see but also, most extraordinarily, the pigments spread out on the palette, and there, quite uniquely, they are simply and solely colour. This is the first important fact of the painter's art to be grasped. These bright and shining pigments will not, however, continue to lie there on the palette as pristine colours in themselves but will be put to use—for the painter paints a picture, so the use of colour has to be conditioned by this function of picture making . . . The painter has two quite distinct systems of colour to deal with—one provided by nature, the other required by art—perceptual colour and pictorial colour. Both will be present and the painter's work depends upon the emphasis they place first upon the one and then upon the other.[4]

This is not a contemporary conundrum but one that has confronted artists of all eras. And yet there is something missing from Riley's formulation of the artist's situation. Pigments are *not* "simply and solely colour" but substances with specific properties and attributes, not least among them cost. How is your desire for blue affected if you have just paid more for it than for the equivalent weight in gold? That yellow looks glorious, but what if its traces on your fingertips could poison you at your supper table? This orange tempts like distilled sunlight, but how do you know that it will not have faded to dirty brown by next year? What, in short, is your relationship with the materials?

Raw color supplies more than a physical medium from which artists can construct their images. "Materials influence form," said American artist Morris Louis in the 1950s; but *influence* is too weak a word when we are faced with the explosive vibrancy of Titian's *Bacchus and Ariadne* (1522–1523), Ingres's *Odalisque with a Slave* (1839–1840), or Matisse's *Red Studio* (1911). This is art that follows directly from the impact of color, from possibilities delimited by the prevailing chemical technology.

But although technology made Yves Klein's monochromes possible for the first time, it would be meaningless to suggest that Rubens did not paint them because those colors were not available to him. It is equally absurd to suppose that, but for a technical knowledge of anatomy and perspective and the chemical prowess to extend the range of pigments, the ancient Egyptians would have painted in the style of Titian. Use of color in art is determined at least as much by the artist's personal inclinations and cultural context as by the materials at hand.

So it would be a mistake to assume that the history of color in art is an accumulation of possibilities proportional to the accumulation of pigments. Every choice an artist makes is an act of exclusion as well as inclusion. Before we can gain a clear understanding of where technological considerations enter the decision, we must appreciate the social and cultural factors at work on the artist's attitudes. In the end, each artist makes his or her own contract with the colors of the time.

LEONARDO'S QUEST

Ernst Gombrich asserts that "art is altogether different from science," but the reason he gives will bring a rueful smile to the lips of many a scientist: "Art itself can hardly be said to progress in the way in which science progresses. Each discovery in one direction creates a new difficulty somewhere else." One can see that Gombrich never dabbled in science.

Exploring the link between art and science is back in fashion, but the debate is dominated by the supposition of cognate *ideas* and sources of inspiration. Artists of all persuasions today may be found mining the rich seam of association that crystallizes from our genetic inheritance, just as one can draw analogies between relativity and Cubism, between quantum mechanics and the works of Virginia Woolf.

This is all well and good insofar as it speaks of the much-needed cultural assimilation of scientific ideas (albeit commonly in a distorted or half-

digested form). But it appears that we are happier in the realm of the intellectual than that of the tangible.

Yet this Cartesian-like division of material and mind has not always reflected the attitude of the practicing artist. It is only in the past half-century or so that every conceivable subdivision and admixture of the rainbow has been available in off-the-shelf tubes. Until the eighteenth century, most artists ground and mixed their own pigments or at least had this process conducted in their studios. The almost sensual pleasure for the material component of color evinced by medieval craftsmen like the Italian Cennino Cennini demonstrates that artists of his time were on intimate terms with their paints and possessed some considerable skill as practical chemists.

Moreover, before the Age of Reason, the distinction between art and science was not synonymous with that between intuition and rationality. In medieval times, men of science were chroniclers of antique knowledge and theory—a practice that did not necessarily require an inquiring mind. "Art," by contrast, implied technical or manual skill, and a chemist was as much an artist as a painter was. The artist was valued not for his imagination, passion, or inventiveness but for his ability to do a workmanlike job.

This was the world in which Leonardo da Vinci lived and worked. Vladimir Nabokov once said that he would be more interested in C. P. Snow's famous "Two Cultures" debate if their disjunction did not seem to him more of a ditch than an abyss. Leonardo barely seemed to notice so much as a ditch. The ease with which he passed between his roles as artist, technologist, and natural philosopher remains remarkable even when we remember that these distinctions were by no means as rigid during the Renaissance as they are today.

Scholarly circles in Leonardo's fifteenth-century Florence were alive with discussion about the role of reason, geometry, and mathematics in art. Leonardo himself was a firm advocate of the need for the artist to imitate nature as exactly as possible, which entailed learning the mathematical rules that governed nature: "Those who devote themselves to [artistic] practice without science are like sailors who put to sea without a rudder or compass and who can never be certain where they are going."[5]

Yet how readily we see Leonardo's boundary-straddling through modern eyes. In stressing the importance of science in art, Leonardo had an agenda that was very much a product of its time. By emphasizing the role of mathematics, he attempted to elevate the status of painting to a liberal art, alongside geometry, music, rhetoric, and astronomy. These arts were

those deemed worthy of serious intellectual study at the universities, whereas painting had been regarded since the Middle Ages as a craft, a lowly manual skill. Such activities had in the classical age often been performed by slaves, and painters of Leonardo's time were desperate to throw off this stigma. By arguing for the acceptance of painting as a liberal art, they sought to advance their own social standing.

The artists would plead their cause by pointing out that many great men of antiquity had shared their trade and that kings and (more recently) popes had conferred favor on them. In his book *Della pittura* (*On Painting*, 1435), the Florentine architect and artist Leon Battista Alberti (1404–1472) reminded his readers that

> the number of painters and sculptors was enormous in those days, when princes and people, and learned and unlearned alike, delighted in painting . . . Eventually Paulus Aemilius and many other Roman citizens taught their sons painting among the liberal arts in the pursuit of the good and happy life. The excellent custom was especially observed among the Greeks that free-born and liberally educated young people were also taught the art of painting together with letters, geometry and music.[6]

Leonardo, Alberti, and their fellow painters questioned how poetry could be accepted as a liberal art while the creation of beautiful images in paint rather than in words was not. "Write up in one place the name of God," said Leonardo, "and put a figure representing him opposite, and see which will be the more reverenced."[7]

The artists' cause demanded that they dissociate themselves from craftsmen and ally their skills with mathematics and abstract thought. "Painting," said Alberti, "was honoured by our ancestors with this special distinction that, whereas all other artists were called craftsmen, the painter alone was not counted among their number."[8]

This could not but have encouraged artists to downplay the material aspects of painting, such as the creation and grinding of pigments. In turn, this surely contributed to the desire of the Florentine painters to emphasize drawing and line (*disegno*) above the use of color (*colore*), initiating a dispute that lasted for centuries. Dismissive comments such as those of Equicola in the sixteenth century could only have egged them on: "Painting has no other concern except with copying nature with various appropriately chosen colors."

By the late fifteenth century, Leonardo and his fellow painters had

largely won their battle, but at the cost of simply reinforcing the bigotry that they inherited from classical times. Nowhere does Leonardo challenge the underlying hierarchy that values the intellectual over the manual. Instead, he seeks to relocate the craft of the medieval painter on an abstract plane. Thus did art begin to fragment into the "pure" and the "applied," a distinction not seriously challenged until the nineteenth century. In *The Two Paths* (1859), John Ruskin deplores art's own "two cultures" and argues that decorative art and craft should not be regarded as "a degraded or separate kind of art." With William Morris and others, Ruskin tried to reunite the craftsperson with the fine artist in the Arts and Crafts movement. It is not clear that they enjoyed much success: Art Nouveau came and went, but artistic elitism remains.

CHEMISTRY AND ART

The relation of painting to the liberal arts in Leonardo's time was wholly analogous to the standing of chemistry in relation to natural philosophy, or what we would now call science. Those who pursued the chemical arts, who dwelt in smoky laboratories and wrought useful things, were excluded from the lofty halls of academic science. Science historian Lawrence Principe says of this prescientific chemistry, or "chymistry":

> It has long been recognized that one of the "problems" of chymistry before the eighteenth century was its status as a practical or technical art rather than as a branch of natural philosophy. The low status of chymistry as determined by its use amongst low technical appliers militated against its acceptance by many natural philosophers.[9]

Thus the Anglo-Irish chemist Robert Boyle, in his polemic *The Sceptical Chymist* (1665), denounces the ignorance of the "vulgar chymists," including not only the out-and-out cheats who sought to profit from faked alchemical transformations but also the "laborants" such as the dyers, distillers, and apothecaries who lacked theoretical knowledge. Leonardo had nothing at all to gain by aligning his cause with such a crowd, and so there is good reason for him to gloss over the chemical aspects of art.

That cannot, however, excuse the persistent perception of unseemliness in the idea that science provides art not only with concepts but also with

materials. The snobbery and ignorance apparent in the words of the Bauhaus architect Le Corbusier (Charles-Édouard Jeanneret) and his collaborator Amédée Ozenfant in 1920 are breathtaking:

> It is form which comes first, and everything else should be subordinated to it . . . Cézanne's imitators were quite right to see the error of their master, who accepted without examination the attractive offer of the color vendor, in a period marked by a fad for color chemistry, a science with no possible effect on great painting. Let us leave to the clothes dyers the sensory jubilations of the paint tube.[10]

Let's not be too distracted by the absurdity of the suggestion that Cézanne—not the Impressionists or the Fauves but Cézanne!—was an undiscerning dauber of raw color. What is more telling is the way that Le Corbusier denigrates manual skills and delight in substance in favor of "form" and abstract space. This passage could almost have been written by the most bigoted of late-sixteenth-century Italian scholars praising *disegno* over *colore*. To deny that color chemistry can have any possible effect on "great painting" is, in the end, to claim that great art is all in the head and cheapened by the sad necessity to reconstruct it from mere matter.

The connection to chemistry was perhaps deemed less distasteful in the nineteenth century, when chemists enjoyed unrivaled respectability (even Goethe used their metaphors). An anonymous writer on artistic technique in 1810 says cautiously: "Chemistry is to painting what anatomy is to drawing. The artist should be acquainted with them but not bestow too much time on either." Yet even this much may be seen as a swan song to the era when the painter was of necessity something of a chemist, when a training in art required at least as great an attention to the mechanical and practical aspects as to the aesthetic and intellectual. By the end of the nineteenth century, the artist was wholly reliant on scientifically adept professionals—"colormen"—to attend to the chemical aspects of their profession. One consequence of this rift is that the colors of some works of that period have weathered less well than the jewel-like fifteenth-century paintings of Jan van Eyck.

Chemistry is a topic that strikes fear into many a heart, and there seems little point in seeking to evade that fact. Unusual among artists, students of ceramics are one group who still must learn some real chemistry—the whole package: balanced equations, the periodic table, atomic weights, and so forth. In my experience, this does not make them feel any better about

it. There appears to be something intimidating about the dizzying varieties in which matter is composed from elemental blends and, if we are honest about it, something vaguely ominous and unsettling about the gray metallic minarets and industrial pipelines within which these blends are concocted today. It is a challenge to the imagination to connect these ugly factories and alien or unsettling names—cadmium, arsenic, antimony—with the stuff that, smeared over canvas, leaves us breathless in art galleries. Can such a villain (and the chemical industry's transgressions are not all imaginary) be responsible for this beauty?

The truth—a dirty truth, if you will—is that new colors for artists have long been a by-product of industrial chemical processes that reach out to a much wider market. Without the engine of commerce to drive it, the manufacture of these new pigments would simply have not been viable. Artificial copper blues, or "verditers," the principal cheap alternatives to expensive blue pigments from the fifteenth to the eighteenth century, were a side product of silver mining. They were largely replaced by Prussian blue, produced primarily for the massive textile-dyeing industry rather than the tiny market in artists' colors. The Mars colors (artificial iron oxides) could not have been made without the availability of cheap sulfuric acid, which was manufactured primarily as a textile bleach. The pigment known as patent yellow was an offshoot of the soda industry, and the manufacture of chrome yellow was stimulated by its use in cotton printing. Textile dyeing also led to a better understanding of the use of metals for the fixing (mordanting) of dyes, which then drove improvements in the preparation of "lake" pigments in the early nineteenth century. The almost ubiquitous white pigment of the twentieth century, titanium dioxide, is produced almost entirely for commercial paints—the amount diverted to artists' materials is trivial.

Might it be exciting to see not only an art history but also an art that reflects these connections? The commercial aspects of color manufacture have indeed influenced some twentieth-century artists. But aren't naked pigments already works of art, the products of skill and creativity, substances of glorious elegance and splendor? The Anglo-Indian artist Anish Kapoor thinks so (Plate 1), and Yves Klein did too.

It is commonly asserted that the interaction between art and science is a one-way street, but in fact the relationship between chemistry and art has been of benefit to both. The modern chemical industry was spawned and nurtured largely by the demand for color. Important advances in synthetic

chemistry in the nineteenth century were stimulated by the quest for arti-
ficial colors. Many of the world's major chemical companies—BASF, Bayer,
Hoechst, Ciba-Geigy—began as manufacturers of synthetic dyes. And the
reproduction of art and color in photography and printing has given rise to
major technological companies such as Xerox and Kodak.

There is, meanwhile, ample precedent for the collaboration between
art and chemistry personified in Klein and Adam. Michael Faraday advised
J.M.W. Turner on his pigments. The German chemistry Nobel laureate
Wilhelm Ostwald worked with the German paint industry in the 1920s,
and his theory of color was hotly debated at the Bauhaus, where Klee and
Kandinsky taught. In more distant times, painters consorted with al-
chemists to procure their colors. In this story about science, technology,
culture, and society, there are no chickens and no eggs. Chemical science
and technology and the use of color in art have always existed in a symbi-
otic relationship that has shaped the course of both throughout history. By
tracing their coevolution, we shall see both how art is more of a science
and science more of an art than is commonly appreciated on either side of
the fence.[11]

FEAR AND LOATHING OF COLOR

Yves Klein invites us to engage with the beauty of raw color. This goes
against our training. What is brightly colored? Children's toys, the Land of
Oz. And so color threatens us with regression, with infantilism. Cultural
theorist Julia Kristeva claims that "the chromatic experience constitutes a
menace to the 'self' . . . Colour is the shattering of unity."[12] What else is
brightly colored? Vulgar things, vulgar people. Color speaks of heightened
emotions, even linguistically, and of eroticism. Pliny is not alone in xeno-
phobically attributing strong color to a kind of decadent orientalism. Le
Corbusier asserted that color was "suited to simple races, peasants, and
savages." He found it in abundance in his "journey to the East" and was
repelled: "What shimmering silks, what fancy, glittering marbles, what op-
ulent bronzes and golds . . . Let's have done with it . . . It is time to crusade
for whitewash and Diogenes"[13]—which is to say, for cool reason over all
this unseemly passion.

The nineteenth-century art theorist Charles Blanc (what's in a name?)
insisted that "design must maintain its preponderance over color. Other-

wise painting speeds to its ruin: it will fall through color just as mankind fell through Eve."[14] Here, then, is another reason to distrust color: it is feminine. Contemporary artist David Batchelor argues that a fear of color —"chromophobia"—pervades Western culture.[15] "Man," said Yves Klein, "is exiled far from his colored soul."[16]

But perhaps chemists, who are on intimate terms with the materiality of color, who have seen the majestic rainbow progression of manganese through its different states of oxidation, who have watched the royal, clear blue of ammoniacal copper sulfate emerge from the pale, opaque blue of its alkaline precipitate—perhaps they are especially attuned to and appreciative of unadulterated color. Oliver Sacks recalls the allure of chemistry's liquid colors in his childhood:

> My father had his surgery in the house, with all sorts of medicines, lotions, and elixirs in the dispensary—it looked like an old-fashioned chemist's shop in miniature—and a small lab with a spirit lamp, test tubes, and reagents for testing patients' urine, like the bright-blue Fehling's solution, which turned yellow when there was sugar in the urine. There were potions and cordials in cherry red and golden yellow, and colourful liniments like gentian violet and malachite green.[17]

To the chemist, color is a bountiful clue to composition and, if measured carefully enough, can reveal delicate truths about molecular structure. It takes a particular turn of mind to see chromatic beauty lurking in the molecular structures of alizarin and indigo, to sense the rich hues within the stark, schematic depictions of these dye molecules. The Italian chemist and writer Primo Levi intimates how this relation between color and constitution broadens the chemist's sensitivity to color: "I find myself richer than other writers because for me words like 'bright,' 'dark,' 'heavy,' 'light,' and 'blue' have a more extensive and more concrete gamut of meanings. For me 'blue' is not only the blue of the sky. I have five or six blues at my disposal."[18]

NAMING COLORS

Before we can adequately explore what color means to the artist, we must ask what we mean by color itself. This might seem uncontentious enough. In spite of the old solipsism that I can never know if my experience of red

is the same as yours, we both agree when the term is appropriate and when it is not. Yet there are hordes of "lower-level" color terms in most modern languages over which the scope for dispute is limitless: When does puce become russet, burgundy, rust red? This is partly a matter for perceptual psychology, but the language of color reveals much about the way we conceptualize the world. Linguistic considerations are often central to an interpretation of the historical use of color in art.

Pliny claimed that the painter in classical Greece used only four colors: black, white, red, and yellow. This noble and restrained palette, he said, is the proper choice for all sober-minded painters. After all, didn't Apelles, the most famous painter of that golden age, choose to limit himself to this austere range?

We cannot check the accuracy of this claim, for all of Apelles' works are lost, along with almost every other painting his culture produced. Yet we do know that the Greeks possessed a considerably wider range of pigments than these four. As for the Romans, no fewer than twenty-nine pigments have been identified in the ruins of Pompeii. Might Pliny have exaggerated the paucity of Apelles' palette? And if so, why? In part, the reason might be metaphysical: four "primary" colors equates neatly with the Aristotelian quartet of elements: earth, air, fire, water. But the breadth of color use in classical painting may also be obscured by linguistics. In interpreting archaic writings on the use of color in art, there, is for example, ample scope for confusion of red and green. The medieval term *sinople*—derived from Pliny's *sinopis*, which in turn stemmed from the geographical source of a red earth pigment at Sinope on the Black Sea—could refer to either red or green until at least the fifteenth century. The Latin *caeruleum* carries a similar ambiguity between yellow and blue (its root is the Greek *kuanos*, which can in some contexts denote the dark-green color of the sea). There is no Latin word for brown or gray, but this does not imply that the Roman artists did not recognize or use brown earth pigments.

How could red and green ever be conflated? From a modern-day perspective this appears absurd, because we have in our minds Isaac Newton's rainbow spectrum and its corresponding color terminology, with its seven bands firmly delineated. The Greeks saw a different spectrum, with white at one end and black at the other—or more properly, light and dark. All the colors lay along the scale between these two extremes, being admixtures of light and dark in different degrees. Yellow was toward the light end (it appears the brightest of colors for physiological reasons). Red and green

were both considered median colors, midway between light and dark—and so in some sense equivalent. The reliance of medieval scholars on classical Greek texts ensured that this color scale was perpetuated for centuries after the temples of Athens stood in ruins. In the tenth century A.D. the monk Heraclius still classified all colors as black, white, and "intermediate."

The confusion of blue and yellow may have been purely linguistic, or it may have its origin in the naming of colors after the materials that supplied them. For reasons that are far from clear, blue and yellow are categorized together in many languages and cultures, including some Slavic tongues, the Ainu language of northern Japan, the Daza language of eastern Nigeria, and that of the Mechopdo Native Americans in northern California. The Latin *flavus*, meaning "yellow," is the etymological root of English *blue*, French *bleu*, and German *blau*.

The location of blue at the dark end of the scale gives us another reason to be wary of its apparent exclusion from Pliny's list: it was seen as a variant of black, and Greek terms for the two overlap.

Thus whether or not an artist considers two hues to be different colors or variants of the same color is largely a linguistic issue. The Celtic word *glas* refers to the color of mountain lakes and straddles the range from a brownish green to blue. The Japanese *awo* can mean "green," "blue," or "dark," depending on the context. Vietnamese and Korean also decline to distinguish green from blue. Some languages have only three or four color terms.

As there are no culture-independent concepts of basic colors, it seems impossible to establish a universal basis for a discussion of color use. In 1969, however, anthropologists Brent Berlin and Paul Kay attempted to bring some order to the mass of conflicting categories by proposing a kind of color hierarchy, according to which hues emerge in a universal order as the complexity of a culture's color terminology increases. First, they said, comes a distinction between light and dark, or white and black. Australian aboriginals and speakers of the Dugerm Dani tongue of New Guinea have only two color terms, with essentially these meanings. Red is the next color to be identified as a distinct hue. Then either green or yellow is added to the list, followed by the other of the two. After this comes blue, and gradually the more complex secondaries and tertiaries are included— brown first, then (in any order) purple, orange, pink, and gray. So according to Berlin and Kay, there can be no language that has terms for just black, white, and green, or just yellow and blue. Color vocabulary, they said, unfolds in a strict sequence.

The validity of Berlin and Kay's idea, which was based largely on anthropological and linguistic studies of contemporary nontechnological cultures, has been much questioned. For example, Hanunoo, which is spoken by a Malayo-Polynesian people in the Philippines, has four color terms: "dark" and "light," which we can equate readily enough with black and white, but also "fresh" and "dry" (insofar as they can be matched with English words at all). Some prefer to ally these two with green and red, but they seem to allude to texture as much as to hue. There is no Hanunoo word meaning "color."

Yet Berlin and Kay's synoptic scheme nevertheless affords some foundation for a discussion of what has been meant by "color" through the ages, and there seems good reason to regard it as expressing at least a partial truth. A part of the difficulty of applying the theory is that it presupposes the existence of "basic" color terms—words for hues that have no dependence on context. This is not always true even in complex modern languages. The French *brun*, for instance, is not the strict equivalent of English *brown* but can be supplanted by *marron* or *beige* in certain situations while implying "dark," rather than a specific hue, in others.

In ancient Greek it is all but impossible to identify basic color terms in the sense of Berlin and Kay. This has led some commentators to assume that the Greeks had poor color awareness. In 1921 Maurice Platnauer claimed that "colours made a much less vivid impression upon their senses . . . or . . . they felt little interest in the qualitative differences of decomposed and partially absorbed light."[19] Color technologist Harold Osborne reiterated the point in 1968, saying that the Greeks were "not given to careful discrimination of color hue."

But there is no reason to suppose that our ability to distinguish colors is limited by the structure of our color vocabulary. We can tell apart hues to which we cannot ascribe names—indeed, the vast majority of distinguishable hues are not named specifically in any language. So we should rather conclude that for the Greeks, "color" had a rather different meaning (although they had a word—*chroma* or *chroia*—that is usually translated in this way). Since their colors lay on a scale between light and dark, brilliance or luster, as well as hue, could be valid discriminants. Platnauer suggested that "it is lustre or superficial effect that struck the Greeks and not what we call colour or tint"—an oversimplification, perhaps, but probably true in essence. He points out that the same word is used in the Greek literature to describe darkened blood and a cloud or to describe the glint of metal and a tree. This is presumably the explanation for Homer's famously puzzling

"wine-dark" (*oinopos*) sea in the *Odyssey*. Ludwig Wittgenstein voiced the same idea in his *Remarks on Color*: "Mightn't shiny black and matte black have different color names?" (In his black monochromes of the 1960s, the American minimalist artist Ad Reinhardt used these two as if they were indeed distinct colors.)

The Greeks certainly possessed color terms, but none that are obviously "basic." *Red* is generally equated with *eruthos* (to which it is etymologically related), but there is no good case for giving this term primacy over *phoinikous* or *porphurous*, as there is for *red* over *scarlet* or *crimson*. Similarly, *green* could be rendered as *chloros*, *prasinos*, or *poodes*, depending on the context.

Linguist John Lyons suggests that it is safest to conclude only that colors "are the product of language under the influence of culture." The fluidity of color terminology led to a frequent reliance on materials, rather than abstract concepts of hue, as the basis of a discussion about artists' use of color. Pliny's four classical colors were not simply "black," "white," and so forth, but "white from Milos" and "red from Sinope on the Black Sea"—they were embodied in specific pigments. Without a secure theoretical basis for classification, talk of color needs to be rooted in the physical substances that provide it. Yet this simply creates fresh scope for ambiguity, for the substance can mutate into a color term in its own right. Scarlet, for example, was once a kind of medieval dyed cloth that need not have been red at all.

TRUE COLORS

It is tempting to regard modern and abstract painters as the first to consciously decide that they would not simply try to paint "what they saw." Yet the most casual of glances at any image from the Renaissance or the Baroque period shows how much the work is guided by certain conventions and at the same time by imagination and interpretation, rather than being an attempt to depict nature as faithfully as possible. Many artists through the ages have talked of painting "true to nature," but this means many things, of which the advent of photography has encouraged us to select just one.

For example, until the late nineteenth century, using color to mimic nature was necessarily an artifice in at least this respect: nearly all paintings were produced in studios with reliance on the painter's judgment about

"proper" composition and contrast. It was only when the painting of finished works (as opposed to reference studies) out of doors was pioneered by the French Realists and later adopted by the Impressionists that artists began to liberate themselves from academic notions about light and shade, to see the purples and blues in shadows, the yellows and oranges in "white" sunlight.

Let us nevertheless accept the idea that Western art from antiquity to the advent of abstraction has purported to depict the forms of nature in a basically representational manner. So, then, the artist presumably sought sufficient pigments to permit an accurate translation of his or her visual impressions? If only it were so simple! Since (as the ancients believed) the world could be depicted by good drawing alone, was color not merely superfluous decoration? "One who haphazardly throws around even the most beautiful colors," said Aristotle, "cannot delight the eye as one who has drawn a simple figure against a white background."

Moreover, classical art was not slavishly imitative but largely symbolic. Pliny's four-color scheme was linked more closely to metaphysics than to any relation with the hues of nature, which on a fine day in the hills of Greece would be saturated with the very colors—green and blue—that the scheme omits.

Furthermore, the Greek penchant for idealization and intellectual abstraction led to the notion that mixed colors are inferior both to "pure" natural pigments and to the "true" colors of nature. So there was little point in attempting to match artists' colors to nature's by mixing them together. This practice was discouraged by classical scholars: "Mixing produces conflict," says Plutarch in the first century A.D. It was common to refer to the blending of pigments as "deflowering": a loss of virginity. Aristotle calls color mixing a "passing away."

But there was also a technical inhibition toward mixing. Because the available pigments were not pure primary colors, mixing resulted in a diminution of tone toward grayness or brownness and so was indeed a degrading process. This reluctance to mix pigments might explain some of the curious claims about painting made in the classical literature, which would have readily been disproved by experiment: that red and green could generate yellow or that (as Aristotle suggested) no pigment mixture could generate violet or green. Greek painters were prepared to glaze a translucent color over an opaque one, but mixing "on the palette" was usually restricted to the use of white or black for highlights and shadows.

This self-imposed limitation on the range of available colors is just one

of the reasons why it would be incorrect to regard ancient and medieval art as an attempt to render the world naturalistically with an imperfect technique and a constrained palette. As Ernst Gombrich says, "The painters of the Middle Ages were no more concerned about the 'real' colours of things than they were about their real shapes." The painter of the early Middle Ages had no difficulty with the concept of proportion; he simply did not regard it as very important. He was typically an anonymous monk whose task it was to illustrate the stories of the Gospels in a way that conveyed devotion and piety. The picture was schematic, even formulaic—a kind of writing in pictures. In the late Middle Ages, beauty and the display of wealth became as important in religious art as they were in all aspects of Holy Rome's domain, but that did not entail any need for naturalism. Quite the contrary—it became desirable to display the most costly and wonderful pigments in flat, unbroken fields of color: vermilion, ultramarine, and gold. These colors had merely to be laid out on the panel to inspire admiration and awe in onlookers.

Thus medieval color use is seldom complex. The skill lay not in creating subtle gradations of color but in arranging raw pigments harmoniously in the scene. This is why a late-medieval craftsman like Cennino Cennini could, in *Il libro dell'arte* (*The Craftsman's Handbook*, c. 1390), provide the artist not just with practical advice about the preparation of pigments and panels or the techniques of painting *alla fresco* and *a secco* but also with prescriptions for depicting flesh, drapery, and water as if painting were nothing but a mechanical craft. Similarly, Leon Battista Alberti discusses juxtapositions of color almost as if arranging a series of wooden blocks—or in this case the robes of a series of nymphs:

> If red stands between blue and green, it somehow enhances their beauty as well as its own. White lends gaiety, not only when placed between grey and yellow, but almost to any colour. But dark colours acquire a certain dignity when between light colours, and similarly light colours may be placed with good effect among dark.[20]

There is in this advice a hint of the ideas about color harmony that were to recur throughout artistic theory from the Renaissance to the twentieth century. But with Alberti it is a question of juxtaposed color fields, reminiscent of the works of a modernist like Mondrian, rather than the blending and contrasting hues of the Venetian Old Masters. Moreover, Alberti betrays an abiding concern with the integrity of the pure pigment—with

preserving the raw color and avoiding practices that would muddy it or de-
grade its brilliance. Highlight and shadow, he advises, should be rendered
simply by adding white and black—and with great restraint, lest the virtue
of the color be degraded:

> Those painters who use white immoderately and black carelessly should be
> strongly condemned. It would be a good thing if white and black were made
> from those pearls Cleopatra dissolved in vinegar, so that painters would be-
> come as mean as possible with them, for their works would then be both
> more agreeable and nearer the truth.[21]

Here "truth" means true to the glory of the materials rather than cap-
turing what nature reveals to the eye. All the same, Alberti's remarks on
color reflect the humanism of the Renaissance more than the symbolic ma-
terialism of the Middle Ages. His book concerns itself only with secular
painting, whereas Cennino makes several references to religious works,
like a workman describing how to lay the bricks for a church. For Alberti,
the use of the finest colors is not to please God but to satisfy the patron
who has commissioned the work and who, in all likelihood, contractually
specified the pigments to be used.

A LEAP INTO THE VOID

At the center of Alberti's discussion of color is the question that all painters
had to address once the prescriptive approach of the Middle Ages was dis-
carded: how to *organize* color. The artist of the twentieth century faced the
same question, although the rules had changed dramatically. Whereas Re-
naissance painters disagreed over *how* to paint, they had little dispute over
what to paint. But in the early twentieth century, painters began first to
abandon "naturalistic" coloring and then to discard naturalistic form.

The consequent problem was analogous to that confronting the con-
temporaneous atonal composers: If trees can be blue, skies pink, and faces
yellow, how does one choose the color at all? Without a "natural" refer-
ence—the mathematical rules of musical harmony or the hues of nature—
how does one escape the incoherence threatened by such multiplicity of
choice? What is the appropriate organizational system that apportions col-
ors "truthfully"?

Arnold Schoenberg found a musical answer in serialism—the twelve-

note compositional method. But nothing so general was to emerge for the modern colorist. Wassily Kandinsky (1866–1944) recognized almost with horror the obligation of the abstract artist to discover guiding principles: "A terrifying abyss of all kinds of questions, a wealth of responsibilities stretched before me. And most important of all: what is to replace the missing object?"[22]

His answer was a very personal and subjective one. He sensed that colors have symbolic and spiritual connotations. This belief seems to have been profoundly influenced by the fact that Kandinsky experienced synesthesia, a perceptual condition in which two different sensory sensations are triggered simultaneously by the same stimulus. This is most commonly manifested as "color-hearing": the association of specific colors with timbral or pitch sensations. The composer Alexander Scriabin was affected by the same condition: he heard the key of C major as red and D major as yellow, and he composed in colors for a "keyboard of light" (clavier à lumière).

Kandinsky was deeply influenced by theosophy, a spiritual philosophy derived from Goethe's simplistic division of the world into polar contrasts. Theosophy appealed also to the Dutch painter Piet Mondrian (1872–1944), whose efforts to arrange rectangles of primary colors on a heavy black grid evoke a kind of mathematical angst. He was an advocate of the theosophist M.H.J. Schoenmaekers, who argued that all colors except the three primaries were superfluous—providing Mondrian with his own distinctive answer to the problem of color.

Theosophy's dogmatic categorization is reflected in Kandinsky's conviction that color acts as a universal language of the soul. Of course, color *does* speak to our emotions—but not, it seems, in a way that everyone agrees on, independent of cultural conditioning. Yet Kandinsky believed there are concrete, objective color associations so that an abstract composition can, through the calculated use of color, invoke a very particular emotional response. It was simply a matter of cracking the code—or, in a more Kandinskian metaphor, of using color mechanistically to pluck the strings of the emotions: "Generally speaking, color directly influences the soul. Color is the keyboard, the eyes are the hammers, the soul is the piano with many strings. The artist is the hand that plays, touching one key after another purposively, to cause vibrations in the soul."[23]

Kandinsky explained his chromatic language in his book *Concerning the Spiritual in Art* (1912), where we find such claims as this:

Yellow is the typical earthly color. It can never have profound meaning. An intermixture of blue makes it a sickly color . . . Vermilion is a red with a feeling of sharpness, like glowing steel which can be cooled by water . . . Orange is like a man, convinced of his own powers . . . Violet is . . . rather sad and ailing.[24]

He attempted to establish these "meanings" of colors through "scientific" experiments at the Bauhaus art and design school in Germany. He distributed a thousand test cards to a "cross section of the community" on which recipients were asked to match the three primary colors to three geometric shapes—a square, a circle, and a triangle. There was some consensus that the triangle was yellow but disagreement about whether blue belonged in the square or the circle.

A link between color and music is not unique to synesthesia but has been perceived since the time of ancient Greece. Kandinsky, a violinist and cellist himself, collaborated with Schoenberg and hoped to find a way of incorporating "dissonance" into existing "harmonious" schemes for organizing color. He felt that a work of art should have a symphonic structure, and his "color music" compositions are generally regarded as some of the first truly abstract paintings, devoid of all reference to recognizable objects (Plate 2).

Kandinsky's fruitless search for the emotional language of color, like the tangles of color linguistics, reminds us that it is futile to be dogmatic about color. There can be no consensus about what colors "mean" or how to use them "truthfully." Color theories can assist the construction of good art, but they do not define it. In the end, the modern artist's struggle to find form for color is an individual quest. To Bridget Riley, it is precisely this that makes color so powerful a medium of artistic expression: "Just because there is *no* guiding principle, *no* firm conceptual basis on which a tradition of colour painting can be reliably founded, this means that each individual artistic sensibility has a chance to discover a unique means of expression."[25]

PLUCKING THE RAINBOW

THE PHYSICS AND CHEMISTRY OF COLOR

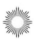

"There is no such thing as colour, only coloured materials."
　　　—Jean Dubuffet (1973), "L'Homme du commun à l'ouvrage"

"Inorganic nature has only the language of colour. It is by colour alone
that a certain stone tells us it is a sapphire or an emerald."
　　　—Charles Blanc (1867), *Grammar of Painting and Engraving*

"What is paint after all? Colored dirt."　　　　　　—Philip Guston

Much currency has been made, in the tug-of-war between art and
science, of Isaac Newton's "unweaving the rainbow." John Keats
expresses it thus in *Lamia* (1819), a poetic lament about the
detrimental effect (as he perceived it) of scientific knowledge on mystery
and wonder in the world. Yet the bright arc's threads remained tangled in
art long after Newton had elucidated their prismatic sequence. We can
hardly be surprised that an anti-Newtonian like Goethe would rearrange
the colors to oppose nature; but even a keen observer of nature like John
Constable was known to get the order wrong in the secondary bow (where
the sequence is inverted). The Pre-Raphaelite artist John Everett Millais
had to correct the same mistake hastily after it was pointed out to him in
his *Blind Girl* (1856).

Newton's achievement was not, in any event, to demonstrate that daylight was woven of many hues that the rainbow separates. That much had been long evident in the spectrum prized from sunlight when it passes through glass. Nor was it Newton who showed how sunlight becomes focused into a circular band by refraction inside water droplets in moist air: René Descartes explained the basic science of rainbow formation in 1637. But Newton brought color to Descartes's white bow by identifying the rainbow's irreducible colors and showing that they are refracted at slightly different angles. In Newton's *experimentum crucis*, conducted in 1665 or 1666, he deduced that "light itself is a heterogeneous mixture of differently refrangible rays" and demonstrated that these rays, separated by their passage through a prism in a darkened room, were "uncompounded colours" that could not be further split by a second prism. Passed through a lens, they merged back into a beam of white light.

Scientists keen to celebrate Newton's reductionism, and artists eager to decry it, overlook the strong mystical thread in his work—something that seems anomalous today, when the lens of centuries allows us to split science from magic. But it was quite in keeping with the spirit of his age that Newton saw fit to identify an arbitrary seven subdivisions of the prismatic spectrum purely to establish consonance with ideas about musical harmony: "Do not several sorts of rays make vibrations of several bignesses, which according to their brightness excite sensations of several colours, much after the manner that the vibrations of air, according to several bignesses excite sensations of several sounds?"[1] And so the Newtonian rainbow acquired its indigo and violet where I defy anyone to see other than a blue deepening to purple.

Color comes from plucking this rainbow. Newton's analogy with music is misguided in any concrete sense but useful as a metaphor. Matter sings to many different notes and chords in the chromatic scale. When the resonances are sounded in the glare of the white "noise" that is sunlight, these notes are absorbed from the multipitched stimulus and fall silent in the echo. What we see as color is the remains, after the material has absorbed its own private and unique chime. A red berry sings to the tune of green and blue, a yellow flower to the strains of blue and red.

Artists have expressed diverse opinions about the value of scientific theories of color. Some have seen little need to comprehend color scientifically. Despite its title, *Science de la peinture* (*The Science of Painting*, 1891) by the French artist and academician Jean-Georges Vibert contains a pungent

lampoon on the nineteenth-century scientists who claimed to uncover the "truth" about color. Veronese, Rubens, and Delacroix are better equipped than any scientist to instruct the artist on color, says Vibert, because "with their colors they created a language which speaks to the soul, which communicates emotion and life."

I think Vibert is probably right. Delacroix showed some interest in the color theories of his age, but the Old Masters wrought their miracles through an intuitive feeling for color that the discoveries of Newton do not touch. The Neo-Impressionists Georges Seurat and Paul Signac longed for a thoroughly scientific use of color in painting, but the result, even by Signac's own admission, could turn out "gray and colorless." Painters benefit from some instruction about the effective use of color, but this is tantamount to acquiring rules of thumb that do not require a strong basis in theoretical knowledge of color physics. Indeed, the tricks employed with informed deliberation by the Impressionists can be found in some works of Renaissance artists, who reached the same conclusions empirically. Trying to paint according to scientific rules of color, said Paul Klee, "means renouncing the wealth of the soul."

Yet there are several reasons why this chapter on the science of color is indispensable for what follows. Since in this book we shall be concerned primarily with the material rather than the abstract theoretical role of science in art—with how color is manufactured—I could leave it as a mystery that copper gives blues and greens, that whites and reds may be had from compounds of lead. But only by appreciating the why can one truly understand the social and technological factors that brought these colors onto the palette. Moreover, some basic facts about color mixing have a strong bearing on the uses to which painters have put their pure and shining pigments (whether they knew it or not). Lest this sound like an apology from Logos to Eros, I should reprise my assertion that in the end the differentiation between the two is only a relatively modern idea. I feel sure that Leonardo would have damned any book that claimed to speak of color without explaining it.

THE MANY CAUSES OF COLOR

"Colour," Newton averred, "always answers to the sort or sorts of the Rays whereof the Light consists, as I have constantly found in whatever

Phaenomena of Colours I have hitherto been able to examine."[2] By making light neither the activating principle of color as Aristotle believed nor the vehicle of color as perceived in medieval thought but the medium of color itself, Newton was inviting the inquiry: What, then, is light?

Not until another two centuries had passed did the Scottish physicist James Clerk Maxwell give the answer. Light, said Maxwell in the 1870s, is a vibrating electromagnetic field, a combination of self-supporting electric and magnetic fields oscillating in step but oriented perpendicular to one another, like two ropes tied to a pole and shaken vertically and horizontally. The frequency of the vibrations determines the color of the light and increases progressively from the red to the blue end of the visible spectrum. Electromagnetic radiation with lower frequencies than red light is infrared or, at still lower frequencies, microwaves and radio waves. High frequencies beyond the blue and violet correspond to ultraviolet and then to X-rays and gamma rays.

The wavelength of the vibration is inversely related to the frequency: it declines as frequency increases. Frequency and wavelength are the modern correlates of Newton's "vibrations of several bignesses."

This picture was refined at the beginning of the twentieth century with the realization that, with that perversity for which quantum theory is notorious, light is not just wave but particle too. Light comes in packets or "quanta," each quantum containing an amount of energy proportional to the frequency. These quanta of light are called photons. Albert Einstein proposed this heretical notion in 1905, and it later won him his Nobel Prize.

A substance's color may be generated by absorption of light, a phenomenon governed by the material's resonant frequencies. Think of an undamped piano wire humming in sympathy with a sung note; in the same way, matter sings along with sunlight. The resonant vibration absorbs the energy of the light at that frequency, and so it strips out a particular color from the spectrum of the light. Rays whose frequencies do not correspond to some resonant frequency of the material either pass right through it (if the material is transparent or translucent) or are reflected (if it is opaque). Only these "rejected" rays reach our eye. So, paradoxically, it is on the basis of *their* frequencies—their position in the visible spectrum—that we award the material a color.

For absorption of visible light, these resonances involve the clouds of electrons that surround the tiny, dense nuclei of atoms like bees swarming around the hive. The light may be absorbed if it can boost the electrons

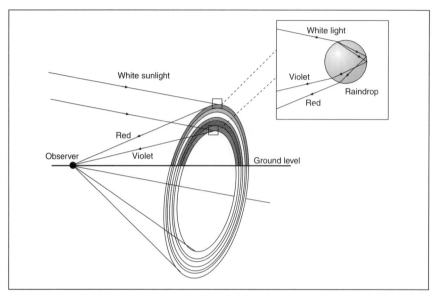

Figure 2.1: How the rainbow is formed. Light of different wavelengths is refracted by raindrops through different angles, and so beams of white light are separated into their spectral components.

from one energy state to another, just as the piano wire's energy is increased when it is stimulated into resonant vibration by sound waves. Because the electrons' energies are governed by the rules of quantum physics and increase in discrete steps like the shifting of gears in a car, only rays of certain frequencies have the right energy to stimulate these color-inducing "electronic transitions."

Not all color is generated in this way. The rainbow's variegated arc, for instance, is not the result of light absorption by the raindrops but of refraction: the bending of rays of different wavelengths through differing angles (Figure 2.1). This is an example of light *scattering*, which is the major *physical* way in which color can be produced. Light absorption, in contrast, depends on the *chemical* composition of the substance.

As light enters a raindrop, the ray is bent (refracted). The angle of bending depends on the wavelength of the light, being sharper for shorter wavelengths. So blue light is deflected more than red light, and the various colors in sunlight are unraveled. Each color reaches your eye from a slightly different region in the rainbow's arc. The scattering of light can therefore separate colors according to wavelength. The sky is blue because blue light is scattered by dust in the atmosphere more strongly than red light and so

seems to come from all directions. Distant hills acquire a blueness for the same reason: the reflected light is augmented by the omnidirectional blue before reaching the eye. (In art, this blueing of the distant landscape, described by Leonardo, is called aerial perspective.) As the sun sinks low in the sky, its rays travel through a thicker slice of the atmosphere before reaching the observer, and the blue component of the light may be scattered so strongly that it never gets to the eye. Goethe had but a hazy intimation of this: "As the sun at last was about to set . . . its rays, greatly mitigated by the thicker vapours, began to diffuse a most beautiful red colour over the whole scene around me."[3]

Natural pigments obtain their colors by absorption of light. But some colors in nature result from physical scattering processes. In particular, no vertebrate animals contain blue pigments: their blue markings are produced by light scattering. The blues on butterfly wings are the result of a microscopic ribbed structure of individual scales on the wing (Figure 2.2). These ridges have a spacing that induces preferential scattering of blue light. But the scattering, and thus the hue, varies somewhat depending on the angle of reflection (or equivalently, the viewing angle). So the color is iridescent, seeming to shimmer and shift as the wing moves. The same is

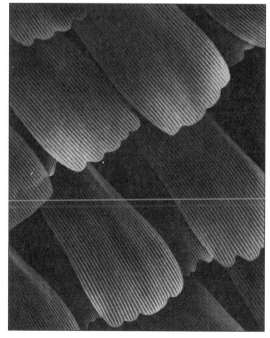

Figure 2.2: The iridescent blues and greens of a butterfly's wings are formed by light scattering from microscopic ribs on the wings' scales.

true of blue insect cuticle and of the kaleidoscopic colors of a peacock's tail: the peacock's feathers are laced with a tiny grid of pigmented black bars that scatter light like the ribs of butterfly wing scales. The rainbowlike color changes of these feathers have long fascinated artists; a Byzantine writer of the seventh century A.D. asked: "How could anyone who sees the peacock not be amazed at the gold interwoven with sapphire, at the purple and emerald-green feathers, at the composition of the colours of many patterns, all mingled together but not confused with one another?"[4]

Alexander Pope's sylphs in *The Rape of the Lock* clearly share with insects an iridescence caused by light scattering:

> While ev'ry beam new transient colour flings,
> Colours that change whene'er they wave their wings.

Light is scattered most strongly when the scattering objects are of comparable size to the wavelength of the radiation. Water droplets in clouds are the right size to scatter all visible light, creating the sky's milky billows. Glass wool and ground glass, made of the same fabric as windows, look white and opaque for the same reason. Ground-up stained glass becomes paler with prolonged grinding: smaller particles have a greater total surface area to scatter from, and so scattering (which is indiscriminate about wavelength across the visible range) dominates over absorption (which picks out certain wavelengths). This is why the grinding of a colored powder may affect its hue—a phenomenon exploited by the artists of the Middle Ages, who controlled the shade of a pigment by the degree of grinding.

COLOR FROM THE EARTH

Until the advent of modern synthetic pigments in the nineteenth century, many artists' colors were finely ground minerals: metal-containing compounds pulled from the earth. Their colors are usually determined by the nature of the metal atoms they contain—and this is true of many of the new synthetic colors too, among which chromium, cobalt, and cadmium compounds feature prominently. Strongly colored minerals commonly contain so-called transition metals, which occupy the center of the periodic table, chemistry's group portrait of the elements.

Ancient and medieval scholars played a fruitless game in trying to assign particular colors to the four Aristotelian "elements." We now know that an

element's color depends on its context. Nevertheless, some elements exhibit recurring chromatic themes. Ask any chemist to assign colors to the most common transition metals, and she will know the game at once. Red is for iron, resplendent in blood and rust and the red ochers daubed by painters since the Stone Age; copper claims for itself the turquoise shade associated with that mineral and which is echoed in the greenish patina of aging copperwork. Rich, deep blue stands for cobalt, and nickel takes a sea green. Only chromium provokes some hesitation—an elemental chameleon and named for it too.

These are not rigid identities—copper, for instance, can form rust-red salts, and iron offers greens and yellows, even the dark luster of Prussian blue. But nonetheless these metals make chromatic choices that are by no means arbitrary. Why is that?

In inorganic compounds such as crystalline minerals and salts, metal atoms are *ions*—they are deficient in electrons and so bear a positive electric charge. This is compensated by negative charges on surrounding ions of nonmetallic elements—oxygen, chlorine, and sulfur, to name a few. These ions are stacked in the crystal with the regularity of apples and oranges in a greengrocer's window display, but with rather more inventiveness. The electrical attraction of opposite charges holds the whole assembly together, providing a glue of great strength. Ionic crystals are robust substances on the whole, and much sweat was shed during their grinding in an artist's workshop.

Transition metals engender color because their ions tend to have electronic transitions whose resonant frequencies fall in the range of visible light. But the precise wavelength required to stimulate such a transition depends on the atomic-scale environment in which the metal ion sits. The combined electric fields of the surrounding ions—the so-called crystal field—modify the energies of the electrons on the metal ion. Not just the chemical composition of the metal ion's neighbors but even their geometrical arrangement matters. So a metal ion doesn't impart a unique color—it depends on the other chemical constituents with which it is compounded in the crystal and on how they are arranged.

Sometimes the variations in crystal field from one substance to another make only a minor difference in the frequency at which a metal ion absorbs light. Copper ions, for instance, usually absorb in the red part of the spectrum, and so copper salts appear bluish green; but exactly how blue or how green depends on the chemical nature of the other ions. In other cases, dif-

ferences in the crystal field can impart a striking shift in color. Chromium impurities color various gemstones: they are deep red in ruby but sea green in emerald because the crystal field is significantly stronger in emerald than in ruby. The host material of rubies and emeralds—aluminum oxide, or corundum—becomes blue sapphire when laced instead with iron and titanium.

Heat may alter the chemical composition or structure of a mineral and so induce a color change. Heating blue copper sulfate to drive out water molecules from the crystal lattice turns it almost white. The pigment known as white lead turns red and then yellow when heated. White lead is "basic" lead carbonate, which has water (more precisely, hydroxide ions) locked into its crystal structure. When white lead is heated, water and carbon dioxide (formed from the carbonate ions) are expelled from the crystal as gases, leaving behind the compound lead tetroxide. This "red lead" is a very ancient pigment. All the lead ions are now surrounded by oxide ions, and this different environment makes them absorb photons in the green and blue parts of the spectrum, leaving red to be reflected. If white lead is heated more gently, however, a different compound—lead monoxide, or "litharge"—is formed. This still contains only lead and oxide ions, but in a different ratio and a different arrangement, so the lead again absorbs light at different frequencies. This substance is yellow and has in the past afforded another lead-based pigment, once called massicot.

In many transition metal compounds, the rearrangement of electrons induced by light absorption is confined largely to the metal ions themselves. But in some cases the electrons are shifted more dramatically. Iron's red signature is produced by the movement of an electron onto the metal ion from an adjacent oxygen ion—a so-called charge transfer process, which in this case diminishes the positive charge on the iron. The same thing, more elaborately staged, is played out in the pigment Prussian blue. Here the crystal lattice contains a mixture of iron ions in two different charged states, interspersed with cyanide ions. Absorption of red light can send an electron across a cyanide "bridge" between metal ions of different charge.

The color of some important mineral pigments arises through a far-reaching rearrangement of electrons: absorption of light liberates electrons entirely from their orbits around particular ions and sets them free to wander through the solid. When this happens, the material becomes more electrically conducting. Semiconductors are substances that need only a little

extra energy to boost electrons into such a mobile state. Among them is cadmium sulfide, introduced as a pigment in the nineteenth century. It absorbs violet and blue light and can range in color from yellow to orange, depending on how it is prepared. The deeper hue of cadmium red is produced by replacing some of the sulfur with selenium. Mercury sulfide, which occurs naturally as the mineral cinnabar, is also a red-tinted semi-conductor. A synthetic version corresponds to the renowned pigment vermilion. One hazard of vermilion is that its constituent ions can reshuffle from their usual positions to new locations in a form of the compound called metacinnabar. This absorbs red light as well as blue and green, and so it appears black—fatal, of course, if it happens on the canvas.

In pure metals, such as iron, copper, silver, and gold, some electrons are intrinsically mobile; this is why metals are good electrical conductors. The interaction of these mobile electrons with light creates a reflective, metallic sheen. The light is not absorbed but is instead reflected without much scattering, resulting in a mirrorlike appearance. But metals like copper and gold do absorb some of the short-wavelength (bluish) rays that strike them, and so they take on a reddish tinge. To medieval artists, this allied pure gold leaf with red pigments.

ORGANIC COLOR

Although rose quartz acquires its color from titanium or manganese impurities, no such metals tint the rose itself. The colorants in living organisms are organic compounds: discrete molecules containing perhaps several dozen atoms each, with backbones of interlinked carbon atoms. Until the nineteenth century, nearly all dyes were natural products, which is to say, organic substances derived from animals or plants. In addition to being used for coloring textiles, they tinted inks and, fixed to particles of a colorless inorganic powder, were the coloring agents of so-called lake pigments.

Tyrian purple, the imperial color of Rome, was drawn out of shellfish. Blue indigo was the frothy extract of a weed. Madder red came from a root, cochineal from an insect. Today virtually all dyes are synthetic organic molecules, their carbon skeletons custom-built by industrial chemists. While barely a dozen natural dyestuffs proved stable enough to be useful in the ancient and medieval world, more than four thousand synthetic dyes now bring color to our industrialized societies.

Nature owes its verdancy to the most abundant of natural pigments,

chlorophyll, which imbibes the red and blue of the sun's rays and channels
the energy into the biochemical processes of the cell. At the heart of the
chlorophyll molecule sits a magnesium ion, which undergoes electronic
transitions under the glare of the sun. The oxygen-binding part of the he-
moglobin molecule in blood has a similar molecular architecture to chloro-
phyll's light-harvesting eye, except that iron in all its ruddiness substitutes
for magnesium. And much the same structure crops up, studded with a
copper ion, in the synthetic blue dye known as monastral blue, familiar
from its use on the covers of old Pelican books. No longer do John Donne's
words reflect our state of ignorance:

> Why grass is green, or why our blood is red
> Are mysteries which none have reach'd into.

Why roses are red and daffodils yellow is a question of the same order,
though the answer must invoke different species of pigment. The yellows,
oranges, and reds of many flowers, as well as of carrots, tomatoes, and
sweet corn, are produced by molecules called carotenoids. Plant pigments
called flavonoids are responsible for blues, purples, and reds. Carotenoids
are also found in some animals. In lobsters these pigments are nearly black;
boiling degrades them to redness, as Samuel Butler avers in his satire *Hudi-
bras*:

> And, like a lobster boil'd, the morn
> From black to red began to turn.

 Light absorption by organic pigments is fundamentally no different
from that by inorganic minerals: it involves a rearrangement of electrons.
Often this takes place in floppy electron clouds smeared out across the car-
bon backbone. This is the case, for example, in the aniline dyes synthesized
in the mid-nineteenth century, where the electrons are distributed in
doughnut-shaped clouds around "benzene rings" of six carbon atoms.

THE MEDIUM MATTERS

That color is a treacherous thing is a lesson learned in childhood. The peb-
bles that glittered so richly when plucked from a seaside pool turn to un-
remarkable grayish lumps when pulled dry from the bag at home.

This change is due to the fact that light is affected by its passage from one transmitting medium—say, air—to another, such as water. Light travels more slowly in water than in air, which is why light rays bend as they pass into limpid rock pools, deceiving us about the depth.[5] This change in speed, characterized by a quantity called the refractive index of the material, determines the strength of light scattering: the greater the change in refractive index, the greater the scattering. So because light passing from air to rock at the surface of a dry pebble experiences a greater change in refractive index than light passing from water to rock when the pebble is wet, more of it is scattered rather than being reflected directly to our eye. This makes the dry pebble look paler and chalkier than the wet pebble.

Unfortunately, the same effect can undo the bright promise of pigments: glorious as dry powders, they might become dark or semitransparent when mixed with a binding agent such as linseed oil. This degradation of brilliance when a pigment meets the liquid medium of a paint is what dismayed Yves Klein and led him on his chemical quest for a new binder that honored the vibrancy of the raw pigment. The principal binding media before the fifteenth century were water (in frescoes), gum or egg white (in manuscript illumination), and egg yolk (in tempera painting on panels). When artists began to use oils, which have a higher refractive index, they found that some of their most treasured pigments were no longer so beautiful. Ultramarine is darker, vermilion less opaque, chalk white almost transparent. Other changes were for the better. In oils, translucent colors such as red lakes become not only more transparent but warmer and give rich results when glazed in thin layers over other colors.

So the color of a paint depends not only on the color of the pigment but also on the fluid binding medium, as well as the reflective properties and absorbancy of the surface to which it is applied, the texture of the finish, and the shape and size of the particles themselves, not to mention the effects of aging (discussed in Chapter 11). This is why, although I shall be concerned primarily with the substances that have been dug up, synthesized, pulverized, and purified to lend color to paint, I cannot survey the topic of color manufacture for painting without also occasionally considering the technology of paints as a whole—including the binder.

WHEELS OF LIGHT

"In the Rays [Colours] are nothing but their Dispositions to propagate this or
that Motion into the Sensorium, and in the Sensorium they are Sensations of
those Motions under the Forms of Colours."[6]

We can perhaps forgive Newton a little vagueness about how we *see* colors,
given his great achievements in explaining how they are generated. But his
detractor Goethe was right to stress that color is not about light alone.
There is also the matter of how we perceive it—and this is the trickiest
business of all.

For instance, color depends on the circumstances under which we look
for it. There is a sense in which we can regard leaves as possessing a kind of
latent greenness, in that they contain a compound (chlorophyll) that ab-
sorbs red and blue from white light. But of course, green leaves are not
green under all circumstances—under starlight, for instance, or viewed
through a red filter. Color is a function of the illumination.

This may seem obvious enough, but it is thoroughly confusing if, like
the ancient Greeks, we were to regard color as an intrinsic property, re-
quiring light only to activate it like electricity activating a light bulb. This
confusion is apparent in Aristotle's views on the relationship between color
and light:

> Things appear different according to whether they are seen in shadow or in
> sunlight, in a hard or soft light, and according to the angle at which they are
> seen . . . Those which are seen in the light of the fire or the moon, and by the
> rays of the lamp differ by reason of the light in each case; and also by the mix-
> ture of the colours with each other; for in passing through each other they are
> coloured; for when light falls on another colour, being again mixed by it, it
> takes on still another mixture of colour.[7]

He claims, in other words, that color is a property that does something to
light. For Descartes and Newton, color was equated with the light itself
and not the illuminated object. Newton's prism experiments helped clarify
that apparently colorless light contains color within it.

In the nineteenth century the emphasis shifted again. Strictly speaking,
there is no such thing as colored light, only electromagnetic radiation of
different wavelengths. Color is a matter of perception, a result of the effect
of light on the eye and brain. Newton had an inkling of this, commenting

that "the rays . . . are not coloured." It is astonishing that we perceive such major (and uneven) changes in hue for rather small changes in wavelength—as if the sea were to switch from green to red as the wind drops and the waves lengthen.

Only in the past two centuries has it really been appreciated to what extent color itself, as opposed to measurable features of materials such as light absorption, is a contingent phenomenon. The many tricks that our visual system plays when colors are presented in different contexts attest to this.

Everyone who has spent early years mixing paints with the child's engaging blend of instinct and empiricism is astonished upon first seeing that mixing red and green light produces not brown light but yellow. A little more knowledge and a little more thought only make the puzzle more profound. Yellow light has a wavelength of around 580 nanometers (a nanometer is a millionth of a millimeter), while the wavelengths of red and green light are typically about 620 and 520 nanometers. Do the latter two then somehow combine to create electromagnetic radiation with a different wavelength? Not at all. "Yellowness" is not intrinsic to the light signal but arises in our perception of it. Newton was right—the rays do *not* have to be "colored" yellow for us to experience this hue.

But we are taught that yellow is a primary color, which cannot be made by mixing others. Were we misled, then? How many fundamental colors, after all, will suffice to mix all the others, and which are they? The question of "irreducible" primary colors is one that has long preoccupied color theorists in both the arts and the sciences, and it underpins one's entire conceptual and semantic landscape of color. Newton's experiments on light seemed, if anything, to make this issue less clear than ever.

MAPPING COLOR SPACE

The idea that colors, like chemical substances, have elementary components from which they are composed goes back to antiquity. For the Greeks there were just two vast primary kingdoms in color space, and they did not exactly correspond to colors at all but to light and dark. Blue was dark with a little light added, red was light and dark in equal measure, and so forth.

It was not until the seventeenth century that the three modern primaries—red, yellow, and blue—became established. In 1601 an Italian professor of medicine named Guido Antonio Scarmiglioni proposed that there

were five "simple" colors from which all others were presumed to be constituted: white, yellow, blue, red, and black. Robert Boyle, the chemist who is commonly credited for the modern concept of a chemical element, echoed this quintet with more authority in 1664, claiming that with these five "the skillful Painter can produce what kind of Colour he pleases, and a great many more than we have yet names for."

But how do these relate to the "irreducible" colors of Newton's rainbow? White sunlight is clearly not just composed of the three primaries but also contains green, orange, and (if we acknowledge the arbitrariness of Newton's final two subdivisions) purple light. Yet these three are the *secondary* colors, which can each be mixed by the painter from two primaries. In the rainbow, green falls tidily between yellow and blue, and orange between yellow and red. But purple, the mixture of red and blue, lies (in the guise of violet) beyond blue, at the end opposite red. The obvious invitation is to unite the spectrum in a loop: a *color wheel*. This is just what Newton did in *Opticks* (1706), marrying up red against violet via a color not "of the prismatick Colours, but a purple inclining to red and violet."

In terms of physics, the color wheel is a wholly artificial device, since the light that it denotes increases in frequency from red to violet before

Figure 2.3: Isaac Newton's color wheel divides the spectral colors according to their proportions in the rainbow.

(a)

(b)

(c)

Figure 2.4: Many systems for organizing colors in the nineteenth century, such as Auguste Laugel's color star from *L'Optique et les arts* (1869) (a), tended to favor symmetrical arrangements in order to emphasize the primary and secondary relationships and the juxtaposition of complementary colors. George Field's color wheels from *Chromatography* (1835) (b) and Charles Blanc's color star from *Grammaire des arts du dessin* (1867) (c) find space for tertiary colors, too.

leaping across a discontinuity back to red. But the wheel organizes color space into a pleasingly symmetrical pattern in which primaries and secondaries alternate with their mixing relationships clearly defined. This is not, however, quite how Newton saw it: he awarded no particular prominence to the hues we now regard as primary, and his wheel was a seven-spoked affair of unequal slices (Figure 2.3). Subsequent color theorists tended to emphasize the symmetry (Figure 2.4).

Even if there was not total agreement over the number of subdivisions, the color wheel became iconic within the color theories of the nineteenth and early twentieth centuries, and few artists were unfamiliar with this emblematic representation of the territory they negotiated. One of the most impressive color wheels was that published by the French theorist and chemist Michel-Eugène Chevreul in his book *Des couleurs et de leurs applications aux arts industriels* (*On Colors and Their Applications in the Industrial Arts*)

(1864). Here the smooth gradations from one color to the next (Plate 3) stretched the contemporary color-printing technology to its limits, and the printer, Monsieur Digeon, won an award for the work from the French Société d'Encouragement pour l'Industrie Nationale. It was well deserved: the original wheel looks as stunning as ever today.

The color wheel provides an organizing principle for artists, but it does not help us resolve the apparent discrepancies between the primary colors in pigment mixtures and those in mixtures of light. In the former case, yellow is primary and green secondary; in the latter case, the reverse is true. In addition, red, yellow, and blue paints mix to black (or nearly so), whereas Newton claimed that the entire rainbow of hues mixes to white. Goethe and his acolytes were quick to seize on this apparent inconsistency in Newton's theory. Any fool could see that no mixture of pigments gave one pure white, nor anything remotely like it.

James Clerk Maxwell dispelled the confusion—among scientists, at least—by showing in 1855 that three kinds of colored light suffice to generate almost any color: orange-red, blue-violet, and green. (This triad is usually denoted simply as red, blue, and green.)

Mixing light, Maxwell explained, is not the same as mixing pigments. By blending light rays of different wavelengths, one is *synthesizing* color by the addition of various components, which together stimulate the retina in the eye to create a particular color sensation. This is called *additive* mixing. Instead of using light rays, one can achieve additive mixing by rapidly alternating the separate colors in the visual field. Maxwell's initial experiments, assisted by the Scottish color theorist and interior decorator D. R. Hay, employed spinning disks painted with the three additive primary colors. The disks were made from interlocking and overlapping segments that allowed Maxwell to vary the proportions until they mixed to an achromatic silvery gray. In 1860 Maxwell devised an instrument that enabled him to synthesize a wide range of colors directly from light by mixing rays of three different wavelengths ("red," "blue," and "green") in various ratios.

A blend of pigments, by contrast, *subtracts* wavelengths from white light. That is to say, the pigments themselves are not the sources of the light that triggers a color sensation but are media that act on a separate source of illumination. A red pigment plucks out the blue and green rays and much of the yellows; only red light is reflected. A yellow pigment might take out the reds, blues, and much of the greens. So a mixture of red and yellow reflects only those rays in the narrow range where the absorption of both materials is not too strong—in the orange part of the spectrum. Each time a

pigment is added to a blend, another chunk of the spectrum is subtracted from the reflected light. As a result, the color gets duller and murkier. Each time a light ray is added to a mixture, in contrast, more photons are injected into the resulting ray, and the combined light beam gets brighter.[8] Making colors by mixing pigments is therefore called *subtractive* mixing.

Subtractive mixing inevitably penalizes the luminosity of the pigments, since more of the illumination is absorbed by the mixture. For example, most red and yellow pigments inevitably absorb a little orange light. So the orange that results from their mixture isn't very brilliant—some of the orange light is lost from the white light that illuminates the image. In contrast, a genuine orange pigment absorbs virtually no light in the orange part of the spectrum and so doesn't suffer from this defect. This is why a genuine orange pigment may be more vibrant than a mixture of red and yellow. The nineteenth-century color technologist George Field explains this in his book *Chromatography*, at the same time alluding to the *chemical* hazards of mixing (the possibility that the pigments might react with one another; see Chapter 11):

> Now, the more pigments are mixed, the more they are deteriorated in colour, attenuated, and chemically set at variance. Original pigments, that is, such as are not made up of two or more colours, are purer in hue and generally more durable than those compounded . . . Cadmium Orange, for instance, which is *naturally* an orange pigment and not composed of red and yellow, is superior to many mixtures of these colours in a chemical sense, and to all such mixtures in an artistic sense.[9]

So the ancient taboo on mixing was still strong in the nineteenth century; until this time, there was not a single good, pure orange pigment available to artists—no violet, either.

"CALLED-FOR" COLORS

The six-part color wheel captures another set of color relationships that is of vital significance for the artist. Each primary sits opposite the secondary composed of the other two primaries: red against green, blue against orange, yellow against violet. You could say that each of these pairs contains everything, colorwise, that the others do not. They are *complements* of one another, like the positive and negative prints of a photographic image. (The analogy here is exact, in fact.)

Goethe recognized that strong hues tend to generate an impression of

their complementary color in the surrounding field, like a contrasting halo. The same effect arises in the afterimage produced when one stares at a color for long moments and then looks away. Goethe relates how, at an inn lit by a setting sun, he saw an afterimage of a fair-skinned girl in a red dress as a dark-faced figure robed in "beautiful sea-green." He called these opposites "called-for" colors, as though each one demanded its complement.

The observation was not wholly original: among those who had previously remarked on the phenomenon of afterimages in the eighteenth century were the French naturalist Comte de Buffon, the color theorist Moses Harris, and the scientists Joseph Priestley and Benjamin Thompson (Count Rumford). But Goethe appreciated that this sensation of complementaries is a product of the visual system and has nothing to do with the light reaching the eye at that moment. "Every decided color does a certain violence to the eye and forces it to opposition," he suggested, more or less correctly. It is for the same physiological reason that a color looks more vivid if juxtaposed with its complementary: the two colors enhance each other and generate a kind of vibration at their interface. This idea was to become central to the thinking of all coloristically inclined artists in the nineteenth century, particularly the Impressionists.

That certain color combinations work well was again by no means Goethe's discovery. Such ideas were common currency at least by the fifteenth century, and Leonardo da Vinci's keen eye allowed him to anticipate Goethe's pairings of complementaries: "Of different colors equally perfect, that will appear most excellent which is seen near its direct contrary . . . blue near yellow, green near red: because each color is more distinctly seen when opposed to its contrary than to any other similar to it."[10]

THE LENS OF THE MIND

Both the additive mixing of red and green light to yellow and the vibrancy that red and green *pigments* acquire side by side are linked to the way that color sensation is created in the eye. As Goethe rightly intimated, a full scientific understanding of color has a biological as well as a physical dimension. Maxwell gave his weighty endorsement to this suggestion: "The science of colour must . . . be regarded as essentially a mental science."

Newton assumes throughout his *Opticks* that light has a corpuscular nature: this fitted with his view of the universe as a system of colliding bodies

obeying his laws of motion. But the Dutch physicist and astronomer Christiaan Huygens argued in 1678 that light is comprised not of particles but of waves, propagating through an all-pervading ether. At the beginning of the nineteenth century, the English scientist Thomas Young adduced compelling evidence for Huygens's theory. (In the end, both Newton and Huygens were right, thanks to the ability of quantum physics to support two interpretations at once.)

Young's interests extended beyond physics to include medicine, and in 1801 he combined the two to propose a theory of color vision. He assumed that the retina—the part of the eye that light stimulates—contains light sensors that respond to the rays by vibrating in resonance. These vibrations create a signal that is dispatched from the retina along the optic nerve to the brain. But Young deemed it impossible that the infinite gradations of color across the visible spectrum could have a correspondingly infinite number of resonators at every point on the retina. Noting that the three colors then considered to be primaries—red, yellow, and blue—could be mixed to generate almost any color, Young proposed that three receptors alone were enough to enable the eye to perceive a full range of colors: "Each sensitive filament of the [optic] nerve may consist of three portions, one for each principal colour." He imagined that color blindness arises from the absence of one of the three sets of color receptors in the eye.

Young's theory was elaborated by the German physicist and physiologist Hermann von Helmholtz, who provided indirect evidence for the existence of three color receptors. Maxwell's studies of additive mixing of light in the 1860s gave strong support to the proposal that the retina can develop full color vision with receptors that respond to just the three primaries (albeit the *additive* primaries: red, blue, and green). But direct experimental confirmation of the idea did not arrive for another hundred years.

The light-sensitive entities in the eye—Young's resonators—come in two classes, distinguishable under the microscope by shape. They sit in the retina at the ends of millions of filaments from the optic nerve, and they are either rod-shaped or cone-shaped (Figure 2.5). There are 120 million rods and 5 million cones in each human retina. Most of the cones are located in a depression of the retina called the fovea centralis, which lies at the focal point of the eye's lens. This little pit is devoid of rods, which outnumber cones everywhere else on the retina.

Rods and cones stimulate nerve signals when they are struck by light. The rods absorb light over the entire visible spectrum but do so most

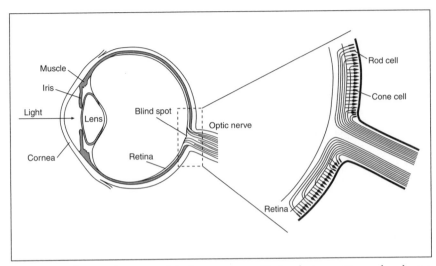

Figure 2.5: The visual system of the human eye, with its photosensitive rod and cone cells arrayed on the retina.

strongly in the blue-green range (that is, the chance of the light's being absorbed is greatest for blue-green light). Absorption of light by a rod triggers an identical neural response regardless of the wavelength. So rods do not discriminate between colors, only between light and dark. They are extremely sensitive and are the main light receptors that we use in very dim illumination such as starlight. This is why it is hard to identify colors under such conditions. Because their response is greatest for blue-green light, objects that reflect these wavelengths (such as leaves) appear brighter than red objects at night.

In bright sunlight, the color-sensitive cones supply the visual signal to the brain. Under these conditions, the rod cells are "bleached"—saturated with light and unable to absorb photons. Only when the bright light is shut off can the rods relax to their initial state, ready to absorb photons and trigger nerve impulses. This relaxation takes many minutes, which is why we gain night vision only gradually after leaving a brightly lit building. If we are outside at dusk, night vision takes over quite smoothly as the sun's last rays disappear. The differing color sensitivity of rods and cones results in a change in the perceived intensity of blue and green objects relative to red as twilight deepens. This effect was first clearly identified in 1825 by the Bohemian physiologist J. E. Purkinje, although artists had noticed it previously.[11]

Young's hypothesis for color vision was verified by experiments in the

1960s that measured the absorption properties of single cones and confirmed that they fall into three classes with different color sensitivity. The blue-light cones are the least sensitive, which is why fully saturated blue looks relatively dark. Blue's late historical arrival as a true color, as opposed to a kind of black, is thus ultimately for biological reasons.

The overall sensitivity of the eye to the colors of the spectrum is the sum of the responses for all three types of cones, and it rises steadily from red to yellow and then falls off steadily from yellow to violet. So yellow is perceived as the brightest color. The yellow band in a rainbow stands out not because it is more intense (not, that is, because there are more yellow photons than others) but because the yellow photons generate the biggest optical response from the eye. Curiously, yellow is regarded in many cultures as the least attractive color, and its metaphorical and symbolic associations are often denigrating. It is traditionally the shade of treachery and cowardice, and clothing designers admit that it is a terribly difficult color to sell. Yellow is popular in China (it is the emperor's color, *huang*), but in the West you had better call it gold.

Each "seen" color is constructed in the visual system from the combined stimuli from the three types of cone cells. Red light excites mostly the red-sensitive cones. But a mixture of red and green rays can stimulate red and green cones in the same ratio as pure yellow light does—and so the color sensations are identical. If blue light is added, we see white. (Although the three types of cones are often linked to Maxwell's primaries of red, green, and blue, this is a crude shorthand. Their peak sensitivities are in fact to yellow, green, and violet, respectively.)

The rod and cone cells are studded with many thousands of individual light receptors called photopigments. Each of these is a single protein molecule, embedded in the stacked folds of the cell membranes. All photopigments contain a light-absorbing molecular unit called retinal, which has a zigzagging, smeared cloud of electrons very similar to that in the carotenoid pigments of plants. Retinal acts as a kind of switch. There we stand, say, before Yves Klein's blue sculptures, flooding us with reflected blue light. A blue-sensitive photopigment absorbs a photon of blue light, and in response its retinal unit changes shape from kinked to straight. This enables the photopigment to set in train a sequence of molecular events that leads to a change in the electrical impulses in the nerve to which the cone cell is attached. Some region in the visual cortex of the brain stirs into life, and we register "blue." Where we go from there is our own business.

MEASURING COLOR

The color wheel has come a long way since Newton. Its most popular modern incarnation is less pleasing to the eye but a lot more informative: a color diagram drawn up by the Commission Internationale de l'Éclairage (CIE) (Plate 4), starchily called the CIE chromaticity curve. The "pure" wavelengths of Newton's spectrum lie on the tongue-shaped periphery, while the colors inside it are the result of various additive mixtures of these rays. Any color that lies along a line connecting two points on the edge may be mixed from those spectral colors. If the line passes through the white region in the center, the two peripheral colors may be mixed to white. Thus white light can be created from blue and yellow alone (as it is in monochrome television screens) but not from red and green.

The artificiality of the union of red and violet in the color wheel is emphasized by the flat base of the tongue—along here the colors are, as Newton confessed, not found in even the finest unweaving of the rainbow's strands.

Yet for all its glory, the CIE diagram doesn't show us all colors. Where is brown? Where is pink? There is clearly a lot more of color space than the mandalas of color wheels can accommodate.

The defining characteristic of a colored material is not whether its hue sits closer to the kingdom of red than blue or whatever but what its total spectral composition is: how it absorbs and reflects light across the continuum of the visible spectrum. A color's most discriminating signature is thus a wiggly line that traces the variation in intensity of the reflected light as the wavelength varies.[12] The signature of pure white (though not of sunlight) is a straight line: all wavelengths are reflected fully. Black makes the same mark, but at zero rather than full intensity: every wavelength is negated. What, then, is gray? Along with black and white, gray is sometimes classified as an oxymoronic "achromatic colour"—we might say that gray has no color as such but is more of an intermediary between light and dark. Gray is what we perceive when all wavelengths are absorbed partially, yet more or less equally, from white light. It is, if you will, white light with the volume turned down.

Brown is another difficult one. It sits on the border between a real color and an achromatic one—a "dirty" color akin to gray. Brown is in fact a kind of gray biased toward yellow or orange. A brown surface absorbs all wavelengths to some extent, but orange-yellow somewhat less than others. An-

other way of saying this is that brown is a low-brightness yellow or orange, the sensation generated when low-intensity light of these wavelengths impinges on your eye. It is a physiological and linguistic curiosity that whereas we might classify low-intensity blues, greens, and reds still as blues, greens, and reds, we feel the need for a new basic color term (in the sense of Berlin and Kay) for low-intensity yellow.

Brown and gray don't feature on the CIE diagram because it doesn't show the colors produced by brightness variations. To do that requires a whole stack of CIE diagrams, with the white center getting progressively grayer. As it does so, the orange-yellow part of the diagram gets progressively browner.

This illustrates the fact that color space—the kind of thing you see in trade paint catalogues—is in fact three-dimensional. The CIE diagram shows just two of the three parameters of color—two "dimensions" portrayed on a flat plane. One of these is hue, which is what we usually mean colloquially by "color." Strictly speaking, the hue is the dominant wavelength in the color, and it is what enables us to characterize a color as basically red, green, or whatever. In this sense, the hue of brown is yellow or orange, while gray has no hue—no dominant wavelength—and so can be regarded as achromatic. In the CIE diagram, the hue varies around the perimeter of the tongue. Purples lie along the sloping bottom side, between violet at the lower left-hand corner and red at the lower right. The diagram brings home rather forcefully the oddity that in English and most other European languages there is still no generally accepted color term for the hue between yellow and green or that between green and blue, even though these occupy appreciable parts of the perimeter.

The second parameter of color on the CIE diagram is saturation, sometimes called the purity or (potentially misleadingly) the intensity. This refers to the extent to which white (or black or gray) is mixed in with a pure hue. Roughly speaking, the saturation of a color varies along the line between the "pure" hue on the periphery of the diagram and the pure white spot in the center. Notice, incidentally, how large the white area is: there is a wide range of whites. True white is defined in the CIE scheme as "equal energy" white, the white obtained from an equal mixture of the three primaries that lie at the extremities: red light of 770-nanometer wavelength at the lower right corner, violet light of 380 nanometers at the lower right, and green light of 520 nanometers at the topmost point of the upper curve. Sunlight lies slightly to the yellow side of true white.

Omitted from the CIE diagram is the third parameter of color: brightness, which can be crudely considered as the shade of gray the color generates in a black-and-white photograph. By the early nineteenth century, color theorists were already beginning to appreciate that flat color wheels gave only a partial picture of color space—a mere slice through the landscape. Some theorists expanded their wheels to include tertiary colors, which are made by mixing the three primaries in different ratios (see Figure 2.4b). The German Romantic painter and color theorist Philipp Otto Runge went further, presenting a color *sphere* in his book *Farben-Kugel* (*Color Sphere*, 1810) that, roughly speaking, made allowance for variations in brightness of Newton's spectral colors. The fully saturated primary and secondary colors are situated around the equator of the globelike sphere. Toward one pole, the colors get progressively lighter; toward the other, progressively darker. So one pole is pure white and one fully black.

Yet even this will not suffice, for it does not properly accommodate independent variations in saturation and brightness: gray appears nowhere on the sphere. Its surface is still two-dimensional, whereas real color space is three-dimensional. In the early 1900s the American artist and teacher Albert Munsell made one of the first attempts to codify all of this space. Munsell hoped that his scheme would allow him to classify colors perceived in nature so that he could reproduce them accurately on canvas in his studio. His first color scale was published in 1905 and was expanded in the *Atlas of the Munsell Color System* in 1915 (Plate 5). The full Munsell scheme is somewhat like a 3-D CIE chart, except that the profile is more like a polychromatic spider than a tongue. As in the CIE chart, hue changes around the perimeter while saturation varies along radial lines toward white at the center. The brightness varies in the vertical direction, as in our hypothetical stacks of CIE charts, so that the central point runs from pure black through gray to pure white.

Munsell updated his color notation scheme again in 1929, dividing the color space into discrete blocks that were intended to progress, in any direction, through equal perceptual steps. Careful psychological tests were conducted by the Optical Society of America to try to ensure that Munsell's color space was as even as possible.

The Munsell color scale, in the form of colored plastic counters or chips, has been used extensively by psychologists and anthropologists conducting research into color perception. But its value in this arena remains limited by its attempt to impose scientific quantification on concepts of

color that inevitably carry a lot of cultural baggage. John Gage recounts with some glee how Danish anthropologists arrived on a Polynesian island in 1971 ready to test their Munsell chips on the indigenous people, only to receive the deflating response "We don't talk much about color here." The anthropologist Marshall Sahlins expressed the point very neatly in 1976: "A semiotic theory of color universals must take for 'significance' exactly what colors do mean in human societies. They do not mean Munsell chips."[13]

By the same token, color does not mean Newton's rainbow or (as the *Oxford English Dictionary* suggests) a material's propensity for light absorption or a sensation produced by stimulation of the optic nerve. It is all of these things, but to artists they are mere abstractions. Painters need color to be embodied in *stuff*; they need to be able to purchase it and get it smeared across their overalls. That is the bottom line, and I would not like to see it obscured (as sometimes it has been) among multihued wheels and globes and charts. Painters need paint. Color is their medium of expression and communication, but to make their dreams visible, it needs substance.

THE FORGE OF VULCAN

COLOR TECHNOLOGY IN ANTIQUITY

"Now that even purple clothes our walls, no famous picture is painted. We must believe that when the painter's equipment was less complete, the results were in every respect better."
—Pliny (first century A.D.), *Natural History*

"I don't suppose you ever thought painting involved so much chemistry and cooking."
—Robertson Davies (1986), *What's Bred in the Bone*

"For my part, I cannot believe, that the four capital colours of the Ancients would mix to that surprising perfection we see in the works of Titian and Rubens. And if we have no certain knowledge of *their* methods of Colouring who lived in the last Century, how should we understand theirs who lived Two Thousand years ago?"
—Thomas Bardwell (1756), *The Practice of Painting*

The exhibit best remembered from the Great Exhibition of 1851 in London is not any of the fine products of art or commerce on display but the edifice in which they were housed: the Crystal Palace, erected in all its vitreous glory in Hyde Park. Designed by Joseph Paxton and allegedly inspired by the shape of a water lily, this marvelous glass menagerie was ransacked by fire in 1936 after its reconstruction at the commanding brow of a hill in Sydenham, in southeast London.

The daunting task of decorating the building for the exhibition fell to the Welsh interior decorator Owen Jones. He felt that such splendor could be matched only by an appeal to antiquity, saying, "If we examine the remains of the architecture of the ancients, we shall find everywhere that in the early periods the prevailing colours used in decoration were the primaries—blue, red and yellow."[1]

This was largely true. The walls of Pompeii were colored to a degree that we might now consider gaudy, adorned with brilliant vermilion and polished to a high gloss. The Greeks painted much of their stonework, from pillars to reliefs to statues. Figures were depicted on rich grounds of red, yellow, blue, and black. As this became evident to archaeologists in the early nineteenth century, Western architects presented brightly colored reconstructions of how the temples—the pallid stone of their surfaces now laid bare—would have looked in their heyday. Jones was one of those who began to incorporate classical features, painted in strong primaries, into their own designs.

Yet Jones's scheme for the Crystal Palace was based more on the system of primary colors proposed by one of his contemporaries, the English colormaker George Field, than on any principles of color organization upheld by the ancients. He stipulated that the three colors should be distributed in a specific ratio of three parts yellow, five parts red, and eight parts blue, proposed by Field as the ideal of harmonious coloring. Other architects balked at this idea, deemed somewhat indecorous to sober Victorian tastes. As it happened, Jones got his way—but only to a degree, for he was limited by materials. The industrial paints he had to use were by no means as bright as the artists' pigments of the time, and so the Palace was adorned with dirty off-yellow, pale blue, and a heavy brownish red.[2]

Color in the art of antiquity is a strange mixture. The early Egyptians devoted more effort and skill to making artists' colors than any other civilization west of the Nile for several thousand years. The Greeks and Romans showed a taste for interior decoration that would look decidedly bold and modern today, yet many of the fragmentary paintings that remain show a chromatic range scarcely greater than that in some cave art. The classical Greek painter Apelles was admired by Titian, the prime colorist of the Renaissance, yet—as we saw in Chapter 1—Apelles reputedly employed just four colors. Nonetheless, the Greeks did not hesitate to use sumptuous gold as a pigment. In comparison with the flat pictograms of Egypt, the scanty remnants of Greek art occasionally show us images painted with a skill and delicacy that puts one in mind of the High Renaissance—but the

artistic techniques they used had to be reinvented at the beginning of the fourteenth century. To the Renaissance masters, classical Greece represented a golden age of art; to us, it is now almost an entirely blank page. What little we do know of the painting methods and materials of that age comes largely from the accounts of Roman writers, which are now the main window onto not only the art of antiquity but also the ancients' ability to rearrange the chemical elements.

THE FIRST CHEMISTS

Chemistry is unusual among the sciences in being defined at least as much by practicalities as by theoretical understanding—by what it does as well as what it says. It is the science of transforming matter, and this, it must be said, is something that can be achieved as effectively by blind adherence to the recipe book as by informed planning. But placing the line that divides "true science" from technology between these two poles is merely revisionism—the imposition of modern criteria on the historical world.[3] The fact that the ancient Egyptians were able to conduct chemistry scarcely less refined than that of European chemists at least four millennia later surely forces the issue of why we should choose to regard one but not the other as quantitative, reproducible science.

The blue pigment known as Egyptian frit or Egyptian blue, which has been identified in artifacts dating from around 2500 B.C., is not a product of blind chance, a serendipitous outcome of fusing natural materials at random. It is wrought with precision and forethought, a blend of one part lime (calcium oxide) and one part copper oxide with four parts quartz (silica). The raw ingredients are minerals: chalk or limestone, a copper mineral such as malachite, and sand. They are fired in a kiln at temperatures of between 800 and 900 degrees Celsius (1,470–1,650 degrees Fahrenheit). The temperature is crucial, and we must suppose that the Egyptians were able to control the firing conditions with considerable accuracy. The result is an opaque, brittle blue material, which is made into a pigment by grinding it to a powder. It is the oldest synthetic pigment, a Bronze Age blue.

The transformation of raw ingredients to artists' materials in ancient Egypt was a task requiring highly specialized knowledge and practical prowess. How else, for example, could their painters have been supplied with the synthetic pigment lead antimonate? This pale yellow substance has

a vexed history of nomenclature—as the medieval *giallolino* or *giallorino* it was never clearly distinguished from several other lead-based yellow pigments, and the seventeenth-century label "Naples yellow" today signifies a particular hue rather than a chemical composition.[4] We do not know what the Egyptians called it. But they knew how to make it, using reagents that were themselves synthetic: lead oxide or carbonate and antimony oxide, both obtained by chemical transformations of minerals.

This kind of manipulation of nature's materials reveals ancient Egypt as a civilization with a genuine command of chemistry.[5] We might even entertain the notion that such an organized technology—one might reasonably call it an industry—*defines* a civilization. Paleolithic artists were decorating cave walls at least thirty thousand years ago, long before the last ice age ended, and they were not wanting in proficiency with the dull earth pigments then available. The cave paintings of Lascaux, Altamira, and the Pyrenees display an elegance of line every bit as refined as that in the Egyptian wall paintings several millennia later. But whatever interpretations anthropologists might place on the cave art, they do not speak in the same way of the social order and stratified division of labor that we see in Egypt. They are not the product of a culture whose citizens have a trade to offer.

It is of course the injustice of history that the most ancient of scientific innovators, the equals of Newton, Lavoisier, and Darwin, predate any means by which their names might be passed down the ages. We can never now erect monuments to the fellow who, around 3500 B.C., discovered how to win copper from its ores and thereby take the immense leap from physical to chemical manufacture of artifacts. Neither is the inventor of bronze from the smelting together of tin and copper ores accorded due credit, nor even he or she who, shortly before the time of Homer in 1000 B.C., brought forth iron from its mineral oxide. If the history of science teaches us anything, however, it is that discoveries like this are not made by accident. Good fortune may give one a sporting chance, but as Louis Pasteur remarked, only the perceptive and receptive mind turns it into discovery. Whether we regard these innovations as early science or not is beside the point. To the early artist, making colors was part of the game of art.

RAW EARTH

Although the birth of chemistry as such had to await the first settlements of the Middle East, the deliberate manipulation of natural materials for the purposes of art came much earlier. Cave painters took their palette from the environment. Red and yellow "earths" came from the iron oxide hematite crystallized with varying degrees of water; green earths from the aluminosilicate clays celadonite and glauconite; black from charcoal; brown from manganese oxide; and white from chalk and ground bones. At Altamira and Lascaux there is even a violet pigment made from manganese. With the exception of greens and violet, these substances are widely available. So we see in the caves of France and Spain an earthy version of the "classical" spectrum of black, white, red, and yellow (Plate 6). There seems to be surprisingly little made of the fact that the primordial hues of Berlin and Kay are just those that the earth offers up in abundance.

Yet we should not underestimate the ingenuity with which these unnamed hunter-gatherers made use of nature's hues. It is one thing to smear a charcoal line on a cave wall but quite another to grind hematite systematically into a fine powder with a mortar and pestle, mix it with an organic binding medium such as vegetable oil, and apply it to a surface—a Stone Age oil paint, no less. And who was it who dreamed up the idea of spray-painting the pigment with breath blown through a tube?

This is not all. The Upper Paleolithic (so-called Middle Magdalenian) artists who created the images in the Niaux caves of the Pyrenees around 12,000 B.C., for example, devised new recipes from nature's bounty. No chemical transformations yet, but a physical mixture of pigments with "extenders," neutral materials that made the precious pigments go further and improved their properties in a paint. Mixed with potassium feldspar, hematite becomes a little darker but sticks better to the rock surface and cracks less readily. Better still was the recipe of the Upper Magdalenians (around 10,500 B.C.), in which the feldspar extender contained some biotite, a mixture readily obtained from ground granite. The temptation to see Paleolithic cave art as homogenous on stylistic grounds is thus challenged by evidence of technical innovation over a millennial time scale that in paleontological terms is positively speedy.

THE TECHNOLOGIES OF COLOR

The ancient chemist had little more than a single agent of transformation: fire. Heat may stimulate a reaction and is all one needs to conjure up yellow lead antimonate or blue frit. It will expel gases—turning carbonate minerals like chalk and malachite into oxides by driving out carbon dioxide.

Heat is a pretty blunt tool of transformation, to be sure, but the civilizations of the Nile valley refined it to a degree that commands admiration. Furnaces in Babylonia and Assyria exhibit a range of designs that testifies to considerable experimentation with firing conditions.

Yet it is clear that the technologists of Egypt, Greece, and Rome also had some sophisticated chemistry at their fingertips. They made rudimentary use of acids and alkalis—although until the strong "mineral" acids (sulfuric and nitric) were discovered in the early Middle Ages by the Arabic alchemists, acid treatment could involve nothing stronger than vinegar. That was enough, however, to corrode lead and copper metal into, respectively, white lead and the green pigment verdigris. The chemical processes of fermentation (using yeast to make alcohol from sugar), sublimation (heating a solid to a gaseous state), precipitation (extracting a solid from a solution), and filtration (capturing fine solid particles in a suspension) were standard procedures in the ancient world.

But the chemical technology that existed for color-making in ancient times was not developed specifically for that purpose. The necessary ingredients and skills were fostered by more prosaic crafts, such as glassmaking, pottery glazing, and soap manufacture. In other words, pigment manufacture in antiquity was an offshoot of a large and thriving chemical industry that transformed raw materials into the substances needed for daily life. We shall see in subsequent chapters that this situation obtains throughout the ages: pigment manufacture has been made both economically viable and technologically possible because of its embedding in a much broader landscape of practical science. Art speaks to the spirit but feeds on the mundane.

The manufacture of both glass and soap requires alkalis. In the ancient world these were primarily soda (sodium carbonate) and potash (mostly potassium carbonate). Sodium carbonate occurs naturally as a mineral, called natron in seventeenth-century Europe after the Arabic word for it, *natrun*. But this is hardly a widespread resource, and much of the soda and potash used in the ancient and medieval world came from wood and plant

ash. It is extracted by leaching—allowing water to percolate through the ashes, whereupon it dissolves the alkali. Most ash yields potash, but that made from coastal plants contains more soda.

Who first realized that sand and soda will give you glass when heated to the melting point? Pliny offers a fine tale for this discovery, which he attributes to the Phoenicians inhabiting the area around the Belus River on the Mediterranean coast, north of Mount Carmel:

> There is a story that once a ship belonging to some traders in natron put in there and that they scattered along the shore to prepare a meal. Since, however, no stones suitable for supporting their cauldrons were forthcoming, they rested them on lumps of soda from their cargo. When these became heated and were completely mingled with the sand on the beach, a strange translucent liquid flowed forth in streams; and this, it is said, was the origin of glass.[6]

It is a pretty scenario but surely apocryphal, since campfires do not reach the temperatures of around 2,500 degrees Celsius (about 4,500 degrees Fahrenheit) required to melt sand and soda. Besides, glass was being made more than two millennia before Pliny's account—and not in Phoenicia but in Mesopotamia, the land now occupied by Iraq and Syria.

The earliest true glass is found here and dates from around 2500 B.C. The discovery of glass was surely serendipitous, but perhaps not so casual as Pliny would have us believe. It was possibly the offshoot of experiments in another practical craft, the manufacture of colored pottery glazes.

Blue-glazed soapstone ornaments, imitating the prized blue mineral lapis lazuli, were produced from around 4500 B.C. in the Middle East by powdering the surface of the stone and heating it in the presence of a copper mineral such as azurite or malachite. This blue glassy substance has become known as Egyptian faience (Plate 7), although it was produced in Mesopotamia long before it developed into an industry in Egypt. First appearing in the valley of the Tigris and Euphrates Rivers, faience was being made in the lower Nile region by 3000 B.C., and fifteen hundred years later, trade had spread it throughout Europe.

To generate the high temperatures needed for fusing the minerals in faience manufacture, a fire must be fanned or blown. The artifacts were protected from smoke and ash by containment in a lidded vessel or a kiln chamber—pottery kilns in Mesopotamia date back to 4000 B.C. It seems likely that the developments in kiln technology afforded by the early manufacture of blue-glazed objects led to the discovery of copper smelting from its ore. A love of color ushered in the Bronze Age.

One can imagine that sand might regularly have mingled and fused with the ashes during the firing of faience and that puzzled or delighted artisans would have discovered within the cooled furnace the hard, translucent lumps of coarse glass.

The Mesopotamians found that glass is improved by a dash of lime. A recipe in an ancient cuneiform text reads, "Take sixty parts sand, a hundred and eighty parts ashes from sea plants, five parts chalk, heat them all together, and you will get glass."[7] If it was tainted with copper ore from faience manufacture, the glass would turn out blue. No doubt Egyptian blue frit was another fortuitous offshoot of such experiments, for it shares the same ingredients.

In ancient Egypt glass became a significant technological product around the middle of the third millennium B.C. Color turned it into a material fit to hold the unguents of pharaohs and queens. Cobalt minerals yielded a deeper blue than copper; greens came from iron or copper oxides, yellow and amber from iron oxide, and purple from manganese dioxide. Some metal compounds create opaque colors: yellow from antimony oxide, white from tin oxide. These recipes were used with little change to make the glorious cathedral windows of the Middle Ages.[8]

It is more of a challenge, in fact, to make *uncolored* glass, for impurities of iron oxides in the natural ingredients impart a greenish or brownish tint. (The Latin word for glass, *vitrium*, stems from the word for a blue-green color. The Celtic word *glas* also denotes this hue.) Medieval artisans found that the color could be removed by adding small amounts of manganese dioxide, which became known as "glassmaker's soap."

Glass made from sand and soda ash or natron later replaced soapstone as the vehicle for the faience glazing technique in Egypt. Clay objects were also colored in this way; some of the earliest Egyptian glazes are found on clay beads made by firing them with a mixture of soda and copper minerals.

A true glaze, however, is applied to the surface of the finished artifact, whereas in faience the copper mineral is mixed into the body of the item it tints. There is more opportunity to control the thickness and color of a glaze applied post hoc. The earliest pottery glazes were basically thin coats of colored glass, mixtures of soda and sand with a little clay to provide adhesion. Many of the pottery glazes on Egyptian earthenware are colored with the same minerals as those used for glass; we can only speculate about whether the potter or the glassmaker exploited them first.

These "alkaline glazes" (so called because of their soda content) were

difficult to apply and tended to shrink as they cooled, causing cracking and peeling. From about 1500 B.C., glazes throughout the Middle East commonly included lead, which reduces shrinkage. Lead-glazed bricks and tiles were widespread in Mesopotamia from around 1000 B.C. The Babylonians made lead glazes simply by grinding the mineral galena (lead sulfide) to a fine dust and painting it onto the pottery clay. When heated, the lead compound melts to produce a smooth, shiny coating. This can be colored by adding oxides of copper, iron, or manganese.

The characteristic red and black ware of the Greek and Roman civilizations is colored with a clay slip containing red clay and organic matter or iron oxides. Inspired by a desire to imitate the ceramics of the East, this glazing technique was apparently devised around 1500 B.C. in Mycenae and was improved substantially by the Attic Greeks in the sixth century B.C. The secret of red and black ware was lost to the West after the fall of Rome around the fourth century A.D.

Some seven hundred years later, the Europeans developed a taste for Moorish "lusterware," sparkling with iridescent glazes containing pure metals or their sulfides. They were made in a complex process that involved copper or silver sulfides, ocher, and vinegar, attesting to the formidable prowess of the Arabic chemists. The white pottery ware called *maiolica*, coated with an opaque tin-containing glaze, was also an Eastern innovation. It was introduced to Italy via Majorca, possibly as early as the twelfth century, and gave rise to a major industry in central Italy during the ensuing four hundred years.

The other main engine of color innovation in ancient times was the textile trade, for colored garments served the important function of indicating social hierarchy (arguably they still do).

Traditionally, dyes were bound into cloth by mordants, substances that help attach the coloring agent (usually a natural organic compound) to the fibers of the fabric. Pliny speaks with admiration of the mordanting techniques of the Egyptians:

> In Egypt, too, they employ a very remarkable process for the coloring of fabrics. After pressing the material, which is white at first, they saturate it, not with colors, but with mordants that are calculated to absorb color. This done, the fabrics, still unchanged in appearance, are plunged into a cauldron of boiling dye and are removed the next moment fully colored. It is a singular fact, too, that although the dye in the pan is of one uniform color, the material when taken out of it is of various colors, according to the nature of the mor-

dants that have been respectively applied to it: these colors, too, will never
wash out.[9]

Pliny does not specify the mordants used here, but they were generally
alum (aluminum sulfate).[10] Elsewhere he says that *alumen*, a "salty earth," is
found in many locations from Armenia to Spain. Alum was mined from the
beginning of the third millennium B.C., and its use for fixing dyestuffs dates
at least from the beginning of the second millennium. Its astringent prop-
erties made it valued also as a medicine.

Alum production was a large medieval industry. In the thirteenth and
fourteenth centuries, most of it came from the Greek islands and the Near
East. The capture of Constantinople by the Turks in 1453 cut off this trade
and led to an alum shortage, which was later relieved by the discovery of
deposits of alunite (a mineral form of potassium alum) in the papal territo-
ries in Italy. Mineral forms of alum should ideally be purified before use as
a mordant to rid them of iron salts, which are usually present as impurities
and can damage the dyes. The Arabic alchemists knew this as early as the
thirteenth century, when they described a purification process involving
treatment with ammonia-containing stale urine.

Dyers benefited from the discovery of caustic soda (sodium hydroxide),
first mentioned in Pliny's *Natural History*, written in the first century A.D.
Known in medieval times as lye, this is made from soda and quicklime (cal-
cium hydroxide). Quicklime is the result of heating chalk or limestone to
make lime (calcium oxide) and then slaking it by adding water. Lye, a more
potent alkali than soda or potash, aids the extraction of dyes from their
natural sources. It is also used to make soap, an invention seemingly not of
the "civilized" Romans but of the "barbaric" Gauls. Hard soap, made by
boiling fats or vegetable oils in caustic soda, seems to have been widely
used throughout Europe by A.D. 800.

And then there were the colors themselves. Among the finest ancient
dyes were blue indigo (discussed in Chapter 9) and a deep red colorant ob-
tained from a species of insect. In his thunderous warning of the wrath of
the Lord to the kingdom of Judah, the prophet Isaiah informs us of the red
dye technology of the Holy Land in the eighth century B.C.:

> Though your sins are like scarlet,
> they shall be as white as snow;
> though they are red as crimson,
> they shall be like wool.[11]

Scarlet and crimson are chosen here to evoke the hue of blood, and two millennia later Cennino Cennini acknowledges the dye's "sanguine color." In the Middle Ages it was called kermes, from the Sanskrit word *kirmidja*, "derived from a worm." The Hebrew name for it was *tola'at shani*, "worm scarlet." The red compound is extracted from a wingless scale insect, *Kermes vermilio*, that dwells on the scarlet oak (*Quercus coccifera*) in the Near East, Spain, southern France, and southern Italy. The dye, principally an organic compound that chemists call kermesic acid, is extracted by crushing the resin-encrusted kermes insects and boiling them in lye.

Kermes is the linguistic root of the English *crimson* and *carmine* and the French *cramoisie*. But because an encrustation of kermes insects on a branch resembles a cluster of berries, Greek writers such as Aristotle's pupil Theophrastus (c. 300 B.C.) refer to them as *kokkos*, meaning "berry." In Latin this becomes *coccus*, a word found in Pliny's writings on kermes dye.[12] Yet Pliny also uses the term *granum* ("grain"), again alluding to the deceptively vegetative appearance of the insects. Grain thus became one of the perplexing names by which this crimson dye was known in medieval Europe. Chaucer refers to a cloth that is "dyed in grain," meaning dyed crimson. Because of the strong, lasting nature of this color, the phrase came simply to mean deeply or permanently dyed. From this comes the English word *ingrained*. In *Twelfth Night*, Olivia says of her complexion, " 'Tis in-grain sir! 'twill endure wind and weather"—which is more than can be said for many of the dyes of Shakespeare's time.

The terminology became still more confused in early medieval Europe. In the fourth century, Saint Jerome calls the kermes dye *baca* ("berry") as well as *granum*. But he is aware that the source is no berry at all but an animal, and so he employs the synonym *vermiculum*, meaning "little worm." From this comes the word *vermilion*, a synthetic red pigment made from sulfur and mercury. How a term for an organic dye extracted from an insect became applied to an inorganic pigment made by alchemy is a puzzle that makes sense only within the context of the medieval view of coloration, whereby similarly colored substances of very different origin might end up with conflated names because hue was deemed to be closely linked to composition.

RECIPES FOR COLOR

From this cauldron of practically (one might even say domestically) motivated chemistry emerged prescriptions for making pigments that ancient painters could use. Two of the most valuable and revealing windows into these remote crafts were opened in the early nineteenth century when Johann d'Anastasy, the Swedish vice-consul in Alexandria, purchased a collection of ancient papyri written in Greek and probably looted from a tomb. D'Anastasy presented some of the manuscripts to the Swedish Academy of Antiquities in Stockholm; he sold others to the government of the Netherlands, which deposited them at the University of Leiden. They were translated at a leisurely pace, and it was not until 1885 that one of the Leiden manuscripts, designated Papyrus X, was found to contain a number of chemical recipes for making pigments. In 1913 a similar manuscript, written in the same hand, was unearthed from the Stockholm collection (which had since been relocated to Uppsala). They were believed to be the work of an Egyptian artisan in the third century A.D. but no doubt represented compilations of information from earlier times.

The Leiden and Stockholm papyri are apparently extracts from a workshop instruction manual. Whoever wrote them evidently wished to be understood by fellow craftspeople. Where the texts are obscure, this is more because the author has taken certain knowledge for granted than because of any deliberate attempt (characteristic of the contemporaneous alchemical literature) at concealment. The Stockholm papyrus contains recipes for dyeing, mordanting, and making artificial gemstones. The Leiden papyrus focuses on metallurgy: its 101 recipes tell of methods for gilding, silvering, and tinting metals, including such tricks as "giving objects of copper the appearance of gold."

The documents reveal an impressive amount of chemical skill, a distillation of knowledge accumulated over many centuries. The nineteenth-century French chemist Marcellin Berthelot recognized in the Leiden papyrus a mine of information about the chemistry of antiquity, and he published a French translation of it along with an extensive critical analysis.

Yet to what extent are these recipes informed by real understanding of chemical principles? It is tempting to conclude that they have nothing more to do with science than the fashioning of stone tools has. After all, did not the Assyrians believe that the chemistry of craftsmanship was susceptible to magical and astrological influences?

If one insists on searching these ancient texts for analogues of modern chemical concepts, they will indeed seem ill informed. But the efforts of the ancient protochemists to create new colors established some pivotal ideas in the development of chemical theory. The importance of the very idea of transformation cannot be stressed enough. That the substances of the earth are not fixed in composition but are mutable under human influence is a phenomenal realization. The very notion of elements—fundamental constituents of matter—would not have been half so powerful and fecund if it were not believed that they could be interconverted. Without the conviction that base metals can be transmuted to gold, a great deal of practical chemistry would not have been undertaken. In Western natural philosophy the emphasis has long been placed on the immutable in nature: absolute, unchanging principles of geometry, mathematics, physics, and astronomy. Even today this bias continues to blinker our perception of the scientific enterprise. Some commentators claim to identify the origins of science in the attempt by Thales of Miletos, around 600 B.C., to "find a fundamental unity in nature" (in the words of biologist Lewis Wolpert). But Thales realized that any such unity can obtain only through the agency of change and transformation. To the Ionian school of classical philosophy that Thales founded, "everything is in a state of change." Thales's unifying principle—water—fulfilled its role by virtue of its ability, seemingly unique at that time, to adopt the solid, liquid, and gaseous forms of matter.

If the Leiden and Stockholm papyri carry a scientific message, it is this: we can *create*. We can alter the shape, form, and appearance of matter. And in doing so, we can add to the beauty of the world.

COLORS OF THE GODS

The author of these papyri spoke for generations before him, as well as for many that followed. His Egypt was not the same as that of the First Dynasty (c. 3100 B.C.), but it had a comparable technology of color. The early Egyptian civilization was considered by its citizens to be the work of the great Creator, the god Ptah of Memphis. Just as Ptah brought order to the elemental chaos of a primeval world of water, so the Egyptian priest-kings regarded art and craft as a rationalization of everyday life. The High Priest of Ptah was denoted the Greatest of Craftsmen, and the craftsman's skill was highly esteemed.

One of the most striking aspects of Egyptian painting is its mundanity,

in the literal sense. It is, to the good fortune of anthropologists, a documentary art. Here are people going about their daily duties: fishing, washing, building, hunting, taking offerings to the pharaoh (Plate 8). The overall impression is of a calm, orderly society. The world of the Egyptians did not necessarily conform to this harmonious image; rather, the artist depicted an ideal, a wish that chaos should yield to order and reason. And art was an instrumental means to this end, since it was invested with a magical power to transform the world. The completion of a work of art was accompanied by a ritual through which it acquired this divine influence.

The social importance of Egyptian art was reflected in the culture's systematic accumulation of bright pigments. Most of these were simply ground-up natural minerals: the copper ores malachite (green) and azurite (blue), the arsenic sulfides orpiment (yellow) and realgar (orange), along with the dull earth colors such as the ochers (iron oxide), soot black, and lime white. The Egyptians occasionally made greens by mixing blue and yellow pigments—blue frit and yellow ocher, for example. Natural copper silicate offered another variety of green; the Greeks called this mineral *chrysocolla*—"gold glue"—and used it as an adhesive for gold leaf.

For painting on papyrus, these pigments were generally mixed with a water-soluble gum, creating a primitive version of watercolors. Size—a kind of glue made from boiled animal skins—and egg white were also used as binding agents. Thus Egyptian painting technique was basically what we would call a tempera method (see page 90).

But the Egyptians knew that nature's palette can be made more vivid by chemical "art." In addition to blue frit and lead antimonate, a few discoveries deserve special mention: the manufacture of white and red lead and the creation of lake pigments from organic dyes.

ENDURING WHITE

Lead may have been liberated from its ores as early as the third millennium B.C.; there is extensive evidence of lead smelting in Anatolia from around 2300 B.C. The manufacture of white lead from the metal is remarkable partly for its methodical and protracted character and partly for its longevity: much the same process described by Theophrastus, Pliny, and Vitruvius, and most probably employed centuries earlier in Egypt, was still in use in the nineteenth century. It is likely that this method was also practiced in China from around 300 B.C.

White lead is basic lead carbonate. It is made via an intermediate sub-
stance, a salt called lead acetate, which is formed when acetic acid reacts
with lead metal. Acetic acid is a primary constituent of vinegar and was in
no short supply in the viticultural society of Egypt.

This is how the transformation was achieved. Lead strips were placed in
clay pots that had a separate compartment for vinegar. Stacks of these pots
were left in a sealed shed with animal dung. The vinegar fumes convert lead
to its acetate, while carbon dioxide gas from fermentation of the dung
combines with water to generate carbonic acid. This acid advances the
transformation from lead acetate to lead carbonate. It really amounts to
nothing more than the corrosion of the metal by acids. But lead is an inert
metal, sluggish to react, and so the white pigment could take a month or
more to mature.

The blue-green pigment verdigris (copper acetate, which the Greeks
called *ios*), was made in a similar process, by corroding copper metal with
vinegar fumes. Theophrastus provides the earliest known account of the
method. Having described the manufacture of white lead (which he calls
psimythion), he says, "Also in a manner somewhat resembling this, verdigris
is made, for copper is placed over lees [dregs] of wine, and the rust which
it acquires by this means is taken off for use."[13]

Pliny repeats this description, calling the pigment *aerugo*, or "copper
rust." He says that *aerugo* can also be scraped from natural copper ore, indi-
cating that he drew no distinction between verdigris proper (the acetate
salt) and the naturally occurring copper carbonates of similar appearance.

From white lead one could make red lead, called minium in medieval
manuscripts. In a tenth-century text describing the Roman arts of color-
making, the monk Heraclius describes how the transformation is effected
by heat. Vitruvius asserts that the process was discovered by the accidental
exposure of white lead to fire, which seems entirely likely. Pliny calls red
lead "false sandarach," true sandarach being the rare orange-red realgar. The
abundant use of minium in the small, exquisite scenes of medieval man-
uscript illumination gives us the word *miniature*, from the Latin *miniare*,
"to color with minium." The contemporary connotation of a miniature
as a small-scale work is thus quite unconnected with the Latin *minimus*,
"smallest."

Red lead is used lavishly in Oriental art. Its manufacture is described in
a Chinese manuscript from the fifth century B.C., and it was known during
the Han Dynasty (second century B.C. to second century A.D.) under the

name "lead cinnabar" (*ch'ien tan*), cinnabar being a different red mineral. Red lead features particularly prominently in Indian and Persian miniatures from the fifteenth to the nineteenth centuries, which are finely detailed but by no means tiny.

It is hard to imagine a history of art that lacked white lead, for the early alternatives—chalk and ground bone—cannot provide the ivory opacity that any artist needs. Not until the nineteenth century was white lead superseded by newer synthetic products; before this, it was the only white pigment on the European palette for easel painting in oils. How else but with this chemically manufactured substance could the bright highlights of Renaissance chiaroscuro have been achieved? Where else could the Dutch Masters of the Baroque era have found a white to stand up to their deep blacks? And as an added bonus, the ubiquity of this pigment lets us see the prevarications of the Old Masters. Lead absorbs X-rays strongly, and so X-rays reveal the white underpainting of a work's planning stages (see Chapter 11).

LAKE COLORS

Cinnabar and red lead have an orange tint, and red ocher is dull. The dyers of ancient Egypt enjoyed the richer, darker hue of kermes, but with occasional exceptions such as indigo, dyes are too translucent to serve as paints on wood, stone, or plaster. The Egyptians knew of a solution to this shortcoming, although we cannot tell if they invented it. The water-soluble crimson dye is affixed to an inorganic, colorless carrier powder, generating a relatively opaque solid material called a lake pigment.

Lake is now a generic label for any dye-based pigment, but once it pertained to red alone. In the Middle Ages red lake was made not just from the gummy secretion of the kermes insect (which became known as carmine lake) but from a related resin called lac (also spelled *lak* or *lack*). This encrusts the twiggy branches of trees indigenous to India and southeast Asia and is exuded by the scale insect *Laccifer lacca*. The modern lacquer shellac is a processed form of lac resin. Lac was imported to Europe in large quantities from the early thirteenth century, and as a result it became a blanket term for all red dye-based pigments, including those already in circulation, such as carmine.

Making a carmine lake pigment from kermes dye involved a tour de force of early chemistry. Medieval recipes are remarkably detailed, and

there is no reason to suppose that the procedures of the ancient Egyptians were substantially different. A common method involved the roundabout route of first dyeing cloth or silk in the raw dye extracted from the crushed insects and then boiling the clippings in lye to redissolve the dye.

The dye was then extracted from the hot alkaline solution by adding alum, which precipitates fine-grained alumina (hydrated aluminum oxide) when the solution is cooled. The dye is absorbed onto the surfaces of the alumina particles, which dry to a dark red powder.

Thus the lake pigment was often a by-product of the dyer's trade, manufactured from the offcuts and shearings. Cennino warns against this kind of secondhand product, however, saying, "It does not last at all . . . and quickly loses its color."

The Egyptians also made a deep red dye from the root of the madder plant, of which more is said in Chapter 9. To judge from Heraclius' text in the tenth century A.D., the art of making madder lake was well known to the Romans.

THE FOUR COLORS OF GREECE

Egyptian chemical art was of a robustly practical variety. But the ancient Greek philosophers were more comfortable with theorizing than with experimenting. It is for this reason that the chemistry of classical Greece is relatively barren; most of the Greeks' practical knowledge was imported from the East and was conducted by craftsmen who held a lowly position in society. It is here that we find the origins of the prejudice against manual skills that pervaded medieval thought, influencing the views of Renaissance artists, and persisting even today in the division between "pure" and "applied" science or between science and technology.

How else but through a distaste for experimentation can we explain the curious ideas about color mixing advanced in the writings of Plato and Aristotle, which a craftsman could have dispelled in an instant? Democritus, the "father of atoms," maintained resolutely that pale green (*chloron*) could be mixed from red and white. Plato defended his assertion that leek green (*prasinon*) could be made from "flame color" (*purron*, presumably an orange) and black (*melas*), with the lofty disclaimer that "he . . . who should attempt to verify all this by experiment would forget the difference of the human and divine nature."

Although not wholly averse to experimentation, Aristotle too preferred doctrine, which is why his text *On Colors* is scarcely a painter's handbook.[14] He stresses that the true study of color was to be conducted not "by blending pigments as painters do" but by comparing reflected rays—in effect, by removing the physical substance (as Newton would later do so brilliantly).

Where did these scholars get their seemingly strange beliefs about color-mixing relationships? To understand a culture's preconceptions about color use, we must look to its color theory and terminology. The Greek light-dark scale described in Chapter 1 reveals why, for example, Plato believed that red could be shifted toward green by adding a little "light" (white).

It is hard to say to what extent the Greek dislike of pigment mixing motivated by theoretical prejudice and to what extent practical experience— the loss of brilliance—played a part. Either way, it accentuated the painter's dependence on materials. There are plenty of hues in nature for which no pure pigment was available to the ancient artists, not the least of which was a convincing flesh tone for portraiture. Theophrastus states that a kind of red ocher called *miltos* (from Miletos) was found in many shades, some of which approached the rosiness of flesh. But most flesh tints, as well as other graduated shades, in the art of the ancient world were achieved by crosshatching tones rather than mixing pigments.

Because so little painted art of the early Greeks survives, we are forced to make deductions about their use of color from ancient writings, and these largely from the later writers of the Roman Empire such as Plutarch, Vitruvius, and Pliny who, unlike the classical Greeks, wrote about art for its own sake. The belief, prevalent until the mid-Victorian era, that Greek sculpture was left in chalky whiteness rather than being colored is probably the most famous example of modern misconceptions about classical art derived from a misguided aesthetic bias (the supposed "purity" of white). To the Greeks there was nothing sacred about plain stone that need preserve it from an enlivening lick of paint. Nor were they subtle about it: beards were deep blue (a kind of black, remember), and if we can judge from Roman statues and relief, gods often had bright red faces.

There is ample reason to suppose that most, if not all, of the pigments known to the Egyptians were available also to the Greek painters. Yet, as noted in Chapter 1, both Pliny and Cicero insist that four-color painting was a strong tradition during the heyday of classical Greek art, around the fourth century B.C. The age-induced discoloration of many of the pigments

in surviving Greek and Roman art has no doubt encouraged the belief in this somber palette, but there is more to it than that. Pliny names several renowned four-color artists from this period: the preeminent Apelles, along with Aetion, Melanthius, and Nicomachus. Cicero's list has a slightly longer reach, including the early-fifth-century painter Polygnotos as well as Zeuxis and Timanthes from the early fourth century. The tradition of limiting the palette seems to have begun in the mid-fifth century B.C., when Empedocles was refining the idea of the four elements and Democritus was postulating atoms.

Nietzsche proposed rather contentiously that the Greek painters avoided blue and green because they "dehumanize nature more than any other color." But the real reason is probably more practical than metaphysical. During the fifth century B.C. the Greek artists began to paint three-dimensionally, using a chiaroscuro ("highlight and shadow") technique to depict depth. This development might have motivated the four-color technique as a means of bringing color under control while artists worked out how to manage light and dark. As Renaissance artists were to discover, the larger the palette, the more difficult it is to achieve harmony of hue and tone so that no one color stands out jarringly from the others. By restricting the range of hues, and moreover by rendering them in low-keyed earth pigments rather than bright ones, it becomes easier to master a three-dimensional world of light and shadow.

Once this system was in place, it may have metamorphosed from a technical necessity into an aesthetic principle. Pliny makes no bones about his preference for "austere" over "florid" colors. That Rome inherited the tradition can be seen, for instance, in the four-color Alexander mosaic (Plate 9) in the House of the Faun at Pompeii (which is in fact a copy of a painting by Philoxenos of Eritrea, a pupil of Nicomachus).

Yet pure, bright colors were not shunned in decorative arts. They were used by the Greeks to adorn buildings, as evident in the reds and yellows at Olynthus, dating from the fifth to fourth centuries B.C. Egyptian blue frit has been found in wall paintings at Knossos in Crete dating from before 2100 B.C., on buildings from the Mycenaean period of ancient Greece (around 1400 B.C.), and on artifacts throughout the waxing and waning of Greek civilization. Theophrastus says that an artificial blue pigment was imported from Egypt, suggesting that the Greeks did not know how (or did not bother) to make it. The Etruscans used Egyptian blue in the sixth century B.C., as did the Romans who succeeded them. It is found not only on

the walls of Pompeii but also unused in the city's color shops, as well as in the tombs of Roman painters. There was ample justification for Owen Jones's choice of the antique palette, in spite of the formal absence of blue from Pliny's list of colors.

Chemistry ignited when West met East in the crucible of Hellenistic Alexandria, bringing the logical worldview of classical Greece into contact with the Eastern penchant for practical experimentation. By the same token, the use of color in Western art became more inventive and more gorgeous when Alexander's empire found new aesthetics and new materials in the East.

The bright red mineral cinnabar (mercury sulfide), for example, was used as a pigment in China long before it appeared in the West. Even the Egyptians may have been ignorant of it, and evidence of it in Greek art before Theophrastus' time is rare. Indigo was imported from India: the Greeks called it *indikon*, and Vitruvius tells how the Romans used it as an artist's pigment in the first century B.C.

The Indian "blood of dragons and of elephants" that Pliny disparages is a red resin extracted from Asian plants: according to one account it came from the fruit of the rattan palm, *Calamus draco*, although art historian Daniel Thompson attributes it to the sap of the shrub *Pterocarpus draco*. Dragons, the legendary source, have left their mark in either case. In medieval times the colorant was known as dragonsblood and was still believed to be literally that. Pliny is the first to mention the myth; later it became luridly embellished, as Jean Corbichon indicates in his translation of Bartholomew Anglicus' thirteenth-century *De proprietatibus rerum* (*On the Properties of Things*):

> According to Avicenna [an Arabic alchemist], the dragon wraps his tail around the legs of the elephant, and the elephant lets himself sink upon the dragon, and the blood of the dragon turns the ground red; and all the ground that the blood touches becomes cinnabar, and Avicenna calls this dragonsblood.[15]

But perhaps more significant than an infusion of new "florid" pigments was the brightly hued artistic aesthetic of Persia and India, contrasting with the austerity of the Greeks. It was this influence that led to the gorgeous riches of Byzantine art, later to inspire the Europeans toward bolder use of color when it was brought to the West in the Crusades.

The Hellenistic culture had a more relaxed attitude toward color mix-

ing, based on empiricism rather than misconceived dogma. Alexander of Aphrodisias in the third century A.D. explained how (contrary to Aristotle's belief) green could be made from yellow and blue, and violet from blue and red. But, he said, these "artificial" (mixed) colors are no match for the corresponding pure hues seen in nature. And indeed they are not, for mixing requires good primaries to avoid a loss in brilliance. Limitations of materials were restricting the artist's capabilities.

WAX WORKS

The classical artist sat at no easel, held no palette board, and did not create a work by applying a brush to a surface. For painting on wooden panels, Greek and Roman artists used the technique of wax encaustic (from the Greek *enkaustikos*, "to burn in"). Beeswax was heated over coals and mixed with pigments (and sometimes with resins), and the molten mixture was applied to the surface with a hot spatula. Finally, the colors were burned into the wood with hot irons held close to the paint surface.

This method is surprisingly robust, and attempts have been made to revive it in later times, notably by the German J. H. Müntz in the eighteenth century through his book *Encaustic, or Count Caylus's Method of Painting in the Manner of the Ancients* (1760). The German art academic Max Doerner recounts how one Herr Fernbach touted an elaborate and spurious recipe for the "Pompeian" encaustic technique in 1845 that involved "wax, oil of turpentine, Venice turpentine, amber varnish, and India rubber."

Nonetheless, says Doerner, paintings in wax encaustic may be "durable beyond a doubt." The wax does not discolor and creates a hard, strongly colored finish. It is stable enough in the hot, dry Mediterranean climate but translates less well to the dampness of northern Europe. Apelles reputedly invented a dark protective varnish that, says Pliny, softened the tones of his paintings and made them look even more naturalistic.

Wax encaustic does not work well for murals, however—Pliny calls it "alien to that application," and no instances have been found of its use on interior or exterior walls at Pompeii. (All the same, wax colors are seen on stonework such as Trajan's column in Rome, and a wax layer was often applied to painted walls for protection.) Wall paintings were generally produced by brushing the pigment, mixed with a little water and gum, onto wet, fresh plaster—the technique is now known by its Italian name, *fresco* ("fresh"). The plaster for wall murals was typically made from sand and

lime. The lime binds the sand grains as it dries and is then slowly transformed in air to chalky calcium carbonate. The pigment is applied as a wash over the penultimate layer of wet plaster, and a final thin layer of plaster is applied over the top. The pigment becomes dispersed and fixed in the plaster as it dries. This method tends to produce colors with a slightly chalky appearance.

The fresco technique used at Pompeii, which Vitruvius describes, is very elaborate. Six coats of plaster were applied—the first three with increasingly finer grades of sand, the final three with ground marble instead to give a hard, glossy finish. The dried wall was then polished to a mirror-like smoothness. This laborious process paid off: many of the Pompeiian murals have lasted extremely well (Plate 10). But others were done more quickly and cheaply, using pigments mixed in glue (distemper) and applied to the dry plaster walls (*a secco*, as the Italians would say). Colors applied this way can be rubbed away simply with a wet finger and will not last long when exposed to sun and air. The twentieth-century Swiss artist Arnold Böcklin once attended an excavation of some frescoes at the Forum in Rome in which the colors, as fresh as if recently painted when the fragments were first exhumed, rapidly faded once out in the open. Sometimes the past is too fragile to bear our gaze.

SECRET RECIPES

ALCHEMY'S ARTISTIC LEGACY

"For although men normally accord highest rank to, and guard with the greatest care, every precious thing that has been sought after with much sweat and acquired at extreme expense, yet if now and then similar or better things turn up or are found for nothing, they are guarded with similar or even greater vigilance."
—Theophilus (c. 1122), *De diversis artibus*

"Simple substances, vegetable, mineral, and viscous. Leave to simmer in the crucible of the well-born artisan's heart, stir well, and serve flaming." —Georges Duthuit (1950), *The Fauvist Painters*

If we are to judge from Ben Jonson's play *The Alchemist*, first staged at London's Globe Theatre in 1610, the art of alchemy was not highly esteemed in Shakespeare's England. Subtle, the title role, is an unabashed "coz'ner at large," a con man who bedazzles the credulous with mystical prattle while cheating them of their money. Although there is never any doubt that Subtle is a bogus alchemist, it is possible that Jonson wished to cast similar aspersions on those who claimed to be authentic practitioners too. The mockery is all the more pointed because Jonson is no ignorant outsider constructing straw men. It has been asserted that his knowledge of alchemy "was greater than that of any other major English literary figure, with the possible exceptions of Chaucer and Donne." When Subtle speaks

in impenetrable alchemical language, he is by and large using the same terms as practicing alchemists, and with the correct sense. It is likely that he is modeled after Simon Forman, a contemporaneous pseudo-alchemist who was several times imprisoned for deception but managed to make a lucrative living selling love potions, charms, and "many strange and uncouth things" to the gullible society ladies of London.

Chaucer shared Jonson's skepticism. The Canon in his *Canterbury Tales* (c. 1387) is an archetypal "puffer," one who labored in vain in a smoky laboratory to make the Philosopher's Stone that would transform base metals into gold. As such, he is a shabby, bedraggled sight: "His over cote is not worthe a myte . . . it is al filthy and to-tore." As his assistant says in "The Canon's Yeoman's Tale," others of the same profession are no better than Subtle: one of the Yeoman's former employers swindled an avaricious priest with a fraudulent demonstration of the transmutation of metals into silver.

This popular image of alchemists as charlatans and mountebanks has left chemistry eager to evade association with its predecessor. But in recent times alchemy has begun to shed its tarnished reputation as scholarly studies have fleshed out a more faithful picture of its goals, its practitioners, and its legacy. Without a doubt there were many rogues and tricksters who claimed alchemical allegiance, and there were also the ignorant puffers for whom greed rather than curiosity was the prime motivation. But for most true and knowledgeable adepts of the esoteric art, wealth was not the objective. Theirs was an inquiry into the nature of the world in which the properties of matter and its transformations were inseparable from the attributes of man and his spiritual life.

Until the seventeenth century it was perfectly common for educated people to have some knowledge of alchemy. The great thirteenth-century scholars Albertus Magnus and Roger Bacon were familiar not only with alchemical tradition and literature but also with its practical methods; Bacon's experimental skill enabled him to improve the recipe for gunpowder. Martin Luther confessed that "the art of alchemy . . . appeals to me very much . . . on account of its allegories and secret meanings, which are quite beautiful." Luther's contemporary Paracelsus, the Swiss physician often regarded as the father of chemotherapeutic medicine, was one of the most influential alchemists of the sixteenth century. Isaac Newton spent possibly more time on his alchemical experiments than on the physical theories that transformed eighteenth-century science—but by his day such interests were regarded as somewhat disreputable, and he took great pains to conceal them.

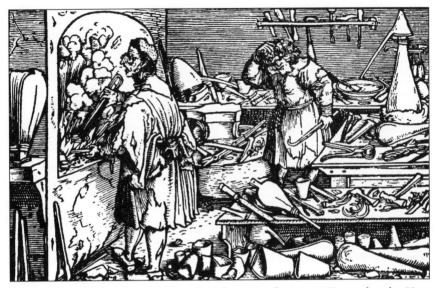

Figure 4.1: An alchemist at work in his laboratory, from a 1520 woodcut by Hans Weiditz. The prominent bellows, used for raising the temperature of the furnace fires, are a reminder of why alchemists were often disparaged as "puffers."

Several artists, too, were alchemically literate. The woodcut illustrator Hans Weiditz of the Augsburg school, a contemporary of Albrecht Dürer and Lucas Cranach, left us one of the most arresting visions of the alchemist at work in a picture dating from 1520 (Figure 4.1). Dürer himself filled his copperplate engraving *Melencolia* (1514) with alchemical symbolism, which features also in works by Cranach, Grünewald, and Jan van Eyck. The influence of alchemy was not confined to the north: the Italian artists Giorgione, Campagnola, and Parmigianino also appear to have woven alchemical allegories into their pictures.

Alchemy's principal influence on art is not, however, as a source of cryptic symbolism, for its origins lie not in the metaphysics but in the practical crafts of ancient times. Alchemy is, at root, an art of transformation. It provided a theoretical framework that enabled experimenters to make some sense of the changes that the agencies of fire, water, air, vapors, and time wrought on materials. Since, as we have seen already, these changes were often accompanied by an alteration in color, it can come as no surprise that practical alchemy would be the means by which artificial colors were provided to artists.

Cennino Cennini, ever a practical man, refers time and again in *Il libro*

dell'arte to the preparation of pigments by alchemy, and there is no reason to suppose that he was doing anything other than telling his readers that their materials could be manufactured industrially.

But in its day, "alchemist" meant many things. The medieval artists bought their materials from apothecaries and pharmacists—tradespeople who may have manufactured pigments personally. They were a distinct bunch from the "chrysopoeian adepti," those who sought the esoteric secrets that enabled the transmutation of lead into gold or who wrestled with the philosophical and religious aspects of the art. In his seminal work *The Sceptical Chymist*, the chemist Robert Boyle makes it clear that there is a line to be drawn between the practical "laborants"—Chaucer's puffers, whose brains, says Boyle, were "troubled with the smoak of their own furnaces"— and the theory-oriented adepti. Charlatans and fools populate the former group, Boyle asserts, while the latter are serious-minded fellows.

At least that is what he would like us to believe, since Boyle aspired to be an adept himself.[1] But the distinction was surely more akin to that often drawn today between graphic and fine art or between technology and science: the laborants might harbor a desire to attain the status of adepts; the adepts look upon the laborants as vulgar recipe followers. The two may not share a common cause, but they draw from the same intellectual well. In alchemy, color is the crucial link between theory and practice. It was the key to the chrysopoeian art, and one can hardly imagine that the discoveries made in these endeavors would not have filtered down to the prosaic level of pigment manufacture. It is no coincidence that artists and alchemists were using the same materials.

And we must remember that magic was as real to the ordinary folk of the Middle Ages as it was to the alchemical adepts. Magic was woven into the fabric of Western culture, and for long centuries the threads would have parted without it. It was blended with religious belief, to the occasional discomfort of the Church. Painting, too, was primarily a religious affair, at the same time a mundane craft and a devotional activity that could be invested with a spiritual power akin to that of the art of ancient Egypt. Small wonder, then, that the colors of the painter could surpass their own materiality and take on an almost divine significance. When the sixteenth-century Venetian writer Paolo Pino called the composition of colors on canvas "the true alchemy of painting," we must bear in mind that he is not using the word *alchemy* in the glib and debased manner that is popular today. He means to imply a genuine correspondence whereby, as art historian

Martin Kemp writes, the materials "mysteriously transcend the nature of their individual parts."

THE GREAT WORK

Take the vitriol of Venus . . . and add thereto the elements water and air. Resolve, and set to putrefy for a month according to the instructions . . . Separate and you will soon see two colours, namely white and red. The red is above the white. The red tincture of vitriol is so powerful that it reddens all white bodies, and whitens all red ones, which is wonderful. Work upon this tincture by means of a retort, and you will perceive a blackness issue forth. Treat it again by means of the retort, repeating the operation until it comes out whitish . . . Rectify until you find the true, clear Green Lion . . .[2]

Never before or since the Middle Ages was color so central to chemistry. Although half obscured by the alchemists' secretive terminology, the transformations that these protochemists were conducting in their elaborate alembics and pelicans can be recognized by the resulting color changes. For all its mythical resonance, vitriol of Venus is nothing other than blue copper sulfate, familiar from many a school laboratory.

Color underpins the alchemical belief in transmutation. A substance's color was deemed an outward manifestation of its inner properties. Lacking much information beyond this superficial characteristic, alchemists had every reason to suppose that a metal with the appearance of gold was none other than gold itself. Thus we risk mistaking genuine conviction for improbity. The scientist and historian Joseph Needham has pointed out that the distinction between counterfeiting and transmuting gold is a cultural one—it depends on what you think you are doing. In the chemistry handbooks of antiquity, fraud tends to be explicit: a recipe in the Leiden papyrus for faking gold from copper comments reassuringly on the difficulty of detection, while another for faking silver warns of the possibility that silversmiths might notice the difference.

The language of dyeing and coloring suffuses the alchemical literature. Stones and metals may be "dyed" as readily as textiles. The Philosopher's Stone itself is commonly called the Tincture.

It has been suggested that this wondrous red substance, also called the Red King, was none other than vermilion, the medieval painter's finest red pigment. Vermilion is a synthetic form of mercury sulfide; as we saw ear-

lier, the natural form (the mineral cinnabar) served as a pigment from an-
tiquity. According to the tradition of the influential eighth-century Arabic
alchemist Jabir ibn Hayyan (known in the West as Geber), sulfur and mer-
cury (medieval writers call it "quicksilver") are the elementary "principles"
from which all metals are formed. In Jabir's scheme, base metals like lead
differ from gold only in their relative proportions (or purity) of the two
principles, and so they can be elevated to gold simply by adjusting the mix-
ture. Albertus Magnus writes, "We may say that in the constitution of met-
als Sulfur is like the substance of the male semen and Quicksilver like the
menstrual fluid that is coagulated into the substance of the embryo."[3] These
two principles were brought into perfect balance in gold, whose yellow tint
was attributed to the presence of sulfur. Thus vermilion apparently contains
the two ingredients necessary to effect the transmutation of all metals.

But we must be careful. The sulfur and mercury of vermilion are not at
all the same as Jabir's Sulfur and Quicksilver. These principles are "subtle,"
intangible substances, of which earthly sulfur and mercury are but corrupt
shadows. Thus it is highly doubtful that vermilion was ever truly regarded
as the Tincture, especially since it was relatively easy to manufacture. Some
recipes for the Philosopher's Stone, in fact, use cinnabar as the mere start-
ing material.

Vermilion—a marriage of fundamental substances—was nonetheless of
indisputable interest to alchemists, and knowledge of its synthesis was de-
rived from their writings. The process may have been invented in China,
and around A.D. 300 the Hellenistic alchemist Zosimus of Panopolis hints
that he knows of it. But the first clear description occurs in the eighth-
century manuscript *Compositiones ad tingenda* (*Recipes for Coloring*). The
works attributed to Jabir also mention how mercury and sulfur unite to
form a red substance, and the ninth-century text *Mappae clavicula* includes
two recipes for making it.

All this cannot but have been to the advantage of painters, who consid-
ered synthetic mercury sulfide superior to cinnabar. Cennino says that the
pigment "is made by alchemy, prepared in a retort." But he cares little for
the symbolic resonances of this process and declines to relate the technical
details with the dismissive comment that it would be "too tedious." Buy it
ready-made, he advises—but in an unbroken lump, for unscrupulous
apothecarists were known to dilute the precious substance with red lead or
brick dust.

The Benedictine monk Theophilus (Roger of Helmarshausen) is more

expansive in his technical handbook *De diversis artibus* (*On Divers Arts*, c. 1122), describing a dramatic alchemical synthesis in which sulfur and mercury are placed in a sealed pot and buried in "blazing coals." "You hear a crashing noise inside," he says, "as the mercury unites with the blazing sulfur." Perhaps Theophilus is more entranced by the mystery: the manufacture of vermilion was still novel in Europe in the twelfth century, whereas it was commonplace in Cennino's lifetime.

Daniel Thompson regards the synthesis of vermilion as the central technological innovation of medieval painting:

> No other scientific invention has had so great and lasting an effect upon painting practice as the invention of this color . . . If the Middle Ages had not had this brilliant red, they could hardly have developed the standards of coloring which they upheld; and there would have been less use for the inventions of other brilliant colors which come on the scene in and after the twelfth century.[4]

It was certainly the medieval prince of reds. It is used sparingly in early medieval manuscripts; until at least the eleventh century it remained as costly to cover the page with vermilion as with gold. But by the early fifteenth century it is employed with abandon (Plate 11), and during the Renaissance it is ubiquitous.

The pigment in these pictures was produced by the direct synthesis of the elements, as Theophilus relates—the so-called dry process. This generally produced a lump of solid red vermilion. "If you grind it every day for twenty years," said Cennino, "the color would still become finer and more handsome."

The dry-process synthesis was later modified in Holland, which became the principal center of vermilion manufacture in Europe in the seventeenth century. In the Dutch method, mercury and sulfur combine to create a black form of mercury sulfide, sometimes called the *Aethiops mineralis*, with a slightly different crystal structure from the red form. The black material is then pulverized and sublimated by strong heating, whereupon it is converted to red vermilion.

In 1687 a German chemist named Gottfried Schulz found that the Ethiops mineral can be converted to red vermilion by heating it in a solution of ammonium or potassium sulfide. This wet process is less laborious and less costly than the Dutch method and also produces a finer powder with uniform grain size and an orange-red color, compared to the bluish

red of the dry-process product. Most vermilion in the West today is made using the wet process.

MAKING THE TINCTURE

There is good reason to argue that red is the primary hue of both medieval chemistry and art. Alchemy accords red a special significance. It is the "color" of gold, deemed more beautiful when more ruddy, and it signifies the culmination of the Great Work: the creation of the Philosopher's Stone. "Red is last in the work of Alkimy," says the fifteenth-century alchemist Norton of Bristol.

The preparation of this fabled substance is described in several surviving medieval texts. In general, these recipes say that a particular sequence of color changes indicates the successful progress of the work. Before ending in red, the transformations were commonly supposed to generate the other three principal colors of the classical world, black, white, and yellow, in that order.

The American chemist Arthur Hopkins, attempting in 1934 to unravel the actual chemical transformations that alchemists were conducting, regards the critical color sequence as black-white-yellow-purple, a progression reported by Zosimos. According to Hopkins, the alchemist began his work with a black alloy of lead, tin, copper, and iron known as the *tetrasoma*, or four-membered body. Adding arsenic or mercury formed a white surface coating. Yellowing was achieved by adding gold or "sulfur water" (a solution of hydrogen sulfide). The final step of *iosis* generated a purple color that Hopkins regards as a violet-bronze gold-containing alloy.

Some modern scholars of alchemy have asserted that *iosis* denotes the formation of a red rather than a purple substance. But to the medieval scholar this is a meaningless distinction, since purple was generally deemed a kind of red. The medieval red pigment sinoper, for instance, was equivalently known as porphyry, from the Greek word for purple. And it seems likely that an adept of the Middle Ages would have perceived a symbolic significance in the association of the chrysopoeian sequence with the color quartet of antiquity. Thus the appearance of *either* a bright red or a deep purple color in the retort would have been considered a sign of success. It is no wonder that one adept might have been experimenting on quite a different set of compounds from another.

Both arsenic and lead form simple compounds that can be intercon-

verted between red, yellow, white, and black materials, some of which were used by artists. For the alchemical adept, an attraction of arsenic—not then recognized as an independent element—was that it was commonly confused with sulfur. Yellow arsenic sulfide—orpiment—was often regarded as a variant of pure sulfur. It is found naturally in mineral form, but artists preferred a synthetic version. Cennino considers this synthesis a task best left to the alchemists, for orpiment is "really poisonous," and the painter should "beware of soiling your mouth with it." As for realgar, the orange form of arsenic sulfide, "there is no keeping company with it . . . Look out for yourself."

We can conjecture that lead held a similar attraction to alchemists, but for the drawback that its compounds are harder to purify using heat alone. It, too, can be interconverted between black (metallic lead or lead dioxide), white (white lead), yellow (massicot or lead monoxide), and red (red lead or lead tetroxide) forms by chemical transformations involving heat. Red lead shares the orange tint of vermilion or cinnabar, and there was much scope for confusion of the two. Georgius Agricola calls red lead *minium* in *De re metallica* (1556), but to Pliny *minium* denotes cinnabar, and red lead is merely *minium secondarium*. The distinction may have been further blurred by the common practice of adulterating ground vermilion with the cheaper lead pigment.

Red lead was also conflated with realgar (Pliny's sandarach). And Cennino creates more confusion by speaking of a red pigment called cinabrese, apparently not related to cinnabar but to sinoper, the red ocher preferred by the classically minded Pliny. Says Daniel Thompson, "The confusion of medieval terminology in regard to red colors is immense. *Minium* and *miltos* and *cinabrum* and *sinopis* and *sandaracca* are a complicated tangle"—into which we can also weave the problem of vermilion and *vermiculum* mentioned previously. There is no reason to suppose that these distinctions were any clearer to the chrysopoeian alchemists than to the pharmacists and apothecaries who made and supplied artists' colors or the scholars who wrote about them.

Close inspection of the recipes given for pigment manufacture reveals an influence not only of the practical but also of the theoretical side of alchemy. The ratio of sulfur to mercury recommended for the synthesis of vermilion by several sources, including Theophilus and Albertus Magnus, does not accord with their actual proportions in the compound. The substance contains a little over six times more mercury, by weight, than sulfur, yet medieval recipes specify a ratio of typically two to one. The practical al-

chemists were certainly skilled enough to spot an error of this magnitude, which would be evident from a residue of unreacted sulfur in their flasks, yet apparently they persisted with the "wrong" quantities. This can be rationalized, however, if one assumes that equal amounts of sulfur and mercury were considered necessary to give a perfect "balance" in chrysopoeian terms. This corresponds to a two-to-one ratio according to the relative weights posited by the Aristotelian system of elements, which underpins all of medieval alchemy. Thus the recipes may be knowingly erroneous to fulfill theoretical criteria. Whether Theophilus and other writers of handbooks knew of these considerations or simply perpetuated an error picked up from alchemical sources is not clear.

Art conservator Spike Bucklow has suggested that some of the other pigment recipes recorded by Theophilus and Cennino can also be interpreted in terms of alchemical theory. Theophilus tells how to make a color called Spanish gold (the name immediately speaks of a Moorish, and hence alchemical, origin). Among the sound practical advice in his manual, Theophilus' prescription here seems to suffer an outbreak of pure magical thinking: "There is also a gold named Spanish gold, which is compounded from red copper, basilisk powder, human blood, and vinegar. The heathen, whose skill in this art is commendable, create basilisks for themselves in this way."[5] He goes on to explain how these fabulous creatures emerge from hen's eggs hatched by toads fed on bread. "When the eggs are hatched, male chickens emerge just like chickens born of hens, and after seven days serpent tails grow on them." The blood, meanwhile, must come from a red-haired man and must be dried and ground. Of course, there is nothing particularly outlandish in a twelfth-century belief in basilisks, but Bucklow suggests that this can be seen as an allegory for the preparation of an alchemical elixir from a red "sulfur" (the blood) and a white "mercury" (the basilisk ash). Certainly, the reference to the pigment as "a gold" suggests that the author saw no reason to distinguish it from the metal itself.

Bucklow also posits alchemical influences in some of the recipes for yellow pigments, such as mosaic gold and lead-tin yellow. Their ingredients can be interpreted as allegorical sulfurs and mercuries combined with a third "principle," salt. This triumvirate was popularized by Paracelsus, but its origin is probably older.

Alchemical theory and pigment manufacture intersect even in the works of Robert Boyle. In *Origine of Formes and Qualities* (1666), Boyle describes the extraction of a blue tincture from copper metal, leaving a residue of a white metal "exactly comparable to silver." The idea of tingeing

(or in this case, bleaching) metals was clearly alive and well in the seventeenth century.[6]

READING NATURE'S SECRETS

There is a striking contrast between the writings of the alchemists, wreathed in arcane terminology and symbolism designed to exclude the noninitiate, and the ingenuous recipe lists of Theophilus and Cennino, who talk about some of the same chemical transformations in plain terms and in the same breath as they describe how to make engraving tools, church organs, distempered walls, and body casts. Nevertheless, many of the craftsmen's manuals from which much current knowledge of ancient and medieval pigment manufacture derives, such as the Leiden and Stockholm papyri, stem directly from the alchemical tradition.

Technical handbooks ambivalently called "Books of Secrets" were widespread in the early Middle Ages. These works were bizarre anthologies, collating medical and culinary recipes and practical tips on crafts such as gilding and stained-glass making, amalgamated with magical formulas, parlor tricks, and practical jokes. They came from a long tradition of encyclopedic compilations, which can be traced as far back as the Assyrian civilization and embraces the synoptic works of Roman writers, such as Pliny's *Natural History*. These were regarded in their time as shortcuts to the vast learning of the ancient world.

In Hellenistic Egypt, steeped in alchemy, these collections metamorphosed into a more cryptic format. Pliny's *Natural History* purports simply to describe nature, whereas the alchemical or "Hermetic" compilations of Egypt take a different attitude toward the natural world. Scientific truths known to the ancients cannot, they say, be accessed by rational inquiry or from literary inscriptions but only by divine revelation. This lends a decidedly ambiguous flavor to the Leiden and Stockholm papyri. At face value they are plain lists of recipes. Yet they seem to be descended from an alchemical treatise of the first century A.D. called *Physica et mystica* by Bolos of Mendes. The author of the papyri was probably an alchemist, but the works have lost the mystical dimension of *Physica et mystica*, in which this mysterious declaration is appended to all the recipes: "One nature delights in another nature; one nature triumphs over another nature; one nature dominates another nature."

In the technical craft manuals of the early Middle Ages, this alchemical

or esoteric theoretical component has atrophied, and what is left is a strange mixture indeed. The recipes persist, copied with uneven fidelity from older texts, but their utility as guides for the craftsman is highly questionable. Poorly transcribed and "born of drudgery, not inspiration," as engineer and historian Cyril Stanley Smith puts it, they had become confused and all but useless as "how to" instruction booklets. It is clear from the misconceptions they perpetuate that the authors had little practical experience in the arts: they were monks working as copyists, perhaps with no interest at all in the material. These books of rote prescriptions hold a distorted mirror to the learning and technology of ancient times, and they show scant evidence of having been subjected to the wear and tear of a workshop environment.

So what purpose did they serve? Probably an esoteric one. No longer explicitly magical, the books were nevertheless apparently regarded as "keys" to the lost wisdom of the classical world. To the early medieval monk, this knowledge bordered on the sacred. The word of Aristotle (or whatever version of it found its way to medieval eyes) had an almost divine authority, and dissent was akin to heresy. One of the works in which this knowledge was brought together is the *Mappae clavicula*, the "Little Key to Painting," which originates from ninth-century southern Italy. Only fragments of this work survive, some of them later transcriptions. "Key" is to be understood here not in the sense of a step-by-step set of instructions, despite the recipes for making pigments, colored glass, and so forth. Rather, the key unlocks ancient insights—or such was the hope of the monks who would have kept the text in the library and referred to it with reverence: "For just as access to locked houses is impossible without a key . . . so also, without this commentary, all that appears in the sacred writings will give the reader a feeling of exclusion and darkness."[7]

These works were rather repetitive and derivative: recipes from the *Mappae clavicula* can be found in scores of later manuscripts and can themselves be identified in a slightly earlier manuscript, the *Compositiones ad tingenda* of the eighth or early ninth century, which is itself linked to Alexandrian alchemical works. The implication that these works were "keys" is particularly explicit in *De coloribus et artibus Romanorum* (*On the Colors and Arts of the Romans*), a tenth-century work by the Italian monk Heraclius: "Who is now able to show us what these artificers, powerful by their immense intellect, discovered for themselves?" he asks. "He who, by his powerful virtue, holds the keys of the mind, divides the pious hearts of men among various arts."[8]

These manuscripts are clearly from the secretive tradition, circum-scribed with warnings not to let this arcane lore fall into vulgar hands. The author of the *Mappae clavicula* swears that he will hand on his learning to no one except his son, "when he has first judged his character and decided whether he can have a pious and just feeling about these things and can keep them secure."

But despite their lack of inspiration, the compilations provide valuable insights into the chemistry of the Middle Ages. The *Compositiones*, for exam-ple, introduces the term *vitriol* for iron sulfate, later to become associated with acids. A twelfth-century version of the *Mappae clavicula* includes a recipe for distilling alcohol, a "water" that burned.

As the arts and crafts became increasingly secular in the Middle Ages and the profession of painting was transferred from monks to lay trades-men, little more than lip service was paid to the need for secrecy in transmitting the "secrets of nature." Indeed, the Books of Secrets became a genre in which the very suggestion of forbidden knowledge was used as a marketing strategy. Writers could make a living by recycling these puta-tive arcana in a popularized manner. The German translation of Pseudo-Albertus' *Secreta mulierum* (*The Secrets of Women*) by Walther Hermann Ryff notched up thirty editions and was a best-seller in sixteenth-century Ger-many. The advent of printing turned such efforts into the popular science of its day, spawning the German *Kunstbüchlein* ("skills booklets"), which became extremely widespread in the sixteenth and seventeenth cen-turies.

Some of the *Kunstbüchlein* drew heavily on the *Secreti* (1555) of Alessio Piemontese, who was possibly a pseudonymous character invented by the Italian writer Girolamo Ruscelli (1500–c. 1566), complete with an exotic personal history to lend color to his work. These "secrets" are fairly mun-dane: medical treatments for burns, bites, sores, fevers, and warts and recipes for domestic items such as perfumes, body powders, and soaps. (In the sixteenth century the physician Cornelius Agrippa recounted a proverb: "Every alchemist is either a physician or a soapmaker.") But scat-tered through the *Secreti* are technical procedures for the craftsman, includ-ing a recipe for creating ultramarine and descriptions of the methods of Italian artists. Translations of the *Secreti* may have been a primary source of information on these matters for northern European painters and crafts-men.

FROM MONK TO GUILDSMAN

Against this checkered history of the transmission of technical know-how in the arts and crafts, Theophilus' book stands out for its unusual directness and clarity. It is no random collection of snippets from ancient books but rather presents systematically the techniques of the practicing artist. Indeed, unlike the authors of most of the recipe collections, Theophilus *was* a practicing artist: his formulations bear the stamp of experience. And there is no call for secrecy, but instead an entreaty toward openness: "Let [the artisan] not hide his gifts in the purse of envy, nor conceal them in the storeroom of a selfish heart but . . . let him simply and with a cheerful mind dispense to those who seek."[9]

To Theophilus, art was a devotional activity, the aim of which was to glorify God. To this extent he exemplifies the painter of the twelfth century: a monk whose work is exclusively religious and who is accomplished in a variety of arts and crafts including manuscript illumination and metalwork. All of these, including painting, were conducted as anonymous activities— opportunities for pious meditation rather than for self-advancement. Even secular works in the early Middle Ages are usually unsigned. And the largest body of religious art from this time consists of illuminated manuscripts, the painstaking and often gorgeous work of innumerable nameless monks.

Little is said in Theophilus' book about design and composition. The emphasis is all on techniques and materials, strengthening the impression that much monastic painting was formulaic. The monk did not need guidelines for how to compose a scene—he'd merely copy one. Moreover, his choice of style and materials reflected a view of the world in which icons and images are not simply symbols of devotion but are invested with the power to intervene in everyday life. Several illuminations depict painters being rescued from misfortune as they work on images of the Virgin Mary. In one, from the thirteenth-century manuscript *Las cantigas* of King Alphonso the Wise of Castile, the devil causes a painter's scaffolding to collapse, but he is saved from falling by adhering to the picture of the Virgin on which he is working (Figure 4.2). Don't be misled by the resemblance to an amusing cartoon strip; scenes like this show that a well-made icon or picture was considered to possess real religious efficacy. The artist's use of precious materials, such as gold and ultramarine, does not simply imply a wish to show piety by lavishing expense but reveals the hope that the supernatural potency of the work will thereby be enhanced.

But between the eleventh and the fourteenth centuries, the practice of painting was transferred from the monastery to the towns, where it was conducted by lay professionals who considered themselves tradespeople with skills for hire. Inevitably, this had consequences both for working practices and for the art that was produced. Even if the distinction between monastic and lay craftsmen is sometimes overemphasized—secular painters were sometimes employed by monasteries only to stay on and become monks—nonetheless artists were increasingly members of a profession, the "peynturs" as they were known in England. They followed a trade like any other. Like the woodworker, the potter, the baker, and the weaver, the painter offered his technical proficiency for a fee. He was by no means above asking the baker for use of his ovens to make charcoal, employed as a black pigment. Nor would the artist sneer at the cook, with whom he had

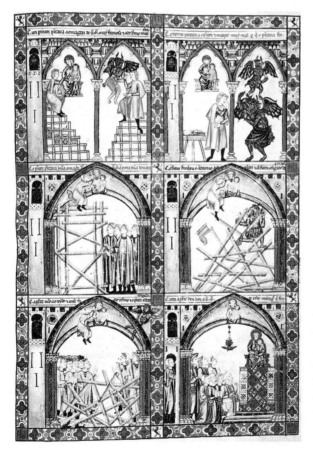

Figure 4.2: A painter working on an image of the Virgin Mary is saved from a fall when a devil demolishes his scaffolding. The power of the image itself confers protection.

many skills in common. Cennino assumes that artists know what he means by the instruction that plaster should be made as if preparing batter.

One of the consequences of this transition from monk to artisan was increasing specialization. Painters were painters, not to be confused with illuminators, dyers, or workers in wood and metal. Such distinctions were rigidly enforced by the guilds that developed to safeguard the employment of tradespeople against competition and economic uncertainty, and heaven forbid that a painter should be called in to illuminate a book page. There were even fine distinctions drawn among painters. In fifteenth-century Spain one could find specialists in altarpiece painting, fabric painting, and interior decorating. Concomitant with these divisions was a hierarchy of trades in which status tended to reflect the value of the materials. Goldsmiths were the most prestigious and powerful artisans, painters more humble, and woodworkers still more so. Guild restrictions prohibited the use of the most valuable pigments, such as ultramarine, for vulgar purposes such as the painting of playing cards, carts, or parrot perches. Thus these valuable pigments played a role in establishing the social standing of painters: it was in their interests to use fine materials.

Yet the art of painting was still regarded as a mechanical process. There was good and bad, to be sure, but the task of the painter was to meet the specifications of a contract, not to give free rein to artistic inspiration. It was the employer—the patron—who called the shots. Initially, the patrons of lay painters, when not ecclesiastical, tended to be royal or aristocratic, and the painter could find himself affiliated to a court. But as a prosperous middle class emerged during the late Middle Ages, the base of patronage broadened, and artists could find commissions among the mercantile echelons of society.

Patrons were not noted for their originality of taste. Often they might request a painting imitating another that had caught their fancy. The artist might find room for personal flair in executing his designated subject, but under this system, conservatism was the order of the day. So dominant was the patron in determining the subject matter of an image that *patron* in medieval terminology is a synonym for *design*.

It was the patron, moreover, who would typically specify the materials to be used, generally insisting on the most lavish and opulent while demanding that the painter keep his fees reasonable. A patron might even determine the supplier from which the artist bought materials—either by written agreement in the contract or by designating a price for the finest

pigments, which ensured the artist did not seek them at lower cost from an inferior source. Assessors could be called in to verify that the painter had followed the contractual obligations concerning pigments.

Yet many patrons were not averse to economy, and the painters' guilds would often have to insist on their members' right to be permitted good, pure materials in the face of attempts to get a job done on the cheap.

Membership in a guild was attained by apprenticeship. Aspiring painters would serve a training period of typically between four and eight years in a workshop, beginning as all apprentices do with the most menial of jobs, such as grinding pigments and making glue. Pigment grinding was a particularly arduous and time-consuming job, and painters might need to allow several days for this alone in their scheduling for a commission (Plate 12). To qualify as a "master painter" ready to accept contracts, an apprentice would present a "master piece" to the guild for approval. Strange, then, that this term has come to refer to an artist's most accomplished piece of work rather than his or her first attempt to gain recognition.

A workshop undertook a commission as a group, much as a band of builders or thatchers would (and still does) perform a job collectively. The master, or *magister*, was responsible for the overall execution of the work, but the application of paint to surface was as much, if not more, the responsibility of his apprentices. Thus the signatures that appear on later medieval art are simply trade stamps, denoting the name of the workshop's master. This traditional training accorded little value to personal talent or inspiration: a person became a painter simply by dint of hard work, dedication, and adherence to the master's demands. "Skill," or what Theophilus calls *ingenium*, was the product of diligence.

Cennino wrote *Il libro dell'arte* in this later social context. The book was, he said, "for the use and good profit of anyone who wants to enter the profession," not for the greater glory of God. To Cennino, the inspiration that drives one to become an artist is not divine, despite his invocation of "High Almighty God, the Father, Son and Holy Ghost." No, it is simply a delight in the creation of art—though the financial motive is not to be sneered at either: "There are those who pursue it, because of poverty and domestic need, for profit and enthusiasm for the profession too; but above all these are to be extolled the ones who enter the profession through a sense of enthusiasm and exaltation."[10] This humanistic spirit looks ahead to the Renaissance. Yet although Cennino's book is a late-fourteenth-century work, his outlook is still rooted in the Middle Ages, and his methods and

attitudes show continuity with the medieval practices depicted by Theophilus almost three centuries earlier.

WORK IN PROGRESS

The tradesman's approach to art is reflected in the products of the medieval artist. These were typically functional and decorative: altarpieces, wall murals, and book pages, rather than works to be hung in a gallery. It is a testament to the human instinct for creativity that unmistakably great art could be generated "on the job," as it were.

The main surface for medieval painting was parchment: the skins of calves, goats, sheep, and deer, dried, stretched, and scraped to a delicate smoothness—and no stranger to chemical treatment. Alkalis were applied to draw out the oils by converting them to soluble soaplike salts. Alum was used to make the material harder. Parchment might be dyed before use. In the most sumptuous works, whole pages were colored a glorious purple using "whelk red," a variant of the famous purple of Tyre, all the better to contrast with yellow gold leaf.

But most of the large-scale paintings of the Middle Ages that are still in existence are rendered on wood, carved and ornamented and often joined into two or more hinged panels in a polyptych. The wood was coated first with size and then with several layers of gesso, a kind of plasterlike undercoat that gave it a smooth surface. Gesso was composed of chalk, gypsum (calcium sulfate), or alabaster, bound with glue or gelatin so that the paste set hard. Thin gesso (*gesso sottile*) was used over areas of delicate carving that should not be obscured, and thick gesso (*gesso grosso*) for flat areas.

The preparation and application of gesso was a tedious affair and therefore fit for apprentices. But it was nevertheless an essential and important part of the process, and Cennino provides very detailed instructions for how to conduct it. The chemistry is not by any means trivial. Ordinary plaster of Paris is made by heating gypsum or alabaster to drive off some of the water bound up in the mineral structure. Adding water to the powdered mineral lets it recrystallize and solidify, but if this recrystallization takes place in a size such as gelatin or glue, it happens more slowly and the crystals are welded together more robustly, with the result that the solid is harder.

Wall painting on plaster was also practiced widely in the Middle Ages,

in churches as well as in private halls and palaces. Fresco painting in wet plaster produced robust results so long as the wall did not become exposed to moisture, but it required the painter to work fast, while the plaster was still damp. Curiously, some painters maintained that only natural mineral pigments were stable enough to use in fresco—a largely false distinction that might nevertheless have severely constrained the palette of fresco painters who heeded advice such as that of the Italian G. B. Armenini in 1587: "Artificial pigments never do well in fresco, nor can any art make them last long without changing . . .You may leave to foolish painters those secrets of theirs, which no one envies them, of using vermilions and fine lakes; because . . . in the long run, their pictures become ugly daubs."[11] Cennino himself proudly traced the provenance of his fresco technique to the Florentine artist Giotto di Bondone (c. 1266–1337), via Giotto's godson Taddeo Gaddi and Taddeo's son Agnolo, Cennino's teacher. The blue heavens in Giotto's frescoes in the Arena Chapel in Padua (c. 1305) (Plate 13) are as glorious today as they were when visitors in the four-teenth century were promised a reduction of one year and forty days off their stay in purgatory.

Giotto was also a master of *secco* wall painting, exemplified by his work in the Peruzzi Chapel in Florence. This technique, like panel painting, re-quired a binding medium or *tempera* for the pigment. The tempera (from the Latin *temperare*, "to mix") holds the pigment particles in place. In Italy, until the fifteenth century the principal binding medium for pictures painted on panels was egg yolk. Pigment mixed with yolk and a little water forms a fluid paste that dries to an opaque, smooth, durable finish. Egg yolk is a natural emulsion, a dispersion of oily droplets in water. The medieval painter might add a variety of substances to egg tempera to modify its be-havior. Vinegar, for instance, acted partly as a preservative (its acidity deters certain bacteria) and partly to offset excessive oiliness (which made the paint hard to work with). Fig tree sap, soap, honey, and sugar are variously mentioned in recipes through the ages, but Max Doerner, one of the twentieth-century authorities on old painting techniques, dismisses such adulteration: "There is no end to tempera recipes. Their number is incredi-bly large. Most of them are not only useless but definitely harmful."

Egg tempera is relatively quick-drying, and so the artist must work swiftly, especially when blending colors. Dry, aged egg tempera paint is vir-tually waterproof and, if skillfully prepared, discolors less rapidly than oil paints. Some of the colors in medieval tempera panels are more vivid today

than those in Renaissance oils. On the other hand, the paint lacks the flexibility of oils and so has a tendency to crack if the wooden panel swells or shrinks owing to changes in temperature or humidity.

Cennino offers several prescriptions for egg tempera, and the rediscovery and translation of his book in the nineteenth century revitalized interest in the method. He recommends egg yolk not as an all-purpose binder but only for specific pigments, since compatibility depends in part on how the yolk affects the pigment's optical properties. Cennino cautions that some pigments, such as blues and certain mixed greens, should be used only with size, a kind of gelatin glue made by boiling up trimmings or scrapings of animal skin parchment or of rabbit skin. In distinction from egg tempera, paints in which pigments are suspended in size are commonly called distempers.

Egg white was used as a binder for illuminated manuscripts under the name *glair*. It was liquified by being whipped and left to stand, or squeezed in and out of a sponge. The eleventh-century manuscript *De clarea* (*On Brightness*) warns against the perils of insufficient whipping: "When mixed with the color, it makes that color string like a thread, and the color is utterly ruined."

The origin of oil painting is a complex and contentious matter, and I shall deal with it in the next chapter. It will suffice here to say that while the techniques of oil painting became preeminent throughout Europe during the fifteenth and sixteenth centuries—the period of the High Renaissance—there is clear evidence of its use at much earlier times, especially in northern Europe. But oil paints were long considered an inferior medium, fit only for mundane interior decoration. Theophilus describes the use of linseed oil as a binder for paint used to "redden doors."

MEDIEVAL COLORS

The red pigments that Theophilus mentions in this passage are minium and cinnabar, inherited from antiquity like most other medieval pigments. Yet there were new discoveries too, and alchemy played a major role both in color innovation and in providing a systematic technology for manufacturing.

The most illustrious of these new pigments was the rich blue ultramarine. It is made by a laborious process (discussed in more detail in Chapter 10) from the blue mineral lapis lazuli. This semiprecious stone was widely used for decorative purposes since the beginnings of Egyptian civilization, but there is no indication that it was used as a pigment in antiquity. It seems likely that the process by which the blue pigment is extracted was an alchemical invention.

Lapis lazuli is found primarily in the East. The principal deposits throughout the Middle Ages were in Afghanistan, where a crude kind of ultramarine has been identified in wall paintings dating from the sixth and seventh centuries. Its use in the West did not become widespread until the fourteenth century. The name reflects the pigment's status as a long-distance import: in 1464 the Italian A. A. Filarete wrote in *Trattato dell'architettura* that "fine blue is derived from a stone and comes from across the seas and so is called ultramarine." This, in conjunction with the difficult process of extraction, meant that the pigment was very expensive and highly prized.

A less costly (but by no means cheap) blue was the mineral azurite, a form of "basic" copper carbonate. Its sources were closer to home for the Western artist: there were deposits in eastern France, Hungary, Germany, and Spain. The Romans used it: to Pliny the mineral was *lapis armenius*, reflecting its Armenian source. Azurite was often called German azure ("azure of Almayne") in medieval England; the Germans themselves referred to it as *Bergblau*, "mountain blue." Albrecht Dürer, like most of his compatriots, relied mostly on local azurite for his best blues, as celebrated in a poem of 1552 by Kaspar Scheit:

> After a few days they
> Crossed the river Saar.
> Close to this place is sited a blue-coloured mountain
> Where the colour for Dürer's panels
> Was taken before he died.[12]

In the Middle Ages a color denoted "azure"—from the medieval Latin *lazurium*, itself derived from the Persian *lajoard*, "blue"—could refer equally to azurite or to a generalized blue; such are the ambiguities when a color term attaches itself to or stems from a material. The potential for

confusion of azurite with lapis lazuli is obvious: although the two were nominally distinguished as citramarine azure and ultramarine azure and are chemically quite different, they have a similar appearance. To tell them apart, the careful apothecarist or paintmaker would heat a small sample of the mineral fragments until they were red-hot: azurite turns black on cooling, whereas lapis lazuli does not. This test is mentioned in many medieval compilations; indeed, Heraclius even suggests it as a means to prepare a black color for painting vases, though it is hard to believe that many craftsmen would have been prepared to squander the valuable azurite in this way. All the same, the painter had to be constantly vigilant to avoid deception or simple misunderstanding: it has been suggested that Dürer sometimes painted with azurite that he believed to be ultramarine. The complexity of the matter is very evident in the fifteenth-century Bolognese manuscript *Segreti per colori* (*Secrets of Colors*), which contains page upon page of diverse recipes for preparing "various kinds of natural azures," with little explicit reference to the distinction between their mineral sources.

When very finely ground, azurite develops a pale sky-blue hue with a hint of green—very suitable for skies but inferior to the purple richness of ultramarine. A darker tone requires coarser grinding, which made the pigment hard to apply and somewhat translucent. Gluelike size, rather than egg tempera, was then needed to hold the large particles securely, and several coats were required to produce a saturated, opaque color. The result could be very beautiful, with each of the coarse grains sparkling like a tiny jewel. Azurite was specified in many medieval contracts, and it was utterly the height of luxury to use ultramarine instead.

In *Saints Peter and Dorothy* (c. 1505–1510), painted by the Master of Saint Bartholomew, the artist has used two different grades of azurite to obtain different colors. Saint Peter's robe is a strong, deep blue, rendered in highest-grade azurite, which would have cost the Master dearly (Plate 14). But a cheaper grade is used for the greenish cuffs, where the lighter shade results from the smaller size of the pigment particles.

Other sources of blue for the medieval artist were dyestuffs: the herbs woad and indigo. They have a greenish or blackish tone that is not particularly attractive, although the color is pleasant enough when lightened with white. The preparation of a kind of lake pigment from indigo is described in a twelfth-century manuscript: ground white marble, "put . . . into hot dung for a day and a night," is mixed with the foam from a cauldron "in which clothes are dyed the color of indigo." "When it is dry . . . it acquires a good

azure color," says the author, adding that white lead can be used as the car-
rier material too. Cennino describes "a sort of sky blue resembling azurite"
that can be made by mixing "Baghdad indigo" with white lead or lime
white.

CROSSING THE RAINBOW

To these traditional blue dyes, the Middle Ages added another: turnsole or
folium, an extract from the plant that medieval scholars call *morella* and
that has been identified with *Crozophora tinctoria*, native to southern France
and called *maurelle* in Provence. The Latin name *folium* may derive from the
practice of keeping the colorant in the form of cloths saturated with the
stuff, which would be placed between the pages (*folia*) of books. Turnsole
is from *torna ad solem*, "turn to the sun," a characteristic of the plant from
which the dye originates.

To extract the folium colorant, the seed capsules were gathered and
gently squeezed. The cloths were repeatedly dipped in the juice and dried
until they were thoroughly permeated with it. Moistening a small piece of
the cloth with water or glair would release the dried color. Its transparent
finish was particularly desirable for manuscript illumination.

The fresh juice of *morella* is not blue, however, but red. Theophilus tells
us that in fact there are "three kinds of folium, one red, another purple, and
a third blue." How is it so versatile? Turnsole is a representative of a broad
class of vegetable extracts that change color depending on the acidity of the
solution: red in acid, purple when neutral, blue in alkali. Litmus, an extract
of a Scandinavian lichen, is another, and so is the juice of red cabbage. Such
substances are still employed in chemistry today as indicators that signify
the pH (acidity) of a solution by their color changes.

Robert Boyle was one of the first to investigate these changes from a
chemical perspective. In his *Experimental History of Colours* (1664), he lists
turnsole among a whole range of extracts from berries, fruits, and flowers
that share the same property. Boyle reveals that knowledge of the color
change stems from the arts, and he makes the first suggestion that it might
be used to measure acidity. A hundred years later this was developed into
the chemical technique of analysis known as titration.

Theophilus describes how to prepare purple and blue folium from the
acidic red plant juice using alkalis: lime and potash. The reversible nature of
the color changes does not appear to have been noticed—perhaps because

rather strong acids would have been needed to achieve it, whereas the only acids known until the fourteenth century were weak organic ones such as vinegar and fruit juices. All the same, the blue form of turnsole had a natural tendency to veer toward purple over time, owing to the slight acidity of moisture in the air.

Folium was one of the very few purple colorants known to medieval artists, and "turnsole violet" was highly regarded in fourteenth-century Italy. Some painters made use of the purple dye extracted from the lichen called archil or orchil (*Roccella tinctoria*). And in the early Middle Ages the purplish whelk red extracted from shellfish native to the coasts of England and France was used for dyeing parchment. It was no doubt as laborious to extract as the Tyrian purple of antiquity and was little used after the eighth century: folium gave a better color for less effort. Most purples in medieval panel painting were, however, made by mixing a blue such as azurite with a red lake. Painters seem to have preferred the purplish reds offered by crimson lake over the delicate violet color of organic extracts.

RED WOODS

Vermilion went unchallenged as the painter's best red pigment until the twentieth century. But medieval painters made extensive use of red lake pigments manufactured from dyestuffs. Kermes crimson lake was widespread, and lac lakes were common in fifteenth-century Florence. Another red dye was extracted from the root of the brazil tree (*Caesalpinia braziliensis*), which was imported to medieval Europe from Ceylon via Alexandria. After the discovery of the New World, the dye was obtained from the species of brazil that is native to Jamaica and South America (*Caesalpinia crista*) and that eventually gave its name to a nation.

The red dye was extracted by soaking and boiling the powdered wood in lye or alum. The lake pigment was made by adding alum to a lye solution or vice versa, precipitating dye-coated alumina particles. Adding white substances such as chalk, white lead, marble dust, or powdered eggshell during the process gave the pigment a rosy pink color; in England brazil lake was known as roset.

Some historians believe that brazil provided the foremost red lake of the Middle Ages; it was certainly cheaper than the insect-derived Kermes lake. Daniel Thompson claims that "the amount of brazil wood color used in the Middle Ages both for painting and for dyeing was colossal." Yet there

is not a *single* case of a positive identification of this pigment in a medieval painting, so one must treat such assertions with caution. Until relatively recently, the dyes in early lake pigments were hard to identify chemically, and much of what we know about their use relies on supposition. Whereas recipe books such as the *Mappae clavicula* indicate that red dyes such as kermes were well known, their conversion to lake pigments is a difficult, complex process that was probably not perfected until the Renaissance. Furthermore, brazil was known to be very fugitive (prone to fade) when exposed to light, for which reason it was sometimes banned by dyers' guilds. Panel painters might well have avoided it for the same reason.

In the late Middle Ages two other red dyestuffs—madder from northern Europe and cochineal from Poland—began to appear. The madder dye is a root extract of the madder plant (*Rubia tinctorum*), which was cultivated in Europe at least since the thirteenth century. Madder lake is more permanent than brazil lake but also more difficult to make. It features prominently in the palettes of artists from the seventeenth to the nineteenth centuries, but it is hard to find in the Middle Ages. Heraclius describes a recipe for madder lake in the tenth century, but it seems unlikely that it was widely used for panel painting until much later. There is madder in Dieric Bouts's *Virgin and Child with Saints Peter and Paul* (c. 1460), and the extensive madder fields of Zeeland made its use more common among the fifteenth-century Netherlandish painters than their contemporaries elsewhere.

If you wanted the crimson lake made from cochineal, you often needed a heavy purse. To harvest the cochineal insects from the perennial knawel plant of eastern Europe, you had to dig up the plant and pick off the resinous crust of insects by hand, then replace the plant in the soil. There was just a two-week window for harvesting, traditionally after the feast of Saint John on June 24. If the crop failed, prices soared. In early-fifteenth-century Florence, cochineal sold for twice the price of kermes.

There seems to be something about red pigments that attracts linguistic confusion. We saw earlier how the *sinopis* of Pliny, a somber red ocher from Sinope on the Black Sea, begat the medieval color term *sinople*, which could stand for either red or green. In medieval England and France another pigment that bore the Latin name *sinopis* was a complex red lake, composed of madder, grain, brazil, and lac. This substance, sometimes called cynoper or cynople in English, became popular in the fourteenth and fifteenth centuries. Yet when Cennino speaks of a "sinoper," he is refer-

ring to a mineral, saying that it is a "natural" color also known as porphyry. Moreover, "the handsomest and lightest sinoper obtainable" he calls cinabrese, promoting further confusion with cinnabar. We might be best advised to draw a veil over these ambiguities and to conclude simply that medieval technologists found both reasons and technical means for preparing complicated red lakes among which the distinctions, even if they were clear at the time, are lost to us now.

GILT COMPLEX

The one color the alchemists could not conjure up for painters was the one they labored the hardest to devise. Struck by slanting rays of the sun, gold set the medieval altarpiece ablaze with light. In Byzantine churches like the sixth-century San Vitale in Ravenna, golden mosaic tiles create a dome shimmering with holy radiance. Whatever the cost of ultramarine or vermilion, gold has ancient associations that make its value transcendental.

Gold is the substance of royalty, so what could be more pious than to offer it up to God in sacred art? And unlike silver and other metals, it was seemingly immune to the passing years—it did not tarnish or lose its splendor.

The use of gold in medieval art shows us more clearly than anything else how the nature of materials took precedence over any concern for realism. Until at least the fourteenth century, holy figures on altar panels are framed not by nature's skies or foliage, not by draperies or masonry, but by a golden field that permits neither depth nor shadow.

In later ages this metallic sheen was pushed back onto the gilded frame that held the canvas, but for the medieval artist gold was a color in its own right. It was applied to the gessoed panels in the form of thin sheets: gold leaf. There was no need to visit the apothecary to procure this color, for it was to be found in the purse of every wealthy person. The craftsmen of the Middle Ages, unrestricted by laws protecting currency, made their gold leaf by hammering and hammering at golden coins, transforming them to sheets so thin as to feel almost weightless.

This task was carried out by professional goldbeaters who, even into the twentieth century, measured the weight of gold leaf by the ducat, the gold coinage of medieval Italy. The thickness of the foil was determined by the number of leaves (each about three and a half inches square) beaten from a single ducat. Cennino specifies which thickness is best for various uses:

> Let me tell you that for the gold which is laid on wooden flats [panels] they ought not to get more than a hundred leaves out of a ducat, whereas they do get a hundred and forty-five; because the gold for the flat wants to be rather dull. If you want to be sure of the gold, when you buy it, get it from someone who is a good goldbeater; and examine the gold; and if you find it rippling and mat, like goat parchment, then consider it good. On moldings or foliage ornaments you will make out better with thinner gold; but for the delicate ornaments of the embellishment with mordants it ought to be very thin gold, and cobweb-like.[13]

The slightest film of moisture will bind these delicate sheets to just about any surface. Glair, gum, honey, and plant juices were all used to stick gold leaf onto manuscript parchment. They were called water mordants—water-soluble substances that mordanted ("bit," or fixed) gold. Because dampness loosens water mordants, a varnish was generally needed to secure the gold on panels. Alternatively, the panel painter might use oil-based mordants, generally mixed with a little colored pigment.

Mordanted gold leaf conforms to all the irregularities of the underlying surface, causing it to scatter light. This produces a rather flat, opaque yellow appearance. Only if the surface is smoothed down (burnished) by rubbing with a hard object does it regain the reflective luster of the metal. A rounded stone or a tooth was often used for this purpose: once the gold leaf has dried fast, Heraclius advises, "make it very brilliant with the tooth of a savage bear." Burnishing literally means "making brown," as it darkens the gold in the shadows while making the highlights more reflective. "The gold then becomes almost dark from its own brilliance," says Cennino.

It seems likely that many of the gold "fields" (*fondo d'oro*) of medieval panel paintings were rubbed to a shining, mirrorlike smoothness before the other elements of the scene were added on top. They usually look unburnished now (Plate 15) because of cracking in the underpainting or because of other irregularities or contaminants picked up over the course of time. The burnished gold lettering on manuscripts has often fared better.

But some gold backgrounds were intentionally left unburnished, fixing the scene within a shimmering, luminous light. Gold is here representing light itself, and it was still used during the Renaissance to suggest an otherworldly illumination. It is the color of halos, of highlights on the robes of saints. Cennino recommends a sprinkling of gold mixed with green paint for "making a tree to look like one of the trees of Paradise." Botticelli laces his goddess's hair with gold in *The Birth of Venus* (c. 1485) and scatters it among the leaves of the trees behind her.

Not all of this gold was laid down as leaf; it was also used as a powdered pigment. But since gold is a soft and ductile metal, not a brittle mineral, the pressure of grinding with a pestle and mortar does more to weld gold particles together than to break them into still finer fragments. Heraclius recommends that gold be ground in wine, and Theophilus gives a detailed description of a mill for grinding gold leaf in water. But this must have been a frustrating affair. So medieval craftsmen had to delve into alchemical metallurgy to develop methods of hardening gold for grinding.

The alchemical conviction that metals were but blends of the same basic ingredients was bolstered by the observation that gold can be blended with fluid mercury. This amalgam is a waxy paste; wrapped in cloth and squeezed to remove excess mercury, it becomes hard and brittle, suitable for grinding. Heating vaporizes the mercury to leave a gold powder, provided that care is taken not to let the heat fuse the gold grains. An alternative technique was to beat gold to very thin leaf and then to grind it with honey or salt, which helps prevent the welding together of the gold particles. Both of these methods are mentioned in the *Mappae clavicula*.

Painting in gold—chrysography—could create some stunning effects, few more so than that in Jacopo Bellini's *Virgin and Child with (?)Leonello d'Este* (c. 1440). Here the Virgin's robe is highlighted using a fine peppering of gold dots, giving the cloth a fine, silky, and quite numinous quality.

No wonder medieval artists seem to have cared little for true yellow pigments—they were pale substitutes indeed for the magnificence of gold. One of their principal uses was to tint white metals such as silver and tin so that they resembled the regal metal. A yellow pigment called mosaic gold (*oro musivo* in medieval Latin, or *aurum musaicum*) was seemingly used in parchment gilding as a "fake gold." It is a form of tin sulfide, and Cennino provides a recipe for it that ranks among his most complex, although even this may be an oversimplification of the process: "Take sal ammoniac, tin, sulfur, quicksilver, in equal parts; except less of the quicksilver. Put these ingredients into a flask of iron, copper, or glass. Melt it all on the fire, and it is done."[14] Whether this substance truly offered a convincing imitation of gold is doubtful, and the association may have been as much a construct of alchemical theory as a description of appearance. Thompson says of a sample of the pigment in a medieval manuscript in Florence, "It is only fair to add that mosaic gold is so little golden that it might easily be mistaken, in a casual inspection, for orpiment, or even ocher."

Orpiment was another suggestive stand-in for gold, particularly in its sparkling mineral form. Its very name recalls this connection: *auripigmen-*

tum, "color of gold." The ancients fostered the distinctly alchemical idea that the superficial resemblance had deeper roots: that orpiment contained gold itself. Pliny says that the Roman emperor Caligula extracted gold from the natural mineral form of orpiment. Wary of its deadly nature— Pliny calls it *arrhenicum*, from which the word *arsenic* is derived—the Romans used slave labor to mine it from the earth. In Cennino's day the painter used synthetic orpiment from the alchemist's laboratory; his seemingly unlikely claim of its "handsome yellow more closely resembling gold than any other color" has a certain chrysopoeian ring to it.

The yellow lead antimonate pigment of the Egyptians was probably the pigment Cennino calls *giallorino*. Much debate has arisen from his claim that it was "produced artificially, though not by alchemy." Some have supposed that Cennino was referring to a natural, volcanic lead-containing yellow mineral found on the slopes of Vesuvius, near Naples; "artificial" would then refer to a chemical transformation wrought by geological, rather than human, agency. In her seminal study of historical pigments in 1849, Mary Merrifield claims that one kind of "Naples yellow" was indeed a natural mineral associated with this region and that another was synthetic lead antimonate.

But exactly how these relate to the term *giallorino* is hard for us now to discern. Medieval painters also used yellow pigments made from lead and tin oxides according to various recipes, now termed lead-tin yellows. No doubt painters often confused these with lead antimonate, although by at least the fifteenth century alchemists could certainly tell their tin from their antimony. Merrifield says that massicot (yellow lead oxide) also went under the name of *giallorino*, and we are probably wisest to regard this as a blanket term denoting any yellow pigment containing lead.

To complicate matters further, a synthetic yellow pigment containing lead, tin, *and* antimony has been identified in seventeenth-century Italian paintings by Poussin and others. It seems that by this time pigment manufacturers knew how to impose some control on the manufacturing process and thus on the hues obtained. The Englishman Richard Symonds, who journeyed to Rome between 1649 and 1651 (where he met Poussin), reported that "there is 3 or 4 sorts of giallo lino some redder, some yellower."

Cennino is more explicit that alchemy supplies the yellow lake that he calls *arzica*, which is made from the weld plant (*Reseda luteola*, also known as reseda or mignonette). Sometimes called "dyer's herb," weld was cultivated for its yellow dye even into the twentieth century; it was particularly

valued for dyeing silk. Yellow lake made from weld could be brilliant and fairly opaque and provided a good (and harmless) substitute for orpiment. But Cennino is not enthusiastic about it, saying that arzica is "little used" and has "a very thin color . . . [that] fades in the open."

More significant for the medieval manuscript illuminator was the yellow lake made from the saffron plant (*Crocus sativus*) and from other crocuses. Mixed with glair, saffron produced a strong, pure transparent yellow; combined with azurite, it offered a vibrant green. Cennino says that a blend of saffron and verdigris produces "the most perfect grass color imaginable."

Georgius Agricola records that verdigris "was first brought to Germany from Spain," from which we might again deduce that it was a product of Arabic alchemy. Even Theophilus four centuries earlier calls it *viride hispanicum*; in modern German verdigris is still called *Grünspan*. An artificial copper-containing green listed in Grünewald's estate inventory after his death in 1528 is denoted simply *alchemy grün*. But the medieval *verd de Grece* implies a Greek origin; the *Mappae clavicula* refers to it as *viride grecum*. The ancient Greeks certainly used it and were not the first to do so.

Verdigris was a popular but unpredictable pigment. The organic acids used to make it have in some cases attacked the parchment or paper on which they are painted, cutting out neat holes as if nibbled by green-loving insects. And some pigments are prone to deteriorate if set close to verdigris. These defects motivated the development of alternative greens by the fourteenth century, chief among them two organic colors called sap green and iris green.

The first is derived from the juice of buckthorn berries, which is thick enough to be used without any binder. With the addition of some gum it makes an excellent watercolor and is still in use in this form (though the "sap green" sold as an oil color in the early twentieth century was in fact a synthetic lake compound). Iris green, made from the juice of iris flowers, was mixed with water and possibly a thickener like alum and used for manuscript illumination. These, like folium and weld, are the colors of the meadow, not the mine, and directly accessible to the diligent monk, as Heraclius observes: "He who wishes to convert flowers into the various colours which, for the purpose of writing, the page of the book demands, must wander over the corn-fields early in the morning, and then he will find various flowers fresh sprung up."[15] These natural juices were well suited to adorn the page but were not robust enough for the altarpiece.

In spite of its reliance on the distorted records and techniques of ancient technology, the Middle Ages was thus a period of considerable innovation in color production. At the same time, the changing social structure moved painting to a new milieu: from a craft concerned with adornment in a religious context to a trade performed by guildsmen for mercantile or noble patrons who drew on a wider range of subject matter. This change reflected a broader transformation of society in which mystery and magic—a world pervaded by spiritual forces, a world in which icons had real power—gave way to commerce, to the primacy of trade over religion, to a practical outlook. To some degree the same process overtook alchemy itself, which kept the trappings of its mystical roots but which was, to a craftsman like Cennino, simply a means of manufacturing. These trends reached their logical conclusion in the centuries that followed, as the forces of rationality began to challenge the authority of the Church and as painters transformed their practice into a wholly secular discipline: not a holy craft but a scholarly and intellectualized "liberal" art.

MASTERS OF LIGHT AND SHADOW

THE GLORY OF THE RENAISSANCE

"Painting is a combination of light and shadow in close mixture with the diverse qualities of all the simple and complex colors."
—Leonardo da Vinci

"I should like, as far as possible, all the genera and species of colours to appear in painting with a certain grace and amenity."
—Leon Battista Alberti (1435), *Della pittura*

Did art reach its peak in the Renaissance? Aspiring to resurrect the ideals of classical times, the painting of the fifteenth and sixteenth centuries reflects nothing of that earlier period's reputed chromatic austerity. Instead, it bears witness to a delight in the riches of raw, lustrous color that was not to be revisited until twentieth-century painters made color art's subject.

It is through their use of color that we can distinguish the Renaissance artists' varied interpretations of this "rebirth." Stripped of the theological certainties of the Middle Ages, with its formulaic approach to painting known as the International Style, artists were compelled to find new ways of organizing the steadily expanding range of colors at their disposal. No longer was it sufficient to present flat fields of expensive pigments as a devotional offering to God; the new watchword was "truth to nature." For the

first time in the history of Western art, painters strove to depict the world exactly as it appears to the eye.

The practical and theoretical chemistry of the fifteenth and sixteenth centuries was not significantly different from that of five centuries earlier. Advances were incremental and evolutionary, sharing none of the revolutionary transformations in the arts and humanities. Yes, new pigments duly left their impression on painting, but there was nothing in this pivotal period of art history to parallel the technical innovations in color chemistry of the nineteenth century, when art gained a wholly new set of clothes. Nonetheless, we do not have to look far to discover how issues of pigment availability and usage left a profound mark on the works that this high point in Western art has bequeathed to us.

THE HUMANIST IDEAL

Italian artists of the fifteenth century perceived that a revival of the noble principles of their classical forebears had been gathering pace ever since the time of Giotto di Bondone, the founder of the Florentine school of painting. Giotto's innovation seems retrospectively almost trivial, but it overturned the medieval artistic orthodoxy. He attempted to show objects in relief, with shadows and highlights picked out by an identifiable source of illumination.

This emergence of light and shade as features of the painter's landscape is one of the distinguishing aspects of Renaissance art. For the first time, people and things cast shadows. The consequence is plain to see: it is as if, with Giotto, the artist's imagined world suddenly leaps to life.

Needless to say, there is more to the Renaissance than the introduction of a technique for painting three-dimensionally. Giotto's approach is a symptom of a profound change in philosophical outlook that affected all areas of learning in the West. The reason medieval artists did not represent figures and scenes as they "really" appeared is not because they lacked the ability or perceptiveness to do so but because such a goal was irrelevant to them. Painting was a way of telling a story without words. What mattered was that each of the important characters could be clearly identified in the scene, in positions and at a scale that suited their status, and in colors that encoded symbolic meanings and redounded to the splendor of the Lord.

Giotto rejects this schematic, narrative kind of illustrative art in favor of what we might naively call realism. The observer is not reading the image

as if reading a book but is present in the scene, a witness to the action. Nothing illustrates this better than the way Giotto was prepared to paint figures with their backs to us, faces concealed—for example, in *The Betrayal of Christ* (c. 1305) (Plate 16) and *The Mourning of Christ* (c. 1306). We see people in this attitude all the time, but to the medieval painter it is meaningless to include a figure without a face because it then becomes a mere blob of color. Equally shocking is the way in which Jesus, in *The Betrayal of Christ*, is all but hidden by the enveloping cloak of Judas, painted in the characteristic yellow of the traitor's clothing. Only the face of Christ remains visible, whereas a medieval artist would have deemed it essential to reveal the Son of God in all his glory.

Within such images lies all that is inherent in the humanistic outlook of the Renaissance. Real human experience is emphasized in preference to the eternal, transcendent verities of theology. Religious scenes contain people who look lifelike, not cartoonlike, and they appear as they might have been seen in the instant. One can say that Giotto's naturalism makes *time* a component of painting—the image is no longer an immutable symbol but becomes fixed at a moment in real, passing time.

The ramifications for the painter were tremendous. In nature, the appearance of a scene depends on the ambient lighting, which changes over time: gloomy and overcast, bleached in the harsh Mediterranean sun, or softened by the glow of evening. This offered the artist new possibilities for creating dramatic atmospheres, but it also demanded that he have a thorough understanding of natural lighting effects. And an insistence on truth to nature freed the artist from the stylized conventions of medieval composition, since nature offers infinite variety of form and color. But at the same time, naturalism raised a new challenge, for there is no law that imposes on nature the kind of harmonious arrangement of colors and objects that the artist requires for a pleasing composition.

In addition to acquiring the dimension of time, the Renaissance artist gained the ability to locate objects precisely in space. The advent of linear perspective, pioneered by the Florentine architect Filippo Brunelleschi (1377–1446), was the essential accompaniment to the introduction of light and shade in allowing the artist to conjure a world from the flat plane of the panel or wall. Brunelleschi deduced the mathematical laws that enabled artists to determine how size diminishes with distance, and his discoveries were enthusiastically assimilated by the Florentine painter Masaccio (1401–1428).

Underlying these innovations was an acknowledgment that to depict the

world in a naturalistic way, the artist needed to study nature carefully and systematically—that is to say, scientifically. To draw the human form faithfully, the painter needed to have a good grounding in anatomy. The artist's skill derived not from rote learning of stylized conventions in a workshop apprenticeship but from rational apprehension of nature's laws and principles.

This appeal to reason is explicit in the writings of Leon Battista Alberti, to whom we owe a great deal of our knowledge of artistic attitudes at the height of the Italian Renaissance. Of Genoese birth, Alberti lived and worked in Florence and, for a time, in the Papal Court. His texts demonstrate just how thoroughly he and his contemporaries, in Florence in particular, dispensed with the theological preoccupations of the Middle Ages. In his influential book *Della pittura*, Alberti says:

> The function of the painter is to draw with lines and paint in colours on a surface any given bodies in such a way that, at a fixed distance and with a certain, determined position of the centric ray, what you see represented appears to be in relief and just like those bodies.[1]

This, he says, may be achieved by the application of rational principles such as perspective. But he stresses that first and foremost the painter must strive for beauty. Recognizing that not all of nature is beautiful, he insists that the artist selects and combines only its most lovely and pleasing aspects. But there is nothing subjective in this procedure. Beauty, to Alberti, is not in the eye of the beholder but is instead an almost quantifiable property, "a kind of harmony and concord of all the parts to form a whole which is constructed according to a fixed number, and a certain relation and order, as symmetry, the highest and most perfect law of nature, demands." Thus beauty is an absolute property on which all well-informed observers could agree.

This emphasis on harmony of proportion is characteristic of the Florentine outlook. To these artists, the most elevated element of painting was skillful rendering of form: the ability to draw well. Color, they said, is secondary. Alberti does attach importance to harmony of color, but he allows colors no intrinsic beauty of their own and in their physical substance finds no inherent merit. He lambasts those who waste their time using gold and rich colors while paying scant heed to their proper deployment.

This division of the artist's craft into line or drawing (*disegno*) and color

(*colore*), and the debate about their relative importance, became a major theme in Renaissance art. The quarrel was to continue until the late seventeenth century; in the French academies the two sides were represented by the Poussinistes and the Rubenistes, advocates of the styles exemplified by the sober Poussin and the florid Rubens. But the discussion eventually came to turn on the merits of formal planning versus spontaneous composition, as opposed to those of drawing and coloring.

It is generally said that in Florence, Alberti's outlook prevailed, *disegno* being most prized, while in opulent Venice there was more stress on the use of rich color. But one should not overlook the fact that the greatest masters of Florence—Leonardo, Michelangelo, Raphael—all gave much thought to the problem of color.

CONTROLLING COLOR

Why should these artists have regarded color as a problem? Because the constraints imposed on the painter both by convention and by limitations in materials meant that there was a discontinuity between his desire to paint nature faithfully and his ways and means of capturing her colors. Although pigments such as vermilion and, for a time, ultramarine became gradually less prohibitively expensive and therefore less revered in unadulterated form, the taboo against mixing pigments remained strong. Until oil-painting methods made mixing both more acceptable and more feasible (as we will see), this meant that the Renaissance painter possessed a range of colors scarcely broader than that of the medieval artist while facing a new need for accuracy in their use.

So there were in fact two problems. First, nature had more hues than the artist. Second, the strident vermilion, gold, and ultramarine color fields of the Middle Ages were unacceptable to an artist whose audience no longer prized the pigments for their own sake, and whose objective was color harmony rather than an ostentatious show of wealth.

One of the difficulties of harmonious composition is that variations in color brightness create imbalance. White and yellow are bright; fully saturated blue and purple are dark. This means that yellow-robed figures leap out of a crowd while those dressed in blue draw the eye far less. This is bad enough as it is, particularly when the painter has little option but to use every color for crowd scenes to achieve all the variety of which his limited,

unmixed palette is capable. How much worse, though, if blue is to be reserved for Christ and yellow for Judas!

The situation is not helped by the shading scheme recommended by Cennino, who derived it from Giotto. He tells us that the pigment is to be used in full saturation for the deepest folds and progressively lightened with white lead as one works toward the highlights (Plate 17). This permits the deepest folds of a robe to be no darker than the fully saturated hue (which, for yellow, is not particularly dark).

Alberti advocated instead that black be added for the shadows. The unmixed, full-saturation color then appears in the midtones. This allows for a greater dynamic range (a greater contrast between light and dark) and a better representation of relief, as well as going some way toward equalizing differences in brightness. But it can also make the colors look somehow "dirty": the works of Antonio Pollaiuolo (c. 1432–1498), for instance, suffer in this respect.

A QUESTION OF STYLE

Not surprisingly, no unique solution to these difficulties emerged. Instead, we can discern several different methods for organizing color in the works of the Italian Old Masters. It seems unlikely, however, that their practitioners applied these schemes in a systematic and prescriptive manner; nor did the use of one imply the exclusion of the others. The late fifteenth century was, after all, a time of stylistic experiment; style, not technical skill, was becoming the painter's most marketable attribute. Moreover, in the use of color more than in just about any other aspect of art, dogmatic systems have never succeeded in making intuition dispensable.

Leonardo da Vinci was perhaps the supreme naturalist among the Florentine painters—and consequently, he was one of the most methodical. The attentiveness with which he observed the shapes, forms, and patterns of nature is attested to by his extraordinary notebooks (although there is little consistency in the conclusions that he drew from them). Like Alberti, Leonardo believed that the creation and judgment of art is a rational process. But he had little interest in trying to improve on nature, as Alberti recommended, by appropriate selection of its best features. He showed nature as it is, beautiful or ugly; indeed, he felt that ugliness could be useful as a foil to make beauty shine all the more brightly. In contrast, Alberti's insistence that figures should conform to a single ideal of harmony leads to

the stilted uniformity of the six archers of Pollaiuolo's *Martyrdom of St. Se-bastian* (1475) or the sterile blandness of the women in Pietro Perugino's *Virgin Appearing to St. Bernard* (c. 1490).

Leonardo studied color carefully. The idea that objects have an intrinsic color, independent of the lighting conditions, reflections, and so forth, has been a persistent fallacy in Western art, but Leonardo's astute observations gave him an inkling of its essential falsity. Describing an experiment on the mixing of colored lights, he even teeters on the brink of establishing the long-confused distinction between additive and subtractive mixing. But it was an experiment he never performed. Had he done so, he would have been astonished to find blue and yellow lights combining not to a "most beautiful green," as he claimed, but to white.

Leonardo's main contribution to the use of color during the Renaissance was the way that he created tonal unity with desaturated neutral colors of a very restricted range of brightness. In the interests of a unified whole, he sacrificed brilliant color and used muted greens, blues, and earth colors whose midtones—used for surfaces neither in highlight nor in shadow—have a similar brightness. This allowed for a more even depiction of relief, but its effect can scarcely be called joyful. Leonardo felt that strong contrasts in tone confused the eye and should be avoided, and he recommended the use of subdued lighting: "When you want to make a portrait, do it in dull weather, or as evening falls." To such methods and principles the Mona Lisa (*La Gioconda*, c. 1502) owes much of her mystery and ambiguity of expression.

The few surviving paintings of Leonardo are made all the more somber by his technique of sfumato—literally, "smokiness." Away from their point of focus, the pictures blend into murky shadows where color is leached away until a dark monochrome is all that remains. This use of graduated shadow enables the artist to direct the eye wherever he wants it to go, by bathing those places in a subdued, hazy light (Plate 18). To achieve this low-keyed tonal unity, Leonardo laid his pigments over an underpaint (ground) of neutral gray or brown.

Allied to the sfumato method and easily confused with it is the technique of chiaroscuro, with which Leonardo is sometimes also improperly credited. Literally "light and shade," this style depicts shadows that are more black than smoky, with abrupt and dramatic transitions from light to shade. There is less tonal restriction than in Leonardo's sfumato, and colors in the midtones appear at more or less full intensity. The result can be very strik-

ing, as testified by the paintings of Correggio (c. 1489–1534) and Caravaggio (1573–1610). Caravaggio's figures are spotlighted in the midst of impenetrable darkness, and as a result the colors are often bleached and subdued in the glare. In *The Burial of Christ* (1604), the pallid flesh and white drapery of the dramatically lit figures are moderated only by earthy reds. In *The Calling of St. Matthew* (1599–1600), the rich red velvet of several of the figures' sleeves glows all the more lucidly amid the sober, earthy hues caught in the slanting light of a high window. These works keep color under such strict constraint that the question of how to organize it scarcely arises.

Sfumato and chiaroscuro together constitute the so-called dark manner of the Renaissance. In contrast, lively, bold colors characterize the style called *unione*, associated with Raphael's early works. Raphael Santi (1483–1520) has a lovely manner with color, and his skill at drawing belies the idea that artists of his time had to choose between *disegno* and *colore*. His genius was to find a way of working with brilliant hues that nevertheless sit together in harmonious balance. Raphael avoids hard contrasts: the ultramarine blue of the Virgin's robe in *Madonna Alba* (1511) is softened with white lead, and the bright red against aquamarine blue in the *Madonna del Granduca* (c. 1505) (Plate 19) is harmonized by the deep shadows and the golden glow of the flesh tones. Raphael's facility with these colors seems almost magical, and his contemporaries thought so too. Certainly, the Florentine writer and artist Giorgio Vasari, who vouched that "unity in painting is produced when a variety of different colours is harmonized together," made his adoration plain enough: "One can claim without fear of contradiction that artists as outstandingly gifted as Raphael are not simply men but, if it be allowed to say so, mortal gods."[2]

If anyone was more worthy of deification in Vasari's eyes than Raphael, it was Michelangelo:

> What a happy age we live in! And how fortunate are our craftsmen, who have been given light and vision by Michelangelo and whose difficulties have been smoothed away by this marvellous and incomparable artist! You artists should thank heaven for what has happened and strive to imitate Michelangelo in everything you do.[3]

Michelangelo (1475–1564) worked primarily with the fresco technique, in which he was much more of a colorist than has sometimes been supposed. The recent cleaning of his ceiling mural in the Sistine Chapel revealed bright colors that shocked those accustomed to its centuries of subdued tonalities.

But he took a bold and unusual path toward color harmony. *Unione* seeks with strong color what sfumato attempts more somberly: an elimination of tonal contrast. The trick called *cangiantismo*, to which Michelangelo was much given, instead balances different color values by shifting hues rather than tones. An object that begins as one color in the highlights might become another in the shadows. This is an artificial use of color (unless being employed to depict "shot" fabrics like silk, which truly look like this). But it is clever and eye-catching—just the thing to appeal to the late-sixteenth-century Mannerist painters such as Francesco Salviati and Vasari himself. Even they, however, acceded to a decorum that prohibited such flashiness from being lavished on revered figures such as the Virgin.

Michelangelo used *cangiantismo* to suggest an otherworldliness in some of his images—something that ran against the grain of the humanist aspiration toward an objective, scientific truth. To Michelangelo, however, nothing was of greater importance than beauty. Yet this is not Alberti's rational beauty but something altogether incommensurable. Michelangelo had little time for the scientifically inclined theorists: "All the reasonings of geometry and arithmetic and all the proofs of perspective were of no use to a man without the eye." In this respect he anticipates the Mannerists, who elevated intuitive judgment and questions of taste above reason in art.

OIL CHANGE

There is a rather gratifying irony in the way that the art of the Italian High Renaissance owes its greatest debt to a technical innovation imported from the north, source of the Gothic styles that to the Italians represented all that was barbaric and uncouth about the Middle Ages. Even the patriotic Vasari, to whom the Florentine painters were surpassed by no one, tells how oil painting was brought to his homeland from the Netherlands, where, he informs us, it was invented by "John of Bruges in Flanders." This John is the Flemish painter Jan van Eyck (c. 1390–1441).

The double twist is that Vasari actually attributes much more to van Eyck than is due. Van Eyck was certainly not the first to use oil as a binding medium for pigments; even Italians were doing so before Antonello da Messina learned van Eyck's methods and brought them back south in the 1470s (which is how Vasari tells it). But it was indeed van Eyck who discovered how to release the true potential of the new medium.

The oils used as a pigment binder are so-called drying oils—primarily linseed, nut, and poppy oils—that form a water-resistant, elastic film as they dry. The oil must be refined carefully to acquire satisfactory drying properties; sometimes drying agents (siccatives) such as metal salts can help. In any event, drying was slow in comparison with egg tempera: it took hours or even days, rather than minutes. This was regarded in the Middle Ages as a distinct inconvenience.

The preparation of nut and poppy oils is described by Dioscorides and Pliny, but they make no mention of their use as paint media. The first written record of this application is by the Roman Aetius in the late fifth century A.D., and a recipe for an oil varnish (in which a drying oil is mixed with natural resins) is listed in an eighth-century document known as the Lucca manuscript. The clearest indication that oil painting of a kind was practiced well before van Eyck's time appears in Theophilus' *De diversis artibus*. Having described the preparation of linseed oil, Theophilus says:

> Grind some minium or cinnabar with this oil on a stone without water, spread it with a brush on the doors or panels that you want to redden and dry them in the sun . . . All the kinds of pigments can be ground with this same oil and laid on woodwork, but only on things that can be dried in the sun, because, whenever you have laid on one pigment, you cannot lay a second over it until the first has dried out. This process is an excessively long and tedious one in the case of figures.[4]

Max Doerner points out that Theophilus (and presumably those who followed his recipes) made his problems worse by using a standard olive oil press to squeeze out the linseed oil from flaxseed. Olive oil is a so-called nondrying oil, which means just what it says; even minor contamination from an imperfectly cleaned press would have had serious consequences. "No wonder the linseed oil would not dry!" Doerner thunders.

The transparency of oil paints also recommended them for tinting metals: thin coats of red (glazes) were applied to gold to make it look more lustrous (the redder the better), and a yellow glaze on tin was used as a cheap imitation of gold itself.

It appears that van Eyck's contribution was to rescue oil paint from its unappealing reputation. He realized that the glazing process has tremendous value for the artist, who, by judicious technique and patience, can obtain deep, rich, and stable colors that egg tempera alone can never match. He developed glazing from a craftsman's decorative technique into a method suitable for the finest of paintings.

Van Eyck's technique was to glaze oils over a tempera ground, combining the quick drying of the latter with the rich luster and blending possibilities of the former. Thus it would be wrong to imagine painters abruptly ditching their tempera methods for the new approach: the two coexisted for a long time and are well suited to such a marriage. A mixture of tempera and oils is very common in fifteenth-century art; one of the earliest examples is Cosimo Tura's gorgeous *Allegorical Figure* (c. 1459–1463) (see Plate 52).

A glaze acts as a kind of color filter: a red lake glaze over a blue ground transforms it to rich purple. By carefully building up layers of oil glazes, van Eyck produced saturated, jewel-like colors that look as sensuous today as they must have seemed at the time. It is hard to imagine his *Virgin of the Canon van der Paele* (1436) ever being any richer than it is now, and the fabulous chromaticity of his *Arnolfini Marriage* (1434) (Plate 20) makes it one of the most admired works in the Western canon.

Whether these techniques were devised solely by van Eyck is unclear. But they were widely practiced by the Flemish painters of the fifteenth century, some of whom—such as Rogier van der Weyden (c. 1400–1464)—took their knowledge south on visits to Venice. The Italians were already experimenting with oils in the early fifteenth century; by the century's end, it had become their predominant medium.

Oil paints have other advantages that enhanced their popularity. In oil, each pigment particle is "insulated" by a layer of the fluid. So pigments that react chemically with one another in tempera might be stably combined in oil. The painter could then be less fearful about making up complex pigment mixtures on the palette. And the slow-drying nature of the paint is a benefit to the naturalistic painter, offering the opportunity for blending tones and blurring outlines on the canvas. This was particularly felicitous for the painterly depiction of skin tones: Willem de Kooning once said, "Flesh is the reason why oil painting was invented." The sharp contours characteristic of tempera work gave way to new styles as oils encouraged painters to engage physically with their materials. Toward the end of his life, Titian was described by one contemporary commentator as painting "more with his fingers than with his brushes."

Vasari, writing in 1550, had no doubts about the virtues of painting in oils:

A most beautiful invention and a great convenience to the art of Painting was the discovery of coloring in oil . . . This manner of painting kindles the pigments and nothing else is needed save diligence and devotion, because the oil

in itself softens and sweetens the colors and renders them more delicate and more easily blended than do the other mediums. While the work is wet the colors readily mix and unite one with the other; in short, by this method the artists impart wonderful grace and vivacity and vigor to their figures.[5]

But changing the medium invariably changes the paint box. Oils, like any binding medium, do not carry raw pigment without modifying its appearance. As the refractive index of oils differs from that of egg yolk, pigments are not necessarily the same color in both. Ultramarine in oil is blacker than in egg tempera; the rich blueness is recaptured by mixing it with a little lead white. In the face of this insult to its purity, ultramarine could scarcely retain its medieval mystique. Similarly, vermilion—the red jewel of the Middle Ages—appears less vibrant in oil, and red lakes were awarded greater favor. The low refractive index of green malachite leaves it fairly transparent in oil, and its use declined. Verdigris suffers similarly in oils and was commonly mixed with lead white or lead-tin yellow to restore opacity. An alternative green called copper resinate, a copper salt of organic acids found in wood resins, became popular around the middle of the fifteenth century. These consequences of using oil media were known, in northern Europe at least, as early as the late fourteenth century: a manuscript from this time called the *Liber diversarum artium* (*Book of Divers Arts*) warns that in oil, "azure" (ultramarine or azurite) darkens, indigo does not dry, and vermilion must be used with red lead. Such adulteration of the once precious red would have horrified medieval artists.

THE ALLURE OF THE NEW

The introduction of copper resinate is just one indication that the chemical technologists of the fifteenth century were still searching for new colors. The pigment was made from verdigris, typically by combining it with turpentine resin extracted from pine trees. A Florentine author named Birelli describes a recipe in 1601:

> Take one pound of fine white turpentine resin, three ounces of mastic . . . and half an ounce of new wax. Put everything together in a small newly glazed pot, and boil the aforesaid things on a moderate fire of charcoal . . . Then add to these things an ounce of verdigris and put it in little by little, mixing it all the time in the jar with a little stick so that it is well incorporated.[6]

Formulations like these give a possibly misleading impression that copper resinate was a well-characterized pigment whose preparation was methodical and deliberate. The truth is murkier. Some of what now passes for copper resinate may be instead the result of adding a little resin-based varnish to verdigris mixed as an oil paint. It was common practice for painters to blend resins with their paints to achieve a smoother, harder finish. Van Eyck probably did so; the legend of his "invention" of oil painting has it that it stemmed from his brother Hubert's experiments to find a varnish made from boiled, thickened oil that would dry in the shade to avoid the cracking caused by sunlight.

"Copper resinate" is therefore something of a modern umbrella term for a variety of mixtures of green copper salts with resins; it is not solitary pigment with the unambiguous status of ultramarine or red lead. Yet in one form or another, this new green was used enthusiastically throughout the late fifteenth and sixteenth centuries, notably by Giovanni Bellini, Raphael, Gerard David, Tintoretto, and Paolo Veronese. But its disappearance soon thereafter may indicate that its Achilles' heel had already become apparent: copper resinate, at least in some formulations, darkens rapidly to brown.

One can imagine that the humanistic concern to match colors to nature placed a greater demand on green than on any other color. Artists overcame their habitual reluctance about mixing to create a wide range of greens from blues and yellows; even precious ultramarine was deployed to this end. We can feel sure that these painters, seeking novelty in place of traditional formulas, were more hungry than ever for new colorants.

RENAISSANCE BLUES

Their appetite was certainly keen for new blues. Ultramarine remained distressingly expensive in the late fifteenth century, and azurite was hardly cheap. The patron or client who wanted a brilliant blue but could afford neither of these had another choice—a synthetic "copper blue," essentially an artificial approximation of azurite (basic copper carbonate). Poorly understood in terms of composition, such pigments are obscured by another lexicological thicket. Manufacturers producing much the same substance by different means might award them different names. And as pigments ceased to be anchored in their substance of origin and became instead generic labels or even abstract color terms, the same name might end up

attached to different substances. Small wonder that artists did not always know what they were using.

To the English artist of the seventeenth century, for example, natural azurite might go by the name of blue bice, or simply bice. In the fourteenth century, *bys* was merely an adjective meaning "dark"; "azure bys" was a dark blue. But by the fifteenth century, *bys* or *byse* was a true color term for blue, by which means it attached itself to the most common blue pigment, azurite. In the seventeenth century, it seems to have had no other meaning. Yet by the eighteenth century we find it applied to a substance without a specific color connotation: *bice* was the generic name for a copper-based pigment (generally a carbonate) and could refer to a green as well as to a blue material. By and by, the word has come to designate an *artificial* copper blue, and it is in this context that one generally encounters it in the modern literature.

Rosamond Harley, in her masterful survey of artists' pigments from 1600 to 1835, draws a distinction between blue bice and the pigment known as blue verditer, which is unambiguously a synthetic copper pigment. But blue verditer already verges on being an oxymoron, since it is not difficult to recognize the term's origin from the old French *verd de terre*, a "green earth," if you please. From this we must infer that the first verditer synthesized was indeed green and that the blue variant followed subsequently.

Both green and blue verditer have the same chemical constituents, which are also those of natural azurite: copper, carbonate, and hydroxide ions. But even small variations in the ratio of carbonate to hydroxide ions alter the color imparted by the copper ions: with less carbonate, the substance is greenish. In azurite, there is as much hydroxide as carbonate; in green verditer, there is twice as much, just as in the copper mineral malachite.

Artificial copper pigments of this ilk were sometimes called "refiner's verditer," a reflection of their origin in silver refining. Native silver is often alloyed with copper. To remove it, the copper metal is converted to copper nitrate, which dissolves in water. The seventeenth-century Swiss physician Sir Theodore Turquet de Mayerne claims that about a hundred years previously, silver miners had cast a copper nitrate solution onto chalk (calcium carbonate), which at once turned green.

Yet this serendipitous process was also fickle and hard to control: sometimes it yielded the green pigment, sometimes the blue. When Robert

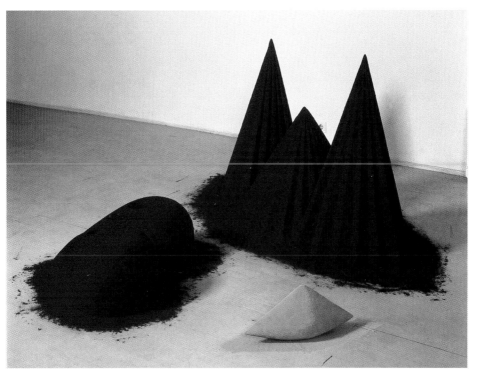

Plate 1: Anish Kapoor's *As If to Celebrate, I Discovered a Mountain Blooming with Red Flowers* (1981) is covered with raw pigment that encroaches onto the surrounding floor, creating an intensity of color that is hard to match with regular paint.

Plate 2: In Kandinsky's *Yellow Accompaniment* (1924), the relation to musical scores is clear.

Plate 3: The color wheel devised by Michel-Eugène Chevreul in 1864 has smooth gradations that taxed the color-printing technology of the day to its limits.

Plate 4: The CIE chromaticity diagram is a modern color wheel, reshaped to permit a scientifically precise measurement of color. The spectral colors appear on the tongue-shaped rim; the straight lower edge links violet and red with nonspectral hues.

Plate 5: A page from Albert Munsell's color atlas, which attempts to map out all of color space in discrete patches separated by perceptually equal steps.

Plate 6: Cave art from Altamira, Spain, dating from around 15,000 B.C.

Plate 8: The riches of Egyptian coloring, including prominent use of Egyptian blue, are evident in this wall painting, probably from the tomb of Nebamun (Eighteenth Dynasty, c. 1350 B.C.).

Plate 7: The ancient technology for making blue-glazed stone known as Egyptian faience may have stimulated the production of glass and the smelting of copper, as well as the synthesis of the Egyptian blue pigment. This is a *shabti* figure from the tomb of Sety I (Nineteenth Dynasty, c. 1290 B.C.).

Plate 9: The Alexander mosaic from the House of the Faun, Pompeii (before A.D. 79). This mosaic is a reproduction of a four-color painting by the Greek artist Philoxenos from the fourth century B.C.

Plate 10: This wall painting from the Villa of Mysteries, Pompeii (c. 50 B.C.), shows that Roman artists were not averse to using bright color.

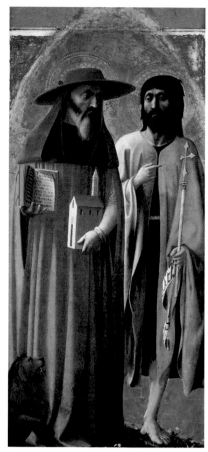

Plate 11: In the altarpiece *Saints Jerome and John the Baptist* (c. 1423–1428), attributed to Masaccio and Masolino, Saint Jerome is robed in the distinctive bright orange-red of vermilion.

Plate 12: The medieval artist at work: the female painter Thamar, with an assistant grinding colors behind her.

Plate 13: The Arena Chapel in Padua, with murals painted by Giotto around 1305.

Plate 14: Saint Peter's robe in the altarpiece *Saints Peter and Dorothy* (c. 1505–1510) by the Master of Saint Bartholomew is painted in two different grades of azurite: the finer is used for the deep blue robes, whereas a lighter, greener grade with smaller particles is used for the cuffs.

Plate 15: Altarpieces of the late Middle Ages, such as *The Ascension of St. John the Evangelist* (c. 1410–1420) by Giovanni del Ponte, are glorified with gold leaf. The gold grounds on which the figures are displayed were often burnished to a high polish, but their reflective gloss has been tempered by time.

Plate 16: In Giotto's *Betrayal of Christ* (c. 1305), some of the figures have their backs turned—an almost unthinkable prospect in stylized medieval art.

Plate 17: The shading method recommended by Cennino Cennini is employed in Nardo di Cione's *St. John the Baptist with St. John the Evangelist (?) and St. James* (c. 1365). Fully saturated pigments are used in the folds of the robes and are progressively lightened with white toward the highlights.

Plate 18: Leonardo da Vinci's *Virgin of the Rocks* (c. 1508) illustrates his sfumato method of shading and his somber palette, as well as his use of highlight to direct the eye.

Plate 19: Raphael's *The Madonna del Granduca* (c.1505) makes complementary red and green seem to belong in each other's company.

Plate 20: Jan van Eyck's *Portrait of Giovanni Arnolfini and His Wife (The Arnolfini Marriage)* (1434) displays the rich, jewel-like colors characteristic of the oil paintings of the Northern Renaissance.

Plate 21: Carlo Crivelli's *Annunciation, with St. Emidius* (1486) uses nonnaturalistic gold to signify otherwordliness in a scene otherwise typical of the Renaissance.

Boyle investigated the manufacture of blue verditer in the seventeenth century, he commented on this unreliability. In 1662 Boyle's contemporary Christopher Merret described the situation as follows:

> 'Tis a strange and great mystery to see how small and undiscernable a nicety . . . makes the one and the other colour, as is daily discovered by the refiners in making their Verditers, who sometimes with the same materials and quantities of them for their Aqua-fortis [nitric acid], and with the same Copper Plates, and Whiting [chalk] make a very fair Blew Verditer, otherwise a fairer or more dirty-green. Whereof they can assign no reason, nor can they hit on a certain rule to make constantly their Verditer of a fair Blew, to their great disprofit, the Blew being of manifold greater value than the Green.[7]

Such puzzles must have posed an irresistible challenge and stimulus to the chemist, although it was not until the late eighteenth century that a Frenchman named Pelletier was able to manufacture the two colors reproducibly. Whether the product is blue or green depends on the temperature at which it is made, and so it seems that the vagaries of the weather may explain the refiners' perplexity.

By the seventeenth century, blue verditer was no mere by-product but an industrial concern in its own right. In France it was known as *cendres bleu*: blue ashes, hazarding confusion with the low-grade pigment called ultramarine ashes. To make matters worse, some English manufacturers in the eighteenth century took it upon themselves to anglicize this name, selling it as "Sanders blue." For a time this pigment was sold (or at least bought) under the belief that it was a *different* pigment from blue verditer—or blue bice, as it might have been called then. It was with some dismay that the chemist Robert Dossie, author of the influential treatise *The Handmaid to the Arts* (1758), discovered that his Sanders blue and his blue verditer were one and the same.

The process of verditer manufacture may lie at the root of late medieval recipes for making a mysterious blue substance purportedly from silver. Before the technique for making ultramarine was perfected, this "silver-blue" was reputedly the best of all blue pigments. The recipes vary but typically involve exposing silver to the vapors of vinegar or ammonia. We might suppose that alloyed copper metal in the silver reacts to form blue copper salts, but the mystery resides in the common specification that the silver must be very pure, free from copper contamination (and medieval silversmiths were quite capable of achieving this). The fact that the recipes

are often said to originate from the "Saracens" tells us of their alchemical origin, so perhaps buried in here is some confusion of metals in which one is assumed to be transformed to another.

Although Cennino makes no mention of artificial blue copper pigments, they seem to have been widely used from at least the sixteenth century. Their relative cheapness commended them to interior decorators. By the seventeenth century, refiner's blue verditer was a standard material for house paint, both as a distemper and as an oil paint. Blue verditer can be found on the walls of many stately homes of England, such as the Great Drawing Room of Bowood House in Wilshire: it was one of the earliest "commercial" pigments.

Dossie had more reason to decry the careless naming of commercial colors than perhaps he realized. Had he purchased blue bice, he might have found it to be not a copper-based pigment at all but something quite different: the blue cobalt-containing glass called smalt.

Smalt has obscure origins. Tradition attributes its invention to a Bohemian glassmaker named Christoph Schürer sometime between 1540 and 1560. But its use by Dieric Bouts in *The Entombment* (c. 1455) belies this, and it has been accredited instead to Italian glassmakers of the fourteenth century. (Giovanni Bellini's use of smalt in the late fifteenth century has been attributed to his interest in glassmaking technology.) Another possibility is that it was not a European invention at all but originated in the Near East. Cobalt ores were, after all, used by the ancient Egyptians for coloring glass and by the Persians for making blue enamels and glazes.

Cobalt occurs naturally in several minerals, notably the ore smaltite, a mixture of cobalt and nickel arsenides. When exposed to air, this forms a brilliant blue fibrous crystal known to miners as cobalt bloom. It is a dangerous flower, for the arsenic compounds in the mineral dust are toxic and corrosive. Cobalt ore is abundant in Saxony, and the silver miners there were warned in Georgius Agricola's treatise *De re metallica* to beware of "a certain kind of *cadmia* [cobalt-zinc ore] which eats away the feet of the workmen when they have become wet, and similiarly their hands, and injures their lungs and eyes." In the German translation of Agricola's treatise, this devilish stuff is called *Kobelt*, the name given to the gnomes and goblins thought to haunt the mines and torment the miners. The scholar Johann Mathesius warned in 1562 that "whether or not the Devil and his hellish crew gave their name to *cobelt*, nevertheless *cobelt* is a poisonous and injurious metal even if it contains silver."[8]

Smalt was a widely used pigment by the middle of the sixteenth century, by which time it was being manufactured on a large scale, most notably in the Netherlands. The method was probably much the same as that described in the seventeenth century by one J. Kunckel, the manager of a glassworks. The ore is roasted, he says, expelling noxious arsenic-containing vapors. The residue is cobalt oxide, which is then pulverized and heated with quartz (sand) and potash to create a molten glass. This is plunged into water, whereupon it cracks into fragments that may be ground to make the pigment. To retain its strong, deep blue color, smalt must not be ground too finely, and its consequent gritty texture makes it a difficult material to paint with.

The best grade of smalt had a purplish cast, commending it as a substitute for ultramarine. But this luster is sadly diminished when mixed with oil; smalt fares better in watercolors or frescoes. It appears, for example, in a fresco in the Fondaco dei Tedeschi in Venice (c. 1508) on which both Giorgione and Titian worked. But the Venetian painters were not shy about using smalt in oils: Titian employed it in *Madonna and Child in an Evening Landscape* (c. 1560), and it is found in many works of Tintoretto, including *Crucifixion* (c. 1560) and the paintings of the Gonzaga Cycle (c. 1579). Paolo Veronese and El Greco used the pigment, as did Van Dyck in *A Woman and Child* (1620–1621), Rubens in *Descent from the Cross* (1611–1614), and Rembrandt in *Belshazzar's Feast* (1636–1638). Smalt is common in works of the eighteenth century and was still being manufactured in the 1950s.

THE COST OF COLOR

The Renaissance painter, having secured his commission from a wealthy patron, was not short of choice for materials. The nature of the commission dictated whether it was to be painted in fresco, on a gessoed wood panel, or increasingly during the sixteenth century, on primed canvas (Botticelli's *Birth of Venus*, painted around 1485, is one of the earliest large-scale works on cloth). But which pigments does he select for his reds, his sky blues, his foliage, his flesh tones?

The patron had a great deal to say about that. In 1434 the Flemish painter Saladijn de Stoevere, for example, was instructed that his Virgin in the altarpiece for the Franciscan church in Ghent was to have a robe of gold cloth lined with fine "azure" (ultramarine or azurite) and glazed with

sinopere (crimson lake). Azurite was specified in the contract between Nicaise Barat of Tournai and the church of Saint Peter at Antoing in 1446. The patrons knew what they were doing; left to their own devices, the artists would be inclined to economize, using smalt or indigo instead of the expensive blues. Dieric Bouts's *Last Supper* (1464–1468) contains no ultramarine but only azurite, perhaps because there were no stipulations about materials in the contract. "What niggardliness wouldn't be forgiven," says Alexander Theroux of the use of ultramarine during the Renaissance, "in places where its application could be avoided?"

Sometimes the contractor would accede to such compromises to keep costs down: the sculptor Otmaer van Ommen was told that his work for the church of Saint Martin in Ypres in 1593 might be painted in either smalt or a cheaper variety of copper blue. In such cases the patron might entreat the artist to use his skill to make a cheaper pigment resemble a finer one.

The craftsmen's guilds enforced such standards as they could. Their regulations forbade members from substituting poorer materials for good ones: the Florentine painters were prohibited by statutes of 1315 and 1316 from using azurite in place of ultramarine, and Siennese regulations of 1355 prevented red earth or red lead from being substituted for fine vermilion. The guilds might also have to argue their members' cause in the face of penny-pinching employers. But the painters were at the mercy of inflation: around 1497 Filippino Lippi was forced to take legal action against the heirs of Filippo Strozzi of Florence, who commissioned him to adorn the chapel of the church of Santa Maria Novella, when Lippi ran out of money owing to rising pigment prices while the work was in progress.

Good red lakes were expensive in the fifteenth and early sixteenth centuries, since their manufacture was still quite new and required specialized skills. Thus it was not unusual for these colors to be specified in contracts, as in Saladijn's. That lakes had displaced alchemical vermilion as the most princely red is evident from the common practice in northern European art of using the latter as mere underpainting for the former.

The patrons did not much care about the yellows, greens, or blacks, which were all relatively cheap, and so artists tended to use lead-tin yellow over the more attractive but more expensive orpiment. Lucas Cranach is the only German artist of this period known to have used orpiment—and one can suppose that this was not unrelated to the fact that he himself owned a pharmacy and so had ready access to more exotic materials.

One of the clearest indicators of the decline in the medieval role of pigments as a display of conspicuous consumption is the use of gold. Gilding is clearly nonnaturalistic: gold leaf laid on a flat surface does not look like a three-dimensional golden object. Alberti warns that its appearance changes depending on how the light is reflected: "When done in gold on a flat panel, many surfaces that should have been presented as light and gleaming, appear dark to the viewer, while others that should have been darker, probably look brighter."[9] He therefore exhorts the painter to render golden surfaces such as brocade using pigments and skill, not the metal itself—for "there is more admiration and praise for the painter who imitates the rays of gold with colours."

It is fascinating to follow the demise of gilding throughout the fifteenth century. A curious transitional piece between the medieval gold grounds and the later more naturalistic use of gold is *The Conversion of St. Hubert*, painted in the second half of the fifteenth century by the Workshop of the Master of the Life of the Virgin in Cologne. Here we find a gold "sky" juxtaposed with an attempt at a naturalistic landscape (although the painter shares none of Leonardo's attentiveness to nature and seems to have learned aerial perspective—the blueing of distant hills—from a book). In *Madonna with Four Saints* (1446) by the Venetian Antonio Vivarini in collaboration with Giovanni D'Allemagna, gold is used for the Madonna's halo and some of the brocade in the robes, but yellow pigments are used for the throne and paneled walls—so adroitly that the eye is almost fooled. Already the artist's skill is taking precedence over the value of the materials. The Magi are still awarded red-glazed gilt crowns in Vincenzo Foppa's *Adoration of the Kings* (c. 1510–1515), but the rest follows the Renaissance style. And Carlo Crivelli's astonishing *Annunciation, with St. Emidius* (1486) (Plate 21) presents us with immaculate, almost pedantic perspective and rich, varied use of color—yet the beam from heaven striking the brow of the Virgin is gold leaf. Here the nonnaturalistic character of the gilding serves to remind us that the heavenly ray is outside of nature. It is like a parting shot from the Middle Ages, before human experience displaced divine authority as the artist's guide and mentor.

As the materials lost their symbolic virtues, the painter's coloristic decisions became purely financial. The price lists of pharmacies—the main suppliers of artists' pigments in the early sixteenth century—give a good indication of why certain colors were preferred over others. In 1471 Neri di Bicci paid two and a half times as much per ounce for good azurite in

Florence as for a good green (*verde azurro*, probably malachite), a good red lake, and a fine yellow lake (*arzicha*). *Giallolino* (here called *giallo tedesco*, probably lead-tin yellow) was one-tenth the price of azurite, and white lead was a mere hundredth of the cost. Ultramarine, meanwhile, was ten times more expensive than azurite. So the price differential was vastly greater than what a painter would encounter today—no doubt with a proportionate influence on the choice of colors.

And the artist had to be prepared to travel for his materials. Although many large towns had a local supplier, the finest pigments were often to be found only in major commercial cities. Florence drew artists from far and wide: Guillaume de Marcillat, a French painter, ordered even lowly smalt and earth pigments from that city for his frescoes at Arezzo. Lippi's contract for the Strozzi Chapel implies that even Florence may not have been able to meet his needs: it mentions that he might need to travel to Venice, presumably to obtain pigments. German and French painters would journey to Cologne; the Flemish artists flocked to Antwerp and Bruges.

These trips were no mean undertakings, as the very need to specify them contractually implies. So the painter would have to plan carefully— he could perhaps sell off excess stock to his colleagues, but running short was another matter. And he was at the mercy of geography, for the availability and quality of different colors varied from region to region.

No wonder, then, that painters treasured their materials so highly and took such care in their preparation and application. Although both activities were often conducted by apprentices in their master's workshop, exacting standards were enforced. Like any other master painter of his time, Dürer did not apply every brush stroke to all the works attributed to him; but when he did, the colors on his palette had been ground by his own hand and mixed with oils that he had purified personally. To protect the finished work, he trusted only his own handmade varnish, fearing (possibly with justification) that those made by others would discolor:

> After a year or two or three I intend to varnish them with a new varnish which is not known to others, so that a hundred years will be added to their life. I will not allow anybody else to varnish them, because all other varnishes are yellow, and they would spoil my panels.[10]

The care and attention that Dürer lavished on his paintings is apparent in a letter he wrote to Jakob Heller in 1508 describing his labors on an altarpiece. "I have it in mind to underpaint some four, five, or six times," he said (and this is just the undercoat). A year later he adds, "I have used the

very best colors I could get, especially good ultramarine . . . and since I had prepared enough, I added two more coats at the end so that it would last longer." We can see that these artists were, as far as they knew how, painting for all eternity.

CITY OF COLOR

If we want to appreciate the extent to which color use in the Renaissance became embroiled with vulgar commerce and lucre, we can look into the heady cauldron where exotic pigments from the East first arrived en route to western Europe: Venice. The island port was trading with the Arabic world as early as the ninth century; Martin da Canal said in his *Chronique des Vénitiens* (1267–1275) that "merchandise passes through this noble city as water flows through fountains." From the Aegean Islands came sugar and wine; from the Far East, spices, porcelain, and pearls. Northern Europe supplied minerals, metal, and woolen cloth, while Egypt and Asia Minor were sources of gems, dyes, perfumes, ceramics, pigments, alum, and rich textiles.

Venice was also the principal conduit for Byzantine art brought west from Constantinople following the Crusades of the thirteenth and fourteenth centuries, in which the Venetian navy participated. This was an art resplendent in dazzling jewelwork, which used rich color to convey an impression of light and space. It was these qualities, not the mathematical perspective of Brunelleschi, that came to preoccupy the Venetian artists. Although they certainly used perspective, they clung to an ideal of space as something felt and seen, not calculated through geometry.

It seems likely that the climate of the city itself also played a part in determining the Venetian style. The steamy atmosphere creates subtle shifts of light, the waterways cast strong reflections, and forms are rendered hazy in contrast to the hard brightness of Tuscany and central Italy. The Byzantine-style mosaics that make the Venetian basilica of San Marco so resplendent educated the city's painters in shimmering optical effects.

The Venetian painters took great delight in experimenting with the new colors that entered the port. Titian used an unusually large range of pigments, including orpiment and the only true orange of the Renaissance, realgar, available in Venice from around 1490. The reputation of Venice as the best source of fine pigments is evident in the travel concession in Filippino Lippi's contract for the Strozzi Chapel; Cosimo Tura came to Venice

from Ferrara in 1469 to procure materials for his work on the Belriguardo Chapel.

The Venetians adopted canvas as the main support for their works from around the 1440s—earlier than the rest of Italy, no doubt encouraged by the presence of a burgeoning shipbuilding industry that produced the fabric for sails. This preference may have been abetted by the tendency of the humid, saline air of the lagoon to attack frescoes more avidly than in central Italy. The coarse texture of the canvas favored imprecise outlines over the crispness that the Florentines executed in panel works. The Venetian artist Tintoretto (Jacopo Robusti, 1518–1594) experimented with the possibilities that this texture offered, abandoning the thick gesso coats usually used to smooth the canvas so as to exploit the grainy weave for effects that in large works would gain in strength from a greater viewing distance. Titian used the grain to develop something like optical mixing, letting undercolors show through in the gaps where a brush stroke had passed over the textured surface. There was none of the invisibility of effort that Vasari so exalted; Titian, like the artists of China and Japan, left the energy of his brush strokes evident, which is why his paintings are bursting with vitality.

Ever since Giovanni Bellini (c. 1431–1516) introduced the techniques of oil painting into Venice in the 1470s, the Venetian painters used them to create bold and luminous colors—the elements of a poetic visual language that spoke of drama, passion, heightened sensibilities. Theirs was a sensual art, a counterpoint to the rational ways of Florence.[11]

Vasari tells us that all three of the great Venetian painters of the High Renaissance—Giorgione (c. 1478–1510), Titian (c. 1490–1576), and Sebastiano del Piombo (c. 1485–1547)—were trained in Bellini's studio, where they would have learned his style of creating rich and complex color gradations by many-layered glazing. Titian's use of this approach is extreme—some of his works have complex layered paint structures that are almost impossible to interpret. "Glazes, thirty or forty!" he is said to have exclaimed. This is surely an exaggeration, but not by so much: an analysis of the black cloak of Bishop Averoldi in Titian's *Resurrection* (1519–1522) has revealed nine distinct layers between the gesso and the varnish, incorporating white lead, vermilion, lampblack, azurite, and some kind of violet lake.[12]

COLOR AS COMPOSITION

Titian uses color as a constructive medium—not for decorative or symbolic purposes but as the very means of artistic expression. His pictures are

composed and unified with color. Previously, paintings were given coherence by rules that dictated spatial composition—for example, the Madonna would always be placed centrally. Titian disregarded such strictures: in *Madonna with Saints and Members of the Pesaro Family* (1519–1528), the Virgin is seated on the right while Saint Peter takes the central position, and pictorial balance is achieved by counterposing the Virgin with—horrors!—a flag. But what a play of bright primaries to satisfy the eye's need for structure! Mary's red gown is matched by the red flag, and her blue robe leads us to the blue of Saint Peter's garments, stunningly contrasted with a yellow robe.

The strong local colors in this and other early works of Titian are clear descendants of the "chromatic painting" of the fifteenth century, with their isolated bright primaries, their Albertian contrasts of reds and greens, blues and yellows. Titian's ability to reconcile these strident hues seems miraculous.

The complexity of the paint surface in Venetian art is not solely a consequence of efforts to achieve new shades. Many of these works were extensively altered while being created—an indication that the Venetians did not always carefully plan and draw their designs first, as a Florentine artist would have done, but composed as they painted. Giorgione was one of the first to work in this way. An X-ray of his famous and enigmatic painting *The Tempest* (c. 1508) reveals a woman dipping her feet in the water, painted out beneath the soldier on the left. This earlier composition would, needless to say, have radically changed the whole mood of the picture, indicating that Giorgione had no fixed idea in mind when he began it. Titian sometimes painted his background in full before laying the foreground figures on top. A fresh white ground beneath the outline of the figures ensured that the colors retained their luminosity.

This is how Titian's most famous work, *Bacchus and Ariadne* (1523) (Plate 22), was put together. The commissioning patron, Alfonso d'Este of Ferrara, sent Titian texts from Catullus and Ovid to inform the artist of the mythological context. The picture shows Ariadne watching the ship of her lover Theseus depart when the god Bacchus arrives and leaps from his chariot to claim her for his own. Ariadne is turning away virtuously, but Bacchus' conquest is ultimately successful.

This painting includes almost every pigment known to the early sixteenth century. The greens are malachite, green earth, verdigris, and "copper resinate." Ultramarine is used profligately—not only in Ariadne's robe but also in the remarkable sky, the distant hills, and even the shadows of

some of the flesh tones. Ariadne's scarf is vermilion, its strong opacity here needed to contrast with the blue robe; and Titian has given it added brilliance by glazing a thin layer of coarse-ground darker pigment over a thick layer that is more finely ground. Such touches make it clear that the painter knew how to extract the best from his materials. The orange robe of the cymbal player in Bacchus' entourage is unusually vivid, for Titian has here taken advantage of Venice's access to realgar.[13]

The picture blazes with bold, differentiated color, yet Titian breaks the rules of Alberti's color contrasts, placing the blue robe adjacent to the blue sea and sky and setting warm orange and tan tones next to each other. He relies on materials to distinguish the robe from the sea—ultramarine for the first, greenish azurite for the second.

The dominating blue sleeve in Titian's *Portrait of a Man* (c. 1512) (Plate 23) shows how far painting had moved on from the stark color fields of the thirteenth century. The blue shifts constantly in tone and hue, and in fact much of it is nearer to gray, yet the overall impression of a higher-keyed tone comes largely from the stronger blues on the shoulder. One is reminded of the remark sometimes attributed to Titian, that the painter should use Venetian red (an earth color) but make it look like vermilion.

In Titian's later works these subtle modulations are used to produce a *continuity* of color, a harmonious overall tonality in a style known as tonal painting. This is what we see in the *Annunciation* (1559–1562), *Tarquin and Lucretia* (1568–1571), *Danaë* (1553–1554), the *Venus* (1538) painted for the duke of Urbino, and the extraordinary, almost Impressionistic *Death of Actaeon* (1559–c.1562), which looks poised to bring us straight into the nineteenth century. The sharply delineated and contrasting colors of the late Middle Ages have been discarded, and a central coloristic theme runs through the whole composition. In *Danaë* this theme is the rosy magenta-pink of the goddess's body and its shadows, which deepens harmoniously to magenta in the draperies or to violet at the fringes of the fiery clouds. There are blues, greens, and grays in this picture, but they are not allowed to disrupt the unity of the scene.

The tonal painting of the Venetians shares something in common with Leonardo's use of color to unite elements rather than to set them apart, but without sacrificing high-keyed color. It was a style adopted, in their own distinctive ways, by Titian's successors Tintoretto and Paolo Veronese.

Titian delighted and awed the Venetians with his dramatic new styles.

Legend has it that Emperor Charles V stooped to pick up a brush that the master dropped as he worked in his studio, a gesture of supplication the gravity of which it is hard for us to appreciate today. For centuries afterward, painters must have felt that they were working in Titian's shadow. How can one possibly supersede such genius?

OLD GOLD

THE REVIVAL OF AN AUSTERE PALETTE

"Begin by painting your shadows lightly. Guard against bringing white into them; it is the poison of a picture, except in the lights. Once white has dulled the transparency and golden warmth of your shadows, your color is no longer luminous but matte and gray."
—Attributed to Rubens

"Dark is the basic tone of [Rembrandt's] paintings, and darkness occupies a large area in them . . . but how full of life is such darkness! Beginning with the most glowing middle tones of brown and yellow, they are gradually deepened through glazes and accents and made so unutterably rich in values!"
—Max Doerner (1949), *The Materials of the Artist*

Titian has been dead some sixty years, and here is Anthony Van Dyck (1599–1641), the Dutch "picture-drawer" to Charles I of England, painting his royal patron's portrait on horseback (Plate 24). The setting—distant hills and sky to the left, forest to the right, the terrain gently sloping to follow the central figure's gaze—is, minus the sea, just like the spot where Bacchus surprises Ariadne. But there the comparison stops.

Where Titian's sky blazed, Van Dyck's is low-keyed and grayish. Titian's greens are those of springtime; the summer has passed in Van Dyck's

somber woodland. Skin glows warm in Titian's image, and his draperies are vivid. Charles and his horse are cool-fleshed; even the royal saddlecloth is muted.

What has happened to the palette that it should have become so sober and restrained? Van Dyck had access to all the colors that Titian used (though some more readily than others). Yet on the palette depicted by Rembrandt's pupil Aert de Gelder in his *Self-Portrait as Zeuxis* (1685), only red shows up as a bright primary in the transition from white through ocher to brown and black—and the picture reflects as much. There is little ultramarine in the sky above Van Dyck's Charles I: it is mostly grayish-blue smalt and white. The saddlecloth is fringed with indigo and white; the foliage and foreground are glazed with ochers, browns, and black.

It would be unfair to attribute all of the picture's drabness to Van Dyck: the varnish has darkened, some of the lake pigments have faded, and the smalt sky is probably discolored. But the artist clearly had no desire to emulate the riches of Renaissance art. Van Dyck did occasionally paint images in bright colors, but his portraits from the court of the English king speak of a new aesthetic that was wary of chromatic brilliance.

The Baroque period represents a strange episode in the story of color's creation and use in art. The painters of the late sixteenth and seventeenth centuries did not value novelty so much as sobriety and control in their color choices. By the dawn of the seventeenth century, the advocacy of Giorgio Vasari and the scholars of the Italian academies had largely secured the superiority of *disegno* over *colore*. The influence of this idea soon spread to France, and a muted palette and dark chiaroscuro became the predominant style of European art. When we remember the Frenchmen Nicolas Poussin (1594–1665) and Claude Lorrain (1600–1682) or the Dutch portraitists Frans Hals (c. 1580–1666) and Van Dyck, it is not for the exuberance of their colors. Rembrandt, as Doerner rightly says, painted deep shadows and golden light, under which all things turn to warm browns that he made beautiful. But in lesser hands this brownness became the hue of conventionality, of an art made to appease the connoisseurs and conservative patrons rather than to excite the senses.

And so we have for a moment to forgo the dizzy excitement that the previous ages offer to the color eye and seek a more subtle savor in the palette of the seventeenth and eighteenth centuries. But the Renaissance did not end with a simple, unanimous capitulation of color. Rather, it lost its way in the late sixteenth century in a maze of frantic experimentation in

which some paths led to gloomy murk while others pointed to lurid, gaudy landscapes. What mattered most was that a painting should capture the eye with drama and novelty. Many painters strove hard (often far too hard) to impress, their contrived works creating the style of Mannerism. Strangely, this superficially libertarian attitude arose in a social context shaped by the reemergence of intolerance, authoritarianism, and dogma. The Church was fighting back.

THE NEW MANNER

Luther's Reformation engendered the Counter-Reformation as if preempting Newton's law of action and reaction. It was a last attempt by the theocracy to assert dominance before the Enlightenment banished God's earth forever from the center of all creation. The Church, seeing its authority undermined by humanistic rationalism, rallied and imposed a theological set of values akin to that of the Middle Ages. Classical (that is, pre-Christian) learning, said papal Rome, was all very well, but the ultimate arbiter of all questions of conscience was God (or his representatives on earth), not science or nature. As judge and gatekeeper of the conscience of man, the Society of Jesus and the Inquisition offered their services.

The ecclesiastical reactionaries were sophisticated enough to recognize that art is a powerful tool for the propagandist. Pictures—the potential text for a "Bible of the illiterate"—speak to the uneducated when words cannot. At the Council of Trent, which began its deliberations on church policy in 1545, it was decreed that religious art should depict things in a transparent manner, with laborious codification. All angels must have wings, all saints halos. If their identity is not obvious, they must bear labels, and never mind the demands of realism or aesthetics. Colors became bright again to appeal directly to the requisite emotions. Nakedness was frowned upon, even in those cases where there seemed to be biblical justification. Prudery abounded. Michelangelo's naked figures in the *Last Judgment* adorning the Sistine Chapel were much disputed. Pope Paul IV ordered that draperies be painted over exposed loins; more were added at the command of Pius IV. Even so, the fresco barely escaped complete destruction (and El Greco mischievously offered to replace the whole thing with a work "modest and decent, and no less well painted than the other"). In 1582 the sculptor Bartolomeo Ammanati professed that had he been able,

he would have destroyed all those images of naked men and women he had carved previously—an attitude that is perhaps unusually extreme among artists but nonetheless reveals the spirit of the age. ·

Artists who continued to uphold the humanism of the Renaissance risked censure and worse. In 1573 Paolo Veronese (c. 1528–1588) was forced to defend his *Feast in the Home of Levi* before the Inquisition, who demanded to know why the work contained figures not mentioned in the Bible. He confessed ingenuously that they were there to fill up space (there was a lot of it to fill). But still he was commanded to rework the picture. Biblical pedantry was the order of the day.

All this would seem to imply that the Counter-Reformers sought a return to a kind of austere medieval simplicity. And indeed some of them, such as Popes Paul IV and Pius V, wanted just that. But it became clear toward the end of the sixteenth century that a more vigorous approach was needed to combat the growth of Protestantism. The Jesuits discerned that ecstatic emotion, not dour abstinence, was the better lever on men's hearts. Their anti-intellectual strategy set the tone of the Counter-Reformation from around 1620, but it left its mark on the arts rather earlier.

It is scarcely to be wondered at that Leonardo's insistence on accurate observation and measurement foundered in such a climate. In 1607 the president of the Academy of Drawing in Rome, the architect and painter Federico Zuccaro (c. 1543–1609), was prepared to pronounce that "the art of painting does not derive from the mathematical sciences, nor has it any need to resort to them to learn rules or means for its own art, none even in order to reason abstractly about this art: for painting is not the daughter of mathematics but of Nature and of Drawing."[1]

Zuccaro, an influential theorist of his day, stands at a curious juncture. Although he is mystically inclined and opposed to the rational aspects of humanism, nevertheless he laments the excesses of Mannerism, which he regards as having ushered in a decline in the standards of Italian art. He complains about the caprice, the frenzy, the furious and bizarre invention of the early Mannerists, yet his own works can hardly be considered free from some taint of these showy impulses.

The wild experimentation of Mannerism no doubt received sanction from the antirationalism of the Counter-Reformation but cannot be wholly ascribed to it. By the mid-sixteenth century, many Italian academic artists had already come to adopt the courtly stylization characteristic of Manner-

ism. The value of a work was increasingly seen as a function of the reputation and judgment of the artist, irrespective of his technical abilities. This attitude pervades the writings of Vasari, for whom the last word in good art is good taste. While paying lip service to the need to imitate nature, Vasari exhorts the painter to excel over nature and to develop a cultured eye before a facility with mathematics. In a declaration apt to endorse all manner of arbitrary artistic snobbery, Vasari claims that the highest virtue of an artist—*grazia*, or grace—is a natural gift and not to be acquired by any amount of diligence. Such refinement is, he says, exemplified by works that hide any sign of the labor that went into them. Vasari dismisses Titian as too dutiful to nature ("some of whose aspects tend to be less than beautiful") and upholds Raphael instead as an exponent of graceful color. He regards "German" (Gothic) art as particularly abhorrent—barbarous and full of "confusion and disorder."

Dispensing with natural rules of proportion and composition, judged and judging only by subjective considerations of taste, and driven almost frantic by the extraordinary outburst of genius that had preceded them, the Mannerists produced some very strange contrivances in an attempt to attract attention. Parmigianino's *Madonna* (c. 1532–1540) is one of the most notorious of these, surely a contender for the ugliest of all "great" paintings. The elegant, sterile Virgin has a neck and fingers of almost absurd proportions, while the infant's head is coupled to a body of much more advanced years. Whether or not this ingenuity passed for beauty or grace in the eyes of the Italian courtesans, it certainly seems now to deserve characterization as "mannered."

Zuccaro was not alone in asserting that such exaggeration had occasioned a general decadence in art. The only antidote, it seemed, was to study and emulate the techniques of the Renaissance Masters. It was a lament that was to recur in the following two centuries, so that even in the 1790s a (fraudulent) claim of the rediscovery of the "Venetian secret"—the techniques and materials used by Titian and his contemporaries—was greeted with credulous excitement.

And so painters of the late sixteenth and early seventeenth centuries worked in a context constrained by a new religious intolerance yet overheated by pious passion. They were acutely aware of the supreme achievements of their recent forebears, yet the rules according to which those works were constructed had vanished. From this confounding maze each individual had to seek his own exit.

IN THE SHADOW OF THE MASTERS

In Venice, Paolo Veronese was the undoubted heir to Titian's fulsome use of color. Born, as his name implies, in Verona, he worked in Venice from 1555 and made avid use of every one of the colors the city had to offer: ultramarine, azurite, smalt, indigo, cochineal red lake, vermilion, red lead, lead-tin yellow, orpiment, realgar, copper resinate. Particularly striking in some of his works, such as *Adoration of the Kings* (1573) (Plate 25) and *Feast at the House of Levi*, is a bright green mixed from three pigments applied in two layers. So indelibly did this become a trademark that the eighteenth-century synthetic pigment emerald green was known in France as *vert Paul Véronèse*. Veronese largely abandoned the sophisticated glazing techniques that earlier Venetians had favored and instead mixed his colors on the palette. Like Titian, he used complementary contrasts to enhance the vibrancy of his colors, and he never let them be overwhelmed by the heavy chiaroscuro that was becoming popular among his contemporaries. If Veronese was touched by Mannerism, it was of a decidedly Venetian variety, for he employs none of the anatomical distortions characteristic of central Italian art at that time.

Tintoretto was less restrained. True to the fashion of the age, he painted to attract attention, even at the expense of coherence. Works such as *Miracle of St. Mark Freeing the Slave* (1548) and *St. George and the Dragon* (c. 1555) (Plate 26) are full of frenzied melodrama, with color often working overtime. In the *Annunciation* (1583–1587), the overwrought perspective is tortured mercilessly, while a stream of cherubs tumbles through the window to almost comic effect. Sharp, strong colors were for Tintoretto simply a means to an end, this being to excite and shock the viewer. It is hardly surprising that conservative academics like Vasari saw in Tintoretto's breathless style a lack of proper care over technique. Vasari calls his sketches "so crude that his pencil strokes show more force than judgment and seem to have been made by chance."

Several of Tintoretto's works are instantly recognizable by their somber, heavy tones, in which figures and objects are picked out in almost ghostly, glowing highlights. He sought tonal unity by using dark, reddish-brown grounds—deeper even than those over which Leonardo wrought his sfumato. Caravaggio used the same technique to envelop his scenes in velvety shadow. Some of Tintoretto's underpainting deploys mixtures so complex that one is forced to suppose that the painter made them simply by scrap-

ing his palette. Like Titian, he used just about every pigment he could lay his hands on, blending them in unusual combinations to "break" the colors.

Unorthodox color choices were regarded by other Mannerists as a way to make their mark. Michelangelo is sometimes counted, in his later years, as one of these. There can be no question that he cared deeply about color, but his use of the nonnaturalistic *cangiantismo* technique testifies to his lack of concern for rigid realism.

But no one embodies the strange excesses of Mannerism more graphically than the Cretan painter Domenikos Theotokopoulos, whose Greek nationality gained him the nickname El Greco (1541–1614). After studying under Titian in Venice, El Greco moved to Toledo, the Holy City of Spain, where he undertook many commissions for the Church. How his extreme nonnaturalistic coloring and alarming distortions of anatomy could have won any critical approval even in the fractious and unrestrained artistic climate of the late sixteenth century remains something of a mystery. What did the painter's contemporaries make of these pallid figures robed in blue, madder, and honey-brown, writhing in a world of ghastly light? El Greco's landscapes—notably his remarkable paintings of Toledo—would not look out of place beside Cézanne's hillsides. Indeed, it was not until twentieth-century styles had retutored the eye that his works were "rediscovered" after being long regarded as incomprehensible. It is telling that the Orphists Robert and Sonia Delaunay, who in the 1910s experimented with abstraction in bright colors, considered El Greco a predecessor.

AUTUMN'S COLORS

Another response to the problem of how to advance the tremendous coloristic invention of the Renaissance was to sidestep it by subjugating color to extreme light and shadow. For Cennino and Alberti, chiaroscuro meant lightening or darkening the tone of pure, bright pigments by adding black or white. But the late Renaissance and the ensuing Baroque period became an era of deep shadows, of brooding blacks placed in dramatic counterpoint to fulvous highlights. Correggio, Caravaggio, and Rembrandt were the thaumaturgists of black and brown.

Can it be coincidental that amid this golden glow and heavy gloom emerged several new yellow, ocher, and brown pigments? Never before the seventeenth century was the artist so well equipped to cover the canvas

with lustrous highlights, modulating through ruddy shades to a pitchy murk.

Browns are surely the least glamorous of all pigments. They have enjoyed scant attention from artificers, since they can be dug from the ground in a wide range of hues. Among the ochers (iron oxides) that have been employed since time beyond record, those from the Tuscan city of Sienna gained special respect during the Renaissance. Raw sienna is a yellowish pigment; roasted to become burnt sienna, it takes on a warm brownish-red shade.

For the somber palette there is nothing to match the profundity of umber. Darker than sienna pigments owing to a liberal proportion of manganese among the iron oxide, umber found its way into European painting around the end of the fifteenth century. Some writers have assumed the name to be of geographical derivation, like sienna, from Umbria in Italy. But "umber" seems more likely to stem from the Latin *ombra*, shadow. European umber was, after all, imported mostly from Turkey rather than Italy, and the rich red-brown of roasted (burnt) umber was highly valued for rendering deep but translucent shadows. The Englishman Edward Norgate wrote in the 1620s that burnt umber is "a Collour greasy and foule, and harde to worke withall if yow grinde him as he is bought, yett of very greate use for Shadowes and hayres etc."[2]

If painters are awarded the colors they deserve, we shall know what to expect in the works of Anthony Van Dyck. The pigment Cassel earth, which became known in England as Vandyke brown from around 1790, is of a singular brown drabness. It is an "earth" only insofar as it is taken from the ground; it is not a mineral but rather an organic material derived from peat or lignite. The earliest sources of the pigment were close to the German cities of Cologne and Kassel; in the seventeenth century alternative names included Cologne earth or corruptions thereof: earth of Cullen, Colens earth. At that time it was often listed as a kind of black, and Norgate praises its qualities for the kind of compositions that were becoming increasingly fashionable: it is, he says, "very good to close upp the last and deepest touches in the Shaddowe places of pictures by the life, and likewise very usefull in Landscape."[3] The transparency of the pigment in oil makes its gloom spacious, and Van Dyck employed it as a sobering glaze.

In nineteenth-century Belgium, Vandyke brown went under the name Rubens brown, for Van Dyck acquired his habits from his teacher, the greatest Master of Antwerp. Max Doerner claims that Rubens used Cassel

earth "mixed with gold ocher as a warm transparent brown which held up well, particularly in resin varnish." It is not an easy pigment to identify unambiguously but has been reported in works by Rubens and Rembrandt and possibly Velázquez. Thomas Gainsborough (1727–1788) made much use of "Cologne earth"—like his rival Joshua Reynolds (1723–1792), his debt to Van Dyck extended to a shared taste in pigments.

Van Dyck and the English school that succeeded him also took their browns from an unappealing tarry substance called asphaltum or bitumen. It is hard to credit that this unpromising stuff, a residue from the distillation of crude oil, would ever have been accorded much value except in an age obsessed with brown. Rembrandt was a skillful enough craftsman to use it without mishap in his reddish-brown glazes, but in the hands of an immoderate experimenter like Reynolds it was disastrous. It does not properly dry at all, and thick films tend to run. Moreover, as the surface layer congeals, it shrinks and wrinkles, causing any material painted over the top to crack and curl. The French painters of the early nineteenth century, in thrall to a version of chiaroscuro that demanded deep, translucent shadows, seized on bitumen's seductive warmth of tone, only to discover its insidious effects too late. Théodore Géricault employed it to his cost in *The Raft of the Medusa* (1819), and even the Realist Gustave Courbet made ill-advised use of it. In the 1920s, Max Doerner cautioned sternly that "its use is advised against in every technique."

Van Dyck was fond of glazing his shadows with a similar dark, tarry pigment called bister—it features, for example, in his portrait *Lord John Stuart and His Brother, Lord Bernard Stuart* (1638–1639). This was made from the soot of burned beechwood or birch bark. It was not a new material, having been used in manuscript illuminations since at least the fourteenth century, but one needed skill and knowledge to make much of it in oils.

How aptly this name now suggests a meaty brown sauce, like the "brown gravy" that the Impressionists despised in early-nineteenth-century academic art and that seeps through the canvases of Reynolds, Gainsborough, and Constable. Nothing reflects the stodgy conservatism of this era better than the words of the artist and connoisseur Sir George Beaumont, patron of Constable: "A good picture, like a good fiddle, should be brown."

(In fairness to Constable, we should remember that he protested by placing a violin against grass to show how nature was not really so somber. Many of Constable's works, austere to modern eyes attuned to vibrant color, were considered daringly bright in their time, to the extent that a

member of the Royal Academy is said to have called one of them a "nasty green thing." Constable pushed against the injunction to tone down colors so as supposedly to match the *contrasts* of nature, but he did not push hard enough to look modern today.)

At least these murky materials were relatively cheap. The same can be said of the red ochers and earths that colonize much of Van Dyck's canvases. Yet color manufacturers of the Baroque period discovered how to make their own versions of these natural pigments and thereby gain control over their hues. Iron, the martial metal of the alchemists, gave birth to the Mars pigments: synthetic iron oxides that ranged in color from yellow through red to brown and even a kind of chocolate purple ("Mars violet").

Just how this innovation came about is not clear. The reaction—the oxidation of iron in air—is simple enough, and we know that medieval alchemists conducted it and called the ocher-tinted product *crocus martis*, a literal Latin rendition of "Mars yellow." Yet there seems to be no mention of this artificial substance as an artist's pigment until Sir Theodore de Mayerne, Hugenot refugee and physician in the court of Charles I, supplies a recipe in an early-seventeenth-century document. Although he too calls it *crocus martis*, or even "saffron," he makes it quite clear that the product is red. In fact, de Mayerne quotes no fewer than three recipes, all merely different ways of making the oxide: by heating iron filings, by dissolving them in aqua regia (a mixture of hydrochloric acid and nitric acid) and roasting the resulting iron salt, or by heating iron sulfate ("martial vitriol") directly.

Later methods of manufacturing Mars red allowed the color of the product to be tailored to order. The real impetus for the production of Mars compounds came, however, in the eighteenth century, when sulfuric acid became an important commercial item, especially as a bleach for the textile industry. Iron oxide is a by-product of the manufacturing process and so, like many other synthetic pigments before and after, enjoyed economic viability by riding on the back of a larger concern within the blossoming chemical industry.

There was no longer much call for the stark orange-tinted tones of vermilion, which served now mainly as an opaque underpaint for red lake glazes. Rembrandt seldom used vermilion, anchoring his red lakes instead with red ocher. It became common for artists of the seventeenth century to adjust their reds by mixing several different lakes—the range was broadened by the colonization of the New World. From Central America came a new kind of cochineal, along with abundant brazilwood and the related fer-

nambuco and peachwood. The New World cochineal caught on: by the nineteenth century, this and madder were the preeminent dyestuffs in red lakes. The new wood-based dyes, however, acquired a reputation for impermanence that was even worse than that of Old World brazil. In 1553 the writer William Cholmeley described brazil as "disceytful," a "fauls colour."

But it was not just from over the Western horizon that alluring new colors were fetched. For this was the age when Europeans began to span the globe in all directions.

SPOILS OF EMPIRE

In 1589 the English explorer Richard Hakluyt served notice of the nascent colonial hubris of Elizabeth's nation. The English, he said, "in searching the most opposite corners and quarters of the world . . . have excelled all the nations and peoples of the earth." The East India Company was born as the new century dawned, and the English and the Dutch were soon pitted one against the other to bring west the riches of the Orient. Caught up in this trade in spices, silks, and other exotica were two bright and mysterious yellow pigments.

It is not known precisely when Dutch traders began to import the mysterious golden material called Indian yellow. It appears in some Dutch paintings of the seventeenth century but does not seem to have found wider use in Europe until the late eighteenth.

The pigment, known in India since about the fifteenth century under the name *purree*, *puri*, or *peori*, seems to be of Persian origin. But what was this stuff, sold in hard, dirty-colored, ill-smelling balls? Speculation abounded, much of it lurid. In the nineteenth century the French colorman J.-F.-L. Mérimée remarked on its smell of urine but was reluctant to entertain the notion, proposed by others previously, that the substance could really harbor such an ingredient. George Field in England was less circumspect, believing that it was made from the urine of camels; others deemed that the fluid came instead from snakes.

It was not until 1883 that these rumors were set right. The Indian T. N. Mukharji made inquiries in Calcutta after the origin of the yellow balls and was directed to the village of Mirzapur on the outskirts of the city of Monghyr in northeast Bihar province. Here he discovered that certain cattle owners—"milkmen"—created the stuff from the urine of cows fed exclusively on a diet of mango leaves. The yellow solid precipitated from

the liquid when it was heated. Pressed into lumps and dried, it was then shipped to Calcutta and Patna for sale. It seems that the entire output of the pigment from India to Europe came from this village.

Given no other source of nutrition for fear that it would diminish the output of the colorant, the mango-fed cows were in a very poor state of health—to the disgust of Monghyr's regular dairy farmers, who called the milkmen "cow destroyers." The discovery of the pigment's source helped accelerate its demise: the practices of the milkmen were denounced as inhumane, and laws were passed to prohibit them. By 1890 the legislation in Bengal to prevent cruelty to animals had become sufficiently stringent to make the manufacture of Indian yellow illegal, and it had all but disappeared by 1908.

Urine is, however, just an incidental component of the pigment. The colorant is a calcium or magnesium salt of an organic acid released by the mango. Despite the unpromising appearance of the raw balls, the ground pigment is rather lovely, giving a deep golden yellow. Its properties are better suited to use as a watercolor than as an oil pigment.

More or less coincident with the introduction of Indian yellow to Europe was that of another organic yellow pigment, called gamboge. Apparently taking its name from Camboja, an old form of the name Cambodia, gamboge was imported by the East India Company from around 1615. It has been identified in works from the Far East dating back to the eighth century. The hard, mineral-like raw material is the solidified resin of trees of the *Garcinia* family native to Southeast Asia. The gum is extracted from incisions in the tree bark, and once hardened, it can be ground to a bright yellow powder. But like many organic colorants, it fades rapidly in bright light.

Gamboge again fares best as a watercolor pigment, but it does appear in some works in oils, notably those by early Flemish painters, who were best placed to benefit from the Dutch trade in India. Rembrandt used it, attracted perhaps by the golden hue that it acquires in oil. Gamboge is also an ingredient of the eighteenth-century watercolor called Hooker's green, in which it is mixed with Prussian blue or indigo. Among its curious distinctions is the use of its fine, dancing particles by French physicist Jean Perrin to demonstrate Brownian motion in 1908, providing evidence of the existence of atoms. Its importation to the West was doubtless boosted by the fact that druggists also sold it as a pharmaceutical.

Another organic yellow common in northern European painting in the

seventeenth century offers us a further glimpse at the mercurial propensi-ties of color terms. "Pink" was a pigment of diverse provenance—recipes identify it as an extract of weld (mignonette), broom, or unripe buckthorn berries—but often of an indisputably *yellow* hue. Pinks were in fact defined neither in terms of their ingredients nor of their color—for there were also green pinks, brown pinks, and rose pinks. It appears that the noun refers instead, like "lake," to the method of synthesis. Pinks were comprised of an organic colorant carried on an inorganic powder. The distinction from lakes is subtle, technical, and a testament to the attention given to the chemistry of the production process by seventeenth-century colormakers. Lakes are generated through a chemical reaction, as hydrated alumina is precipitated from a solution in the presence of a dye. Pinks, meanwhile, re-sult from a purely physical process in which the dye is attached (mor-danted) to an inert white substrate, typically chalk, alum, or baked and ground eggshell. They are thus a kind of pseudolake, distinct from true lakes in that no alkali is used in the making.

A recipe for pink is listed by Edward Norgate in the seventeenth cen-tury, and yellow pink was popular throughout that century and the next, particularly mixed with blue to make "green pink." Rose pink, prepared from brazilwood, was considered different from the lake pigment derived from the same colorant. Toward the late eighteenth century, yellow pink fell into disuse, and although "brown pink" remained in circulation into the nineteenth century, "pink" gradually became synonymous with the light red "rose pink" until eventually the connotation changed from one of manufac-ture to one of color.

ENTERING THE LANDSCAPE

Despite this apparent profusion of new pigments, artists continued keenly to perceive a paucity throughout the sixteenth, seventeenth, and eighteenth centuries. The propensity for experimentation with materials increased over this period, indicating that painters were by no means satisfied with those at their disposal.

There was, for instance, a profusion of prescriptions for greens as land-scape painting came into vogue. In the early sixteenth century the German artist Albrecht Altdorfer was one of the first in the West to paint landscapes for their own sake, although Leonardo had already advertised their attrac-

tions: "What moves you, man, to abandon your home in town and leave relatives and friends, going to country places over mountains and up valleys, if not the natural beauty of the world . . . ?" Could not the painter supply this experience without your having to leave your door? Could he not place you in that landscape "where you have had pleasure beside some spring, [where] you can see yourself as a lover, with your beloved, in the flowering meadows, beneath the sweetest shade of trees growing green?"[4]

Some art historians have perceived in such words a longing for a lost Arcadia that made landscape painting so alluring to a people increasingly embroiled in urban commerce. Others point out that landscapes are not depictions but interpretations of nature. Christopher Wood suggests that landscapes gave artists fresh scope for imprinting their authority on works with a unique grandeur of scale. "Landscape," he says, "was a hospitable venue for pungent colouristic effects."[5] The influential seventeenth-century French writer Roger de Piles clearly felt that painters re-created the landscape to suit their own vision—to such an extent that this "imagined reality" impinged on the artists' very perception of nature: "Their eyes see the objects of nature colored as they are used to painting them."[6]

If this were so, it places a dramatic responsibility on the greens that artists of that era had at their disposal; these pigments were, by some accounts, quite unsatisfactory. In the 1670s the Dutch painter Samuel van Hoogstraten lamented, "I wish that we had a green pigment as good as a red or yellow. Green earth is too weak, Spanish green [verdigris] too crude and ashes [green verditer] not sufficiently durable."[7] The Spanish artist Diego Velázquez (1599–1660) seems to have concurred with these complaints: he never used a pure green pigment in his life but always mixed his own from azurite and yellow ocher or lead-tin yellow.

Painters' manuals were often remarkably specific about how to mix greens for different applications. In *The Compleat Gentleman* (1622), Henry Peacham gives the following advice: "For a deepe and sad Greene, as in the in-most leaves of trees, mingle Indico and Pinke. For a light Greene, Pinke and Masticot [here, lead-tin yellow]; for a middle and Grasse-greene, Verdigreace and Pinke."[8]

In *The Practice of Painting and Perspective Made Easy* (1756)—you can begin to see to what manner of audience these books were addressed—Thomas Bardwell suggests greens for landscapes composed of light yellow ocher, green earth, brown pink, Prussian blue, orpiment, and white. The use of orpiment underwent something of a revival in the eighteenth cen-

tury, being especially popular in a mixed green with the new Prussian blue. In Jan van Huysum's *Hollyhocks and Other Flowers in a Vase* (1702–1720) the greens contain indigo; by 1736, when he painted *Flowers in a Terracotta Vase*, he had replaced it with Prussian blue. Glazing rather than pigment mixing was sometimes employed: a manual from 1795 describes a "very lively and beautiful green" obtained by glazing brown pink over blue.

The great French landscapists Claude Lorrain and Nicolas Poussin used complex mixtures to obtain their variegated greens. One recommended formulation included a green earth, a blue (such as ultramarine), a yellow (lake or ocher), and perhaps a lead white and a black. Such combinations had no pedigree and were often unreliable, exhibiting unpredictable changes over time. The influx of new yellows added to the hazards faced by artists of the seventeenth and eighteenth centuries: many were less stable than the earlier lead-tin yellow and Naples yellow, so the discoloration (of mixed greens in particular) in paintings of these times is often worse than in older works. It is a treacherous business now to discern how these artists chose to represent "the sweetest shade of trees growing green."

NORTHERN LIGHTS

The great Flemish, Dutch, and German artists of the seventeenth century were perhaps better served with materials than those of the Renaissance. The Netherlands had become a major center for pigment manufacture: white lead, smalt, lead-tin yellow, and vermilion flowed from the Dutch factories to brighten the shops of the apothecaries and grocers who sold them. Antwerp was to northern Europe what Venice had been to Italy.

But the traditional fine blues—azurite and ultramarine—were increasingly difficult to obtain: from the early 1600s, the main mineral sources became either exhausted or inaccessible owing to war. One northern painter who persisted with ultramarine was Jan Vermeer (1632–1675), whose characteristic palette of yellow, blue, and pearly white is displayed at its most stunning in *The Milkmaid* (c. 1658). These bold, skillfully harmonized blues seem to come from another age, which one cannot quite place as more ancient or more modern. Yet ultramarine cost a princely sum—45 guilders an ounce in 1626. Charles I's gift of £500 worth of ultramarine to Van Dyck and the English painter Anne Carlisle was indeed generosity on a royal scale.

The sparkling, jewel-like colors of Peter Paul Rubens (1577–1640) make him Titian's Baroque heir. Rubens seems reluctant to exclude any hue from the canvas; his challenge was finding a harmonious arrangement of strong primaries. He was arguably less successful in organizing color than Titian—some of Rubens's works, such as *Allegory on the Blessings of Peace* (c. 1630), verge on the garish, a shortcoming exacerbated by a fleshy choice of subject that, to the modern eye, approaches high camp. But there is no denying the joy with which these works are executed, the brushwork injecting an invigorating energy.

Although German by birth, Rubens was Flemish by descent: his father fled from Antwerp in the wake of Reformation unrest. But the family returned home after the father's death, and it was in Antwerp and its environs that Rubens served his apprenticeship. The magnetism of color led him inevitably south: in 1600, at the age of twenty-three, he set out for Italy. There, as court painter to the duke of Mantua, he traveled widely. Visiting Venice at the first opportunity, he studied and copied the works of Titian with relish. The debt is particularly explicit in Rubens's intimate portrait of his second wife, *Helena Fourment as Venus* (*Het Pelsken*) (c. 1636–1638), inspired by Titian's *Girl in a Fur Wrap* (1535–1537).

Both of Rubens's versions of *The Judgment of Paris* (c. 1600 and 1635–1637) show a Venetian influence in their use of primaries: bright yellow in the heavenly light and draperies, strong blues in the sky, brilliant reds in the flesh tints and garments. The way that these colors are subtly modulated as they are carried out into the scenery is quintessentially (late) Titianesque. Rubens achieved his pure, glowing colors by applying the pigment onto white grounds, rather than using the muted red-browns or grays typical of the time. Nowhere is this more apparent than in *Samson and Delilah* (c. 1609) (Plate 27), where raw color fills the canvas.[9] Delilah's red dress, which overheats the sexual charge of the scene, is almost unadulterated crimson lake, brightened with touches of vermilion and highlighted with lead white.

The servant's blue jerkin, contrasting with the golden glow of the candle flame and Delilah's hair, contains no blue pigment but is developed from lead white, black, and red lake. The same is true of the purple drapery in the background. It was not unusual for black to stand in for blue; greens were occasionally made by combining yellow and black. This ambiguous attitude to blue harks back to the four-color palette of the Greek painters. Titian, too, used the trick in his *Portrait of a Man* (c. 1512) (see

Plate 23), which served as the inspiration for Rembrandt's *Self-Portrait* (1640). Van Dyck evidently learned it from his mentor, for the striking purple of the little girl's dress in *Portrait of a Woman and Child* (c. 1620–1621) is concocted from red lake, charcoal, and white.

There is a telling lesson in Van Dyck's *Charity* (c. 1627–1628) (Plate 28) about how he and other seventeenth-century Dutch painters strove to keep their colors under control. The painting is clearly influenced by Titian and at first glance seems even to share his coloristic enthusiasms. But although Van Dyck had ultramarine available for Charity's billowing drapery, he chose to use grayish smalt, or even a plain mixed gray in some places, for the sky. Even the ultramarine drape is underpainted with dark indigo, which tones down its exuberance. The red drapery is constructed from lake pigments painted over vermilion and earth pigments. The lakes have partially discolored with age, making it hard to judge what effect Van Dyck intended, but a careful analysis of the paint composition and the presence of a brown glaze of Cassel earth in some places make it clear that he did not seek the rich purple-red we would expect from Titian.

The paintings of Rembrandt van Rijn (1606–1669) exude a powerful impression of dark rusty brown, which persuades us of a certain sincerity and honesty in the artist while at the same time reminding us now of his ruinous, impoverished end. By the 1650s, Rembrandt was using just a half dozen or so pigments, mostly of dull earthy tones. He was a master at "breaking" colors—breaking up fields of color by using complicated pigment mixtures. One contemporary commentator praised Rembrandt's use of these mixtures "harmoniously to depict nature's true and vivid life" and went on to denounce those who in contrast "set the hard, raw colours quite bold and hard next to each other, so that they have no relationship with nature." Clearly we have come a long way from Alberti, who would have been horrified at this deflowering of pigments and little concerned about a color's "relationship with nature."

Surprisingly, perhaps, Rembrandt was also an ardent admirer of Titian. More obvious is his debt to Caravaggio, whose heavy chiaroscuro was a prominent feature of the Utrecht school of Dutch painters in the early seventeenth century. Rembrandt adopted this style in his youth and deployed it thereafter as the main vehicle for creating mood and psychological expression in his work. The somber, almost despairing tone of his later pictures, painted in times of great financial hardship, certainly have ample precedent in his works from happier times.

Rembrandt's restricted palette excludes several of the brightest pigments available in the seventeenth century. His blacks (charcoal and bone black) and browns (including Cologne earth, as it would have been called) are supplemented by most of the earth colors: ochers, siennas, and umbers. His red lakes were mainly madder and cochineal. Blues, too, he used with restraint—mainly smalt but sometimes azurite, as in *Saskia in Arcadian Costume* (1635). His principal yellow was lead-tin yellow, which was never the brightest of colors. Rembrandt used chalk as an extender, to add translucency to glazes (it is almost transparent in oils), and to give body to his medium. His thick impasto gained some notoriety, evident from Arnold Houbraken's remark in 1718 that a portrait by Rembrandt had colors "so heavily loaded that you could lift it from the floor by its nose."

But this limited palette had advantages, for it consisted largely of reliable, stable colors that have aged well. This was no mere good fortune: Rembrandt knew which materials would last and how to combine them safely. And that is just as well, for his mixtures attain an almost comical level of complexity. Lurking at the threshold of visibility amid his deep shadows are concoctions of truly baroque proportions. In *An Elderly Man as St. Paul* (c. 1659), the deep, warm brown of the dimly seen book cover is no mere umber but consists of a semiglaze of lakes, red and yellow earth, and bone black. In *Portrait of Jacob Trip* (c. 1661), a deep orange-brown is mixed from red and yellow lake with smalt. And for *Portrait of Margaretha de Geer* (c. 1661), the incidental dark gray-greenish wall in the background on the left has an unbelievable subtlety of pigmentation lavished on it. The lighter part is made up from a dark brown underpaint of red, orange, and yellow earths mixed with bone black and a little lead white, which is then glazed with a mixture of smalt, red ocher, and probably a yellow lake. For the deeper shadow, a glaze of bone black with red lake and red ocher is used instead. Yet this wall is hardly distinguishable from black shadow!

One cannot help but wonder whether these elaborate mixtures were systematically blended or whether Rembrandt was merely making use of the random remnants daubed on his palette. In any event, they bring to mind Monet's determination to mix even the murkiest of shadows from strong, pure colors. The consequence is that Rembrandt's colors are often almost indescribable—beyond tertiaries, beyond words. What is the color of Hendrickje's dress in *Portrait of Hendrickje Stoffels* (1654–1656) (Plate 29), the woman who effectively became Rembrandt's wife after the death of his beloved Saskia? Some might say a pale lilac. Yet once again, there is no

blue on the canvas—if there is a violet tint, it comes from the slight blueness of the mixture of lead white and charcoal black, blended with a little red lake.

What better articulation of Rembrandtian color can we find than the *Self-Portrait with Maulstick, Palette, and Brushes* (c. 1663), painted some six years before his death? Convention focuses on the enormous expressivity of the artist's careworn face. But what is there on the palette cradled in one arm? Nothing but a bare expanse of ruddy brown, so loosely sketched that the dark coat remains visible beneath. And one can almost believe that no more color than this, deftly lightened and darkened, was needed to convey all the introspection, the frankness, and the gravity that the portrait reveals.

THE PRISMATIC METALS

SYNTHETIC PIGMENTS AND

THE DAWN OF COLOR CHEMISTRY

"Chemistry is the art of . . . producing several artificial substances more suitable to the intention of various arts than any natural productions are." —William Cullen, chemist (c. 1766)

"What land, what Eldorado, what Eden flames with this wild brilliance, these floods of light refracted by milky clouds, flecked with fiery red and slashed with violet, like the precious depths of opal?"
 —Joris-Karl Huysmans (1889), "Turner and Goya"

There will never be another fifty years in chemistry like those that began in the 1770s, when everything was up for grabs. At the outset, barely any of the real elements were known, and scholars still spoke in learned tones of phlogiston, the elusive substance that was supposed to be released when something burns. Yet the world was on the brink of a revolution (more than one, since so much of the story was staged in France). By 1820, chemists spoke much the same language as they do today, and chemistry was a profession—potentially a lucrative one. And the list of elements was expanding to proportions no one would have dreamed possible a century earlier. In Antoine Lavoisier's seminal *Traité élémentaire de chimie* (1789), the French chemist listed thirty-three elements; between 1790 and 1848, twenty-nine more were added to the list.

It is no coincidence that this period saw an explosion in the production of new pigments for artists. After centuries of rather little innovation, suddenly painters found themselves awash in choices—and increasingly in need of criteria by which to assess the multitude of products that the nascent paintmaking industry was asking them to purchase. It was a development that would separate the sheep from the goats: Was one to adhere to the traditional, tried-and-tested materials or to experiment with the new? Unsurprisingly, those who chose the latter course tended to be innovators in artistic style too, and ultimately it was to become the very color on the canvas that would discriminate the conservative from the radical.

BUILDING BLOCKS

The chemist's job was scarcely any simpler when there were but four elements on the ledger, but it was less colorful. Set against the riches of the periodic table, in which ninety-two natural elements display their gamut of quirks and idiosyncracies, the Aristotelian earth, air, fire, and water of classical antiquity seem mundane indeed as the primary components of all creation.

Elements are chemistry's cast of characters, and attempts to dissect matter beyond the atom can never have quite the same appeal as the identification of that illustrious company. For protons and electrons have no hue, no one makes paints by mixing quarks or gluons, and the "colors" that physicists give them are but flights of fancy. It is by manipulating the elements—altering their ratios, their unions, their electrical charge—that the chemists do their business, and that is how the colormakers did theirs.

In *The Sceptical Chymist*, Robert Boyle challenged the Aristotelian system of elements, suggesting that there might be more than four, perhaps even more than five. What were they? Boyle, perhaps wisely, does not say. But he raises doubts about whether earth, air, fire, and water are irreducible and fundamental to all matter. For, he observes,

> out of some bodies, four elements cannot be extracted, as Gold, out of which not so much as any *one* of them hath been hitherto. The like may be said of Silver, calcined Talke [talc], and divers other fixed bodies, which to reduce into four heterogeneal substances, is a taske that has hitherto proved too hard for Vulcan [fire].[1]

It is tempting to attribute too much novelty to Boyle. To some extent Aristotle's quartet was vulnerable ever since Conrad Gesner showed in the sixteenth century that it was just one of the elemental systems propounded in antiquity. But Boyle's contribution was to take the debate beyond questions of whether one should omit fire or add sulfur and salt (*pace* Paracelsus) by pointing to the need for direct analysis of the substances into which bodies decompose under chemical transformation: "The surest way is to learne by particular experiments what heterogeneous parts particular bodies do consist of, and by what wayes, either actual or potential fire, they may best and most conveniently be separated."[2] And in this manner he defined the primary task of the chemist for at least a century to come. Yet it was not until a hundred years later that the elementary constituents of two of Aristotle's "elements"—air and water—began to reveal themselves.

Boyle's assistant Robert Hooke was already on the trail with his observation that air contained an inert component that remained after a substance was burned in a sealed container. But it was not until 1774 that the English scientist and Presbyterian minister Joseph Priestley made the first clear identification of the "active" component of air, which Lavoisier was to call *oxygène*. To Priestley this was not an element in itself but air robbed of phlogiston. By making oxygen an element that is taken up by burning substances, Lavoisier pointed chemistry in the right direction, and everything else began to fall into place. Its union with hydrogen, produced by the action of acids on certain metals, gave water—an observation made by Henry Cavendish in 1781 and confirmed (one might say appropriated) by Lavoisier over the ensuing two years.

"Chemistry is a French science," wrote Adolphe Wurtz in 1869, "founded by Lavoisier of immortal fame."[3] And of considerable cunning, he might have added. Lavoisier consolidated his oxygen theory of combustion, in the face of appreciable opposition (in England in particular), by renaming and revising the entire scheme of elements. His *Méthode de nomenclature chimique* (1787), written with French chemists Bernard Guyton de Morveau, Claude-Louis Berthollet, and Antoine-François Fourcroy, gave chemistry a new vocabulary and a systematic tabulation of elements that included eighteen metals (some, such as calcium and magnesium, still disguised as compounds, since they were too reactive to be easily separated from oxygen).[4]

The four French chemists established the journal *Annales de chimie* to propagate their system. They were a curious group. The suave Lavoisier was

overbearing, marked with the arrogance of one born into privilege. He was quick to take credit and slow to acknowledge the discoveries of others. This combination of bourgeois background and haughtiness made Lavoisier's fate all the more certain when he was arrested by Robespierre's agents after the French Revolution, owing to his activities as a tax collector. Fourcroy pleaded with Robespierre for clemency, to no avail. Lavoisier was executed in 1794.

Fourcroy, born of a noble family fallen on hard times, was a supporter of the Revolution and did his bit for *fraternité* by teaching courses on gunpowder manufacturer at the Académie des Sciences. Not by any means a brilliant scientist, he owed his modest successes to diligence. Berthollet and Guyton de Morveau were both of wealthy parentage, though the latter quietly dropped the aristocratic prefix during the Revolution. He became a lecturer in chemistry at the Dijon Academy, where he reclaimed his nobility under Napoleon's reign. It was here that Guyton de Morveau found himself engaged in research for the paint industry as the eighteenth century drew to a close.

LEAD-FREE WHITE

Artists were long accustomed to working with hazardous substances, since capricious nature had made them some of the most strongly colored. Lead is not by any means the worst offender, and there is no indication that the health of bygone artists was disturbed by their minium, massicot, or white lead. Yet as the Industrial Revolution increased the scale of manufacturing and created a permanent workforce exposed for all their working days to such toxic substances, there was no overlooking the fact that white lead is an inimical material. Even in the seventeenth century, Philiberto Vernatti described in the *Transactions* of London's Royal Society the terrible harm suffered by workers in white lead manufacturing: "The Accidents to the Workmen are, Immediate pain in the Stomack, with exceeding Contorsions in the Guts and Costiveness that yields not to Catharticks . . . Next a *Vertigo* or dizziness in the Head with continual great pains in the Brows, Blindness, Stupidity, and Paralytic Affections."[5] Lead white (as it is now more often known) was made in huge amounts, since it was the only white pigment in wide use and was employed not only in artists' materials but also in domestic paints, posing a danger to house dwellers too. By the end

of the eighteenth century, the risk was a matter of serious concern to the public health authorities in France, and an alternative white was demanded.

In the 1780s Guyton de Morveau was approached by the French government to search for a new, safer white pigment. In 1782 he reported that the best candidate was zinc oxide, known as zinc white, which was synthesized at the Dijon Academy by a laboratory demonstrator named Courtois.[6] Not only was zinc white nontoxic, but it did not suffer from the darkening that lead white showed in the presence of sulfurous gases, as the lead carbonate is converted to black lead sulfide.

Zinc was on Lavoisier's list of elements: it had been identified as such by the German chemist Andreas Margraaf in 1746.[7] The white oxide was well known to the Greeks, as it is a by-product of brass manufacture. When copper metal is heated with zinc ore, zinc oxide forms a white vapor that condenses in fluffy deposits. Probably for this reason it was known in medieval times as *lana philosophica*, "the philosopher's wool," and also as "flowers of zinc." The oxide is a mild antiseptic and prevents inflammation; it was recommended as a medicine by Hippocrates around 400 B.C.

Zinc white had a lot going for it but also some crucial drawbacks. First was cost—Courtois's product was four times more expensive than lead white. Artists would certainly pay that much more for a superior material, but at the beginning of the nineteenth century, zinc white did not look at all superior. Its covering power was not impressive; worse still, it dried very slowly, like an oil pigment. For this reason, its first commercial application was as a watercolor pigment: Chinese white, introduced by the English color manufacturers Winsor and Newton in 1834.

Courtois tried to improve the drying time by adding zinc sulfate as a drying agent (siccative). But the problem persisted, and despite intense debate (to which Fourcroy and Berthollet contributed) about whether lead white or zinc white was the better pigment, the initial promise of zinc white began to fade.

It was rescued by the crusading efforts of the French colormaker E. C. Leclaire. In the late 1830s he and a chemist named Barruel identified better siccatives, and in 1845 Leclaire began to manufacture zinc oxide at a plant near Paris. Other French entrepreneurs also braved this risky venture, and by 1849 the status of zinc white was considered secure enough for the French Minister of Public Works to issue a decree cautioning against the use of lead white. By 1909 it was banned from paintwork in all buildings in

France. Mass production of zinc white led to a decline in its cost; by 1876 it was marketed at the same price as cheap lead white.

All European manufacturers of zinc white in the mid-nineteenth century made it by oxidizing refined zinc metal in the so-called indirect or French process. But in the 1850s a new method was introduced in the United States. In a story that has all the trademarks of the apocryphal (but that one would like to believe anyway), it was discovered by accident by a worker named Burrows at the Passaic Chemical Company near Newark, New Jersey. The Passaic Company itself did no business in zinc, but the metal was refined in an adjacent plant. On fire duty one night, Burrows found that one of his company's furnaces had a leaking fire flue. He covered the leak with an old fire grate and for good measure piled on top of it some zinc ore and coal, belonging to the company next door, that happened to be lying nearby. Shortly afterward, he noticed white fumes of zinc oxide arising from the pile. He had the acuity to mention this later to members of the zinc company, men named Wetherill and Jones, who then developed the process into a manufacturing method during the 1850s and 1860s. This "direct" or American process uses the zinc ore itself (sphalerite) as the raw material.[8]

Commercially, zinc white was of immense importance. But artists were hesitant to adopt it. Lead white had served them well for centuries, and its poisonous nature did not pose much of a threat to them—so why change to a new and untested material? Moreover, compared to lead white, zinc white had a cold, flat tone, which did not suit some tastes. So lead white remained the principal white for fine artists throughout the nineteenth century. Even watercolorists deferred: of forty-six English watercolor painters questioned in 1888, only twelve said that they used Chinese white. All the same, zinc white is not hard to find in nineteenth-century art, partly because some paint manufacturers tended to add it to their products as a lightener. It has been found in the works of Cézanne, and van Gogh was particularly fond of it. The Pre-Raphaelite painters used it as a ground for their strong colors in the 1850s.

In his search for a new, nontoxic white, Guyton de Morveau did not confine himself to zinc white. Among the alternatives he tried was the mineral barite or barium sulfate, sometimes called barytes. The mineral was described by Agricola in the sixteenth century, but there is no indication that it was considered as a white pigment. It needed no preparation beyond washing and grinding, and became quickly adopted into the artist's palette

as "permanent white" or "mineral white," as it was known in England in the 1830s. High-quality deposits of barite are rather rare, however, and in the early nineteenth century barium sulfate was manufactured synthetically as a pigment known as *blanc fixe*.

Permanent white is listed in Bowles's *Art of Painting in Water-Colours* (1783), published only a year after Guyton de Morveau's studies. It serves best as a watercolor, being rather transparent in oils. But barium sulfate was commonly mixed with other white pigments as an extender, and it also served as a base for lake pigments. Because it was relatively cheap, it became an important industrial paint, used for airplane camouflage colors in the First World War and as a component of the U.S. Navy's battleship gray from the 1910s.

Zinc smelting was a major industrial process in the early nineteenth century, and zinc white was not the only incidental benefit for the artist. In 1817 the German Friedrich Stromeyer observed that one of the by-products of the zinc factory at Salzgitter was a yellow-colored oxide. His subsequent analysis of this material brought to light a new metal, with chemical properties much like those of zinc. The zinc ore was traditionally called calamine or cadmia, and the association of the new element with zinc prompted the name cadmium.

In investigating the chemistry of cadmium, Stromeyer prepared its vivid yellow sulfide ("sulphuret," as he called it). There is no better illustration of how the chemists of the time had become attuned to the importance of pigment manufacture than Stromeyer's comment in 1819: "This sulphuret, from its beauty and the fixity of its colour, as well as from the property which it possesses of uniting well with other colours, and especially with blue, promises to be useful in painting. Some trials made with this view gave the most favourable results."[9] Stromeyer found that altering the conditions of the synthesis can generate an orange material instead; the hue depends on the size of the pigment grains. Cadmium yellow and cadmium orange are impressive pigments: rich, opaque, and immune to fading in sunlight.

But until the 1840s the supply from zinc smelting was not large enough for cadmium yellow to make an impact. There is evidence of its use in oil painting in France and Germany from about 1829, but in 1835 it still does not appear on the list of any English paint manufacturer. By 1851, however, cadmium yellow was being produced by Winsor and Newton. Yet even in 1870 the English color chemist George Field commented that "the metal

from which it is prepared being hitherto scarce, it has been as yet little employed as a pigment"; the high cost of cadmium transferred to the pigment, and by that time there were cheaper, equally brilliant alternatives.

Nevertheless, cadmium yellow had its supporters; prominent among them was Claude Monet, who made extensive use of it from as early as 1873. It is perhaps Monet's advocacy that encouraged Édouard Manet and Berthe Morisot to use the color in the late 1870s.

CHAMELEON METALS

DEADLY GREEN

Barium takes its name from the Greek *barys*, "heavy," for it is a dense, ponderous metal. It was identified as an element in 1774, and its discoverer was one of the most accomplished of eighteenth-century element seekers, the Swedish apothecarist Carl Wilhelm Scheele. In the same studies, Scheele isolated chlorine—although he interpreted it in the convoluted fashion of the time as "dephlogisticated marine acid." (He was an avowed phlogistonist until his death in 1786 at the age of forty-four.) Scheele isolated oxygen before Priestley, calling it "fire-air." And when in 1770 he collected hydrogen from the reaction of acids with iron or zinc, he believed that it might be pure phlogiston itself.

Scheele's experiments on chlorine compounds such as sea salt led him around 1770 to the discovery of a new yellow pigment, lead oxychloride. A chemical manufacturer named James Turner sought an English patent on the color in 1781, and his subsequent battles against rival manufacturers set an important precedent in English patent law. His struggles left their mark: the pigment came to be marketed as "Turner's patent yellow" or simply patent yellow, though it made rather little impression on the art of the day.

In the course of investigating the chemical properties of arsenic in 1775, Scheele prepared the green compound copper arsenite. He recognized at once its potential as an artist's pigment, and it was soon being manufactured as "Scheele's green." It is not a particularly distinguished color, however, having a slightly dirty tone. J.M.W. Turner used it around 1805 in an oil sketch, *Guildford from the Banks of the Wey*, and it turns up among the throng in Édouard Manet's *Music in the Tuileries Gardens* (1862), but evidence of its use elsewhere is scanty.

Yet this new green might eventually have found more favor with artists had it not been displaced by a superior, related compound. In 1814 the German paint manufacturer Wilhelm Sattler of Schweinfurt, collaborating with pharmacist Friedrich Russ, chanced upon copper aceto-arsenite, whose brilliant green crystals are made by the reaction of verdigris dissolved in vinegar with white arsenic and sodium carbonate.[10] Known in France not only as *vert de Schweinfurt* but also by attribution to other locations—*vert de Vienne, vert de Brunswick*—it became "emerald green" to the English.

There had never been a green like it. To the nineteenth-century artist searching for strong coloration, such as the Pre-Raphaelites and the Impressionists, it must have seemed the natural choice. It was not widely available until 1822, when the German chemist Justus von Liebig published a report of its composition and synthesis—previously a trade secret guarded jealously by Sattler. Winsor and Newton began selling it as an oil color in 1832, and its earliest use by Turner, ever eager to try new materials, dates from about the same time.

As it was relatively cheap to make, emerald green also became popular for interior decoration, and both this and Scheele's green were produced on an industrial scale during the mid-nineteenth century. But their arsenic content brought hazards, and not just to the manufacturers. Imprinted in thick relief on cheap, patterned wallpaper, the colors produce a toxic dust when brushed. And if exposed to damp, the pigments decompose to release arsine, a deadly gas of arsenic trihydride. In the 1860s the *Times* in London raised the alarm about the dangers of domestic uses of these arsenic-laced greens: "It was not very uncommon for children who slept in a bedroom thus papered even to die of arsenical poisoning, the true nature of the malady not being discovered until it was too late."[11] Legend has it that Napoleon Bonaparte died of poisoning from the arsenical fumes exuded by the emerald green paint on the damp walls of his house in exile on Saint Helena.

THE LEMON OF SIBERIA

France has rewarded its chemists with greater commemoration than most countries, but one wonders how many Parisians would now identify their *rue Vauquelin* with the superb analytical chemist who joined the triumvirate of Berthollet, Fourcroy, and Guyton de Morveau at the forefront of

French chemistry in the 1790s. Working alongside Fourcroy, Nicolas-Louis Vauquelin discovered the element beryllium in the mineral beryl, and in 1797 he turned his attention to crocoite, a bright red crystal discovered in the eighteenth century in Siberia.

The French called it *plomb rouge de Sibérie*—Siberian red lead—and it seems to have been first mentioned in the West by the German J. G. Lehrmann in 1762. The mineral becomes deep orange when crushed but found no use as an artist's pigment.

Vauquelin's investigations revealed a new metal in this mineral whose compounds tended to be strongly colored. For this reason, he proposed the name *chrome*, from the Greek for color; we now know this element as chromium. Crocoite is a natural form of the compound lead chromate, but when Vauquelin subsequently synthesized pure lead chromate, he found it to be a rich yellow. In collaboration with Berthollet, he suggested in 1804 that this substance might serve as a pigment. By 1809, when Vauquelin published his full investigation of the color chemistry of chromium in the now-prestigious *Annales de chimie* (on the editorial board of which he served), "chrome yellow" was already on the artist's palette. It appears, for example, in Thomas Lawrence's *Portrait of a Gentleman*, painted in 1810.[12]

The exact hue of lead chromate can be adjusted by coprecipitating it from solution with lead sulfate: half and half of each salt gives a primrose yellow, a mixture with 65 percent lead chromate gives a lemon yellow, and an increasing proportion of the chromate progressively deepens to color. Vauquelin found that the color could also be varied by altering the temperature of the synthesis, which affects the size of the grains. The chemist reports that adding an acid to the solution yields a deep lemon yellow, which he tells us is the most highly prized by painters. And if the pigment is precipitated from an alkaline solution, it takes on an orange hue: a yellowish red or sometimes a beautiful deep red. Predating cadmium orange, chrome orange was the first pure, strong orange pigment that artists had ever encountered (realgar tends toward yellow), and it was soon being deployed to dramatic effect.

But for all their dazzling attractions, chrome pigments had to be affordable if they were ever going to find widespread use. That was never likely while the only source of chromium was in remote Siberia. In 1818 a French dictionary of "natural history applied to the arts" comments that even Russian artists "pay quite dearly" for lead chromate. Yet in that same year, deposits of the mineral chromite (iron chromate) were discovered in

the Var region of France. Chromite was also found in the Shetland Islands off Scotland in 1820. Such was the avidity with which the new pigments were consumed that the Var mines were all but exhausted by 1829. But sources were also discovered in America from 1808, and by 1816 chromium ore was being imported across the Atlantic to England for pigment manufacture.

Pure chrome yellows and oranges remained rather expensive during the first half of the nineteenth century. But because the tinting strength of the pigment is so strong, it can be mixed with appreciable quantities of extenders such as barium sulfate. This encouraged the use of the yellow in commercial paints. It was used on the coaches of Europe before it appeared on the canary-yellow taxicabs of the United States.

Vauquelin's 1809 paper also mentions "an extremely pretty green" prepared by roasting an extract of crocoite. This is chromium oxide, which, because of its excellent stability, soon became valued as a ceramic glaze. "On account of the beautiful emerald color it communicates," Vauquelin enthused, the pigment "will furnish painters in enamel with the means of enriching their pictures and of improving their art." The truth is, however, that pure chromium oxide is a rather dull pigment, and it did not gain much popularity with painters.[13]

But in 1838 the Parisian colorman Pannetier developed a recipe for turning chromium oxide into a deep, cool, and slightly transparent green that became known as *vert émeraude* in France (not to be confused with the English emerald green, copper aceto-arsenite). In England this pigment was called viridian. The Impressionists adored it, and it is Cézanne's definitive green.

Viridian is simply hydrated chromic oxide: there are some water molecules in the crystal lattice. But that makes all the difference, turning the chromium ions to a much more attractive hue than in the pure oxide. Pannetier guarded his recipe closely and charged dearly for the pigment. In 1859, however, the French chemist C.-E. Guignet devised another method for making it, and viridian soon found a wide and receptive market. It eclipsed the poisonous emerald green for printing, domestic, and industrial uses almost at once.

There is potential for confusion of viridian with so-called chrome green, a mixture of Prussian blue and chrome yellow that was marketed commercially in the nineteenth century. The identity of this mixed color is further obscured by the peculiar practice of calling it cinnabar green or zin-

nober green. The mixtures range from strident green to olive, and because they were cheap, they commended themselves to mass use. As an artist's pigment, chrome green has significant drawbacks—it discolors under strong light or in acidic or alkaline conditions—but nevertheless it features in some nineteenth-century works.

Vauquelin's investigations of chromium's prismatic chemistry brought to light other new pigments, leading to a baffling profusion of chromate-based yellows. A pigment sold as "lemon yellow" could have one of many different compositions: not only lead chromate or some admixture with lead sulfate but alternatively chromates of the so-called alkaline earth metals barium and strontium (or more rarely, calcium). Barium chromate, described by Vauquelin in 1809, was also oddly called *outremer jaune* (yellow ultramarine). It is less opaque than lead chromate but more stable—the tendency of chrome yellow to turn brown was much lamented later in the century. Vauquelin also made zinc chromate, which was sold as the artist's color zinc yellow from the 1850s. Because of its rust-preventing properties, it was widely used on military equipment during the Second World War.

THE COBALT RAINBOW

But then there was the question of blue. For painters of the late eighteenth century, there was still no material that compared with the intransigently expensive ultramarine. So seriously did the Napoleonic administration take this deficiency that the Minister of the Interior, Jean-Antoine Chaptal, commissioned the distinguished chemist Louis-Jacques Thénard to devise a synthetic substitute for ultramarine.[14]

Thénard climbed high from humble beginnings. First taken on by Vauquelin as a bottle washer and scullery boy, he was later promoted to the role of laboratory assistant. With Vauquelin's patronage, Thénard became a demonstrator at the École Polytechnique in Paris, where his experiments on Scheele's chlorine secured his reputation as a skilled analytical chemist. Thénard and his colleague Joseph Gay-Lussac concluded (tentatively, since Lavoisier had claimed otherwise) that this substance, then known as oxymuriatic acid, might in fact be an element. And so it was, as Humphry Davy in London soon asserted more strongly. Davy named it "chlorine" for its pale leek-green color, the *chloros* that the Greeks had once upheld as a primary.

In contemplating Chaptal's challenge, Thénard was aware that the potters of Sèvres made use of cobalt-containing salts in their blue glazes. He wondered whether these materials might also furnish a fine blue for artists. Cobalt is, after all, the coloring agent in the medieval pigment smalt, a kind of blue glass. In the early eighteenth century the Swedish chemist Georg Brandt analyzed smalt and identified cobalt, already named for its ore, as the element responsible for the color.

In 1802 Thénard synthesized a blue solid by mixing cobalt salts with alumina. Thénard's blue (cobalt aluminate) had a purer tint than azurite, Prussian blue, or indigo and was taken up immediately as a pigment. The method of synthesis was later simplified so that natural cobalt ore could serve as the starting material. The pigment entered into the artist's repertoire as cobalt blue.

It was expensive but popular nonetheless—the only serious competition came from the synthetic version of ultramarine manufactured from the 1850s. Yet there was more to be had from cobalt, whose chameleonlike propensities rival those of chromium. Another cobalt blue, a mixture of cobalt and tin oxides (cobalt stannate), became available in the 1860s as a watercolor marketed by Rowney in England. By the 1870s it was sold as an oil color: cerulean blue in England, *bleu céleste* in France. Bearing a greenish tinge, it was somewhat comparable to azurite. Cerulean blue had acquired a reputation for impermanence by the 1890s, but the Neo-Impressionist Paul Signac was one of those sufficiently enamored of it that he was prepared to take the risk.

In the mid-nineteenth century, three more cobalt colors appeared on the market. Cobalt green had a composition similar to cobalt blue but with some or all of the alumina replaced with zinc oxide. It had in fact been discovered before cobalt blue, by a Swedish chemist named Sven Rinmann in 1780, but only when zinc oxide became readily available was the manufacture of cobalt green viable. In 1901 the chemist and amateur painter Arthur Church praised it as "chemically and artistically perfect," a bright color with excellent stability. But it did not have particularly good opacity, and like all cobalt pigments, it remained expensive. The same defects hindered cobalt violet, which was manufactured in France from 1859.

The most complex of the cobalt colors was a yellow that painters knew as aureolin and chemists as potassium cobaltonitrite. It was synthesized in 1831 by the German N. W. Fischer but was not sold as a pigment until its independent rediscovery in the early 1850s by the Frenchman E. Saint-Evre

in Paris. It was first marketed in 1861 but found general use only as a watercolor—Winsor and Newton launched a "primrose aureolin" watercolor in 1889. For oil painters, there were better, less expensive yellow pigments readily available.

COLOR ON TRIAL

How was the artist to cope with this sudden expansion of the palette? The new colors looked enticingly brilliant, and many painters fell under their spell at once. But the art academicians advised caution, pointing out that the durability of the new colors was largely unknown. Never before had there been a greater need for rigorous testing of materials. This was a job for the specialist—the chemist. In 1891 the French painter Jean-Georges Vibert recommended a carefully selected list of pigments that the artist could count on to "preserve their brilliance and freshness." Among them were zinc white, cadmium yellow, strontium chromate yellow, cobalt blue, chromium oxide green (not viridian but the nonhydrated, opaque version), cobalt green, cobalt violet, and manganese violet, discovered in 1868.

Such counsel drew on the studies of a new breed of color technologists: men who were chemically adept, familiar with the latest color theories of scientists such as Chevreul, Helmholtz, and Maxwell, and intimately connected to the world of fine art. They were a bridge between science and art and of an ilk that all but vanished when the century turned.

In France, Chaptal, ever concerned that artists should benefit from French eminence in chemistry, commissioned the chemist J-F-L. Mérimée at the École Polytechnique to seek out new colored materials. Having trained also as a painter, Mérimée had analyzed the techniques of the Flemish Old Masters. He felt that artists had better understand these traditional methods if they were to avoid the deterioration evident in some contemporary works: "The paintings of Hubert and Jan van Eyck . . . whose colors, after three centuries, amaze us by their brilliance, were not painted in the same way as those which we can see perceptibly altered after only a few years."[15] This was to be a recurring lament in the ensuing decades. But Mérimée's search for new pigments was not especially fruitful, although it did lead him to a new form of madder lake, *carmin de garance*, which became popular in France.

"A REMBRANDT BORN IN INDIA"

The blazing works of John Mallord William Turner (1775–1851) break through the brown crust of early-nineteenth-century convention. At times his use of *colore* seems intent on dispensing with *disegno* altogether, and even admirers such as John Ruskin sometimes professed bafflement at this new, luminous way of painting. "Pictures of nothing, and very like," was how harsher critics saw it.

Turner was a respected member of the Royal Academy from the end of the eighteenth century until his death in 1851, although his social awkwardness did not endear him to his contemporaries. Even in 1795 the young painter gave some inkling of his program with *Fisherman at Sea*, a work dominated by the coloristic effects of light seeping through auburn and violet storm clouds. The atmosphere dominates Turner's works, in which pale suns struggle to penetrate all manner of mists, fogs, clouds, and tempests. *Sun Rising Through Vapour* (1807) was said by one critic to be a potentially generic title for most of Turner's paintings.

These atmospheric confections needed rich, vibrant color, not the subdued earth colors preferred by Constable. And as Turner's suns and vapors came increasingly to crowd out and veil his landscapes, his oeuvre seemed "to tremble on the verge of some new discovery in colour," according to an encyclopedia in 1823. For some critics it was all too much. As Turner used color in ever less naturalistic ways in his attempts to capture the subjective quality of hazy sunlight, one newspaper entreated in 1826 that "we . . . wish Mr. Turner to turn back to Nature and worship her as the goddess of his idolatry, instead of his 'yellow bronze' which haunts him." When Turner exhibited his classical seascape *Ulysses Deriding Polyphemus* (1829) (Plate 30), a glowing melange of primary reds and yellows, mauves and fire-orange, the *Morning Herald* commented that "this is a picture in which truth, nature and feeling are sacrificed to melodramatic effect . . . In fact, it may be taken as a specimen of colouring run mad—positive vermilion—positive indigo; and all the most glaring tints of green, yellow and purple contend for mastery." Turner's hues were exotic, Oriental—as if "done by a Rembrandt born in India," commented Joris-Karl Huysmans, at that time a prominent art critic.

Such vivid color was unfamiliar and disconcerting. The Victorians preferred, in the words of art historian Eric Shane, "verisimilitude to painterliness, saccharine colouring to the brilliant hues [of] Turner"—Reynolds

and Gainsborough, in other words, who created no doubts about what you were supposed to be seeing. And yet truth of a kind was precisely what Turner and the Impressionists sought rather than shunned: not the "truth" of academic convention, which was a mere idealization and formalization of nature, but the truth of the impression that it leaves in the observer's mind. As for the "brilliant hues," there can be no doubt where these came from and why they shocked, for until the early nineteenth century, no one had seen such greens, yellows, and violets as now radiated from the works of the innovators.

Turner seized on the new pigments almost as fast as the chemists could dispense them. Cobalt blue, emerald green, viridian, orange vermilion, barium chromate, chrome yellow, orange, and scarlet, as well as new yellow and red lakes—he put each novel material to use within a few years of its introduction. To do so was certainly to risk disaster: a contemporary engraver, J. Burnet, remarked that Turner *dared* to use these new pigments when other artists did not. One unfortunate consequence is that by the end of the nineteenth century, the poor stability of some of the new pigments left several of Turner's works in sorry repair.

We can catch a glimpse of Turner's avid appropriation of the new synthetic pigments in a tale of his habitual behavior at the Royal Academy on "varnishing days," when members brought pictures to be hung for varnishing. They were allowed a few days for final retouching before the protective coat was applied. But in the 1830s Turner took to bringing canvases bearing dull, unremarkable compositions. Once they were displayed next to those of his rivals (for this is how Turner regarded them), he began most of the real work in situ:

> Turner went about from one to another of them on the varnishing days, piling on . . . all the brightest pigments he could lay his hands on, chromes, emerald green, vermilion, etc., until they literally blazed with light and colour . . . Artists used to dread having their pictures hung next to his, saying that it was as bad as being hung beside an open window.[16]

What an explicit confession by Turner's contemporaries that their more conservative painting styles did not, after all, come close to capturing the glow of real daylight!

It was not solely by means of new pigments that Turner achieved these dazzling effects. He also knew how to make good use of contrast to en-

hance brilliance, as Constable learned to his regret. On one occasion, an otherwise drab grayish seascape made a daub of red lead, added in situ, all the more bold, outshining the vermilion and red lake in Constable's adjacent picture. "He has been here and fired a gun," said Constable bitterly.

THE COLOR PROFESSIONAL

To acquire the new pigments so rapidly, Turner needed a reliable source. He purchased his colors from several London-based suppliers, including J. Sherborne, James Newman, and Winsor and Newton. But his primary source was the leading English colormaker of the nineteenth century, George Field, with whom Turner forged an acquaintance around the beginning of the century. There can be little doubt that without this collaboration with so adept a chemist, Turner would have been hard-pressed to achieve his brilliant effects with lesser materials. And no doubt we have Field to thank, by dint of his thorough testing of colors, for the fact that Turner's paintings are not now still more discolored than they are.[17]

The paradox of Field's career as a color manufacturer is that he had a rather poor grasp of color theory. He did not believe Newton's ideas; maintaining that "it is not possible to compose white by any mixture of colours whatever," he never appreciated the distinction between additive and subtractive mixing. He was primarily a technologist and by all accounts had little contact with leading scientists, despite his claims to have studied chemistry under Humphry Davy and Michael Faraday. Yet Field's treatise on color and pigments, *Chromatography* (1835), was highly influential among painters looking for guidance on materials. (Ruskin warned students, however, to ignore the book's remarks on "principles or harmonies of colour.") The most prominent artists of the day, including Constable and Thomas Lawrence, came to Field for their colors.

Field began his business by making madder lake in London, later expanding this enterprise into a colormaking factory near Bristol in 1808. He made attempts to cultivate the madder plant, which was much in demand for the dyeing industry. In 1755 the Society for the Encouragement of the Arts offered a premium for successful cultivation of madder in England to reduce dependence on Dutch imports—an unreliable source in times of war with other European nations. Field developed a press for extracting

the dye and improved the preparation of madder lakes, including brown, pink, and purple varieties as well as the rich red madder carmine.

An adherent of the primary trinity of red, yellow, and blue (which he linked to theological considerations), Field regarded it as important to identify and manufacture the pigments corresponding to these pure hues. These, he maintained, were lemon yellow (or at an earlier point, Indian yellow), red madder, and ultramarine. Yet for all that he was contributing to Turner's fireworks, Field's own tastes were far more conservative. He preferred low-keyed landscapes that used tertiary colors: "The chaste eye receives greater satisfaction from the harmony of the tertiaries in which the three primitives [primaries] are more intimately combined." To this end, Field strove also to develop pure pigments for the tertiary colors, cleaving to the old (and not unjustified) belief that "the artist should use his colours as pure and unmixt as possible."

The pigments that Field manufactured were held in high regard by many British artists. Most treasured was his "orange vermilion," a version of the traditional synthetic mercury sulfide that he developed after studying the colors made by the eighteenth-century German painter Anton Raphael Mengs. Field himself claimed that his color gave "purer and more delicate warm carnation tints than any known pigment, much resembling those of Titian and Rubens." It was popular from the 1830s onward and was sold by the color merchant Charles Roberson and later by Winsor and Newton. But Field did not reveal how it was made, and the Pre-Raphaelite William Holman Hunt said after Field's death that "I believe he carried his secret to the grave." All the same, said Hunt, "the tint is still always sold with his name as its best recommendation," though it did not always live up to that promise.

Field's tests of the permanence of new pigments were some of the most exacting of his time. His *Chromatography* contains countless hand-painted samples, whose state of repair today is sometimes a sharp reminder of the hazards the nineteenth-century artist faced. Iodine scarlet, for instance, was a superficially attractive pigment based on the eponymous element discovered by Bernard Courtois around 1811 and named by Humphry Davy in 1814. In that same year, Vauquelin studied the deep red compound of iodine and mercury, and it was introduced shortly thereafter as a pigment. Field's tests left him unenthusiastic about the "treacherous" new color: "Nothing certainly can approach it as a colour for scarlet geraniums, but its beauty is almost as fleeting as the flowers." He seems to have warned Turner

away from this alluring red—it appears in the artist's studio materials, but he almost never used it in oils.[18] It soon became obsolete—and from the patchy, bleached smear in Field's book, we can see why.

Field's relationship with Turner was prone to fluctuations, which is hardly surprising given their very different tastes in color. During the 1820s the two were close, even geographically: Turner in Twickenham, Field in Isleworth, west of London. But in the second edition of Field's *Chromatics; or the Analogy, Harmony and Philosophy of Colours* (1845), the colormaker took Turner to task for

> the beautiful error of applying the prism to his eye while painting, instead of representing objects as they naturally appear through the diffused solar spectrum of broad light and shade, by which error he converts the scene into a fool's paradise, seen through artifice, but not by the natural eye.

There is no need to ask now, of course, which we would prefer: "objects as they naturally appear" or Turner's "fool's paradise" (an old term for the prism). The painter himself was airily dismissive: "You have not told us too much," he said to Field.

THE ROMANCE OF COLOR

Turner's prismatic vision is nowhere more evident than in *Light and Color (Goethe's Theory): The Morning After the Deluge* (c. 1843), an almost abstract composition in which murky, barely visible figures occupy a color field ablaze with primaries. As the title indicates, this picture was painted after the artist had read Sir Charles Eastlake's English translation of Johann Wolfgang von Goethe's *Theory of Colors* (1810).

Perhaps it is for providing some relief from the sluggish current of brown gravy—some reawakening of the possibilities of prismatic color— that we should mostly be grateful to Goethe. The poet's scientific works seem guided as much by subjective dogma as by methodical investigation, and the intemperate attacks on Newton's "veritable fortress of learning" in Goethe's *Contribution to Optics* (1791) and the subsequent *Theory of Colors* are as reactionary as they are mistaken. He reasserts, for example, the Aristotelian idea that color results from a mixture of light and dark. Lacking knowledge of the distinction between additive and subtractive mixing,

Goethe raises the old objection that white light could not possibly be compounded of all the colors of the rainbow (as Newton asserted) because the corresponding pigment mixture gives almost the precise opposite. Yet he could not bring himself to check Newton's experiment by repeating it, advising all and sundry instead to "avoid the darkened chamber, where they show you twisted light."

To Goethe, light and dark could be equated with the only two "pure" colors, yellow and blue. Red, he said, is not "an individual color, but . . . a property which can attach itself to blue and yellow." Thus red arises in some manner by an "overlaying of [blue and yellow] particles." This, he supposed, was distinct from the result when the two colors were "mixed, but not united"—in that case, green was produced. In a manner frequently symptomatic of confused pseudoscientific thinking, Goethe seeks to make such dualities the basis for a whole set of polar opposites: blue is "cold" and "male," yellow is "warm" and "female," and so forth. One of the unhappy legacies of his philosophy is this tendency toward extremely polarized ontologies, later adopted without reservation by the Theosophist and Anthroposophist movements.

Yet out of Goethe's blend of practical experiment and fantastical thinking emerge some useful concepts. His theory of color focused muchneeded attention on the psychological, as opposed to purely physical, aspects of color. And his stress on polarities helped establish the idea of complementary colors that was to be so central to much of the theory and practice of color use by nineteenth-century artists.

Romanticism was the avant-garde of the early nineteenth century, and Goethe's philosophy spoke to its imaginative spirit. In Germany, Goethe corresponded with the Romantic artist Philipp Otto Runge (1777–1810) about color theory. In England, Romanticism found expression in the bright primary colors of paintings by the Pre-Raphaelite Brotherhood and by William Blake (1757–1827).

The impassioned fantasies of the Pre-Raphaelites John Everett Millais (1829–1896), William Holman Hunt (1827–1910), and Dante Gabriel Rossetti (1828–1882) demanded vibrant color, and their use of it incited almost as much uproar in the British art world of the 1850s as the Impressionists were to ignite in France two decades later. The refusal of the Pre-Raphaelites to mute nature's bright tones to conform with the strictures of good taste led the *Times* in 1851 to denounce their "singular devotion to the minute accidents . . . seeking out every excess of sharpness and deformity."

For their part, the Pre-Raphaelites derided the murky chiaroscuro of the Royal Academy and dubbed its head, Joshua Reynolds, "Sir Sloshua Slosh." Hunt inveighed against the way that the Old Masters in the National Gallery had been allowed, through the agencies of time and thick varnishes, to become "as brown as Grandmother's tea tray."

To obtain the best from their pigments, the Pre-Raphaelites copied the habits of Rubens and the Venetian Old Masters by glazing thin coats of barely mixed colors over opaque white grounds to ensure maximum luminosity. Their color merchant, Roberson, provided them with canvases primed with bright grounds of zinc white. Millais's *Ophelia* (1851–1852) is filled with new materials: cobalt blue, chromium oxide, zinc yellow, chrome yellow, and the richest madder lake. The bright greens here are mixed from Prussian blue and chrome yellow. The Pre-Raphaelites tried all manner of mixtures of the new yellows and blues to capture verdant nature: barium and strontium chromates with Prussian blue, synthetic ultramarine, or cobalt blue. The results, said detractors, were "unripe enough to cause indigestion."

Hunt had a deep interest in materials and technique and corresponded with Field about the permanence of pigments. He strove to use them unmixed as far as possible, just as the colormaker recommended. In *The Awakening Conscience* (1853), Hunt employs strong yellows—chrome and strontium yellow—as well as cobalt blue, emerald green, and notably, a relatively new pure orange, Mars orange. Vivid reds and purples stand out in his *Valentine Rescuing Sylvia from Proteus* (1850–1851) (Plate 31), where even the earth glows with the fiery hues of autumn, dappled with a shimmering light that prefigures the revolution in painting about to unfold on the other side of the English Channel.

THE REIGN OF LIGHT

IMPRESSIONISM'S BRIGHT IMPACT

"When you go out to paint, try to forget what objects you have before you, a tree, a house, a field or whatever. Merely think here is a little square of blue, here an oblong of pink, here a streak of yellow, and paint it just as it looks to you, the exact color and shape, until it gives your own naive impression of the scene before you."
—Claude Monet

"Soil three-quarters of a canvas with black and white, rub the rest with yellow, distribute haphazardly some red and blue spots, and you'll obtain an *impression* of spring in front of which the adepts will be carried away by ecstasy. The famous *Salon des Refusés*, which one cannot recall without laughing . . . was a Louvre compared to the exhibition on the boulevard des Capucines."
—E. Cardon, critic at the first Impressionist exhibition (1874)

Among the inventions of the nineteenth century—aspirin, plastics, the laws of thermodynamics—is the image of the artist as lone, misunderstood genius. By the 1800s, painting was no longer a trade but a profession, an academic subject bound by rules and agreed standards of practice and taste. It was respectable, earnest—and moribund. The scene was ripe for a new personification of the artist: rebel and outsider, the archetypes of modern humankind.

There was nothing new about neglected artists living and dying in poverty—that was Rembrandt's fate, after all. But in the nineteenth century we see the emergence of painters whose priorities were neither commercial nor academic. It is true that the Impressionists might indulge in a more popular style and technique for a picture that they hoped to sell (and some of those works we admire today may never have been intended for exhibition), but this group, and those that followed, had no time for the prescriptions of the art establishment or for the conservative instincts of the public or the critics. What rules they applied were to be of their own devising.

One can scarcely be surprised at this when one considers the stifling atmosphere of the fine arts academies at the beginning of the century, epitomized by the École des Beaux-Arts in Paris. Here students learned next to nothing about color; rarely, if ever, would they be allowed to apply raw paint to canvas. Rather, the emphasis was on drawing, on line and form, light and shade—a triumph of *disegno* over *colore* that was secured in the French Academy of the seventeenth century. Painting itself had to be practiced outside the École—the student would enroll with one of the many private studios (*ateliers*), which operated more in the manner of an art school than a workshop where one served an apprenticeship.

And even when the student was considered to have mastered drawing sufficiently to be allowed to hold a paintbrush, the first assignment was to copy the pictures of the Old Masters in the Louvre or those provided by the master of the studio. All of this would be done in a context that suppressed innovation and invention: the artist's hand was supposed to remain invisible in the finished work. The style differed little from that of the High Renaissance in many respects, not least in the choice of "appropriate" subjects such as scenes from classical mythology. It was a training for staid professionals, who could then make a living by selling their safe and unremarkable products to the wealthy middle classes.

The marketplace had its own rigidly imposed conventions. Just about the only way for a young artist in Paris to exhibit work to a wide public was through the exhibition organized every year by the French Academy, called the Salon. Selection for the Salon was conducted by jury, and most of the jurors were academics with traditional tastes. They expected the exhibits to display the smooth, glossy finish of prevailing fashion. Radical new styles stood little chance of being included. And the Salon itself was indeed a marketplace: walls packed from floor to ceiling with works, with no concern for setting and little more for visibility. Yet it was this or nothing.

Small wonder, then, that the Impressionists—Pissarro, Monet, Renoir, Manet, and Degas most prominent among them—caused outrage and sensation, when they were not simply the objects of ridicule. Their works were considered sketchy, unfinished, undisciplined, and they depicted highly indecorous subject matter: real people, for goodness' sake, going about their everyday business!

Impressionism was a movement motivated by the ineluctability of artistic integrity and by the artist's need to search rather than slavishly to follow. But the images it produced, steeped in brilliance of color, could never have been made without the right materials. It is not abstract intellectual thinking alone that provokes such a revolution in art, nor is it fueled merely by reaction against tired convention. Rather, it is when there is a confluence of such forces with new possibilities in the artist's materials that exciting things happen. And so it was: after a half-century of some of the most dramatic innovations in pigment manufacturing that visual art had ever seen, the stage was set for the plot to take a new direction. Art has never looked back.

PATHS TOWARD THE LIGHT

No revolution begins without warning shots, though often they pass unheard. The Impressionists were not the first French artists to challenge the conservatism of the French Academy: Eugène Delacroix (1798–1863) threw down the gauntlet in the 1830s with sweeping brush strokes and bold coloration that proved too heady for the Salon (Plate 32). But by 1855, when the young Camille Pissarro (1830–1903) came to Paris to see the grand World's Fair, Delacroix had become almost an establishment figure. Nevertheless, no one better personified this establishment than Delacroix's archrival, the rigid, bigoted, and haughty figure of Jean-Auguste-Dominique Ingres (1780–1867).

A simplistic dualism labels Ingres as the classical counterpart to the Romantic Delacroix: a conservative painter who championed line over color in the age-old debate, who represented reason in the face of Delacroix's passion. The truth is more complex. Yes, Ingres was firmly rooted in the past ("He is completely ignorant of all the poets of recent times," said Théodore Chassériau, a former pupil who defected to Delacroix), but he was a highly eclectic artist who could draw on Oriental themes and colors as readily as on seventeenth-century subjects and styles or the historical

and mythological topics of Greek and Roman art. In Ingres's hands, even hackneyed scenes could become works of genius when from lesser artists they elicited nothing but sterile emulation.

Perhaps Baudelaire's judgment is the most apt: Ingres, he said, was despotic, "a man full of stubbornness, endowed with highly special capacities, but determined to deny the utilities of those capacities which he does not possess." Obsessive about line, Ingres condemned works, such as those of Delacroix, in which objects were not precisely delineated. He insisted that a "noble contour" could atone for any other deficiencies—of color, for example. Ingres's own works exemplify the smooth textures, free from visible brush strokes, expected by the French academics.

And yet there is ample common ground with Delacroix, if only the two could have brought themselves to acknowledge it. Both were supreme colorists, even if Ingres considered this of minor importance. His *Odalisque with a Slave* (1839–1840) glories in rich reds, greens, and orange. And Delacroix, progressive though he was in many respects, shared Ingres's conviction that there was a hierarchy of subject matter for the painter: works based on grandiose classical themes from history, myth, and religion were inherently superior to landscapes, still lifes, and the depiction of everyday life (disparagingly called "genre painting"). In their "grand" works, both artists show not real people but idealized allegorical figures. How furious Ingres would have been to discover that his "classical" works command scant notice today, whereas his portraits, often painted for purely commercial reasons, are (rightly) regarded as some of the most stunning psychological studies of the age.

But it was color that divided Delacroix and Ingres more than anything else. One can't fail to notice what delight Delacroix found in it. He felt that his contemporaries were largely ignorant of how to use color: "The elements of color theory have neither been analyzed nor taught in our schools of art, because in France it is considered superfluous to study the laws of color, according to the saying 'Draftsmen may be made, but colorists are born.'"[1] He lambasted the academic school of Jacques-Louis David (1748–1825), under whom Ingres trained, for its dull tones and avoidance of rich pigments, in which he perceived an almost classical attitude to the formation of color. These painters imagined, he said,

> that they could produce the tones Rubens got with frank and vivid colors such
> as bright green, ultramarine, etc., by means of black and white to make blue,

black and yellow to make green, red ocher and black to make violet, and so on. They also used earths, such as umber, Cassel, and ochers, etc. . . . If the picture be placed near a richly colored work such as a Titian or a Rubens, it appears what it really is: earthy, dull, and lifeless.[2]

For his part, Delacroix constructed elaborate palettes of up to twenty-three pigments, encompassing nearly all of those available at the time.

He considered color not a localized property, intrinsic to the object, but "essentially an interplay of reflections." Because Ingres took no account of these reflections—of the effect of light falling from an object onto its surroundings and vice versa—Delacroix complained that Ingres's work was "crude, isolated, cold." The tale is told of how Delacroix, seeking to give emphasis to a yellow drapery, decided to go to the Louvre to see how Rubens would manage it. The cabs in Paris were at that time painted canary yellow, and Delacroix noticed that the cab standing in wait for him cast a violet shadow in the sunlight. This was the knowledge he sought; he paid the cabman and returned to work.

Here, then, is where Delacroix antecedes Impressionism: he wished to capture the play of light. But there was no mistaking the official position in 1855: it was Ingres and his imitators who took the medals at the World's Fair and who garnered the favor of the viewing public. Delacroix was repeatedly denied membership in the French Academy, of which Ingres was an influential member. Their enmity became legendary, the subject of newspaper caricatures.

Delacroix would later be lionized by the Impressionists. But another undeniable influence was Turner, who had toward the end of his life come to abandon many classical ideals and to search for artistic integrity in a reign of light. To see Turner's works progress, as they do in a single room of the Tate Gallery, from the Claudian neoclassicism of his early landscapes into the dreamlike swirl of bright primaries of his later paintings is to see the path of contemporary art prefigured in a single man's lifework. Pissarro and Monet saw some of these pictures in London in the 1870s, and they clearly left their mark. Turner's gouache sketch of Rouen Cathedral (c. 1832) is clearly a forerunner of Monet's several studies of the great building painted in 1892–1894. Monet was later reserved in his praise, however, admitting in 1918 that "over the years I have liked Turner a great deal," only to add, "but now I like him far less."

OUT OF DOORS

In the 1860s the German physicist and physiologist Hermann von Helmholtz suggested that it was futile for the artist to attempt to re-create the effects of light and color seen in the real world, for the available pigments were too limited—they necessitated an altered scale of brightness, a toning down of hues, which introduced a certain brownness. This meant that despite their pretense at naturalism, traditional artists were simply applying conventions for representing the play of light that bore only a schematic resemblance to the image that the artist saw. In consequence, said Helmholtz, "it is not the colours of the objects, but the impression which they have given, or would give, which is to be imitated, so as to produce as distinct and vivid a conception as possible of these objects."[3] And this—as good a description as any of what it was the Impressionists were attempting—is something that cannot be achieved in the studio by reconstructing a scene from sketches, imperfect memory, and idealized forms. Rather, it requires that the painter work in the midst of his subject, translating his visual impressions directly to canvas. He (with apologies to Berthe Morisot and Mary Cassatt) has to get out more.

Among the myths that have come to surround the Impressionists is that they were the first painters to work outdoors. Of course they were not; Turner, for one, had fitted out a boat so that he might paint *en plein air*, as it came to be known. And one can hardly imagine that William Holman Hunt could have deduced by pondering in a studio how to capture so brilliantly the prismatic shadows of the late-afternoon sun in his *Our English Coasts* (later *Strayed Sheep*) (1852) (Plate 33). The blues, reds, and yellows in the sheep's fleece and the striking violet of the grass combine to create a natural glow of quite unprecedented persuasiveness—enough to convince John Ruskin that whatever Helmholtz had asserted, Hunt had found a way to translate between sunlight and pigments:

> It showed us, for the first time in the history of art, the absolutely faithful balances of colour and shade by which actual sunshine might be transposed into a key in which the harmonies possible in material pigments should yet produce the same impression upon the mind which were caused by the light itself.[4]

It is striking how both Ruskin and Helmholtz invoke the word *impression*—a reminder that the style of the Impressionists was not uniquely dictated by their intentions.

But the image of the Impressionists out in the middle of nature with portable easel and parasol is an enduring one, encouraged by their own depictions of this activity (both Renoir and John Singer Sargent painted Monet at work outside) and by their endorsement of the myth. Monet claimed in 1880 that "I have never had a studio, and I don't understand how someone could shut himself up in a room"—although his own works bear testimony to later retouching in the studio.

For the conservatives of the French Academy, open-air painting was regarded as a practice suited only to making sketches from which an original would be reconstructed indoors. The immediacy and naturalism of the sketch would be scrupulously erased in the process. The traditional chiaroscuro technique of the academics demanded that the pale tones of a sunlit scene be darkened in their "historical landscapes" to create a highly stylized rendition of light and shadow. This convention was challenged in the mid-nineteenth century by so-called Realist painters such as Camille Corot (1796–1875) and Gustave Courbet (1819–1877). Rather than darkening the tones of his outdoor scenes, Corot added white to the colors to enhance the luminosity of the scene and capture a true record of the visual sensation. "Never lose the first impression which has moved you," he said, in what might as well have been a slogan for the young radicals like his pupil Pissarro.

For the Impressionists, it was absolutely essential to convey onto the canvas at first hand these impressions of exterior light and shade. This sometimes put them to extraordinary trouble. Monet would dart between several works at once, braving rain, wind, snow, and tides, trying to seize the precious moments when in each case the natural illumination returned to its desired state. Morisot lamented the young hordes that would gather around her as she pitched her easel outdoors.

Only this close observation of natural lighting could have revealed to the Impressionists the subtleties in the colors that shimmer across surfaces and lurk in shadows. Writing in Provence, Paul Cézanne said, "The sunlight here is so intense that it seems to me that objects are silhouetted not only in black and white but also in blue, red, brown, and violet." For these painters, nature was alive with a dance of glorious hues that could hardly be mimicked by mixing traditional materials. They needed a wider rainbow. The French poet Jules Laforgue commented in 1883 that "in a landscape flooded with light . . . the Impressionist sees light as bathing everything not with a dead whiteness, but rather with a thousand vibrant struggling colors

of rich prismatic decomposition . . . The Impressionist sees and renders na-
ture as it is—that is, wholly in the vibration of color."[5]

But how did these painters set out to capture the "vibration of color"?
No doubt intuition and empiricism played a prominent part, but the Im-
pressionists also drew heavily on scientific principles, at least insofar as they
could grasp them and translate them into painterly terms. Of greatest sig-
nificance was the concept of contrast in complementary colors, developed
in the early nineteenth century by the chemist Michel-Eugène Chevreul.

THE SCIENCE OF CONTRAST

Chromatic dualisms abound in Goethe's *Theory of Colors*, but it was Chevreul
the chemist, not Goethe the would-be physicist, who did more to instruct
artists in the rational use of complementary colors. In 1824 Chevreul was
made director of the Gobelins dyeworks in Paris and was asked to improve
the apparent dullness of the dyes used there.[6] But he found that there was
no cause for complaint in the dyestuffs; rather, it was the way the dyed
threads were being woven that destroyed their brilliance. Complementary
or near-complementary hues were being placed side by side, and the result
was that when viewed from a distance, the colors could not be distin-
guished but instead merged on the retina to produce a kind of grayness.
This is a form of additive mixing, akin to that generated by James Clerk
Maxwell with his spinning disks (see Chapter 2). Isaac Newton had ob-
served something of the sort in experiments on the mixing of dry pig-
ments. He reports that a mixture of yellow orpiment, bright purple, light
green, and blue blended to give an impression of brilliant whiteness at a
distance of several paces.

Chevreul's observations led him to experiment with the effect of plac-
ing complementaries next to one another, and he found that for a viewing
distance less than that required to generate optical mixing, the juxtaposi-
tion actually enhanced the strength of both colors: "In the case where the
eye sees at the same time two contiguous colors, they will appear as dis-
similar as possible, both in their optical composition and in the height of
their tone."[7] That the perception of a color is influenced by its surroundings
had long been known to painters in an empirical way, but Chevreul sys-
tematized this view with the (increasingly respected) stamp of scientific au-
thority. His findings were published in 1828 and were rapidly disseminated
among art theorists. And when Chevreul expanded and generalized his

work in *De la loi du contraste simultané des couleurs* (*On the Law of Simultaneous Contrast of Colors*) (1839), it became an essential manual for painters.[8]

Chevreul illustrated the relationships between colors with one of the most complex color wheels ever devised, subdivided into seventy-four segments and with degrees of tonal variation between white and black: the beginnings of a rigorous mapping of three-dimensional color space. These color scales were depicted in Chevreul's *Des couleurs et de leurs applications aux arts industrielles*, a technical manual aimed primarily at paint and dye manufacturers.

Delacroix professed a dislike of scientists ("always waiting for someone more able than themselves to open the door a finger's breadth for them"), but any artist interested in color could ill afford to ignore this fundamental aspect of color perception. He drew on Chevreul's insights by using adjacent complementaries in his designs for several interiors, and their influence can be detected (though not as clearly as some have suggested) in *Algerian Women in Their Apartment* (1834) (see Plate 32), which the young Renoir proclaimed "the most beautiful painting in the world." But Delacroix's reputation as a "scientific" colorist is questionable and owes more to the vigorous promotion of this notion by his friend, the art critic Charles Blanc, than to the evidence of his works. Moreover, contrasting complementaries feature also in *Odalisque with a Slave* by Ingres, who places the brilliant red of the drapery against the pale greens of the floor and furnishings—a composition that Delacroix predictably disparaged.

It was not until the 1860s that Chevreul's laws of contrasting complementaries became well known through translations of his book. Blanc's espousal of these ideas in *Grammaire des arts du dessin* (1867) was also to become a standard manual in France and exerted a formative influence on the Neo-Impressionist Paul Signac. But by the 1860s, many painters drew instead on the color-mixing studies of Hermann von Helmholtz, whose seminal paper on the subject in 1852 was quickly translated from German to French. Helmholtz promoted much the same contrasting pairs as Chevreul, and he argued that it was only through the use of color contrasts that the artist could hope to mimic the effects of natural light with pigments that fell short of nature's true radiance: "If, therefore, with the pigments at his command, the artist wishes to produce the impression that objects give, as strikingly as possible, he must paint the contrasts that they produce."[9]

What painters particularly valued in Helmholtz's writings was that

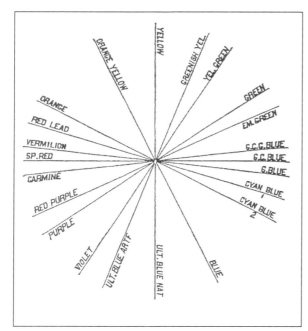

Figure 8.1: In his *Modern Chromatics* (1879), Ogden Rood showed color contrasts in terms of real artists' pigments, as determined by experiments with colored spinning disks.

from experiments with spinning disks, he translated Chevreulean complementaries into mixtures of the specific pigments available to artists. This approach was carried further in *Modern Chromatics* (1879) by Ogden Rood, an American physicist at Columbia University. An amateur watercolor painter with a knowledge of chemistry, Rood was concerned to root color theory in materials. His color-wheel-like diagrams of contrasts augmented the bare hues of blue, green, and so forth with pigments such as ultramarine, emerald green, vermilion, and gamboge (Figure 8.1). Rood's book became a standard text for the Impressionists, yet its author's artistic traditionalism meant that he loathed their works. On seeing them exhibited, he is said to have exclaimed, "If that is all I have done for art, I wish I had never written that book!"

Claude Monet (1840–1926) gives us some of his most Chevreulean color contrasts in works depicting water, where the play of sunlight is at its most luminous. In Monet's *Regatta at Argenteuil* (1872) (Plate 34), the blue water is embellished with strong orange, the red-roofed house sits among green foliage, and violet figures and shadows stand against the creamy yellow sails. Monet was explicit about his intentions—in 1888 he echoed Helmholtz when he said, "Color owes its brightness to force of contrast

rather than to its inherent qualities . . . Primary colors look brightest when they are brought into contrast with their complementaries." When in *Impression: Setting Sun (Fog)* (1872) Monet employs the same bold juxtaposition of orange and blue, the sun's disk seems almost to leap off the canvas.

LIGHT INTO MATTER

Once we appreciate the intentions of the Impressionists, it becomes obvious how indispensable the brilliant new synthetic pigments were to their goals. Jean-Georges Vibert, who worked at the École des Beaux-Arts in the 1890s, called them *éclatistes* ("dazzlers") who worked "only with intense colors," and no doubt he was right. Vibert was not opposed to the novel materials in themselves; as we saw in Chapter 7, he praised and recommended some for their "brilliance and freshness." But what upset the art establishment was the vigor with which the Impressionists put them to use: in unadulterated, energetic strokes, their opulence enhanced by the surrounding hues. "Never paint except with the three primary colors [red, blue, and yellow] and their derivatives," Pissarro advised his student Cézanne, having purportedly purged his own palette of black, burnt sienna, and the ocher pigments.[10]

Vibert was right, moreover, to be concerned about the stability of these unproven pigments. The Impressionists were not always heedful of the dangers and sometimes paid the price. In severing with the formal methods of the past, they were also abandoning the technical training that enabled painters to understand their materials. They accepted the bright new paints with great enthusiasm but with little discernment, generally relying on their suppliers or manufacturers for an assessment of quality. Deficiencies did not go unnoticed—Monet complained in the 1880s about the inadequacies of his materials—but the painters lacked the will or the ability to do much more than register dissatisfaction with their suppliers.

Who were these dealers in the raw substances of art? By the mid-nineteenth century, the provision of artists' materials had become a regular trade with its own well-defined distribution channels. In the seventeenth and eighteenth centuries, pigments, as commercial merchandise, tended to be categorized either with imported spices or with drugs (since some artists' materials also had pharmaceutical uses), and so they were sold by grocers who dealt also in foods and medications—recalling how in ancient

Greece pigments were called *pharmakon*. In the mid-eighteenth century, the grocers (*épiciers*, literally, "spice sellers") of France began to specialize, some becoming primarily dealers in art supplies: *marchands de couleurs*.

But as paint manufacturing became increasingly a matter of chemical synthesis rather than the grinding of solid pigment, it was transformed into an industry, and most retailers did little more than package the ready-made paints from manufacturers. Some of the cheaper colors—lead white, zinc white, chrome yellow, Prussian blue, and synthetic ultramarine—were manufactured and sold on a huge scale for interior decorating.

The boom in amateur painting in the eighteenth century, stimulated by the development of convenient watercolor cakes, created a lucrative market for colormakers who specialized in supplying the finest-quality materials for artists. Among them were the Reeves brothers, William and Thomas, who established their firm in London in 1766. An award in 1781 from the Royal Society of Arts conferred on the company the right to claim royal patronage, which it was not hesitant to mention in its advertisements. Yet business in London in the eighteenth century held alarming perils, as the *Morning Herald* recorded in October 1790:

> Yesterday an overdrove ox ran into the shop of Mr Reeves, Colourman to her Majesty, Holborn Bridge; broke the windows of the shop and knocked down near the whole of the colours and stock; he was at last secured and taken to the slaughter house. He tossed two women in Holborn and bruised them in so dreadful a manner that they were conveyed to an hospital without hope of recovery.[11]

By the early nineteenth century, London was replete with competing suppliers of artists' materials, including the firm of William Winsor and Henry Charles Newton, established in 1832. Winsor and Newton's colors were highly regarded by English painters, including Turner. It was incumbent on such businesses to possess some scientific training: Winsor was a chemist, Newton an artist.

Starting in the 1740s, pigments were crushed between mechanized stone rollers in horse-powered "paint mills." By the 1820s the mill wheels were driven by steam. But hand grinding benefited from the grinder's skill and judgment, and initially the mechanically ground products were rather poor. It was not until 1836 that the Parisian color merchant Blot first began to use them for the "fine colors" demanded by artists.

Another major innovation in paint supplies was the collapsible metal

tube, invented in 1841 by an American portrait painter named John Rand. The tin tubes replaced the parcels of pigs' bladder in which oil paints had previously been stored and made paints far less liable to dry out in their packaging. This was particularly significant for the Impressionists' predilection for painting out of doors; Renoir remarked that "without paints in tubes, there would have been no Cézanne, no Monet, no Sisley or Pissarro, nothing of what the journalists were later to call Impressionism." No Renoir either, one presumes.

This commercialization of artists' supplies contributed to the distancing of the painter from his or her materials—the beginnings of that impersonal, unloving attitude toward the primary substance of paint that was ultimately to impel artists of the twentieth century to take up household emulsions. J.-F.-L. Mérimeé complained in 1830 that painters were no longer able to distinguish good materials from bad.

And there certainly were bad materials around. To the paint merchant, the bottom line was profit, and sellers often cared little for the quality or long-term stability of their colors. These people, said Mérimée, "had a stronger feeling toward their own immediate profit than any regard to the preservation of pictures." They used binding media that gave the paints a long shelf life, but at the cost of creating poor drying properties on the canvas. Because the pigment was the most expensive component of the paint, the colormakers would be inclined to minimize the amounts used. But as all oils turn slightly yellow as they dry, paints with a high oil-to-pigment ratio discolor more markedly. And to keep the paint stiff while lowering the pigment content, some manufacturers added wax, which resulted in a sticky material that was liable to crack. Some retailers adultered their pigments with extenders—inert materials such as chalk or gypsum that merely made the colored stuff go further. There were even cases of deliberate falsification, of one pigment being passed off as another more expensive variety or surreptitiously mixed with it. The ambiguous relation of some paint names to the pigments they contained only heightened the temptation for duplicity.

As a protection against such practices, many artists strove to establish a good relationship with a particular color merchant, relying on him to provide quality control. Pissarro and Cézanne, and later Vincent van Gogh, used Julien Tanguy, who ran a small shop on the rue Clauzel in Montmartre from 1874. The Danish painter Johan Rohde described it as a "paltry little shop, poorer than the most miserable second-hand dealer's in Adelgade [in

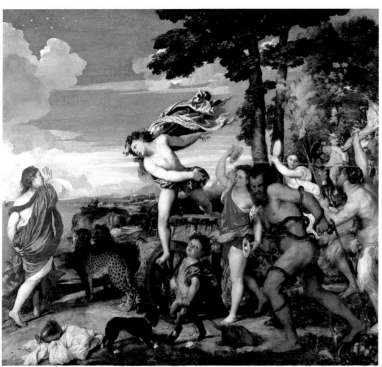

Plate 22: Titian's *Bacchus and Ariadne* (1523) is a chart of nearly every pigment known at the time.

Plate 23: Titian's *Portrait of a Man* (c. 1512) is alternatively known as "Man with a Blue Sleeve"—but this is a real, constantly shifting blue, not the monochrome drapery of the Middle Ages. The identity of the sitter is not known with certainty.

Plate 24: Van Dyck's *Equestrian Portrait of Charles I* (c. 1637–1638) typifies the muted tonality of the Baroque palette.

Plate 25: The bright green favored by Paolo Veronese is evident here in his *Adoration of the Kings* (1573).

Plate 26: Although Tintoretto's use of strong color is recognizably Venetian, the result is often passionate melodrama, as in *St. George and the Dragon* (c. 1560).

Plate 27: There is no mistaking the sexual association of red in Rubens's *Samson and Delilah* (c. 1609).

Plate 29: Rembrandt's *Portrait of Hendrickje Stoffels* (c. 1654–1656) contains such complex mixed colors that we struggle for words to characterize them.

Plate 28: Don't be misled by the Venetian influences in Van Dyck's *Charity* (c. 1627–1628); he seems, on close examination, to have been carefully toning down the strength of his pigments.

Plate 30: Turner's *Ulysses Deriding Polyphemus* (1829) was itself the object of some derision when it first appeared: "colouring run mad," said one critic.

Plate 31: The reds, oranges, purples, and greens of William Holman Hunt's *Valentine Rescuing Sylvia from Proteus* (1850–1851) belong emphatically to the new era of color chemistry.

Plate 32: Eugène Delacroix's *Algerian Women in Their Apartment* (1834) typifies his lively style—"unfinished," by the prevailing standards of the French Academy— as well as his love of the bold colors that were to be found in the East.

Plate 33: John Ruskin claimed that William Holman Hunt's *Our English Coasts* (*Strayed Sheep*) (1852) was the first painting to truly capture the play of sunlight across the landscape. Notice how rich in color are the "white" fleeces of the sheep.

Plate 34: Claude Monet's *Regatta at Argenteuil* (1872) is a study in pairing of complementary colors: blue against orange, red against green, yellow against violet.

Plate 35: The materials typically used in Impressionist paintings. From top left to bottom right: zinc white, lead white, "lemon yellow" (barium chromate), chrome yellow (lead chromate), cadmium yellow, Naples yellow (lead antimonate), yellow ocher, chrome orange (basic lead chromate), vermilion, red ocher, natural madder lake, crimson (cochineal) lake, Scheele's green (copper arsenite), emerald green (copper aceto–arsenite), viridian (hydrated chromic oxide), "chrome green" (Prussian blue and chrome yellow), cerulean blue (cobalt stannate), cobalt blue (cobalt aluminate), artificial ultramarine, and ivory black (bone black).

Plate 36: In Auguste Renoir's *Boating on the Seine* (1879–1880), cobalt blue and chrome orange play against each other in a dazzling display of complementaries.

Plate 37: Monet's *Lavacourt Under Snow* (c. 1879) is a winterscape in cobalt blue, endorsing the Impressionist tenet that "white does not exist in nature."

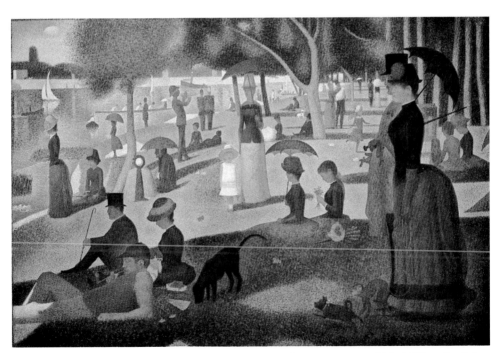

Plate 38: Georges Seurat's *Sunday Afternoon on the Island of La Grande Jatte* (1884–1885) is the definitive Neo-Impressionist work. The colors are mixed not by the blending of pigments but by the close juxtaposition of tiny dots in complementary hues, which was meant to set up a "vibration" in the eye of the viewer.

Plate 39: Paul Cézanne's *Hillside in Provence* (c. 1885) shows his love of viridian and his technique of painting in color patches, or *taches*.

Plate 40: *The Talisman* (1888) by Paul Serusier was an impulsive sketch that inspired the Nabi group to use brilliant color.

Plate 41: Of *The Night Café* (1888), Vincent van Gogh said, "The picture is one of the ugliest I have done." But intentionally so, for "I have tried to express the terrible passions of humanity by means of red and green."

Copenhagen] . . . There were stacks of pictures—no doubt payment for materials—and very valuable things among them," which drew many visitors to the shop. The wild van Gogh was befriended by Tanguy when the artist came to Paris in 1886, and he twice painted the merchant's portrait, despite complaining on several occasions about his wares. Tanguy ground his own colors, and one of the advantages for the artist of such a supplier was that he could provide materials to order: van Gogh, for instance, made specific requests for coarsely ground pigments.

Among the Impressionists, only Edgar Degas (1834–1917) showed much curiosity about what was actually in his colors. His notebooks contain many chemical recipes and technical notes, and he conducted his own experiments on materials, albeit idiosyncratically and barely informed by chemical theory. Concerned about the discoloration that had occurred in some of Manet's paintings, Degas sought for ways to protect his own works from the ravages of time. His abiding interest in the theoretical aspects of color, meanwhile, is attested by a tribute from Huysmans: "No other painter since Delacroix, whom he has studied at length and who is his true master, has understood as M. Degas does the marriage and adultery of colors."

THE IMPRESSIONIST TECHNIQUE

One of the Impressionists' numerous bludgeon-witted critics suggested that they might have achieved their results by loading a gun with bright colors and firing it at the canvas. After a catastrophic auction in 1874, another brayed that "we had good fun with the purple landscapes, red flowers, black rivers, yellow and green women, and blue children." What were these colors that provoked such ire, thinly disguised as wit?

There is, needless to say, no unique "Impressionist palette." But the works of the group's main figures draw on a fairly consistent color range that is biased heavily toward the new materials (Plate 35), and it is these that tend to contribute the most striking effects in Impressionism's radiant repertoire. Of the twenty principal pigments identified in Impressionist pictures, twelve were the new synthetics: lemon yellow (barium chromate), chrome yellow, cadmium yellow, chrome orange, Scheele's green, emerald green, viridian, chrome green, cerulean blue, cobalt blue, artificial ultramarine, and zinc white.

Like Monet, Pierre-Auguste Renoir (1841–1919) heightened the tones of his river scenes with adjacent complementaries. *Boating on the Seine* (1879–1880) (Plate 36) has a strident orange skiff set against the deep blue water, while the red shadows of the prow complement a patch of green foliage in the foreground and pale buildings cast yellow highlights amid the purples of their shadowy reflection. The pigments in this picture (in addition to lead white) are limited to just seven, with all but the reds being modern synthetics: cobalt blue, viridian, chrome yellow, lemon yellow (strontium chromate), chrome orange (basic lead chromate), vermilion, and red lake. They are applied almost unmixed, and the impact of the new pure orange is never more apparent, used in thick, pure strokes for the boat's outline. The river is portrayed in pure cobalt blue, with only white added in places and with a glaze of red lake to produce the purple shadows. This is Impressionism straight from the tube.

Monet, too, made much use of unmixed colors, exemplified by his *Lavacourt Under Snow* (c. 1879) (Plate 37). Here is a very different kind of atmospheric lighting: cold and wintry, veiled in the shadows of a low sun. Yet the hues are anything but subdued—the snow glistens with a harsh blueness, fashioned from pure cobalt blue in its brightest places. Ultramarine and red lake are added to lend the snow field grayish or mauve tints. Cobalt blue, red lake, and viridian can all be found in pure form among the cottages. There are dull tones here, and in the trees and the pale yellowish sky—olive, khaki, red-brown—but they are not ochers or earths; they are mixed from bright hues: cobalt blue, viridian, cadmium yellow, vermilion. With viridian, emerald green, synthetic ultramarine, red lake, and lead white, these make up the entire palette; even in this winter landscape Monet avoids black.

This painting demonstrates with great clarity the Impressionists' attitude toward white, the conventional "color" of snow. Renoir once told a student:

> White does not exist in nature. You admit that you have a sky above that snow. Your sky is blue. That blue must show up in the snow. In the morning there is green and yellow in the sky . . . in the evening, red and yellow would have to appear in the snow.[12]

One might say that the Impressionistic white is always utterly shattered into its spectral fragments. There is a sense in which all the Impressionists

painted in white, for their works are typically spectrally inclusive, leaving out no primary or secondary, as Pissarro's *Palette with a Landscape* implicitly confesses. Thus it has been said that a Monet painting, like the color wheels used by Maxwell to study additive mixing, would blur to a silvery gray if spun.[13]

The other side of the coin is black. Shadows—the complementary counterpart to light, if you will—play a central part in the Impressionistic style. But to these painters, shadows were not dark but infused with color. "Shadows are not black; no shadow is black," said Renoir. "It always has a color. Nature knows only colors . . . White and black are not colors." Van Gogh concurred: "Absolute black does not really exist."

How, then, was Monet to tackle the gloomy, sooty interior of *La Gare Saint-Lazare*, of which he painted no fewer than four versions in 1877? Here is *plein air* painting with a modern, industrial flavor: we look out of the station's canopy through billows of smoke and steam emitted by the idling locomotives. Yet the grays, browns, and indeed the blacks in the darkest work of the series are constructed without earth pigments and almost entirely from complex mixtures of the new bright artificial colors: cobalt blue, cerulean blue, synthetic ultramarine, emerald green, viridian, chrome yellow, again the older red of vermilion—and a strong crimson lake that is probably based on a modern synthetic dye. The white is lead white, and Monet does make some sparing use of ivory black. But on the whole the dark, blackish hues of the roof, trains, and passengers are a result of a fantastic mixture of all the pigments bar yellow and white. In places this dark is tinged with green, elsewhere with purple. It represents an extraordinary demonstration of the Impressionist conviction, taken almost to philosophical extremes, that even the murkiest of shadows are full of color.

The browns, too, which could have been managed with earth pigments, are here painstakingly constructed from intricate blends, such as vermilion mixed with cobalt and cerulean blue along with both greens, the red lake, and the chrome yellow. In contrast to *Lavacourt Under Snow*, unmixed pigments are almost absent.

The other views of the station interior in this series are somewhat brighter: one rich in greens, another in blues, mauves, and yellows. But they all contain complicated pigment mixtures, bearing witness to Monet's determination to construct his scenes from vibrant materials.

If there is no black in nature, do shadows have any particular color? To the Impressionists it was surely violet, the complementary to the yellow of

sunlight.[14] The abundance of purple in Impressionist paintings was the subject of much derision: the Impressionists were accused of "violettomania," and even the more thoughtful Huysmans regarded them for a time as afflicted with "indigomania," as if it were a genuine collective disease, a species of color blindness. Yet there was nothing outstandingly new in this identification of purple shadow. Goethe comments on one occasion that "during the day, owing to the yellowish hue of the snow, shadows tending to violet had already been observable." And in 1856 Delacroix, describing a boy climbing up a fountain in bright sunlight, spoke of the "dull orange in the lights" and the "very lively violet tones for the parts emerging from shadow."

Monet went even further, proclaiming, "I have finally discovered the true color of the atmosphere. It's violet. Fresh air is violet. Three years from now everyone will work in violet."[15]

Despite this predisposition for violets and mauves, the Impressionists tended to achieve them by mixing (generally cobalt blue or ultramarine glazed with red lake) rather than by taking advantage of the cobalt and manganese violet pigments that became available in the 1850s and 1860s. These new pigments had only a modest tinting strength but gave a stronger hue than could be attained by mixtures. Monet favored them more than most; Renoir, however, retained the lake–cobalt blue mixture for the pervasive mauves and purples in *At the Theater* (1876–1877) and *The Umbrellas* (1880–1881).

THE *REFUSÉS*

No innovator can expect an easy ride, but it is a wonder that the Impressionists found the strength of will to pursue their course in the face of the scorn, ridicule, and vitriol that was heaped on them at every step in the 1860s and 1870s. At first they were virtually invisible to the art-viewing public—their works would simply be rejected time and again from the all-important Salon. This was the kiss of death as far as sales were concerned; there are even stories of purchasers demanding a refund if the picture they had bought was subsequently rejected by the jury. The adjudication process remained firmly in the hands of the implacable establishment, even after various reforms in the selection procedure for jurors in the late 1860s.

Among the early group of painters who were to be labeled "Impression-

ists," Édouard Manet (1832–1883) was almost alone in winning the occasional (if grudging) favor of the Salon. Manet, perhaps the least radical of the group, had at least one influential supporter in the person of the aging Delacroix, who by 1857 was no longer regarded as a danger to art and was finally elected a member of the Academy. Manet did not, in fact, consider himself a revolutionary at all, and throughout his life his craving for public and academic acceptance created an uneasy relationship with his companions, particularly the uncompromising Edgar Degas. In many respects Manet felt he was following the trail blazed by Gustave Courbet, who achieved prominence and some notoriety in the 1850s as a Realist painter. Courbet's works, painted directly from nature, captured a spontaneity and sincerity that owed nothing to the calculated grace and poise of the French academic artists. When some of his most prized works were rejected by the jurors of the 1855 World's Fair, Courbet took the dramatic step of constructing his own exhibition near the official building—and incurred much wrath and mockery from critics as a result. Realism was considered dangerous, and at the opening of the 1857 Salon, the French Minister of State entreated artists to remain "faithful to the traditions of their illustrious masters" and to "the high and pure regions of the beautiful and traditional paths."

Claude Monet and Auguste Renoir also admired and imitated Courbet, who remained wary of the homage from these young men whose version of Realism went beyond the pale. Realism informs Manet's *Déjeuner sur l'herbe* (1863) and Monet's *Women in the Garden* (1866), both rejected by the jury. Surprisingly, Manet's nude study *Olympia* (1863) was accepted by the Salon of 1865, though it caused blusters of outrage for daring to portray a real person ("a puny model stretched out on a sheet") instead of the idealized figurines of classical tradition. It was this, as much as the novel use of color and bold execution, that drew antagonism. These young Realists had the vulgarity to show people as they were—often, in fact, one another or their partners. Manet professed to hate using professional models.

The Salon jury of 1863 was particularly severe, rejecting two-thirds of the paintings submitted. This excluded much more than the small band of Realist innovators and caused such an uproar that the Emperor Napoleon III was forced to intervene, decreeing that the refused works should be exhibited separately in another part of the Palais d'Industrie. But this "Salon des Refusés" was a disaster. Stigmatized by its origins, it became simply a spectacle for the public to jeer at, and the jury decided it was "inconsistent with the dignity of art" and not to be repeated.

Yet once established, the idea obviously became a stick with which many a disgruntled artist could beat the Salon, and in 1873 a second Salon des Refusés was held, providing a showcase for the soon-to-be Impressionist group but again meeting ridicule from the press and public. By 1874 the group had had enough, and Renoir, Monet, Degas, Pissarro, Sisley, Morisot, Cézanne, and others decided to hold their own exhibition. Manet, revealing his more conservative instincts, abstained from taking part because he felt that only through the Salon itself could one achieve proper recognition.

Monet took a very casual attitude toward naming his works, and when pressed to declare titles before the 1874 exhibition, he suggested that they simply be prefixed with "Impression"—hence *Impression, Setting Sun (Fog)* (1872), one of the archetypal Impressionist works. The term was taken up by a sarcastic critic of the exhibition, who dubbed the entire group "the Impressionists." They were not at all unhappy with the label and soon began to use it themselves.

The breakaway exhibition was, if anything, more disastrous than the Salon des Refusés, and the entire group was savaged for rejecting "good artistic manners, devotion to form, and respect for the masters." In 1876 the artists held a second group exhibition, to much the same response. Their bright and unfamiliar colors offended the sensibilities of the critics: "Try to make M. Pissarro understand that trees are not violet, that the sky is not the color of fresh butter," said one, while Renoir's "green and violet spots" in areas of flesh were deemed to "denote the state of complete putrefaction of a corpse." Needless to say, none but Manet (and occasionally Renoir) found commercial success, and Monet in particular was frequently in desperate straits, forced to write begging letters to benefactors to avoid being turned out on the street.

POINTS OF COLOR

As with so many revolutionary changes, slowly hostility gave way to indifference and then to a gradual incorporation into the mainstream. By the 1880s the tide of opinion was turning, aided in part by a few critics (such as Huysmans—but most other supporters were outside of France) who had some inkling of what the group was trying to achieve. In 1884 the group of "independent" artists that had arisen out of the original Impressionist circle

established the Groupe (later Societé) des Artistes Indépendants, a formalized foundation for their mutual support.

It was through this group that Paul Signac (1863–1935) became aware of the work of Georges Seurat (1859–1891), who exhibited *Bathers at Asnières* (1883–1884) at the first group exhibition. This intense and haunting work, painted "in great flat strokes, brushed one over the other," struck a chord with Signac, who recognized in it an "understanding of the laws of contrast, the methodical separation of elements—light, shade, and local color, and the interaction of colors—as well as their proper balance and proportion," giving the canvas "its perfect harmony."

Signac had deduced Seurat's program correctly. It was, said Seurat, "the purity of the spectral element" that was "the keystone of the technique . . . Ever since I have been holding a brush, I have been searching on this basis for a formula of optical painting." Seurat's quixotic (as it turned out) quest for pure luminosity in color led him to the most systematic of attempts to achieve a truly scientific approach to coloration in art, and it was this that made his work not really Impressionistic at all. Despite the superficial similarities, Seurat's style was something quite new, and it captivated Signac.

Seurat's training was supremely traditional in many respects. At the École des Beaux-Arts he initially idolized Ingres, though he was also attracted to Delacroix. Perhaps via his interest in the latter, he encountered the color theories of Chevreul and their exposition by Blanc, which inspired him to limit his palette to just the additive and subtractive primaries—red, yellow, blue, and green, which he mixed only with white. Much has been written on how Seurat tried to apply these theoretical ideas to the creation of color on canvas, and much of it is misleading. There has been a tendency to ascribe to him complete mastery of the optical physics of his day, whereas in fact it seems that his understanding was sketchy and imperfect. These limitations doomed his chances of a wholly successful realization of his intentions, but so did the shortcomings of his materials.

Seurat was aware that subtractive mixing—blending—of pigments inevitably degraded their brightness and consequently undermined efforts to portray the luminous glow of sunlight on surfaces. He therefore resolved to achieve his mixtures optically: he hoped that by placing small dots of complementary colors side by side, they would mix optically on the retina to achieve greater luminosity than a mix of pigments. Ogden Rood described this effect clearly in *Modern Chromatics*:

Different colors are placed side by side by lines or dots, and then viewed at such a distance that the blending is more or less accomplished by the eye of the beholder. Under these circumstances the tints mix on the retina, and produce new colors, which are identical with those that are obtained by the method of revolving disks.[16]

This was just what Newton observed in his experiments with colored powders and what Chevreul deduced from his studies of woven threads. John Ruskin described much the same phenomenon in his *Elements of Drawing* (1857), in which he spoke of the blending of colors by painting one with a dry brush over canvas and placing dabs of another "cunningly into the interstices" so as to produce "minute grains of interlaced colour."[17] But most attractive to Seurat was the fact that at the viewing distance just before that where two complementary colors blend, the eye hovers on the verge of seeing two colors become one, and the paint surface seems to flicker as if luminous. This, Seurat believed, was how the artist could truly paint with light, capturing, for instance, the glow of sunlight on grass. He called himself an *impressioniste-luministe*, and he referred to his method of painting in closely spaced dots as *peinture optique*. It later became known as pointillism.

But it is not clear that Seurat had read Rood when he painted *Bathers*,[18] and the work evolved as his understanding of optical mixing deepened. The picture was painted initially not with the pointillist technique but in a kind of precursory style where short brush strokes were interwoven in a crisscrossed manner. Seurat reworked it in 1887 in a more emphatic pointillist style, but only in some places, suggesting that he saw no particular need for uniformity in applying his ideas.

A number of factors are crucial to the attainment of "clean" optical mixing. First, the dots must be sufficiently small. Yet Seurat does not seem to have been too concerned about this question of scale in relation to the distance of the viewer. In his masterpiece *Sunday Afternoon on the Island of La Grande Jatte* (1884–1885) (Plate 38), the size of the dotted brush strokes varies considerably, sometimes to strengthen the edges of objects by making the dots smaller there.

Moreover, the effects achieved by optical mixing depend very much on the colors used to create them. As Thomas Young found when trying to recreate white from spinning disks of the three primaries, spectrally impure primaries will create gray rather than white. With this in mind, one might have anticipated that Seurat would have worried about the nature of his

pigments, rather than taking it for granted that the blues, yellows, reds, and greens with which nineteenth-century chemistry provided him were adequate for the task. Yet he appears to have been content to use a fairly typical Impressionist palette without qualms or further investigation: cadmium yellow, perhaps chrome orange, vermilion, cobalt violet, artificial ultramarine, cerulean or cobalt blue, viridian or emerald green, and chrome green.

Rood's quantitative, pigment-specific prescriptions for optical mixing should have been very useful to Seurat and his followers, except that Rood used several older pigments in his experiments: gamboge, Indian yellow, red lead, carmine lake, Prussian blue. But it is not clear that Seurat or Signac accorded much importance to the critical spectral differences between these "primary" pigments and those on their own palettes. Might it have been otherwise if the artists had been less removed from their materials?

Yet this is not the only gap in understanding that let Seurat down. The critic Félix Fénéon, who provided a detailed (if somewhat misconceived) analysis of Seurat's work in 1886,[19] listed the following distinctions that the artist made among the contributions to perceived color:

1. Local color—the color of the object under white light
2. Directly reflected light—the portion of the illumination that is reflected unaltered from the surface
3. Indirectly reflected light—"the feeble portion of colored light that penetrates below the surface and is reflected after modification by partial absorption"
4. Color reflections projected by neighboring objects
5. Ambient complementary colors

This is a more thorough systematization of Signac's list. But it contains some curious ideas. Seurat was still in thrall to the notion of "local color," which Monet and Renoir had rejected. Local color was a very traditional concept to artists and may have been given weight in Seurat's mind by Rood's comment that what artists call local color is the color of an object in white light. But this color has meaning *only* under white-light illumination and is not some inherent property of the object that manifests itself come what may. In other words, Rood is saying that the color that we perceive is primarily that of the directly reflected light, which becomes "local color" only if the illumination is pure white light. So Seurat's first and sec-

ond items are really the same thing, under different lighting conditions.

Seurat seems to have equated "directly reflected light" with pure sunlight, which necessitated that he attribute some color to sunlight itself. He concluded that it is basically orange ("solar orange"), which was suggested by both Blanc and Delacroix, and this led him to include dots of orange in his green grass.

Fénéon's commentary provides a clearer summary of what Seurat hoped to achieve than anything the artist himself wrote:

> One has . . . not a mixture of colored pigments but a mixture of colored light . . . It is known that the luminosity of optical mixture is always much greater than that of pigmentary mixture, as the numerous equations for luminosity established by Rood show.[20]

But the consequence of Seurat's incomplete understanding was that his dots of paired complementaries tend to create an impression not of luminosity but of grayness, recalling, ironically, Chevreul's problem with the Gobelins tapestries. As a result, his pointillist works seem covered over with a pearly sheen—not the intended effect, but surely nevertheless a reason for the dreamy sensation that the paintings evoke. For Signac, however, this grayness was a failure of strict pointillism:

> Pointillage . . . simply makes the surface of the paintings more lively, but it does not guarantee luminosity, intensity of color, or harmony. The complementary colors, which are allies and enhance each other when juxtaposed, are enemies and destroy each other if mixed, even optically. A red and a green if juxtaposed enliven each other, but red dots and green dots make an aggregate which is gray and colorless.[21]

Seurat's death in 1891 at age thirty-one curtailed his search for a "scientific" approach to color. Nonetheless, when Pissarro first saw the effects of the technique in 1885, he was greatly excited by what he perceived in its possibilities, and for a time he was a convert. He confessed that he sought

> a modern synthesis of methods based on science, that is, based on the theory of colors developed by Chevreul, on the experiments of Maxwell and the measurements of O. N. Rood; to substitute optical mixture for the mixture of pigments, which means to decompose tones into their constituent elements, because optical mixture stirs up luminosities more intense than those created by mixed pigments.[22]

In this regard Pissarro revealed himself as the most supremely open-minded and inquisitive of the "old" Impressionists—unlike his former peers, many of whom (such as Monet) despised the pointillist innovation. Pissarro regarded the older group as "romantic Impressionists," as distinct from the "scientific Impressionists" Signac, Seurat, and himself. In 1886 Fénéon coined a new label for them: Neo-Impressionists. Yet when they contributed to the last Impressionist group exhibition in 1886, they were confined to a separate room, dominated by *La Grande Jatte*. Pissarro's former pupil, the acerbic Paul Gauguin, was especially vociferous in his disdain for the new Impressionists, calling them "little green chemists who pile up tiny dots." And by 1888 Pissarro had lost patience with the laborious process through which pointillist works had to be constructed, so inimical to his fresh and immediate approach. In a letter to his younger associates that is a model of delicacy, he explained that he was abandoning their bold but ultimately narrow methods.

TOWARD ABSTRACTION

Possibly no one among the early Impressionist group was subjected to more scorn than Paul Cézanne (1839–1906), and it is probably no coincidence that he was both the most radical and ultimately the most influential of the group. Cézanne founded no school; instead, one might say that he founded the entire twentieth-century concept of color as the constructive principle of art. Gradually his approach—breaking up a flat field of color into a mosaic of prismatic facets—took him further from the Impressionists, further from the subjective and fleeting in art, and closer to capturing the unchanging aspects of a scene. He began to use blocks of color in an architectural sense to build the fundamental structure of what he saw, the "motif"—an objective reality, without the intervention of mind or emotions. He exhibited with the Impressionists for the last time in 1877, and by 1904 he was voicing an opinion that placed him at an opposite pole: "Light does not exist for the painter."

Cézanne's palette displays a wide variety: from strong, bright tones to subdued, earthy colors. He was influenced by the writings of Chevreul and Blanc on complementaries but embodies them more in the form of color relationships than simple juxtapositions. For Cézanne, modulation was the watchword: his use of high-toned pigments was modulated by more subtle

hues, welding the patches of color into a coherent whole that achieves a pearly warmth rather than the bold, shimmering contrasts of the Impressionists. His use of the new synthetic pigments was restricted and cautious, partly because he was careful to avoid fugitive colors but also because, somewhat surprisingly, he retained a traditional streak to his technique. Of the newest pigments, only viridian features prominently in Cézanne's work, and the only pigment of poor stability that he used seems to have been chrome yellow.

This mix of old and new materials is found in Cézanne's *Hillside in Provence* (c. 1885) (Plate 39), a typical example of the artist's work in the 1880s. There are splashes of brightness, but the overwhelming impression is of strong greens among subdued earths. For the former, both emerald green and viridian are used, while the orange and brown rocks are composed of yellow and ocher earths mixed with vermilion. The foreground is lent a yellowish green tinge by a glaze of yellow lake. There is black pigment in the shadows, in itself a sign of the rift with the Impressionists. The occasional Chevreulean contrasts are depicted in muted tones. One can deduce from this composition that Cézanne did not regard the new pigments with quite the same sense of opportunity as his fellow Impressionists. Although he was one of the foremost colorists of the modern age, his agenda was less a product of technology.

Paul Gauguin (1848–1903) also became increasingly isolated from the Impressionist group in the 1880s, both geographically and stylistically. He grew tired with the Impressionists' tendency to represent nature so literally, to retain "the shackles of representation" (already an indication of how far attitudes had changed since the 1860s). In a comment that anticipates the entire era of modernism, he implored, "Don't copy too much from nature; art is an abstraction." His own style, which he called Synthetism, veered toward a purely imaginative or symbolic use of color. "Since color is itself enigmatic in the sensations which it gives us," he wrote, ". . . we cannot logically employ it except enigmatically." Yet to a deeply imaginative artist such as Wassily Kandinsky, this impulse toward abstraction was suggested even by the "old" Impressionists. When the young Kandinsky saw Monet's *Haystacks* series exhibited in Moscow in 1895, he saw the future of pure color as the basis for an abstract art: it showed him "the object . . . discredited as an indispensable element of the picture."

In 1891 Gauguin left France for Tahiti, drawn by a taste for exoticism that was quite alien to the urbane Impressionists. There he hoped to live

"on ecstasy, calmness, and art," and aside from brief visits to France, he remained in the tropics until his death in the Marquesas Islands in 1903. His palette stayed rich but matured in subtlety of tonality. Not for him the stark contrasts of complementaries, nor did he eschew earth pigments: he found burnt ocher indispensable for depicting the olive-skinned Tahitians.

He used most of the modern colors—cobalt blue, emerald green, viridian, cadmium yellow, chrome yellow, cobalt violet, and a mixture of cobalt blue and barium sulfate called Charron blue—but seldom applied them straight from the tube. Prussian blue and ultramarine were the only colors Gauguin commonly used unmixed, as a substitute for black, which he largely avoided. But in remote Tahiti he suffered the frustrations of poor access to materials. In a letter of 1902 to the picture dealer Ambrose Vollard, who supplied him with materials, he voices his predicament:

> I have opened your box. Canvas and glue—perfect. Japanese paper—perfect. But the colors!!! . . . What do you expect me to do with 6 tubes of white and terre verte, which I seldom use? I have only one small tube of carmine lake left. So you must send me immediately: 20 tubes of white, 4 large tubes of carmine lake, . . .[23]

The list proceeds through the modern palette. In place of canvas, Gauguin often used unprimed hessian and sackcloth—not just for economy but also because he seems to have enjoyed their rough texture.

Gauguin's Synthetism, which he described as "artistic unity, harmonious composition, internal unity of conception, the understanding and the coherence of forms and colors," informed the group of French painters who called themselves the Nabis: Maurice Denis, Édouard Vuillard, Paul Sérusier, Ker Xavier Roussel, Pierre Bonnard, and others. Impelled by an expressive use of color, the Nabis crystallized around a single small work painted by Sérusier on the lid of a cigar box, dubbed *The Talisman* (Plate 40). Sérusier created this chromatic landscape under the guidance of Gauguin at Bois-d'Amour, near Pont-Aven in France. The advice of the older man reputedly ran along these lines:

> Gauguin: "How do you see the colour of that tree?"
> Sérusier: "Yellow."
> "Well, use your very best yellow. How do you see the colour of the earth?"
> "Red."
> "Then use your very best red."[24]

The Nabi group, a kind of spiritual cousin to the Fauves (to be discussed shortly), was short-lived—exhausted by 1900. But Gauguin's influence reached far wider and lasted far longer.

Vincent van Gogh (1853–1890) was another of the iconoclasts who emerged from the Impressionist movement to pave the way to a new kind of painting as the *fin de siècle* approached. Born in Holland, van Gogh went to Paris in 1886 to live with his brother Theo, who had described to him the new style created by the Impressionists. Van Gogh became interested in effects of simultaneous contrast and of complementaries by studying the works of Delacroix, but his palette was initially rather subdued. On seeing the bold, raw colors employed by the Impressionists, his art was transformed. Yet he would later claim that his work was "fertilized by the ideas of Delacroix rather than by [the Impressionists]," and he took the same path as Gauguin in making very free, associative use of color: "Instead of trying to reproduce exactly what I have before my eyes, I use color more arbitrarily so as to express myself forcibly."

And there can be scarcely any more forcible expression of color in all of Western art than in paintings like *The Night Café* (1888) (Plate 41), a pure nightmare of red and green complementaries bathed in an acidic yellow light. "I have tried to express the terrible passions of humanity by means of red and green," he told Theo. "Everywhere there is a clash and contrast of the most disparate reds and greens." Could any but the nineteenth-century greens, yellows, and oranges stand up to these "blood-red" walls? Indeed, this picture tells us just how much red is under challenge, for it alone had not been substantially renewed by the end of the nineteenth century.

Like Cézanne, van Gogh fostered no followers. But his anguished scream of color and his whirling energy gave a vocabulary to the Norwegian Edvard Munch (1863–1944) and to German Expressionism. If Henri Matisse made color the substance of pleasure and well-being and Gauguin revealed it as a mysterious, metaphysical medium, van Gogh showed color as terror and despair. Munch's remark regarding *The Scream* (1893) that he "painted the clouds like real blood. The colors were screaming" echoes van Gogh's sanguine comment on *The Night Café*—it was, he explained, "a place where one can ruin oneself, go mad, or commit a crime."

Van Gogh's café is created from paint piled on thickly, which is all too easy to read as the product of wild, frantic, unfettered strokes of the brush and palette knife. But van Gogh reveals another motivation in one of his letters to his brother: "All the colors that the Impressionists have brought

into fashion are unstable, so there is all the more reason not to be afraid to lay them on too crudely—time will tone them down only too much." Indeed his orders for materials reveal a penchant for some of the most fugitive colors on the market, and clearly van Gogh was neither ignorant of this nor too crazed to care. Rather, one has almost the impression that his primary concern was not for longevity but simply to get these garish visions out of his head.

It was a head that, by all appearances, burned with sickly yellow, the "citron yellow" of his café's lamps, the sulfur yellow he perceived in Arles. In *The Sower* (1888), it is the yellow of the sun, the baleful glow of an orb that offers no warmth or comfort but looms like a sickly, incandescent moon.

Yet colors of all sorts struck van Gogh with unusual intensity. "*Color expresses something by itself,*" he insisted. "One cannot do without this; one must use it; that which is beautiful, really beautiful, is also correct." His every vision was seen in the pure hues a painter might use:

> The deep blue sky was flecked with clouds of a blue deeper than the fundamental blue of intense cobalt, and others of a clearer blue, like the blue whiteness of the Milky Way . . . The sea was very deep ultramarine—the shore a sort of violet and faint russet as I saw it, and on the dunes . . . some bushes of Prussian blue.[25]

All this makes it tempting to suppose that van Gogh worked from instinct alone. Yet his treatment of color, for all its apparent pathology, was methodical. His letters to his brother Theo and the instructions they contain for purchasing paints show that the painter worked hard to get the color combinations right. He had a strong interest in color theory and was aware of Chevreul's laws of simultaneous contrast. To van Gogh, black and white were colors too, and complementary in just the same way as red and green or blue and orange. This was an idea promoted by the psychologist Ewald Hering in the 1870s.

And van Gogh makes clear how essential the new materials were in allowing him to transfer his inspiration onto canvas:

> I have got new ideas and I have new means of expressing what I want, because better brushes will help me, and I am crazy about those two colours, carmine[26] and cobalt.
>
> Cobalt is a divine colour, and there is nothing so beautiful for putting at-

mosphere around things. Carmine is the red of wine, and it is warm and lively like wine.

The same with emerald-green. It is bad economy not to use these colours, the same with cadmium.[27]

Yet the "terrible passions of humanity" were certainly at play in Vincent van Gogh's inner world. When the kindly Pissarro first met him in Paris, he decided that the Dutchman "would either go mad or leave the Impressionists far behind." In the end van Gogh did both: he never truly recovered from his breakdown in 1888 (during which he attacked Paul Gauguin), and despite Pissarro's efforts to find a good doctor for the unbalanced young man, he committed suicide at Auvers-sur-Oise, France, in 1890. "He rests," wrote Theo to his wife, "in a sunny spot amid the cornfields."

A PASSION FOR PURPLE

DYES AND THE INDUSTRIALIZATION

OF COLOR

"Who has not heard how Tyrian shells
 Enclosed the blue, that dye of dyes,
Whereof one drop worked miracles,
 And coloured like Astarte's eyes
Raw silk the merchant sells?"
 —Robert Browning (1855), "Popularity"

"Alchemists of old spent their days and nights searching for gold, and never found the magic Proteus, though they chased him through all gases and all metals. If they had, indeed, we doubt much if the discovery had been as useful as this of Perkins's [*sic*] purple. . . A discovery that benefits trade is better for a man than finding a gold mine."
 —*All the Year Round* (September 1859)

Purple is the magisterium," says essayist Alexander Theroux, and who can doubt it, when the most precious of ancient dyestuffs, the purple of Tyre, was worth more than gold itself? In the third century A.D., a pound of purple-dyed wool cost around three times the yearly wage of a baker.

The tremendous worth of the ancient purple and its association with royalty and high office have become the stuff of legend. It is no coincidence that when the first synthetic mauve dye appeared on the market in the mid-nineteenth century, it was sold under the canny (and wholly inaccurate) name of Tyrian purple.

Yet it is hard now to know to what hue these legends attach themselves. "Purple" is a fluid chromatic concept in antiquity, and the ancient dye ranged in color from bluish to a deep red, depending on how it was prepared and fixed in the cloth.

The Greek word generally associated with purple is *porphyra*, which is rendered in Latin as *purpure*. But throughout the ancient and medieval world, *purpure* could equally mean a shade of dark red or crimson, and indeed purple is steeped in associations with blood. "The Tyrian color," says Pliny, "is most appreciated when it is the color of clotted blood, dark by reflected and brilliant by transmitted light." In the third century A.D., the Roman jurist Ulpian defined as *purpura* all red materials other than those colored by *coccus* or carmine dyes.

The story of dyestuffs is shot through with this sanguine color, whether crimson, scarlet, or the blue-biased luster of a true purple. There is nothing of the violet about these dyes, nothing pale or grayish or retiring. No, the most prized dyes have been bold, strident colors; one might reasonably call them martial colors in the days when dazzling visibility was more desired than camouflaged obscurity. Nature provides these deep reds more abundantly than any other color of comparable brilliance and saturation, and the best of them have long commanded princely sums.

It is remarkable that the era of modern dyes began—by chance rather than design—with a purple to rival the most celebrated of ancient dyes. The influence of the nineteenth century's multiparous chemistry on dye colors is even more dramatic and more emphatic than its impact on pigment manufacture, and its consequences reach further afield. Synthetic dyes were soon thereafter to appear on artists' canvases, but it was their encroachment into the fashions of the city streets that spawned an immense global industry. In this chapter we shall see color's impact on chemistry as clearly as we shall see the converse.

DYED IN THE WOOL

Pliny has no doubts about the virtues of the true purple attributed to the Phoenician city of Tyre,

> that precious color which gleams with the hue of a dark rose . . . This is the purple for which the Roman *fasces* and axes clear a way. It is the badge of no-

ble youth; it distinguishes the senator from the knight; it is called in to appease the gods. It brightens every garment, and shares with gold the glory of the triumph. For these reasons we must pardon the mad desire for purple.[1]

The Phoenicians ventured forth from Crete around 1600 B.C. According to one story, the exodus was instigated by their love of dyeing, for which purpose they made ammonia from stale urine; this unsavory business left the Phoenician dyers shunned by polite society. In Athens, dye shops were relegated to the city's outer limits for this reason, even though their purples were revered.

The manufacture of Tyrian purple was known in Asia Minor since the fifteenth century B.C. The Greeks learned the art from the Phoenicians; garments dyed with Tyrian purple are mentioned in Homer's *Iliad* and Virgil's *Aeneid*. The dye is extracted from two species of shellfish, known in Latin as the *buccinum* (*Thais haemastroma*) and the *purpura* (*Murex brandaris*), native to the Mediterranean Sea. According to George Field, Greek legend has it that Tyrian purple was discovered by Hercules, who, seeing the purple-stained mouth of his dog, attributed it to the shellfish the dog had just eaten. Others say the dog's master was the Phoenician god Melkarth.

The colorants are produced in a gland called the "flower" or "bloom," near the head of the mollusk, which contains a clear fluid. This liquid was extracted either by breaking open the shells or by squeezing them in a press. On exposure to sunlight and air, the fluid becomes transformed from a whitish color to pale yellow, green, blue, and finally purple. It is hard to imagine that the alchemical significance of this sequence would not have excited great interest.

Aristotle describes the extraction process in his *Historia animalium*:

> The "bloom" of the animal is situated between the quasi-liver and the neck, and the co-attachment of these is an intimate one. In color it looks like a white membrane, and this is what people extract; and if it be removed and squeezed it stains your hands with the color of the bloom . . . Small specimens they break in pieces, shells and all, for it is no easy matter to extract the organ; but in dealing with the larger ones they first strip off the shell and then abstract the bloom.[2]

Each shellfish yielded just a drop of the dye, which was why the stuff was so fiendishly precious and why a significant proportion of the Phoenician population was employed in its manufacture. One ounce of the dye

required the sacrifice of around 250,000 shellfish. The shell piles of the Phoenicians still litter the eastern shore of the Mediterranean.

The shade most prized from these extracts was produced by mixing the fluids from the two species. The tincture of *Murex* alone is brightly colored, whereas the hue that the Romans desired was tinged with blackness. Pliny describes the process in his *Natural History*:

> The buccine [*buccinum*] dye is considered unsuitable for use by itself, for it does not give a fast color, but it is perfectly fixed by the pelagian [*purpura*] and it lends to the black hue of the latter that severity and crimson-like sheen which is in fashion. The Tyrian color is obtained by first steeping the wool in a raw and unheated vat of pelagian extract and then transferring it to one of buccine.[3]

This glorious color was reserved in Republican Rome strictly for individuals of high rank. A purple-and-gold robe could be worn only by triumphant generals; generals in the field were allowed a robe of plain purple. Senators, consuls, and praetors were permitted broad bands of purple at the edges of their togas, and knights and others of comparable rank wore narrower bands. But in Imperial Rome the strictures were more severe: by the fourth century A.D., only the emperor himself might don "the true purple," and there were heavy penalties for any who owned cloth colored with this "royal" dye or even with cheaper imitations. (The Stockholm papyrus contains three recipes for imitation purple dyes.) Under Valentinian II, Theodosius I, and Arcadius, the manufacture of Tyrian purple outside the Imperial dyeworks was punishable by death.

These royal associations valorized the color even when dissociated from the dye. Mosaic stones of an inorganic purple material are used for the robes of Emperor Justinian I in the sixth-century church of San Vitale in Ravenna; those of Empress Theodora in the same mosaic are of purple edged with gold. The Byzantine emperors were by this time regarded as Christ's representatives on earth, and so it was natural to transfer the royal color to Christ himself: the San Vitale mosaics show Jesus in a purple gown. The use of red, crimson, and purplish ultramarine for Christ's robes in later centuries gained validity from the link with the Tyrian hue.

But the centuries-old method of preparing purple was lost to the Western world when Constantinople fell to the Turks in 1453. Despite the accounts of the classical scholars, the process remained a mystery for centuries thereafter until a French zoologist named Félix Henri de Lacaze-

Duthiers rediscovered it in 1856—an auspicious year for purple, as it turned out. The Frenchman saw a Mediterranean fisherman mark his shirt with a yellow design using a *Thais* shellfish; the design subsequently turned purple-red in the sun. It was not until 1909, however, that the Austrian chemist P. Friedlander deduced the full chemical nature of the colorant molecule and discovered that it was almost identical to blue indigo.

CHEMICAL COUSINS

Who would suspect that a pea plant native to India should have anything to do with shellfish in the Mediterranean? Yet the organic compound responsible for the Imperial *purpura* differs from the blue extract of the *Indigofera* plant only to the extent of having a couple of bromine atoms where hydrogens sit in indigo. Why shellfish should produce such a close variant (chemists would say *derivative*) of a complex substance found in a plant is not at all clear.

The Roman writer Vitruvius refers to indigo in the first century A.D., the first mention of the dye in the West. Pliny says that it is second in value only to Tyrian purple and hints at the kinship of its rich, dark hue with that of the Imperial color:

> Indigo . . . comes from India, where it attaches itself as mud to the foam of the reeds. When it separates in this manner, it is black; on dilution, however, it yields a beautiful blue-to-purple color. A second kind of indigo floats on the vats in the purple dye houses, which is the foam of purple.[4]

This "second kind" may be the result of light-induced degradation of the Tyrian purple itself to indigo by loss of bromine. Indigo seems to have been employed by the Romans not as a dye but only as a pigment for paints—it was used on the parade shields of the Roman army. Unlike most natural organic dyes, it can be used in pure, powdered form as a pigment rather than having to be made up as a lake.

Using indigo as a dye requires some chemical subtlety, since it does not take well on wool. It must first be treated with a so-called reducing agent, which transforms it to a colorless, soluble form called indigo white or "leuco indigo." One can only speculate at what gave ancient dyers the confidence to persevere with this unpromising stuff, which is taken up by wool fibers only in the colorless form but is then transformed back to the rich

blue on exposure to air. "Think of the existential agony of the protochemist here," says chemist Roald Hoffmann, "to have gained the colored dye with so much labor, then to be forced to watch its color disappear, hoping, hoping that it will come back."

In spite of these complications, indigo dyeing seems to be very ancient. Its presence is suspected on a robe from Thebes dated at around 3000 B.C., it provides the edging stripes on Egyptian mummy bandages from about 2400 B.C., and it is thought to have been used in India from at least 2000 B.C. The Israelites used a blue dye that seems to have been a mixture of indigo and its bromine-seasoned cousin, dibromoindigo—that is, Tyrian purple. The Hebrew God instructed Moses that his people should wear garments bearing fringes of which one strand was dyed a blue color called *tekhelet*. This dye was prepared from the rock snail *Trunculariopsis trunculus*. The male of this species secretes indigo itself; the female releases dibromoindigo. But the secret of making *tekhelet* was lost to the Jewish tradition in the eighth century A.D., and the strands of the prayer shawls of Orthodox Jews have remained uncolored ever since. Hoffmann raises the interesting question of whether authenticity should now be judged according to chemical composition or to means of preparation. It was a question that preoccupied many dyers when other natural dyes were synthesized in the nineteenth century.

The indigo molecule is also the blue colorant in the dye called woad, an extract of the plant *Isatis tinctoria*, which is widespread in Europe and Asia. Woad was used as a dye in northern Europe until ousted by imports of indigo from India starting in the seventeenth century. It was the substance with which the Celts decorated themselves to face the Roman legions, as Julius Caesar reports: "All Britons dye themselves with woad, which makes them blue, in order that in battle their appearance be more terrible."[5]

Despite the chemical identity of the colorant, woad was regarded as a different dye from indigo. Pliny calls it *glastum*, derived from the Celtic word *glas*, connoting blue. Like indigo, the woad dye is extracted from its source plant by fermentation. A recipe in the Stockholm papyrus specifies that the plant be soaked in urine under the heat of the sun and trampled daily for three days. Anyone who believes that natural dyeing is a gentle and benign process will be shocked to discover how destructive and unpleasant woad dyeing was apt to be. The fermentation releases large quantities of ammonia, perhaps one of the earliest examples of noxious industrial emissions. And the woad plant, a nutrient-hungry species, depletes the soil in

which it grows. Consequently, woad cultivators were inclined to be mobile, leaving exhausted, infertile wasteland in their wake. Laws were passed in medieval Europe to curb this devastation.

The art of indigo dyeing was brought very deliberately to the West: by the sixteenth century the superiority of the tinting skills of the Persians and Asians was widely acknowledged. The English explorer Richard Hakluyt commented, with characteristic chauvinism:

> For that England hath the best wool, and cloth of the world, and for that the cloths of the Realme have no good vent if good dying not be added: therefore it is much to be wished, that the dying of forren Countreies were seene, to the end that the arte of dying may be brought into the Realme in greatest excellencie.

To this end he dispatched the master dyer Morgan Hubblethorne to Persia, telling him, "You must have great care to have knowledge of the materials of all the Countreies that you shall passe through, that may be used in dying, be they hearbes, weedes, barkes, gummes, earths, or what els soever."[6]

In due course, indigo began to find its way westward, and there ensued a struggle between the importers and the home-grown woad cultivators. The truth was that indigo, though identical in terms of the coloring agent, made the better dye. Yet whether through inexperience in its handling or pure malicious rumor, word got about that it was not to be trusted: it was denounced as "pernicious, deceitful, eating, and corrosive" in seventeenth-century Germany. The dyers of Nuremberg had to swear an oath even at the end of the eighteenth century that they would not use it, although by then this was largely a formality, since it had already eclipsed woad throughout Europe.

SCARLET FEVER

Whereas ultramarine blue was the most prized pigment for medieval painters, the finest cloth was dyed deep red. This would explain some of the color symbolism in paintings of the late Middle Ages that appears unrelated to the value of the pigments themselves. In Sassetta's *St. Francis Renouncing His Heritage* (1437), the act of renunciation is shown as a casting aside of a precious red robe. And the glorious crimson-red folds of the Madonna in Jan van Eyck's *Virgin with Chancellor Rolin* (c. 1437) (Plate 42)

contrast with the ultramarine garb of earlier medieval paintings while, by virtue of the purplish tint, securing an association with the most valued dye of antiquity.

Scarlet or crimson cloth was generally dyed with the insect extract kermes, the colorant of carmine lake pigment. A dyers' manual from Florence in the fifteenth century describes this rich red as "the first and the highest and the most important color that we have." Yet there was ambiguity as to whether it was the quality of the cloth or of the color that determined the fabric's value, to the extent that the two could become indistinguishable. Though scarlet is today a near-synonym of crimson, in the eleventh century it referred to a type of cloth of unspecified hue. The scarlet of early medieval Germany was a particularly fine woolen cloth that might be dyed almost any color from black to blue to green. Yet inevitably the valuable textiles tended to attract the valuable dyes—why squander one by not coloring it with the other? So good scarlet cloth was most often dyed with kermes. By the fourteenth century, "scarlet" denoted the dye; soon thereafter it became a color word.

For purplish dyes, this same transition happened in reverse. In tenth-century Spain, *purpura* had come to denote a silk fabric, and for several centuries subsequently a "purple" cloth could be pretty much any color. This shows how intimately ideas about color and its uses were linked to the materials that embodied them. As we see in the case of indigo—the extract of both a snail and a pea plant—even naming colors for materials has limited validity so long as the underlying chemical composition of the colored substance stays mysterious. In the nineteenth century this question of identity in the manufacture and use of dyes was to be picked apart as never before. Even the distinction between natural and artificial was to vanish, and in its place came a scheme in which colorants were defined solely by the cryptograms of the chemist.

A PUBLIC TASTE FOR COLOR

In Imperial Rome, one could control the application of and demand for a color by royal decree. By the mid-nineteenth century there was a new determinant of color use in the textile industry: fashion. Once the burgeoning Industrial Revolution created a prosperous middle class, the process began of persuading Europe's populace (the women in particular)

of the supreme importance that adhered to the correct choice of attire. Just as today, the fabric manufacturers flattered their consumers with the conceit that they were the engineers and not the victims of fickle fashion. Scottish dyer John Pullar enthused to the color chemist William Perkin in 1857 about the prospect of winning over "that *all-powerful* class of the Community—The Ladies" to Perkin's new dye. "If they once take a mania for it and you can supply the demand," he assured the young man, "your fame and fortune are secure."

It was no exaggeration. The textile industry—especially cotton manufacturing—was the most significant single sector of the Industrial Revolution. It was largely responsible for Britain's industrial supremacy before 1850, and its travails played a central role in the country's subsequent economic decline. Based in the northern towns of Manchester and Glasgow, the British textile industry depended on the production of cotton garments and on cheap calico printing. Advances in spinning technology have often been stressed as a major factor behind industrialization, but calico printing may in fact have been the dominant aspect of the cotton industry. Woolen and silk products went to a more refined (though still highly lucrative) market—the industrial eminence of Lyon in France relied on its silk factories. Mulhouse and Rouen were the other main centers of French textiles. But it was in Paris, of course, that new dyes stood or fell before the merciless gaze of the doyens of *haute couture*. In the early part of the century Britain and France possessed the most powerful textile industries in Europe; Germany, the Netherlands, and Switzerland were in the second rank.

Dyeing was a firmly established, guild-regulated trade by the late Middle Ages. But its path divided in the seventeenth century. The application of colored patterns to textiles, which became fashionable at this time, posed a considerable challenge to the dyer, who could not then simply soak the entire cloth in the dye. Woad and indigo were patterned on textiles using "resists"—pastes and waxes that masked the blank areas and were subsequently removed. This kind of "blue printing" seems to have been practiced in Europe from around the 1620s. The alternative was block printing, which was applied in Spain and Italy from at least the thirteenth century. Around 1500, book printers began to use engraved copper plates in place of wood blocks, and the textile printers soon followed suit. Because block printing of textiles was carried out with oil paints and inks rather than dyes and because the prints were often hand-finished by brush, the practice was

typically seen as a branch of the painting and printing trades rather than that of the dyers.

This division was reinforced when new methods of textile patterning were introduced to Europe from India in the 1670s. The Indians developed recipes for making colorfast patterns resistant to washing or fading in sunlight. This involved the use of mordants, fixing agents that enable the dye to adhere to the threads of the fabric and to hold fast when washed. The mordant forges a link between the compounds in the fabric's threads and those in the dye. Early dyers typically found the right mordant by trial and error—there was no obvious rhyme or reason for why one substance worked while another did not. Many mordants were metal-containing salts, but certain organic substances such as albumin (a blood extract) or casein from milk were also effective.

The importance of mordants was recognized in Europe before the introduction of Indian patterning methods, but the Indian dyers perfected techniques for combining mordanting with multicolor patterning. The printed textiles imported from India, called chintz in England after their Hindi name *chint*, were typically dyed with madder red. When the European dyers started to use the Indian techniques, a split developed between the "blue printers," who worked with indigo, and the chintz makers, who worked with madder. Blue printers sometimes found themselves in uneasy relation to the dyers' guilds, who considered that they alone were authorized to apply indigo to fabrics. The red chintz makers, allied to ink and oil-paint printers, encountered less complaint from this quarter.

A CAREER IN COLOR

The extraction of dyes from their natural sources and their fixation into textiles increasingly required chemical expertise. Throughout the late eighteenth century, dye manufacturers became ever more aware of the benefits of seeking advice from professional chemists on such matters as the development of new mordants. That chemical art could serve the textile industry was highlighted in 1766 by the Scottish chemist William Cullen: "Does the mason want a cement? Does the dyer want the means of tinging a cloth of a particular colour? Or does the bleacher want the means of discharging all colours? It is the chemical philosopher who must supply these."[7] Of course, Theophilus could have said much the same of alchemy in the twelfth

century. But what was so special to Cullen's time and the century that followed was the appearance both of the means to conduct sophisticated modifications of nature's organic and inorganic substances and of theoretical understanding of what the practical chemist was doing.

All the major dye companies of the early nineteenth century came to employ professional colorists, people versed simultaneously in chemical theory, the applied chemistry of colormaking, and the practices of the textile trade. We can trace their origin not to the dyers of the early eighteenth century but rather to the guilds of painters, draftsmen, designers, and printers.

It was still by no means obvious in the early 1700s that the chemist had a large role to play in the dyer's trade. True enough, the Royal Society in London had in 1664 appointed a commission (which included Robert Boyle) to investigate methods of colorfast printing on fabrics. And early-eighteenth-century chemists such as Georg Ernst Stahl and Pierre-Joseph Macquer had asserted that dyeing could not be practiced without a good knowledge of chemistry. But the idea that dyeing could be competitively conducted along the lines of a medieval craft, by the rotelike handing down of traditional wisdom, was not seriously challenged until certain technological innovations appeared toward the middle of the century.

The foremost of these novelties was the introduction in the 1730s of the "English blue" process, called "pencil blue" in England. This enabled indigo to be printed directly onto cloth from metal plates. Previously, areas that were to be left plain had to be masked off, since the traditional mordanting methods of indigo dyeing were not compatible with printing techniques. This problem was overcome in the English blue process by the expedient of adding orpiment to the vats. In 1764 this approach was combined with mechanical innovations to enable English blue printing using blocks instead of plates. Chemical training was a prerequisite for managing the complex mixture of dyes and mordants in this process.

In addition, direct metal-plate printing of red madder dye became possible from 1752, when Francis Nixon in Ireland devised a thickener for the mordant so that it would stay on the plates. These innovations made multicolor textile printing possible, and soon four-color printing (employing blue, red, yellow, and green) became standard throughout Europe.

The importance of chemistry was further highlighted by the development of bleaches. In the early eighteenth century, textiles were bleached with sulfuric acid, which was scarcely beneficial to the fabric. The French

chemist Claude-Louis Berthollet showed in the 1780s that chlorine, discovered by Carl Scheele, exhibited bleaching power without the corrosive consequences of the acid.

Dye manufacturers tended to find their chemists among the ranks of the painters' guilds, for the association of chintz printing with this guild, rather than that of the dyer, had established a pool of color professionals familiar with the demands not only of artists but also of textile manufacturing and printing. These individuals were to secure the link between professional chemistry and the technology of color.

Writing around 1766, the Basel-based calico printer Jean Ryhiner claimed that a good colorist should possess a sound knowledge of chemistry, of the composition of colors, and of the specific practicalities of textile printing. (He went on to claim, apparently hinting at the indispensability of his own position as factory manager, that such people did not yet exist.) Ryhiner also identified a separate category of colorist—itinerant "arcanists" who sold their secrets of color manufacturing and application from factory to factory. So the medieval idea of arcana—tightly guarded, exotic secrets—was clearly alive and well. Such people were, said Ryhiner, a danger to the industry, but they were not destined to survive for long in the new industrial age. By the late eighteenth century, most colorists were employed by a single firm for many years. And in the mid-nineteenth century, the profession of colorist in a textile printing works was seen as one of the most important career options for the training chemist.

BLACK MAGIC

One of the first progeny of the tentative union between chemistry and the dyeing trade was a yellow dye called picric acid. This organic compound, discovered in the late eighteenth century, could be made by treating phenol with nitric acid. It was manufactured as a dye from the 1840s, after a method was found of making phenol from coal tar, a by-product of the coal-gas works that provided the fuel for gas lighting. Making picric acid from this unappealing viscous black residue was truly a case of drawing gold from baser stuff.

As gas lighting gained in popularity during the 1830s, there was much interest in finding ways to turn its tarry residue into something useful. It was to this very practical issue that the German chemist August Wilhelm

Hofmann turned his attention in the 1840s. Having studied coal tar under Justus von Liebig at Giessen in the late 1830s, Hofmann came to London in 1845 as the first director of the Royal College of Chemistry.

Here Hofmann and his students discovered that distillation of coal tar would yield up all manner of different hydrocarbons, including benzene, xylene, toluene, napththalene, and anthracene. All of these compounds were strong-smelling ("aromatic") and had a curiously high carbon-to-hydrogen ratio relative to the paraffin compounds such as methane, ethane, propane, and butane, found in crude oil. Hofmann's pupil Charles Mansfield devised procedures for separating these pungent compounds from the black mess, and in 1848 he took out a patent on the process—a sign that the commercial possibilities were not unappreciated.

Phenol (also known as carbolic acid) is an acerbic substance with disinfectant properties. It was first developed as a commercial coal-tar product in 1847 by the chemist and industrialist Frederick Crace Calvert in England. From the 1850s, phenol was used in soap, in sewage treatment, and as a disinfectant in hospitals. Benzene and the closely related compounds toluene and xylene found application as solvents—for example, in the newly invented dry-cleaning process. Clearly, there was a market for coal-tar products.

Picric acid's bright yellow crystals provided the first indication that the aromatic substances in coal tar were the potential raw materials of strikingly colored compounds. Silk readily imbibes the saffron hue of picric acid, and in 1845 the Lyon silk dyers Guinon, Marnas & Co. began to use the dye. Four years later they were manufacturing it on an industrial scale, and in 1851 the company's yellow silk was proudly displayed at the Great Exhibition in London.

In the mid-nineteenth century, Britain and France were the great dyestuff centers of Europe, and an innovation in one country would inevitably be copied by the rival nation. Crace Calvert began making picric acid in 1849, and in 1855 the company of Louis Raffard established a factory devoted to its synthesis near Lyon. A means of applying picric acid to wool was discovered at the Guinon factory in the same year. Yet the dye had serious drawbacks and was destined for a short career. For one thing, it was not easy to attach it securely to cotton fibers, preventing its application to calico printing—where the real fortunes resided. But its fate was ultimately sealed by its poor lightfastness. By 1863 it had fallen from grace, although variants were manufactured for many years thereafter.

THE PURPLE YEARS

Another short-lived synthetic dyestuff of the mid-nineteenth century was a purple dye called murexide, which was synthesized from uric acid extracted from Peruvian guano. Huge deposits of these solidified bird droppings, rich in urea and uric acid, were quarried and exported to Europe starting in 1835. In Britain murexide was also sold as "Roman purple" in an attempt to exploit associations with the fabulous dye of antiquity. Indeed, it was even asserted in the 1850s (quite falsely) that murexide was chemically identical to Tyrian purple, whose secret was rediscovered, to the excitement of Paris but to no commercial benefit, toward the end of that decade.

Perhaps the marketing trick worked, for the fashion-conscious of the midcentury developed a taste for purple. An alternative to this synthetic color was the so-called French purple, a rich, relatively colorfast natural extract of certain European lichens. Related to the turnsole of medieval dyers and also to the litmus extract used as an indicator of acidity, this substance could vary in hue from blue to red depending on the fixing agent. But it was the strong purple form that was most in demand, and in 1853 the dyer James Napier commented that "could this color be obtained of a permanent character, and fixed upon cotton, its value would be inestimable." It could be applied to silk and wool without mordants, and the discovery in the late 1850s of a suitable mordanting process for cotton led to much enthusiasm for French purple. It was also known as *mauve* in France (the name for the mallow plant), and by 1857 this word was a color term in England rather than an identifier of a dyestuff. Mauve became the color of high fashion; the late 1850s and early 1860s constituted the "Mauve Decade." The glorious swath of purple fabric that dominates Arthur Hughes's *April Love* (1856) (Plate 43) offers a paean to the color.

Frederick Crace Calvert narrowly missed the opportunity to make a decisive contribution to the mauve movement. He was one of the first to see how chemistry, particularly when applied to coal-tar products, might open up a new world of synthetic dyestuffs, and in 1854 he experimented on another coal-tar extract, aniline. That this compound might be intimately connected with agents of coloration was implied by its appearance as an extraction product of indigo. The name itself is derived from *anil*, the Portuguese word for indigo, which in turn comes from the Arabic *an-nil*, an adaptation of the Sanskrit *nila*, meaning dark blue.

Crace Calvert reported that when aniline was treated with oxidizing

agents, which introduced oxygen-containing chemical groups into the compound, it yielded purple and red dyes that could be fixed onto suitably mordanted silk, wool, and cotton. A dyer and chemist named Alexander Harvey in Glasgow obtained similar results when he oxidized aniline using bleaching powder. But as rich crimson dyes were already available from the extract of the madder plant, these synthetic alternatives were not developed further.

At that time there was probably no chemist in the world who knew more about aniline than August Wilhelm Hofmann. During the 1840s he elucidated its close relationship to phenol and to the parent compound from which both are derived, the hydrocarbon benzene. In the 1850s Hofmann began to suspect that coal-tar compounds might supply suitable precursors for the chemical synthesis of quinine, the principal antimalarial drug. Malaria was still rife in Europe in those days, and there was great demand for quinine. The substance, first isolated chemically in 1820, was extracted from the bark of the South American cinchona tree. It was expensive to produce and to import, so a method of synthesizing it from abundant raw materials such as coal-tar extracts would be of tremendous medical (not to mention commercial) value.

In the mid-1850s Hofmann set one of his young students, William Henry Perkin, on the quest for synthetic quinine. The son of a London builder, Perkin showed a talent for chemistry in his teens under the tutelage of Thomas Hall at the City of London School. Hall, a former student of Hofmann's, arranged for Perkin to enter the Royal College of Chemistry in 1853, when the lad was just fifteen years old. Hofmann set him the task of making aniline analogues of aromatic coal-tar hydrocarbons, and Perkin set up his own personal laboratory in his parents' home. This was not a new situation to the Perkin family. William's grandfather Thomas Perkin had conducted experiments in the cellar of his house at Black Thornton in Yorkshire, gaining a local reputation as an alchemist.

So it was in a garden shed at his home in Shadwell, East London, that Perkin attempted in 1856 to make synthetic quinine. His starting material was a compound called allyltoluidine, derived from coal-tar toluene. Perkin reasoned by little more than counting atoms that two molecules of allyltoluidine might unite with oxygen to generate one molecule of quinine and one of water. In other words, he hoped that oxidation of allyltoluidine might be a means of securing synthetic quinine.

It wasn't. When Perkin treated allyltoluidine with the oxidizing agent

potassium dichromate, all he obtained was a reddish-brown sludge. Organic chemists quickly become familiar with this kind of reaction—generally it means that the reagents have combined to give an unintelligible mess that is best flushed down the sink. But Perkin was naive enough to believe that the matter was worth investigating further. And this is how the eighteen-year-old young man launched the chemicals industry, experimenting at home like a teenager in his bedroom.

Perkin decided to conduct the same reaction using aniline as his starting material. This time, oxidation produced a black solid that dissolved in methylated spirit to give a purple solution. Would cloth take up this color? Perkin coolly explained many years later that "on experimenting with the colouring matter thus obtained I found it to be a very stable compound dyeing silk a beautiful purple which resisted the light for a long time." The color is indeed glorious even today (Plate 44).

While striking and unexpected, Perkin's discovery was not of its own accord a breakthrough in dye manufacture. Others before him had found bright reddish colors from coal-tar compounds, and yet nothing had come of it. What made the difference in Perkin's case was that with his youthful vigor and inexperience, he was not deterred at once by the formidable obstacles to making his discovery commercially useful.

Making a dye from aniline was all very well in the laboratory, but aniline was already an expensive substance, made in two steps from coal-tar benzene. First, benzene is converted to nitrobenzene using nitric acid; then this is "reduced" to aniline.[8] At that time, multistep chemical synthesis was unheard of on an industrial scale: if you couldn't make the product in one pot, said conventional wisdom, it was not worth bothering with.

But before confronting this problem, Perkin needed to know if his dye was any good. He sent samples for testing to the Scottish dyers John Pullar & Sons in Perth, who were impressed by the results—provided, they said, that "your discovery does not make the goods too expensive." That was enough to persuade Perkin to apply for a patent, and he traveled to Perth to collaborate directly in attempts to find a suitable mordant for cotton. But the Glasgow calico printers that he visited were underwhelmed, observing that the purple dye was removed by bleach, and fearful of its cost. Perkin's aniline purple seemed destined to be a high-value-added specialty product for silks, not wool or cotton.

At this point, Perkin had several choices. If he had been prone to caution, he might have abandoned the whole idea and resumed his academic

studies. Alternatively, he could have sold the rights to Pullar or some other company and left others to wrestle with the dye's commercialization. But instead he persuaded his father, George, and his brother, Thomas, that they should set up a business. In October 1856 he resigned from the Royal College of Chemistry, to Hofmann's dismay, and the Perkin family began to look for a location in which to build a small factory.

Now there was no avoiding the issue of how to scale up the synthesis without making it prohibitively expensive. Perkin identified a relatively cheap way to convert nitrobenzene to aniline, but the large-scale production of nitrobenzene from benzene and nitric acid was hazardous. Iron vessels could not be used because they were corroded by the concentrated acid, so huge glass containers were employed—with the attendant risk of breakage and explosion. Benzene could be bought at a reasonable price from coal-tar distillers, but in a form so impure that it had to be redistilled before use.

Perhaps it was the craze for purple that saved the Perkins' enterprise, at face value a mad act of faith. In France, the manufacturers of French purple held a virtual monopoly on purple dyes that the Lyon silk dyers wanted to break. The announcement of Perkin's discovery by the Chemical Society of London in March 1857 left it open to plagiarism in continental Europe, where Perkin's patent did not apply. His attempt to secure French patent rights failed, and both French and German color chemists began experimenting with aniline purple. By late 1858 it was being used by French calico printers, and this placed pressure on the British calico printers to reconsider their own reluctance. Orders increased at the Perkins' factory, now fully operational at Greenford Green, near Harrow.

Perkin continued to confront the technical problems associated with the manufacture and use of the dye. In 1857 he found a mordanting procedure effective for cotton. Later the Perkins were able to replace their glass vessels with iron ones by using less concentrated nitric acid mixed with sulfuric acid. They marketed the dye at first as "Tyrian purple," but by 1859 it had become known simply as "mauve"—there was more benefit to be had from an association with Parisian *haute couture* than with antiquity. By May 1857, John Pullar in Perth was able to tell Perkin that "a rage" had begun for his new color, and in the next few years it overtook the competitors, murexide and French purple.

The mania for mauve was positively gaudy by today's standards, and conservative commentators frowned on it. The British periodical *Punch*

complained that London was afflicted with "Mauve Measles." Others were more charitable. Charles Dickens's periodical *All the Year Round* sang Perkin's praises in September 1859 (while failing, however, to spell his name right):

> As I look out of my window, the apotheosis of Perkins's purple seems at hand—purple hands wave from open carriages—purple hands shake each other at street doors—purple hands threaten each other from opposite sides of the street; purple-striped gowns cram barouches, jam up cabs, throng steamers, fill railway stations: all flying countryward, like so many migrating birds of purple Paradise.[9]

THE ANILINE BOOM

It seemed unlikely even to the dullest color chemist that aniline purple was the only rich hue to be had from coal-tar derivatives. Many entrepreneurs set about experimenting with aniline, often armed with little more than determined empiricism. One such was François-Emmanuel Verguin, one-time manager of the picric acid factory of Louis Raffard near Lyon. Verguin seems to have treated aniline with whatever reagents he could find on his shelves, and in late 1858 or early 1859 he struck pay dirt.[10] He mixed aniline with tin chloride and obtained a deep red substance that he called fuchsine, an invocation of the color of the fuchsia flower.

Verguin left Raffard in early 1859 and sold his discovery to the rival dyemakers Francisque and Joseph Renard, who began making fuchsine, or "aniline red," in 1859. In the same year, a new procedure for synthesizing the red dye was discovered in England by Edward Chambers Nicholson. Both Nicholson and his business partner George Maule were former students of Hofmann's at the Royal College of Chemistry. Together with George Simpson, a London paintmaker, they set up business in Walworth, South London, in 1853 to manufacture fine chemicals. From 1860 the firm of Simpson, Maule & Nicholson manufactured aniline red under the trade name "roseine." But the color became more popularly known as magenta, named in honor of the Italian town where the French army fought and defeated the Austrians in June 1859.

Hofmann himself discovered in 1863 that treating aniline red with ethyl iodide produced a violet compound. Manufactured under license by Simpson, Maule & Nicholson starting in 1864, this "aniline violet" began to generate stiff competition for Perkin's mauve. And in 1860, French chemists

Charles Girard and Georges de Laire discovered by accident that altering the recipe for magenta yielded a new dye, aniline blue.

The aniline dye industry was now in full swing, and new companies abounded in England, France, Germany, and Switzerland. Some of these are now the world's major chemical companies. In Germany, Friedrich Bayer began in 1862 by selling fuchsine and a range of aniline blues and violets. A collaboration of industrial chemists established the aniline dye manufacturers Meister, Lucius & Co. at the town of Höchst, near Frankfurt-am-Main, in 1863. And in 1865 several small German companies merged to form a dye-and-alkali firm called the Badische Anilin und Soda Fabrik. As Bayer, Hoechst, and BASF, these three German companies now dominate the European chemical market.

Switzerland provided a haven for French industrialists stymied in France by the fact that French patent law applied to the product and not the process. Here in 1859 the silk-dyeing business of Alexandre Clavel in Basel began manufacturing aniline dyes, as did the dye factory of Johann Rudolph Geigy. These two companies, Ciba and Geigy, now merged into one corporation, became the chemical giants of Switzerland.

THE INFLUENCE OF THEORY

A vigorous campaigner for academic chemistry, Hofmann did not miss the opportunity to advertise the success of the new synthetic dye industry as an indication of the value of research in pure chemistry—one of the earliest expositions of the now common refrain that pure research can have valuable technological spin-offs.

Whereas practical men like Perkin and Nicholson applied their chemical prowess to the development of new dyes and better techniques for making and fixing them, Hofmann was determined to develop some understanding of the constitution of these compounds and how this related to their colors. In 1863 he articulated the ambitions that the accelerating understanding of chemical science was fostering: "Chemistry may . . . ultimately teach us systematically to build up colouring molecules, the particular tint of which we may predict with the same certainty with which we at present anticipate the boiling point and other physical properties of the compounds of our theoretical conceptions."[11]

This clear statement is really the fulcrum of my story. Chemical tech-

nologists since antiquity were not lacking in interest about *why* the arts that they conducted brought about transformations of color, nor were they indifferent to the composition of their dyes and pigments. But the main concern was a practical one, and theoretical understanding came after the fact, if it came at all. By Hofmann's time, the chemical climate had shifted. The time was ripe, he thought, for a rational synthesis of color. Future chemists would produce colors to order from an understanding of the physical and chemical principles that underlie their manifestation in matter. The chemistry of color was to be no longer a matter of trial-and-error but rather an exact science.

Between the late 1860s and the 1880s, Hofmann's dream began to materialize. From empiricism and a makeshift union of academic science and industrial research was to emerge a science-based dye and color industry that was increasingly guided by theory. This was made possible only by the giant leaps that were taken during these years in fundamental organic chemistry.

The chemistry of dyes is organic: focused on carbon-based compounds. Until the nineteenth century, almost all such substances were extracts of living organisms. The study of these "natural products" was pioneered by Carl Scheele in the eighteenth century, although it was the archanalyst Antoine Lavoisier who deduced that the common factor among natural products was carbon. The methods of analytical chemistry available at that time allowed one to establish nothing more than the relative proportions of the various elements—generally carbon (C), hydrogen (H), oxygen (O), and nitrogen (N)—in these compounds.

This defines the substance's *chemical formula*, a list of the ratios of different elements, written in the chemist's shorthand where subscripts (or, before the late nineteenth century, superscripts) denote the number of each type of atom. Thus benzene is C_6H_6—six atoms each of carbon and hydrogen—and quinine is $C_{20}H_{24}N_2O_2$. When Hofmann and Perkin set about synthesizing quinine from coal-tar products, this was all they had to go on. Indeed, it was only their lack of theoretical understanding that prevented them from recognizing how daunting a challenge it truly was.

At that time, however, these formulas were not considered to reflect the actual constitution of the molecules concerned; they were little more than codifications of the experimental results of elemental analysis. And there was nothing to indicate how the atoms were arranged in space, nor was there even a clear concept of such an "atomic structure" of molecules, in the sense of a well-defined architectural arrangement of its component

atoms. Little was said about how atoms were arranged because nothing was known. It was rather like writing words by collecting together all the same letters and denoting their multiplicity, so that *quinine* becomes qui$_2$n$_2$e, or a word like *acceptance* is a$_2$e$_2$c$_3$ptn (or, for that matter, pc$_3$na$_2$te$_2$). How to make sense of these formulations, to extract from them their true meaning and form? And harder still, how to reformulate one arrangement into another?

This difficulty was most pronounced in chemistry's organic branch, in which the formulas were commonly complex even though the range of elements was small. The formulas could look similar for compounds that behaved very differently, or they might look different for comparable compounds. And there was such a proliferation, a seemingly endless diversity, of combinations of these elements. Inorganic compounds, in comparison, seemed to be restricted to a rather more limited set of permutations.

So the underlying challenge for organic chemistry in the early nineteenth century was classification, and much of the work until the 1850s was concerned with synoptic schemes, methods of arranging different organic compounds into groups that showed some commonality of chemical properties. One of the most fruitful ideas in this endeavor was due to the French chemist August Laurent, who proposed in the 1830s that organic compounds contain a "nucleus" or "fundamental radical" that determines the group to which it belongs. Compounds should, in other words, be grouped according to their "nuclei," which are variously embellished with peripheral clusters of atoms.

Uncontentious though it might sound, Laurent's idea was highly controversial because it conflicted with the popular belief of the time that organic molecules, like many inorganic substances, were fundamentally binary, being composed of two oppositely charged "radicals." Laurent supposed that the nuclei of organic compounds are basically frameworks of carbon in which the number of carbon atoms provides the basis of classification. This idea of a carbon framework underpins all of organic chemistry today. In Laurent's scheme, the nucleus of aniline (C_6H_7N) is the group C_6H_5 (today called "phenyl"), derived from benzene (C_6H_6). Phenol (C_6H_6O) belongs in the same class.

In 1852 the Englishman Edward Frankland formulated a second crucial concept in organic chemistry. He proposed that all atoms of any given element form a specific number of bonds with other atoms—neither more nor fewer. This later became enshrined in the notion of "chemical valence." As Frankland put it, "The combining power of [an] element is always satis-

fied by the same number of atoms." This is the central rule of molecule building.

The German chemist Friedrich August Kekulé revealed the full meaning of valence for the architecture of organic molecules when in 1857 he showed that the carbon atom is four-valent: it forms four bonds with other atoms. That is why, for instance, the methane molecule (CH_4) contains four hydrogen atoms. By 1858 Kekulé understood that carbon's centrality in life's chemistry stems from its propensity to form chains, offering endless structural variety from the same basic constituents.[12]

But one more concept was needed in organic chemistry before its multitude of substances could be interpreted at the molecular level. Benzene's formula C_6H_6 cannot be rationalized by any chain structure in which all the carbon atoms are attached to four other atoms. The molecule does not seem to contain enough hydrogen to satisfy carbon's fourfold valence. Hofmann showed in the 1850s that many of the coal-tar aromatics, such as toluene, xylene, and phenol, were related to benzene, sharing the same hydrogen deficiency.

Kekulé's interest in these aromatic compounds was enhanced by the rich applications they were finding in coal-tar dyes. His solution to the mysterious structure of the aromatic molecules is now the stuff of legend—with all of a legend's ambiguity. How much did the German chemist embroider his retrospective accounts of the breakthrough? How much did he really owe to a dream of a serpent devouring its tail in a closed loop, and how much inspiration did he in fact find in earlier studies of the problem? All we can really be sure of is the published record: in 1865 he proposed that the aromatics have a nucleus, in Laurent's sense, comprised of a *ring* of six carbon atoms.

Benzene, then, is a hexagonal ring, with hydrogens capping the carbon atoms at each corner.[13] In phenol, one of the hydrogen atoms is replaced by a hydroxy group (OH), while in aniline it is replaced by an amino group (NH_2). With this insight, chemists had a structural basis for their exploration of aniline dyes. The first fruit of this new understanding was both to show that nature's chemistry could be equaled in the laboratory and to initiate the ascendancy of synthetic over natural dyestuffs.

Once that happened, says art historian Manlio Brusatin,

> there would be a different way of seeing and perceiving colors because there would be an entirely different way of producing them, with the birth of a

modern industry of chemical colors on the horizon, looming over the back room of the old dyeshop with its rare, dyed garments and its antiquated trade in privilege.[14]

REMAKING NATURE'S COLORS

The madder plant (*Rubia tinctorum*), source of the crimson red dye used in madder lake pigments, was probably first cultivated in India. Madder was widely cultivated in Asia and the Far East in ancient times, and there is evidence of it in classical Greece. The dyestuff became common in Europe after the Crusades, and fields of madder flourished in medieval France and Italy. Although it seems unlikely that chemical technologists were able to produce good madder lake pigments before the seventeenth century, the extract was much prized as a dye, giving a strong, permanent red. It was employed primarily in so-called "Turkey red" dyeing of cotton, a complex operation using metal-based mordants that produced relatively colorfast results.

In 1820 two French chemists, Jean-Jacques Colin and Pierre Robiquet, isolated a red compound from the madder root that they identified as the principal constituent of the dye. They called it alizarine, after the Arabic-derived word for madder used in the eastern Mediterranean region, *alizari*. The root extract also contained a second, related compound which they christened purpurine, responsible (despite the name) for a slight orange tint in the natural dye. (The final *e* was later dropped from both names.) By 1850 a chemical formula had been assigned to alizarin (albeit incorrectly, suggesting an apparent relationship with the coal-tar extract naphthalene), and the search was on for a synthesis that might offer this commercially important dye at a lower cost than the cultivated variety.

Little progress was made until 1868, when German chemists Carl Graebe and Carl Liebermann deduced the correct formula: $C_{14}H_8O_4$. Graebe and Liebermann were working under Adolf Baeyer, one of the finest organic chemists of the age, at the Gewerbe Institut in Berlin. Like the Royal College of Chemistry in London, this establishment placed considerable emphasis on dyes and dyeing, and the two young Germans both came to Baeyer with practical experience in the dye industry.

A fourteen-carbon framework indicated a kinship with anthracene, not naphthalene.[15] In the summer of 1868, the persistent efforts of Graebe and

Liebermann culminated in a three-step synthetic route from anthracene to alizarin. The synthesis was a long way from being industrially viable, particularly since it required expensive bromine, but Graebe and Liebermann were able nonetheless to sell the rights to the eager Badische dye company, soon thereafter renamed BASF.

Consider for a moment what this synthesis represents. Mauve and magenta were synthetic dyes—compounds that did not exist in nature and were discovered by chance. Alizarin, on the other hand, was a natural product, a complex organic molecule found in a living organism, and its construction from readily available raw materials was a matter of rational planning and deduction.[16] So the creation of synthetic alizarin—a molecule identical to the natural product but made by artificial means—was arguably a more significant step than the invention of aniline dyes. It showed that organic chemists were becoming nature's equal and that the natural dyes that had been the mainstay of textile coloration since antiquity no longer needed to be coaxed from many thousands of times their own weight of animal or vegetable matter. The natural and the artificial had converged.

But a better scheme than that of Graebe and Liebermann was needed before synthetic alizarin could be commercialized. It was not long in coming: the answer was to use sulfuric acid in place of bromine. Given the enormous market for alizarin and the interest therefore attached to its synthesis, it is not surprising that this solution was attained independently by three groups, all in 1869. Ferdinand Riese, a chemist at Hoechst, was one; Graebe himself was another, working in collaboration with BASF's chief chemist, Heinrich Caro, one of the most creative industrial chemists in Germany. And in Britain, none other than William Perkin came to the same conclusion, thereby revitalizing his ailing company at Greenford Green. BASF and Perkin filed patents just one day apart, and to avert disputation they agreed to divide the market between them: Perkin would sell synthetic alizarin only in Britain, BASF only in mainland Europe.

Yet because of the disruptions caused by the Franco-Prussian War, Perkin was for a short time virtually the sole producer of synthetic alizarin in the world. "In 1870 we produced 40 tons," he later recalled. "In 1871, 220 tons; in 1872, 300 tons; and in 1873, 435 tons." Then in 1873, a rich man at the age of thirty-five, he sold Perkin & Sons to Brooke, Simpson & Spiller, the dye company that was once Simpson, Maule & Nicholson. The increasing competition and the tribulations of a still hazardous trade left

Perkin of the opinion that "the prosperity of alizarin [was] past and gone." He returned to the delights of pure research and let the passing of time weave him a shy kind of fame.

NEW HORIZONS

Synthetic alizarin was both brighter and, soon enough, cheaper than the natural version. As dyers and printers came (not without reluctance) to accept this in the 1870s, alizarin became the color of the decade, rendering aniline dyes obsolete. Madder cultivation too was suddenly redundant, and within ten years it was moribund. In less than a decade, alizarin manufacture in Germany expanded nearly a hundredfold: twelve thousand tons were produced in 1880. This consolidated the dye industry as one of the major industrial concerns of the age, and Germany dominated the market: by 1878 it produced about 60 percent of the dyestuffs sold globally.

The synthesis of alizarin provided an indication, if any were still needed, that competitiveness required active support of chemical research by the dye companies. They could no longer make do with colorists prospecting by haphazard trial-and-error; the development of new dyes was now a matter for theoretically knowledgeable chemists. The foundations of modern industrial research can be located in the decade that followed Graebe and Liebermann's triumph.

Academic chemists continued to play a vital role in industry. Frequently, only the acumen of a Hofmann or a Kekulé would suffice to answer difficult questions about chemical structure, now essential knowledge for the practicing chemist. It was Hofmann who unraveled the structure of eosin, a bright pink substance made from the coal-tar derivative fluorescein, which BASF began marketing in 1874. And in 1866, Kekulé clarified the molecular architecture of another tremendously important class of dyes, called azo dyes.

These compounds were discovered in the late 1850s by a German chemist named Peter Griess, who arrived at the Royal College of Chemistry in 1858 to work with Hofmann. His appearance was reportedly outlandish and scarcely indicative of a soul finely attuned to color chemistry. The college porter refused to grant entry to this character wearing "a reddish-brown overcoat surmounting a pair of sea-green unmentionables, a bright red knitted muffler, and a massive top-hat of a size and shape rarely seen in Oxford Street before or since." The chemist, meanwhile, simply

shouted at the porter, in German, "My name is Griess, and here I stop!" until Hofmann came to relieve the fracas.

The first azo dye was a bright yellow called aniline yellow, made by reacting aniline with nitrous acid. This and other azo dyes were commercialized by Simpson, Maule & Nicholson in 1863. In 1876 the German chemist Otto Witt, working in London, guided dye chemistry into new waters. His careful studies of the relationship between the structures and the colors of azo dyes allowed him to predict successfully the color of a new orange dye *before* it was synthesized. For the first time, chemical research was shown to be not just a vehicle for post hoc understanding that guided synthetic refinements; it could be a predictive tool. Colors could—at least, this was the hope—be manufactured to order.

As they gained in chemical skill, the industrial chemistry laboratories began to diversify. In the 1870s aniline and other aromatics were examined for medicinal use. The analgesic properties of an extract of willow bark had long been known to folk medicine, and in 1860 the German chemist Hermann Kolbe showed that this compound, called salicylic acid, could be synthesized from phenol. A more palatable derivative was marketed by Bayer in 1897 under the trade name Aspirin. Hoechst began to move into the pharmaceutical market in the 1880s.

But the concept of chemotherapy—the use of synthetic compounds as drugs—stemmed largely from biological application of coal-tar dyes by the German Paul Ehrlich. In the 1870s Ehrlich used synthetic dyes for staining cells, which made them easier to study under the microscope. He noticed that the dyes adhered to some tissues but not others. (Chromosomes, the gene carriers, owe their name—"colored bodies"—to their tendency to absorb stain.) Ehrlich hypothesized that similar factors were at play here to those that determine whether dyes will stick to textile fibers. When he observed that some dyes killed the microorganisms that absorbed them, Ehrlich began to see therapeutic possibilities. He synthesized dye compounds to test as drugs, and in this way he found in 1909 an arsenic-containing dye that destroyed the spirochete microorganism responsible for syphilis. Under the name Salvarsan, this drug offered the first relief from the deadly disease since the medieval use of mercury.

By the early twentieth century, several coal-tar dyes had found their way into pharmaceutical use: Congo red was used to treat rheumatism and diphtheria; Acridine yellow, Prontosil red, and Gentian violet became antibacterial agents; and the fluorescein dye Mercurochrome was applied as a

disinfectant. The *Manchester Guardian* pronounced in 1917 that "whatever serves the modern dyemaker directly serves national health."

So strongly did the products of coal-tar chemistry impinge on everyday life that they became celebrated even in the popular press. *Punch* was to be found singing their praises:

> There's hardly a thing a man can name
> Of beauty or use in life's small game,
> But you can extract in alembro or jar,
> From the physical basis of black coal tar:
> Oil and ointment, and wax and wine,
> And the lovely colours called aniline:
> You can make anything, from salve to a star
> (If you only know how), from black coal tar.[17]

At no other time has the demand for color fueled scientific advancement more than it did in the final decades of the nineteenth century. According to historian of technology Anthony Travis, "Once dyemaking evolved into an expanding science-based activity, the modern chemical industry was born." Out of bright purples and lustrous reds, shocking pinks and brilliant yellows emerged all that is good and bad in this most mercurial of modern technologies: cures for devastating diseases, cheap and lightweight materials, mustard gas and Zyklon B, enough explosives to fuel two world wars and more, liquid crystals, and ozone holes. The modern age, in other words.

FADED BLUES

But there was one more challenge to be met before night fell over the nineteenth century and modernism arrived with all its glamour and horrors. Even in the 1880s one of the world's major dyestuffs was still a natural extract. It came out of India, under the colonial auspices of Britain, for whom the indigo industry was the empire's most lucrative activity in Asia. In 1870 there were twenty-eight hundred indigo factories in India. Used in vast quantities for such mass-produced items as military uniforms, as well as being the staple textile colorant in China, the blue dye was a global concern. And the market was commanded by Britain, to the chagrin of the expanding Swiss and German dye manufacturers. A synthesis of indigo would break this dependence.

From 1876 Adolf Baeyer began a collaboration with Heinrich Caro at BASF to make indigo. Baeyer deduced that the compound indole is the "mother substance" of indigo, in the same sense as anthracene is the "mother" of alizarin. But anthracene comes ready-made in coal tar, whereas indole has no convenient source. The framework itself must be constructed. This made the synthesis of indigo a challenge of a different order.[18]

Baeyer first succeeded in 1877, using toluene, a compound whose high price precluded industrial application. It was not until three years later that he identified a more practical route, by which time Hoechst, too, was sponsoring him. This and other synthetic strategies were patented over the next few years, but still they were not suitable for commercialization. In part Baeyer was hampered by a lack of knowledge of the molecular structure of his target, which he solved only in 1883. This eminently applied work broke so much new ground in organic chemistry that it won Baeyer the Nobel Prize in 1905.

It was not until 1890 that a good method was found for manufacturing indigo on a large scale—and then it was Karl Heumann at the Swiss Federal Polytechnic in Zürich, not Baeyer, who cracked the nut. Heumann devised two synthetic routes to indigo from relatively cheap hydrocarbon compounds. One of these began with naphthalene, which was first converted to phthalic anhydride. The key to making this synthesis of indigo viable was the acceleration of the reaction with a catalyst of mercury sulfate. In one of the many serendipitous accidents through which the dye industry has advanced, this catalyst was discovered when a mercury thermometer broke during the production of phthalic anhydride in Germany and the mercury metal reacted with the sulfuric acid in the vat.

It is again a reflection of the difficulty of the problem—not to mention the tenacity of the dye companies—that production of synthetic indigo took a further seven years to blossom. Although the cost was at first slightly greater than that of the natural, imported variety, by 1897 BASF was able to manufacture synthetic indigo at the competitive price of 16 marks per kilogram. Over the next seven years the price dropped to less than half that. One thousand tons of artificial indigo were manufactured in Germany in the first six months of 1900, and indigo cultivation in India began to flounder.

Thus local economies in India based on indigo farming were wholly at the mercy of technological developments taking place in distant Europe.

When exports to the West were no longer in demand, the Indian industry was ruthlessly abandoned. This is all the more ironic when one remembers that Europe had learned the skill of fine calico printing from Indian craftsmen. At the same time, it is worth remembering that indigo cultivation was fantastically wasteful of land resources. In October 1900 the managing director of BASF, Heinrich Brunck, proposed that land cultivated for indigo in India should now be turned over for growing food crops—a worthy objective if one overlooked the fact that the Indian economy was built on the export business.

The implications of synthetic indigo were painfully apparent to Britain. A report in 1899 pronounced that "from a scientific point of view, the production of artificial indigo is undoubtedly a grand achievement, but if it can be produced in large quantities at such a price as to render indigo planting altogether unprofitable it can only be regarded as a national calamity."[19] In an attempt to stave off such a crisis, the British government decreed that all its military uniforms should be dyed using only natural indigo, not the German synthetic product. But this was grasping at straws: by the beginning of the Great War, over 90 percent of the European market for natural indigo had vanished, along with a corresponding amount of indigo-growing land in India. The chemical industry had won.

Yet Britain did not begin manufacturing its own indigo until 1916, eventually compelled by the need to dye military uniforms. Even then, it was German technology that provided the means. The dye company Meister & Lucius, augmented by a third partner, Brüning, set up a factory at Ellesmere Port, near Manchester, in 1909 to produce indigo for the British market while evading German patent law. The plant was commandeered during the war and taken over by the enterprising Manchester dye company of Ivan Levinstein.

After the war, Levinstein merged with British Dyes Ltd. to form the British Dyestuffs Corporation, which in turn amalgamated with other companies in 1926 to become Imperial Chemical Industries (ICI). In part this consolidation was an attempt to compete with the German giants, who had undergone the same process. In 1916 a group of dyemakers centered around the Hoechst company merged with an extant consortium of Bayer, BASF, and the Berlin dye manufacturers Aktiengesellschaft für Anilinfabrikation (Agfa) to become the mighty Interessengemeinschaft Farbenindustrie AG, or IG Farben. It is an amusing yet telling comment on the power that this cartel wielded in the first half of the twentieth century that in his

novel *Gravity's Rainbow*, Thomas Pynchon (probably the most chemically literate novelist short of Primo Levi) presents IG Farben as the shadowy superpower orchestrating the course of the Second World War. Fantasy it may be, but not beyond plausibility.

COLORFAST AT LAST

It is sobering to realize that most of the major classes of dye now in production—the azo dyes, the "anthraquinone" dyes related to alizarin, and indigo—had already been discovered by the beginning of the twentieth century. Perkin, Hofmann, Baeyer, Caro, and their contemporaries had given us a new rainbow: the red of alizarin, the yellows and oranges of azo dyes, the aniline greens and blues, indigo itself, and aniline violets and purples. Aniline dyes have now all but vanished from the marketplace, but the azo and anthraquinone dyes can each span the spectrum on their own. Adolf Baeyer's synthesis of the yellow compound fluorescein in 1871 led to the important family of rhodamine dyes, manufactured by BASF since 1887.

The early azo dyes lacked any affinity for cotton—a major weakness. But in 1884 the German chemist Paul Böttiger created a red azo dye that could be used on cotton without a mordant. This was sold with great success by Agfa as Congo red and led to other colorfast azo dyes in yellow, brown, and blue.

The blue and green phthalocyanine dyes—the second most important class of dyes after the azo colors—were another accidental discovery. In 1928 a blue substance was noticed during the manufacture of a fine chemical called phthalimide by the Scottish Dyes company (which later merged with ICI). The chemical constitution of this contaminant was elucidated in 1934 by R. Patrick Linstead of Imperial College in London and was found to be identical to a compound discovered independently by German chemists H. de Diesbach and E. von der Weid in 1927. Christened phthalocyanine by Linstead, it has an affinity with the plant pigment chlorophyll, containing a metal atom embedded in a ringlike organic molecule. A copper-containing phthalocyanine dye called Monastral Fast Blue, with a deep, rich turquoise color, was developed by ICI between 1935 and 1937. A green version, made by adding chlorine, became an important dye in the 1950s. These colorants are widely used in lake pigments for modern oil paints.

The introduction of synthetic fibers, beginning in the 1920s with cellu-lose acetate and later extending to polymers such as nylon and polyesters, brought new complications for the dye industry. In contrast to cotton, the fibrous molecules in these synthetic threads are so tightly packed that they are relatively impermeable to dye molecules, and traditional dyes do not adhere well. Moreover, the molecular interactions that fix dyes to cotton fibers typically do not operate in the water-repelling synthetic fibers. The commercialization of cellulose acetate was greatly delayed for want of suit-able means of dyeing it.

In 1922 the British Dyestuffs Corporation introduced "ionamine" dyes. These do not dissolve in water but are instead dispersed throughout the liq-uid as a very fine powder and will stick to fibers such as cellulose acetate, nylon, polyacrylonitriles, and polyesters. In 1923 the BDC and the British Celanese Company simultaneously discovered a new class of anthraquinone dyes that will adhere to acetate fibers.

Cotton, still the most important commercial fabric, has posed a persis-tent problem for dyers, who have long struggled to find a way of making dyes take to the fibers in a truly colorfast manner. The mordants that fixed aniline dyes such as Perkin's mauve to cotton were adequate for their day but not for the standards of permanence we would expect today. Even by 1904 the Berlin Aniline Company was still lamenting that "absolutely fast dyes do not exist; sunshine and rain finally bleach them all."

But in 1954 two British chemists, Ian Rattee and William Stephan at ICI, found how to make dyes take permanent root in cotton. The ideal so-lution is to create a strong chemical bond between the dye molecules and the (cellulose) molecules in the cotton fibers. Rattee and Stephan devised a general method of linking dyes to fibers via a coupling molecule. With the coupler attached, the dyes become "reactive," capable of forming bonds to cellulose and woolen fibers.

iCI marketed these "reactive dyes" in 1956 under the trade name Pro-cion. Inevitably, Ciba-Geigy, BASF, Hoechst, and Bayer rapidly developed their own versions. For the first time it became possible to manufacture bright, colorfast cotton clothing; within a few years, bold patterns awash with primaries and secondaries became one of the fashion statements of swinging London.

COAL TAR ON CANVAS

In view of the venerable history of indigo and madder as artists' colors, one might imagine that the impact of coal-tar dyes and their successors on fine art would have been tremendous. Some painters of the late nineteenth century would rather it were not. For Jean-Georges Vibert, aniline dyes were a "catastrophe for painting," and he called for urgent testing of the new materials. Their loveliness was the very problem: this allure was often a false promise, for the lake pigments made from the new colors tended to discolor or fade rapidly. According to Max Doerner, "Their precipitous and ill-advised introduction into painting was the cause of a great deal of damage." Vincent van Gogh was one who did not heed the warnings, and a fugitive eosin lake that he favored has played havoc with some of his works.

When coal-tar colors were first introduced to artists, their deterioration was sometimes so swift—happening in a matter of days—that it did not take long for the new materials to acquire a bad reputation. Thus they do not feature strongly in nineteenth-century art. In the list of pigments recommended as "reliable for oil painting" in Arthur Laurie's survey of artists' materials from 1960, there is not a single color based on a synthetic dye aside from "alizarin lakes."

This degree of caution was, however, unwarranted. It was certainly wise to be wary of coal-tar colors before the turn of the century, but matters improved thereafter. In 1907 the manufacturers of synthetic colors for artists agreed that their products should be subjected to stability tests over several years before being marketed. Alizarin lake was already acknowledged as a more permanent pigment than natural madder lake, and it was decided that other synthetic colors should be of comparable reliability before they were offered to painters.[20] Doerner's account of subsequent events will not, however, surprise anyone jaded by the realities of the commercial world: "Unfortunately this agreement was broken by one manufacturer, and the others soon followed to meet competition. Enthusiastic claims and extravagant advertising ensued, to be followed by a return to a more sober consideration of the facts."[21]

Lemon-yellow coal-tar colors, for instance, which were marketed as brighter, more permanent materials than the existing chrome and cadmium yellows, turned out to be quite the opposite. But gradually the gold was sifted from the dross. In 1911 the so-called Hansa pigments, related to the azo dyes, were introduced in Germany. Hansa Yellow G proved even

more permanent than alizarin lake. Even the wary Doerner advised the use of IG Farben's synthetic Indanthrene Yellow, mixed with cadmium yellow, as a substitute for golden Indian yellow, and Indanthrene Brilliant Pink as a trustworthy color midway between vermilion and light madder lake. IG Farben's Helio Fast Red, he adds, might be risked as a substitute for vermilion, and Indanthrene Blue for Prussian blue. If a greenish blue was desired, phthalocyanine blue lake was regarded as a perfectly safe option by the 1940s.

Having to contend with hundreds of synthetic dye-based colors by the mid-twentieth century (Figure 9.1), artists found that their deliberations were not made any easier by the manufacturers' capricious choice of names. Companies had no qualms about naming a new pigment after its

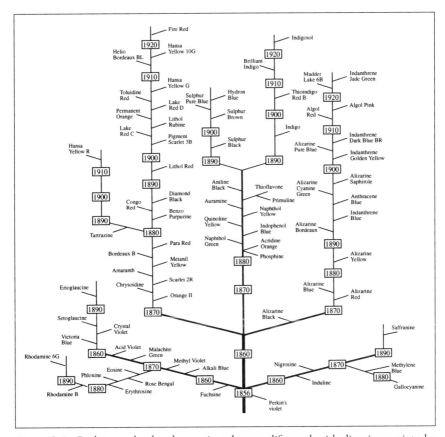

Figure 9.1: Coal-tar and related organic colors proliferated with dizzying variety by the early twentieth century.

classical equivalent, as if deciding that "Indian yellow," "vermilion," or "cobalt blue" designated not a substance but a hue. "Often the most arbitrary, fantastic names and mixtures are invented," Doerner complained in 1934, "which are impossible to check and therefore are better avoided." But there was, in the end, no avoiding synthetic colors—and increasingly, artists felt little inclination to do so. For many of them, the new materials were not just so many new hues for the palette but something more profound: representatives of a new age, in which technology reigned supreme.

SHADES OF MIDNIGHT

THE PROBLEM OF BLUE

"What bliss there is in blueness. I never knew how blue blueness could be." —Vladimir Nabokov (1938), *Laughter in the Dark*

"Blue gives other colors their vibration." —Paul Cézanne

"What is blue? Blue is the invisible becoming visible . . . Blue has no dimensions. It 'is' beyond the dimensions of which other colors partake." —Yves Klein

What is it about blue that has lured painters so consistently? Majesty, yes; melancholy, certainly; and mystery too. According to Kandinsky, "The power of profound meaning is found in blue . . . Blue is the typical heavenly color. The ultimate feeling it creates is one of rest. When it sinks almost to black, it echoes a grief that is hardly human."[1]

Is this grief in the dark sky of the painting that is reputedly van Gogh's last, *Crows Flying over a Cornfield* (1890)? Picasso's Blue Period (1901–1904) coincides with his poverty-stricken years in Paris, when the artist was brooding over the suicide of his close friend Carlos Casagemas. Carl Jung suggested that Picasso's cool, bleak portraits of sick, hungry, aged, and poor beings bathed in a blue glow represent a mythical journey into hell,

where "there reigns the blue of night, of moonlight and of water, the Duat blue of the Egyptian underworld." *The Absinthe Drinker* (1901) and *Old Woman* (1901), still bearing the influence of Impressionism, are clothed in midnight blues; *The Blue Room* (1901) and *La Vie* (1903) have a subdued, shadowy cast.

But there are exuberant blues too, as Titian's *Bacchus and Ariadne* is among the first paintings to proclaim. The dress of Henri Matisse's *Lady in Blue* (1937) leaves little room in the frame for the accompanying primaries (Clyfford Still's *1953*, painted in that year, leaves even less). In *The Artist and His Model in the Studio at Le Havre* (1929), Raoul Dufy embeds the two figures in a sky-blue room that simply continues the view of sea and sky from the open window. In Matisse's visionary *Blue Nude* (1907), the model herself takes on this shade without yielding her vigor. Her angular figure seems to anticipate the totemic Cubist women of Picasso's *Demoiselles d'Avignon* (1907), who are surrounded in blue like an enfolding sheet.

Kandinsky's affinity for blue took concrete form in 1911 when he and the German painter Franz Marc created an art almanac called *Der Blaue Reiter* (*The Blue Rider*), named after a painting by Kandinsky from 1903 that features a blue horseman. Marc pursued the theme with dogged literalness in *Blue Horse I* (1911) and *Large Blue Horses* (1911). The name of the almanac became attached to a group of artists centered around Marc and Kandinsky, which included, for a time, Paul Klee and the Parisian Robert Delaunay. Marc died in the First World War in 1916, but Kandinsky sustained his passion for blue in Die Blaue Vier (the Blue Four), the group he formed in 1924 with Klee, Lyonel Feininger, and Alexei von Jawlensky.

In surveying the history of colormaking, one can hardly avoid the conclusion that blue has always been special; this much should be apparent already. It is the most ancient of synthetic pigments and was venerated in the late Middle Ages as emblematic of divine purity. Yet it did not take its place as a primary color until centuries after red and yellow. And despite the appearance, around 1704, of a blue pigment representing the first of the modern artificial colors, a lack of accessible, high-quality blues was keenly felt by painters until the early nineteenth century.

In short, a good blue was hard to find.

THE BIRTH OF BLUE

The problem we face in tracing the importance of blue back to antiquity is that because it was not clearly recognized as a color in its own right, the oldest color terms connoting blue are equivocal. Clearly, blue pigments were available to the first civilizations, including azurite, indigo, and Egyptian blue frit. Yet there is no sense, in the classical literature, of the primary nature of blue. It was regarded as a color related to black—a kind of gray, if you will. In the fifth century B.C., the Greek philosopher Democritus wrote that a color equivalent to indigo (*isatin*) can be mixed from black and pale green (*chloron*, one of Democritus' four "simple" colors). We can imagine the result of this union, which gives some indication of the casual regard the Greeks had for the integrity of the color we know as blue.

It would perhaps be more accurate to say that blue, to the Greeks, was a species of darkness. The word that signifies "black" in most Greek texts is *melas*, denoting darkness, the opposite of *leucos*, or light. In many surviving fragments of Greek painting, blue is used as a darkener, and a distinctly bluish gray can be obtained by mixing some black charcoal pigments with white. (Indeed, we have seen how artists such as Rubens were still making blues this way two millennia later.) It seems that rather than dulling the senses to blues, this attitude of "blue as dark" may have heightened the ancients' ability to detect blueness in melancholy hues. The Roman Vitruvius describes a recipe for making a black pigment by burning the dried dregs of wine and says, "The use of the finer wines will allow us to imitate not only black but indigo."

Plato and Aristotle inherited much of Democritus' philosophy (although they did not much approve of his atomism). Aristotle's attitude toward blue, and toward primaries generally, is rather hard to discern. In *On Sense and Sensible Objects* he identifies deep blue as one of the "unmixed" intermediate colors between light and dark, and his *Meteorology* lists only red, green, and purple as the unmixed colors of the rainbow. Aristotle's *On Colors* offers only white and golden yellow as primaries—the colors, he asserts, of the four elements.

All this is not to imply that the ancients had no *perception* of blue as we know it—of the blue of sky and sea. There are several Greek words that seem to translate as this hue; one is *kuanos*, the origin of our *cyan*. Yet none of these is equivalent to the English *blue* as a basic, context-independent color term in the sense of the classification of Berlin and Kay. It is as if the

Greeks got by with terms like our *cyan, ultramarine, indigo, navy, sapphire*, and *azure* without having a word to class them together as a single perceptual concept.

As we have seen, facing such an uncertain theoretical basis for talking about color, classical and medieval authors would anchor a discussion of artists' colors to the material substance of the pigments. In principle this is commendable, since the painter never uses "blue" but instead indigo, cobalt blue, Prussian blue, or whatever. In practice, however, there remains ample scope for confusion. A classic example, bizarre to us today, is the blurring of the distinction between blue and yellow in the Middle Ages.

Pliny's account, in *Natural History*, of the four-color palettes of the Greek painters Apelles, Aetion, Melanthius, and Nicomachus lists not hues but pigments. Among these is "Attic yellow," a yellow pigment from Attica. But the word Pliny used for yellow is a mineral term, *sil*, not the more clear-cut *crocum* or *glaucus. Sil* is a kind of yellow ocher. But when, in the sixteenth century, blue emerged as a basic color, some authors felt that it should surely feature in Pliny's list. The Italian Cesare Cesariano made the improbable claim in 1521 that *sil* was ultramarine. By the later part of that century, *sil* had become, in a French encyclopedia of the arts, associated with a shade of violet.

It is perhaps because Pliny states that both the ocher *sil* and the blue mineral *caeruleum* (which is probably azurite) are found in gold and silver mines that the two were initially confused. But the tangle was further raveled by the use of the term *cerulus* for yellow in the late Middle Ages. Even the Old French *bloi*, from which the English *blue* and the French *bleu* are derived, could mean either blue or yellow in the Middle Ages.

This idea that the four-color classical palette must have contained blue was established more firmly in the influential *Commentary on Painting* (1585) by Louis de Montjosieu, who said, "It is certain that these four colors, white, black, red, and blue, are the fewest needed in painting, and from a mixture of which all the others are composed." This transformation of the four-color palette was achieved by claiming that while indeed the mineral *sil* could be one of several colors—sometimes yellow, sometimes violet— the *sil* from Attica was blue. (Even George Field, in 1808, regarded silicates—"silex"—as the mineral origin of blues.)

It is hardly surprising that the absence of yellow from de Montjosieu's four-color scheme was in its turn to cause concern. (As far as de Montjosieu himself was concerned, yellow could be made from red and green—

an idea derived, it would seem, from Aristotle.) In the mid-seventeenth century the Frenchman Marin Cureau de la Chambre could not bring himself to believe that Apelles managed without yellow, and he concluded that by *sil* Pliny must have meant both blue *and* yellow, since *sil* could apparently be either color.

Such linguistic juggling reflects the need to reconcile Pliny's authority with the growing desire, by the seventeenth century, to incorporate all of the modern primaries—red, yellow, and blue—into the set of basic colors of which all the others are composed. We can locate the entry of blue into these schemes around the late sixteenth century, and it is safe to say that by the seventeenth century there was little argument that blue had to be included. In *Experiments and Considerations Touching Colours* (1664), Robert Boyle asserted this emphatically:

> There are but few Simple and Primary Colours (if I may so call them) from whose various compositions all the rest do as it were Result . . . I have not yet found, that to exhibit this strange Variety [a painter] needs employ any more than *White* and *Black*, and *Red*, and *Blew*, and *Yellow*; these *five*, variously *Compounded*, and (if I may so speak) *Decompounded*, being sufficient to exhibit a Variety and Number of Colours, such, as those that are altogether Strangers to the Painters' Pallets, can hardly imagine.[2]

It was soon to be white and black, the classical origins of all colors, that had to defend an increasingly arbitrary status as primaries. Isaac Newton showed that they were certainly not so in any generative sense. In the nineteenth century Michel-Eugène Chevreul continued to allow that these two, in addition to red, yellow, and blue, featured as primary colors in the palettes of the ancients, but Thomas Young's theory of color vision left no room for them in a scientific dissection of color.

ACROSS THE SEAS

Blue could in any case hardly have remained a subordinate color when, during the late Middle Ages, it was manifested in the most celebrated and precious pigment, ultramarine. How could a color that cost more to procure than the finest red (vermilion)—indeed, more than the medieval analogue of yellow, gold itself—be anything other than a primary? Ultramarine, vermilion, and gold were the glories of the medieval palette, and

surely a culture that equated value with virtue could not but be inclined to accord the hues of this venerated trinity some privileged status. I think we would not be overstating the case to suggest that it was due to a technical advance in pigment manufacture, as much as to any theoretical considerations, that blue emerged so prominently in the lore of the painter's craft.

Lapis lazuli simply means "blue stone." It is a deep, rich, alluring blue (Plate 45), but the purity of the color vanishes on grinding, which is why azurite instead provided the natural blue pigment of the ancient world. The blue stone is actually a mixture of minerals; the color comes from the dominant component, a mineral called lazurite (not to be confused with azurite).

Ultramarine is unusual among inorganic pigments in that its vibrant color does not derive from the presence of a transition metal. Lazurite is an aluminosilicate compound, a member of a class of minerals in which the basic framework of the crystal is composed of aluminum, silicon, and oxygen atoms. Aluminosilicates are usually colorless, but lazurite is distinguished in possessing sulfur in its makeup. The sulfur atoms cluster in groups of two and three, and the crystal absorbs red light by shuttling an electron between different sulfur atoms.

The deep blue of lapis lazuli is typically flecked with golden streaks, which add to its attractiveness as a semiprecious gemstone. These are fool's gold—iron pyrite, a compound of iron and sulfur. Calcite (calcium carbonate) and other silicate minerals are generally present too, and they account for the grayness of the powdered stone. Lapis lazuli was nevertheless sometimes used as a pigment prepared by simple grinding. It appears, for example, in Byzantine manuscripts from the sixth to the twelfth centuries, in wall paintings from the sixth and seventh centuries in Afghanistan, and in eleventh-century Chinese and Indian paintings. But unless the stone consisted of exceptionally pure lazurite, the results were not very grand. Ground lapis lazuli (which we should distinguish from true ultramarine) has not been identified in any Egyptian, Greek, or Roman art.

The technique for making ultramarine seems to have been a medieval invention: Arthur Laurie, the Royal Academy's expert on artists' materials in the early twentieth century, suggests that good-quality ultramarine began to appear in Western art only around 1200. Theophilus, writing in the 1120s, makes no mention of it—his *azure* is azurite.

Lapis lazuli is a rare mineral. Virtually the sole source throughout the Middle Ages was Badakshan, now in Afghanistan. Poorly accessible at the headwaters of the Oxus River, the lapis quarries seem nonetheless to have

been mined for the precious blue stone since the days of the Mesopotamian civilization. Only much more recently were significant deposits found in Siberia and Chile.

Marco Polo visited these quarries in 1271 and marveled at them: "Here there is a high mountain, out of which the best and finest blue is mined. There are veins in the earth of stones out of which the blue is made and mountains whence silver is mined. And the plain is very cold."[3]

We do not know who discovered the method for extracting the princely pigment from the detritus of powdered lapis lazuli. Daniel Thompson suggests that true ultramarine was imported to Europe from the East before the Europeans knew how to make it. Why else, he asks, would they persist in calling it "ultramarine" when many other raw materials for pigments were also imported? Early descriptions of the extraction process in the Arabic alchemical literature support this idea. One recipe is ascribed to the alchemist Jabir ibn Hayyan but dates from well after his death in the ninth century and so is one of the many such works that borrow the authority of his name.

The basic challenge is to separate the blue lazurite from the impurities. Most recipes say that ground lapis lazuli should be mixed to a paste with melted wax, oils, and resins. This paste, wrapped in cloth, is then kneaded in a solution of lye. The blue particles are washed out and settle to the bottom of the liquid.

The process employed since the late Middle Ages is described carefully by Cennino Cennini and gives us an indication of the lengths to which the craftsman was prepared to go to obtain this finest of colors:

To begin with, get some lapis lazuli. And if you want to recognize the good stone, choose that which you see is richest in blue color, because it is all mixed like ashes. That which contains least of this ash color is the best. But see that it is not the azurite stone, which looks very lovely to the eye, and resembles an enamel. Pound it in a bronze mortar, covered up, so that it may not go off in dust; then put it on your porphyry slab, and work it up without water. Then take a covered sieve such as the druggists use for sifting drugs; and sift it, and pound it over again as you find necessary. And bear in mind that the more finely you work it up, the finer the blue will come out, but not so beautifully violet in color. . . When you have this powder all ready, get six ounces of pine rosin from the druggists, three ounces of gum mastic, and three ounces of new wax, for each pound of lapis lazuli; put all these things into a new pipkin, and melt them up together. Then take a white linen cloth, and strain these things into a glazed washbasin. Then take a pound of this lapis

lazuli powder, and mix it all up thoroughly, and make a plastic of it, all incor-
porated together. And have some linseed oil, and always keep your hands well
greased with this oil, so as to be able to handle the plastic. You must keep this
plastic for at least three days and three nights, working it over a little every
day; and bear in mind that you may keep it in the plastic for two weeks or a
month, or as long as you like. When you want to extract the blue from it,
adopt this method. Make two sticks out of a stout rod, neither too thick nor
too thin . . . And then have your plastic in the glazed washbasin where you
have been keeping it; and put into it about a porringerful of lye, fairly warm;
and with these two sticks, one in each hand, turn over and squeeze and knead
this plastic, this way and that, just as you work over bread dough with your
hand, in just the same way. When you have done this until you see that the lye
is saturated with blue, draw it off into a glazed porringer. Then take as much
lye again, and put it on to the plastic, and work it over with these sticks as be-
fore. When the lye has turned quite blue, put it into another glazed porringer,
and put as much lye again on to the plastic, and press it out again in the usual
way . . . And go on doing this for several days in the same way, until the plas-
tic will no longer color the lye; and then throw it away, for it is no longer any
good . . . And every day drain off the lye from the porringers, until the blues
are dry. Then when they are perfectly dry, do them up in leather, or in blad-
ders, or in purses.

It is extraordinary that the method works at all, since it is not perfectly un-
derstood even now. Possibly it depends on the surface properties of the
mineral grains, the lazurite being wetted most readily by water and so be-
ing the first to leave the dough and become suspended in the solution. As
Cennino indicates, several successive kneadings in fresh lye are required to
extract all the pigment. The largest, most richly colored particles come out
first, while the last washings release colorless impurities as well as the blue
particles. This low-grade "ultramarine ash" was used for creating pale blue
oil glazes. "Bear in mind," says Cennino, "that if you have good lapis lazuli,
the blue from the first two yields will be worth eight ducats an ounce. The
last two yields are worse than ashes: therefore be prudent in your observa-
tion, so as not to spoil the fine blues for the poor ones."[4]

It is inconceivable that the cost and effort involved in making ultra-
marine would have been tolerated if the result were not so beautiful. Its
hue marks the transition from dusk to night, with a purple tint to enhance
its majesty. Cennino sings its praises rhapsodically: "Ultramarine blue is a
color illustrious, beautiful, and most perfect, beyond all other colors; one
could not say anything about it, or do anything with it, that its quality
would not still surpass."[5]

SYMBOL AND SUBSTANCE

I have already indicated the painterly consequences of the pigment's expense. To use ultramarine was not only to display wealth but—more important in the sacred works of the Middle Ages—to confer virtue on the painting. Nowhere is this more apparent than in the ubiquitous blue robe of the Virgin. To the monastic painter, the use of such materials conveyed due reverence. But as artists worked increasingly under private contract to a wealthy patron, the use of ultramarine might be stipulated to emphasize the patron's own piety and merit, not to mention his wealth and social standing. Thus, for example, we find a contract from 1417 commissioning an artist to paint an altarpiece of the Virgin "with fine colors and especially fine gold, fine ultramarine blue, and fine lake." Similarly, the contract for Andrea del Sarto's *Madonna of the Harpies* (1515) requires the Virgin's robe to be rendered in ultramarine "of at least five broad florins the ounce."

There is thus a very wordly reason why the mother of Christ is so typically robed in blue (Plate 46)—a convention that persisted long after the Renaissance. Yet historians have often sought to justify the choice of blue on symbolic grounds: blue is the "heavenly" spiritual color, connoting humility or whatever (one does not have to look far to find suitable symbolic correlates for any of the primaries). Johannes Itten, the foremost color theorist of the Bauhaus art school, suggested that "the retiring nature of blue, its meekness and profound faith, are frequently encountered in paintings of the Annunciation. The Virgin, hearkening inward, wears blue."[6] Clearly, color theory risks overlooking the obvious if it does not embrace the substance of color.

The inception of oil painting, however, presented a challenge to ultramarine's eminence, for in oil it was no longer quite so majestic. To recover the fully saturated blue, artists were forced to add lead white and thus to corrupt the purity of the material. This technical exigency was no doubt more acceptable as humanism eroded the reverence for materials as agents of religious valorization, but it probably contributed to this erosion too. According to art historian Paul Hills, "Adding white to blue—a seemingly small change—is a telling sign of the turn from medieval to early modern color."

Giovanni Bellini was one of the earliest Venetian painters to embrace the oil technique, and in his *Doge Agostino Barbarigo Kneeling Before the Virgin and Child* (1488), the mother of Christ is robed in a blue lightened only to

the bare minimum with lead white so that the modeling of the folds is rather shallow. But Bellini's pupil Titian gives us a much paler blue for the Virgin's robe in *Madonna and Child with Saints John the Baptist and Catherine of Alexandria* (c.1530) (Plate 47); by this time painters had become much less inhibited about mixing ultramarine, and Titian was using painterly skill to suggest the riches of blue silk rather than depending on the primary attributes of his materials. This change in turn freed the artist to create a far wider range of blues, and Hills believes that it helped flood Renaissance canvases with light:

> Only once the long-standing reluctance to mix ultramarine with white was overcome were painters free to discover the value of a whole range of blues in gradations of lightness. . . Blue by the fifteenth century was moving away from its association with starry night, the vault of the heavens, to the cheerful sky of day.[7]

The proclivity for lavish use of ultramarine was confined mostly to Italy, mainly for reasons of commerce: its ports were the conduits through which the pigment came west. Although ultramarine is not uncommon in northern European art, it is used with more restraint: a commentator remarked in 1566 that it was seldom found in Germany. Albrecht Dürer was one of the few German painters to use it, and then not without complaining loudly of its expense in letters to his patron. In 1521 he purchased ultramarine in Antwerp at one hundred times the cost of some earth pigments.

For mural painters, who worked with much larger areas than panel painters, this vast expense virtually prohibited the use of the finest of blues. An exception described by Vasari reveals just how cautiously the precious blue was apportioned. He tells how Perugino was commissioned by the Gesuati friary in Florence to paint a fresco, for which the budget had been stretched to include precious ultramarine. The Gesuati friars were themselves among the most renowned suppliers of ultramarine in Florence, which is no doubt why they could afford it.

But the prior feared that Perugino might try to substitute some cheaper material, and so he watched over the painter as he worked. Offended by this distrust, Perugino sought revenge. As he dipped his brush into the waterborne pigment, he surreptitiously squeezed the bristles before applying the paint to the wall. In this way, he appeared to be running out of pigment much faster than he really was, since the brush marks were so faint. And so

he kept asking for more pigment to be added to the dish, which gradually accumulated at the bottom. Perugino later recovered this valuable stuff for his own use when the prior was not watching.

The story is probably pure invention, but its message is accurate enough. It brings to mind the tale of how, when the Pre-Raphaelites Dante Gabriel Rossetti, William Morris, and Edward Burne-Jones were painting a mural at Oxford University, Rossetti upset an entire pot of natural ultramarine, still even then a hugely expensive pigment. The committee who had to foot the bill was mortified.

The Gesuati prior's anxieties about substitution of a cheaper pigment were in any case misplaced, since for frescoes there was no good, convincing alternative to ultramarine. Indigo tends to turn blackish, and smalt had a reputation for being difficult to work with. The usual stand-in, azurite, is useless for fresco, as it turns green when exposed to water: the crystals take up more water, and the copper shifts its hue. Azurite can be applied dry (*a secco*) to walls, but this makes it far less durable and liable to flake off. As a result, blue is not much in evidence in medieval and Renaissance frescoes. The glorious exception is Giotto's work in the Arena Chapel in Padua (c.1305) (see Plate 13), where expense seems to have been no constraint. Proust's Marcel in *À la recherche du temps perdu* says of the astonishingly well-preserved murals that "the entire ceiling . . . and the background of the frescoes are so blue that it seems as though the radiant day has crossed the threshold with the human visitor."

In the late sixteenth century, supplies of azurite became temporarily scarce, and this created a greater demand for ultramarine—which meant that the Italians, through whose ports it came, appropriated most of it. There was something of a crisis outside Italy in the supply of fine blues. Whether this explains why Pieter Brueghel the Elder used neither ultramarine nor azurite but lowly smalt for the Virgin's robe in *Adoration of the Kings* (1564) is not clear, but almost a century later, the Spaniard Francisco Pacheco wrote that even wealthy painters in Spain were unable to procure ultramarine.

BLUE BLOOD

Although things were not always so bad as this, fine blues remained a luxury item for painters for hundreds of years. Compared with reds (vermil-

ion, red lead, madder and carmine lakes) and yellows (Indian yellow, gamboge, Naples yellow, orpiment, lead-tin yellow), the choice of blues was very limited. Smalt and blue verditer were cheap options that approximated azurite, but indigo was for centuries the only alternative with a depth of tone comparable to ultramarine. Yet it is a poor substitute, with a greenish tinge that compares ill with ultramarine's gorgeous purple.

That situation was somewhat alleviated at the beginning of the eighteenth century by a chance discovery of a Berlin colormaker named Diesbach. It was the kind of happy accident that characterizes so much of the history of artists' colors and indeed so much of technological innovation in general. I strongly suspect that we would find the same motif accompanying the inception of the older pigments if the details had not long since joined the book of time's forgotten tales. Diesbach was trying to make one thing and ended up making another, a happy victim of impure reagents. The advance of chemistry has relied heavily on the carelessness of distillers, refiners, and manufacturers, and I mean that with no disrespect.

Diesbach was making cochineal red lake, which required iron sulfate and potash. He secured his potash from an alchemist named Johann Konrad Dippel, in whose laboratory Diesbach was laboring. Presumably in an attempt to economize, Diesbach requested that Dippel give him a batch of potash that had been contaminated with animal oil, which was waiting to be thrown away. Diesbach discovered soon enough that it was a false economy, since his red lake turned out extremely pale. Making the most of a bad job, he attempted to concentrate it, whereupon it turned purple before becoming deep blue.

Perplexed and lacking much chemical knowledge, Diesbach turned to Dippel for an explanation. The alchemist deduced that the blue color came from a reaction between iron sulfate and the contaminated alkali. More than that he was unable to say, but in retrospect we can see that the alkali had reacted with Dippel's oil, prepared from blood, to make potassium ferrocyanide (a compound still known in German as *Blutlaugensalz*). This then combined with iron sulfate to form the compound that chemists call iron ferrocyanide, known more familiarly (even to them) by its pigment name, Prussian blue.

Diesbach made his serendipitous discovery sometime between 1704 and 1705, and the blue substance was soon being manufactured in Berlin as an artists' material. It seems to escape mention in the chemical literature until 1710, when an anonymous communication in the *Miscellanea*

Berolinensis praises its beauty and advocates it as a color "equal to or excelling Ultramarine."

This report went on to claim that "it is harmless: nothing here is arsenical; nothing contrary to health, but rather a medicine. Without danger, those things which are made from sugar can be painted with this colour and eaten." Surprisingly (given its cyanide content), this is largely true: the pigment is not significantly toxic and is used in cosmetics.

Of the synthetic procedure, French chemist Jean Hellot remarked in 1762 that "nothing is perhaps more peculiar than the process by which one obtains Prussian blue, and it must be owned that, if chance had not taken a hand, a profound theory would be necessary to invent it." That was undoubtedly true, and the synthesis was a jealously guarded secret until an Englishman, John Woodward, acquired from Germany a description of the process, which he promptly published in the *Philosophical Transactions of the Royal Society* in 1724. The method he related was unnecessarily elaborate; so little was known about the product that no one could be sure what was essential and what was not.

By this time the pigment was also being manufactured in Paris by Diesbach's pupil De Pierre, with whom he had shared the secret recipe. (The color has also borne the name Paris blue for this reason.) The German chemist Georg Ernst Stahl gave a detailed account of the discovery of the blue pigment in 1731, and by 1750 it was widely known throughout Europe. At just a tenth of the price of ultramarine, Prussian blue was a very attractive alternative. It was much used by painters in the late eighteenth century, including Thomas Gainsborough and Antoine Watteau.

Its fullness of hue commended Prussian blue to some color theorists and technologists as a candidate for primary blue. Jacob Le Blon used it as such in his early attempts at three-color printing in the eighteenth century (Chapter 12). Although it is translucent because of its extremely fine particles, Prussian blue has a high tinting strength—a tiny amount added to white will impart a strong blueness. In the United States, where it was known with characteristic bluntness as "iron blue," the color was used from at least 1723 as a house paint, and it also proved amenable as a dye for silk and calico.

Artists and colormen were more cautious. In 1850 George Field remarked that it was "by no means equal in purity and brilliancy to those of cobalt and ultramarine, nor [has it] the perfect durability of the latter." In *Ancient and Modern Colours* (1852), W. Linton called it "a rich and fascinating

pigment to the colourist, but not to be depended upon; and yet difficult to avoid."

The color became increasingly less difficult to avoid in the nineteenth century, but nonetheless Prussian blue is not hard to find in works from the eighteenth to the twentieth centuries. By 1878, Winsor and Newton was selling a range of paints based on the material—not only Prussian blue itself but also Antwerp blue (mixed with white) and two greens in which it was mixed with gamboge. William Hogarth, William Blake, and John Constable were among the artists who used it for mixed greens, and it is found in the blues of Monet, van Gogh—strikingly in *La Mousmé* (1888)—and Picasso, for whom its slightly grayish-green tone better suited his melancholy purpose during the Blue Period than the bright tones of cobalt blue or ultramarine. Though not one of the most popular of colors for modern painters, Prussian blue has been employed in dramatic fashion by the British artist and sculptor Anish Kapoor—bound with a resin into a slurry that coats the surfaces of the shapes in *A Wing at the Heart of Things* (1990) (Plate 48).

Prussian blue and related ferrocyanide colors are still manufactured in vast quantities today (by a considerably simpler method), being favored for commercial paints primarily because of their cheapness. The blue was also used as a printing ink until being superseded by aniline dyes.

SYNTHESIZING MAJESTY

Yet for the artist, Prussian blue was still no substitute for ultramarine. Like indigo, it takes on a greenish tint, and as George Field remarked, it could prove unstable. By the dawn of the nineteenth century, strong, affordable blues were still desperately sought.

Chemists had by that time become accustomed to the idea that nature's inorganic materials could be re-created by laboratory synthesis. Surely the chemist's art should be able to conjure up artificial ultramarine?

But synthesis required knowledge of the chemical composition, and that was frustratingly elusive. The problem is that the mixture of elements in ultramarine (more properly, in lazurite) is not only complex but also variable: the sodium and sulfur (and sometimes calcium) content can differ, and some samples also contain chloride or sulfate ions in the crystal lattice.

In 1806 the French chemists J. B. Désormes and F. Clément published

Plate 42: The Virgin in Jan van Eyck's *Virgin with Chancellor Rolin* (c. 1437) is robed not in the traditional blue of ultramarine but in crimson, reflecting the great worth of cloth dyed in this color.

Plate 43 (below left): Arthur Hughes's *April Love* (1856) reveals the influence of the so-called "Mauve Decade."

Plate 44 (below right): A silk dress from around 1862 dyed with Perkin's mauve, and (inset) a bottle of the aniline dye.

Plate 45: Lapis lazuli, the stone from which ultramarine can be laboriously extracted.

Plate 46: Duccio's *Virgin and Child with Saints* (c. 1315) typifies the medieval use of ultramarine for the Virgin's robe.

Plate 47: Titian's Virgin in *Madonna and Child with Saints John the Baptist and Catherine of Alexandria* (c. 1530) is robed in a far lighter blue than medieval artists would have deemed suitable, for the transition to oil paints compelled artists to mix ultramarine with lead white.

Plate 48: Anish Kapoor covered the rocklike forms of *A Wing at the Heart of Things* (1990) with Prussian blue.

Plate 49: Yves Klein's International Klein Blue, seen here in *IKB 79* (1959), is basically a kind of synthetic ultramarine that is combined with a binder that does not diminish the luster and intensity of the pigment.

Plate 50: Pigment as art: Yves Klein's *Ex Voto for the Shrine of St. Rita* (1961)

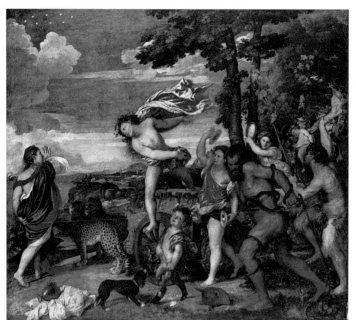

Plate 51: Before it was cleaned in the 1960s, Titian's *Bacchus and Ariadne* gave a misleading impression of color use in Renaissance Venice.

Plate 53: A cross section through a paint layer from Gerard David's *Canon Bernardinus de Salviatis and Three Saints* (after 1501), taken from a part of Saint Donatian's purplish cloak, shows how the color is built up from a mixture of red lake and azurite over a reddish underpainting. The black particles are charcoal from the underdrawing.

Plate 52: Cosimo Tura's *Allegorical Figure* (c. 1459–1463) was one of the earliest Italian works to be executed (partly) in oils.

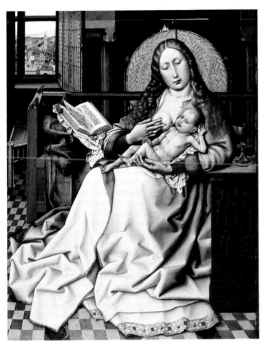

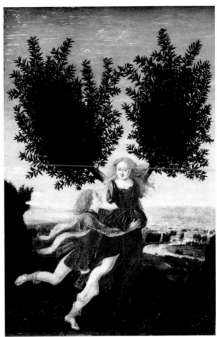

Plate 54: The purple robes in *The Virgin and Child Before a Firescreen* (c. 1440) by a follower of Campin have blanched with time as the red lake used by the artist has faded.

Plate 55: The dark foliage and brownish landscape in Antonio del Pollaiuolo's *Apollo and Daphne* (c. 1470–1480) were not intended; they are the result of the discoloration of green "copper resinate."

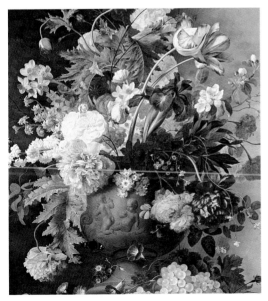

Plate 56: Jan van Huysum's *Flowers in a Terracotta Vase* (1736) seems to depict strange blue leaves. They were once green, but the yellow lake has faded.

Plate 57: Jacob Le Blon's three-color printing process, used to produce this image around 1722, was capable of impressive and subtle modulations of color.

Plate 58: George Baxter's color prints, such as *Hollyhocks* (1857), after V. Bartholomew, were made using oil paints instead of inks, giving them unusual vibrancy and longevity.

(a) (b) (c)

Plate 59: The effect of different "cluts" on a digitally recorded image of *View of Delft* by Jan Vermeer: (a) a well-chosen clut; (b) a clut that captures the original less well; (c) a wholly inappropriate choice of clut.

Plate 60: The Fauvist use of bright color is rarely bolder than in André Derain's *Pool of London* (1906).

Plate 61: Household paints produce strong, bright colors free from the "painterly" brush marks of traditional oil paints. For works such as *Pottery* (1969), Patrick Caulfield used house paints made by Crown and Dulux. "I haven't got any brush strokes, you know," he said. "I'm not Rembrandt."

Plate 62: Does Mark Rothko's Color Field painting *Ochre and Red on Red* (1954) retain the vestigial traces of landscape?

Plate 63: *VAV* (1960) by Morris Louis was made by pouring highly thinned acrylics down the canvas.

Plate 64: Kenneth Noland's "Target" paintings, such as *Drought* (1962), use acrylics and PVA emulsions to achieve a flat paint surface with sharp edges.

Plate 65: Frank Stella's *Six Mile Bottom* (1960), painted in aluminum industrial paint, exemplifies the materialist minimalism of the American Hard Edge school.

Plate 66: Beyond minimalism, beyond paint: Stella's *Guadalupe Island* (1979) is part painting, part relief sculpture, made from aluminum honeycomb used in aerospace engineering. Whatever else was in the studio might end up in the picture: "We had cans of those sequin things and [pigment] powders . . . We did throw a lot of ground glass around."

in *Annales de chimie* the first accurate analysis of the composition of ultramarine: a compound, they said, of soda, silica, alumina, and sulfur. This led to the subsequent identification of apparently similar blue compounds generated as impurities and by-products of various industrial chemical processes, notably the manufacture of soda. Such substances had in fact been known for some time, albeit with little understanding of their chemistry. In 1787 Goethe commented on the blue deposits found on lime kilns in Italy and remarked that they were often used locally as substitutes for lapis lazuli in ornamental work. Here, then, was a clue to making the genuine article synthetically.

In 1814 the French chemist M. Tassaert asked Nicolas Vauquelin to analyze a blue material taken from the soda kilns of a glass factory. Vauquelin reported that the substance was similar in composition to the formula Désormes and Clément proposed for ultramarine, and Tassaert suggested to the Société d'Encouragement pour l'Industrie Nationale that chemists might use this insight to develop artificial ultramarine. In 1824 the Société took up the idea by offering a prize of 6,000 francs to anyone who could devise a viable industrial process for its manufacture, provided that the product could be sold at less than 300 francs per kilogram. The bait was not the first of its sort: the Royal College of Arts in England offered a much more modest sum for the same achievement in 1817.

Six thousand francs was enough to attract all manner of charlatans, and the initial entries were nothing more than variants of Prussian blue or of the cobalt blue discovered in 1802. But in February 1828 the Société decided that the color manufacturer Jean-Baptiste Guimet from Toulouse had met the challenge. Guimet established a workshop in Paris for making ultramarine, and he began selling it at once for 400 francs per pound—about a tenth the cost of the natural pigment. Guimet was awarded the prize.

Yet just a month later the Société received a rival claim from the German chemist Christian Gmelin at the University of Tübingen. Gmelin had independently arrived at a slightly different process for making the pigment—and moreover, he said, he had done so a year earlier but had not published at that time. Guimet retaliated with an assertion that he had in fact concocted his own process as early as 1826 but had kept it secret until informing the Société.

The matter was disputed for several years. Guimet was in the end apparently able to substantiate his claim to the satisfaction of the French commitee (if not to those outside France), and the prize money remained his.

As a result, artificial ultramarine retains even today the name "French ultramarine."

Although he did not enter the fray, a third industrialist, the German F. A. Köttig, also developed a manufacturing method around the same time as Guimet and Gmelin. Köttig was based at the porcelain works at Meissen, where he manufactured ultramarine during the 1830s. Guimet began industrial-scale production at Fleurieu-sur-Saône in 1830, and there were soon factories making the stuff elsewhere in France and Germany and then in England, Belgium, and the United States.

The methods of both Guimet and Gmelin were based on the same process, which amounts to little more than throwing all the necessary elements together and cooking them. A mixture of china clay (kaolin, an aluminosilicate), soda (sodium carbonate), charcoal, quartz or sand (silica), and sulfur is heated in a furnace, and the *green* glassy substance that results ("green ultramarine") is ground and washed to remove soluble impurities. The dry green material is reheated, converting it to a blue substance, which is then washed again and ground to yield the pigment. The precise color of the product can be varied by altering the amounts of the ingredients.

One might imagine that given the costs associated with natural ultramarine, artists would have welcomed the synthetic product with open arms. The truth is more complex, reflecting perhaps the awe with which ultramarine had long been regarded. Could the product of an industrial furnace really offer something comparable? Nevertheless, the French chemist J.-F.-L. Mérimée reports that Guimet's ultramarine was used by Ingres in *The Apotheosis of Homer*, a painting that is dated 1827, before Guimet had even claimed his prize. This would certainly help support Guimet's claims of priority, not to mention revealing a progressive streak in the conservative Ingres.

As noted in Chapter 7, Turner was much inclined to experiment with novel pigments, and there is some evidence that he used the synthetic ultramarine as a watercolor in 1828 or 1829. Yet there is no clear indication that he risked the new material on works in oils, aside from the fact that artificial ultramarine has been found on two of his palettes, one of them the last he used before his death in 1851. Indeed, Turner is said to have been deterred from helping himself to some ultramarine on someone else's palette for a work hung for varnishing at the Royal Academy by the cry that it was "French"—that is to say, synthetic. The artificial pigment suffered, undeservedly, from a poor reputation in England in the first half of the

nineteenth century, and Turner was apparently swayed by the prevailing opinion. George Field, whose advice weighed heavily with Turner, continued to make his own ultramarine from lapis lazuli.

Yet the phenomenal difference in cost could scarcely be ignored. Around the beginning of the 1830s, natural ultramarine cost 8 guineas an ounce in England, whereas the synthetic version could be had for between 1 and 25 shillings per pound: a differential of between about 100 and 2,500. Moreover, despite the rumors, the synthetic material weathered about as well as the natural one. By the 1870s, artificial ultramarine was the standard blue for painters—even more so than cobalt blue, which was appreciably more expensive. It features prominently in the palettes of the Impressionists, notably Renoir's blue-heavy *The Umbrellas* (c. 1880–1885), and was also used in delicate mixtures by Cézanne. The bright blues of van Gogh's *Wheatfield, with Cypresses* (1889) rely on it.

TWENTIETH-CENTURY BLUES

There is something poignant in seeing ultramarine, the undisputed queen of pigments in the Middle Ages, relegated to just another off-the-shelf blue in the twentieth century. It is a common trajectory for painting materials: from exotic and illustrious import, with all the mystery of rare spices or incense, to cheap commodity. But maybe this is to take too pessimistic a view, for art has certainly benefited from the tremendous broadening of the palette. And that process continued in the twentieth century with the introduction of still more shades of blue.

Two new blue pigments arrived in 1935: monastral blue and manganese blue. The first is the English trade name for a lake pigment made from ICI's copper phthalocyanine. Bold claims were made for it—that it was the "most important discovery since that of Prussian blue and artificial ultramarine"—and there is no doubting its considerable commercial impact. As a blue pigment, it shares none of the luxuriant hue of ultramarine, but its importance lies more in the fact that it absorbs red and yellow almost totally while transmitting or reflecting blue and green, making it the ideal cyan color for three-color printing.

Manganese blue—barium manganate attached to particles of barium sulfate—also displays a slight greenness of tint. It was patented in 1935 by the German color cartel IG Farben and was initially used to color cement.

It has never become a major pigment for artists—these days, the blue market is too tough to crack unless you have something very special to offer.

As indicated at the beginning of this chapter, we need not look far for blue themes in twentieth-century works. I wish to single out Yves Klein because of his uncommon engagement with the technology of color, which led him to invent a new blue that bore his name.

Klein's early monochromes of the late 1940s and early 1950s left him troubled by the effect of the binding medium on the pigments. He adored the richness of the dry powders—"what clarity and lustre, what ancient brilliance"—but recognized that this was always diminished once they were mixed with the binder to form a paint: "The affective magic of the colour had vanished. Each grain of powder seemed to have been extinguished individually by the glue or whatever material was supposed to fix it to the other grains as well as to the support."[8] Klein longed to find a means of retaining the intensity of the pure color and so realize its full potential to awaken the emotions of the viewer.

He sought the assistance of Édouard Adam, a Parisian chemical manufacturer and retailer of artists' materials. With Adam's help, Klein found his solution in 1955: a fixative resin called Rhodopas M60A, manufactured by the Rhône-Poulenc chemical company, which could be thinned by mixing with ethanol and ethyl acetate. "It allowed," he said, "total freedom to the specks of pigment such as they are found in powder form, perhaps combined with each other but nevertheless autonomous."[9]

To Klein, the matte, velvety texture that resulted possessed a kind of "pure energy," allowing every nuance of color to reveal itself as "a living creature of the same species as the primary colour." He used the binder to create textured monochrome surfaces in spectacular colors: golden yellows, deep rose pinks. Yet he found that audiences seemed to appreciate his bright canvases largely for their decorative effect, which was not his intention at all. Klein therefore resolved to restrict himself to working in a single color. It would consequently have to be a truly extraordinary one.

And what could be more extraordinary than Cennino's illustrious ultramarine—albeit now a product of synthetic chemistry, divorced from its mineral source. Yet while Cennino delighted in the grandeur of the material, Klein was attracted by something more abstract, an idea of blueness that would draw the viewer beyond any superficial splendor. For him, the technical achievement involved in realizing this blue was a means to a conceptual end. Thus his patenting of the new color, International Klein Blue, in 1960 was not so much a commercial act as, on the one hand, a formal

validation of the metaphysical idea that his medium represented and, on the other, insurance against the possibility that others would use it in ways that corrupted the "authenticity of the pure idea."

Klein's exhibition in Milan in 1957, Proclamation of the Blue Epoch, disclosed his program in a series of blue monochromes. To emphasize his intention to transcend the superficial, Klein gave each canvas a different price, despite the fact that all were "identical." Value, he felt, should reflect the intensity of feeling that had gone into the creation of the work and not what it looked like. The product was simply a record of that creative energy. This stress on the *making* is an enduring aspect of Klein's contribution to modern art.

The Milan exhibition was a great success. In Paris, where the elite of the avant-garde were prone to bitter factional controversies, the reception was more mixed. But Klein's bold concept soon won him international acclaim as "Klein le monochrome." These shimmering blue works, mostly identified simply by a numbering scheme prefixed with "IKB" (Plate 49), have to be seen at first hand to be fully appreciated; no reproduction can do them justice. Klein applied the paint with a roller or with sponges, which in 1958 he began to incorporate into the work itself, preserved with a resin and impregnated with the blue pigment.

As Klein's work broadened into new conceptual areas—his Pneumatic Epoch with its focus on the Void, his kinetic sculptures with Jean Tinguely, his body imprints or *anthropométries*—he remained largely true to his blue manifesto. *Hiroshima* (1961) captures blue silhouettes against a deeper blue space, their outstretched limbs recalling the ghostly white shadows of vaporized victims of the atomic bomb. The joyous blue outlines of *Humans Begin to Fly* (1961) mark his conviction that people can surmount all physical limitations. His exquisite votive offering (*Ex Voto*) to the shrine of Saint Rita at the Cascia Convent in Italy, made in 1961, carries his coloristic aims to their logical conclusion by presenting unadulterated pigments enclosed in clear plastic (Plate 50). Here is a prayer accompanied by a primary trinity of medieval descent: ultramarine, gold, and a thoroughly modern deep pink to replace vermilion.

In the IKB-coated world of *Blue Globe* (1957) and the topographic *Planetary Reliefs* (1961), Klein revealed his utopian vision of a planet rendered comfortable and harmonious by a "permanent miracle" of climate regulation. Nothing served to strengthen this vision more than cosmonaut Yuri Gagarin's words from 1961, a year before Klein's premature death: "Seen from space, the earth is blue."

TIME AS PAINTER

THE EVER-CHANGING CANVAS

"In the history of modern art the use and abuse of colours would furnish a sad chapter, telling of a gross ignorance, and a grosser indifference." —George Field (1869), *Chromatography*

"A color known as red lead . . . is good only for working on panel, for if you use it on the wall it soon turns black, on exposure to the air, and loses its color."
 —Cennino Cennini (c. 1390), *The Craftsman's Handbook*

" 'Restoration' is a very poorly chosen term, and, strictly speaking, it signifies something which cannot be done. The genuine restoring of a painting is obviously something which is possible only to its original creator." —Max Doerner (1921), *The Materials of the Artist*

Titian's *Bacchus and Ariadne* blazes on the wall of London's National Gallery as an unforgettable testament to the Venetians' love of strong color. But what a different impression we should have had of them before the picture was cleaned in 1967–1968 (Plate 51). The radiant azurite sky was a muddy brownish mauve, and the whole image was pervaded by a murk that makes the most "gravy-brown" Constable look positively radiant.

No wonder the unveiling of the cleaned picture provoked outrage. Even a public acclimatized to the garish hues of twentieth-century art were un-

prepared for the idea that Titian's tones were similarly strident. As far as attitudes toward the Old Masters were concerned, it seemed that little had shifted in public taste since the Victorian age, during which disastrous "restoration" work transformed one of the most glorious images in art into a gloomy mess, deemed concordant with the sober preferences of a conservative aesthetic.

We can see in the sorry fate of *Bacchus and Ariadne* exactly what restoration meant in those earlier times. Although cleaned to something like its present state in 1806–1807, the paint surface was flaking badly, partly as a result of the picture's having been rolled up in the sixteenth and seventeenth centuries (one of the hazards of painting on canvas instead of board). To redress this, the picture was repainted in the most damaged areas, and little by little it was colonized by a reinterpretation in nineteenth- and early-twentieth-century styles. Each repainting was accompanied by a heavy coat of the honeylike varnish beloved by Victorian restorers. So the modern cleaning actually involved stripping away several layers of varnish and paint.

Yet at least cleaning was all that was needed. I have often felt mystified at why van Gogh's *Sun Flowers* commands such high regard—it seems a drab, lackluster piece, uncharacteristic of the artist. But that is because we are not seeing what the artist painted. Those dirty ochers were once bright, but the pigment (chrome yellow) has degraded over time, and we are left with a shadow of the true painting. Max Doerner believes that we should in this case give thanks to time for making the sunflowers more mysterious. I can't agree; I feel that a van Gogh is almost the last place to look for mystery in art. Be that as it may, this is by no means the only work of the Dutch painter that time has irreparably revised.

We can see, then, that a picture is never finished. No artist has ever painted an image frozen in time; all painting is a perpetual process, with every scene destined to rearrange its tonal contrasts as time does its work on the pigments. When John Ruskin said, "Every hue throughout your work is altered by every touch that you add in other places," he might have added, "and all that happens subsequently." When the artist has been reduced to the dust of centuries, time—sometimes personified by an overzealous restorer—goes on remodeling the colors, bringing darkness here and bleaching there, mocking our attempts to pronounce authoritatively on the coloristic intentions of the image's creator. Even the simple act of cleaning is, as one art restorer noted, "an act of critical interpretation."

So we must ask: Is there ever an "original" version of any work? How

much retouching can a painting withstand before it becomes primarily a superimposed copy, however sensitively executed? The Devonshire Hunting Tapestries that hang in august preservative gloom in London's Victoria and Albert Museum are said to be so extensively renovated that not a stitch of the originals remains (yet they are still treated as the genuine item). It is legitimate to ask whether we can ever talk in great detail about the color practices of, say, the Venetian Renaissance when our only points of visual reference are five-hundred-year-old patches of pigment. And how much more complex the question of "true" color becomes when the artist has applied colors in the knowledge that time will temper them.

I think we can have confidence, however, that diligent restoration and careful analysis of pigment samples allow us to reconstruct the intentions and techniques of the artist in considerable detail. Moreover, it is not necessary to see exactly how a work looked when it was painted in order to be able to deduce the artist's attitude toward color and how it was influenced by the materials used. What we see is what we get, but not necessarily what we were *meant* to get. The materials of the artist can be substances of great beauty, but they are treacherous too.

RESCUING THE PAST

Any major gallery must have a team of dedicated conservators if its collection is not to fall quickly into a sorry state. The technical reports produced by these teams make sobering reading. Here you might encounter your favorite pictures, like *Bacchus and Ariadne*, in a barely recognizable form before the conservators got to work on them. Soon enough you are prowling the galleries with a suspicious eye, asking yourself: Is this a *before* or an *after*? Should these skies really be so washed-out, these greens really so murky? Many changes are, sadly, irreversible, yet an ability to recognize them allows one to reevaluate the picture, to sense what beauty must have been present before this ultramarine went black, before that red lake faded. You will soon begin to appreciate that no critical analysis of paintings should be undertaken without a sound knowledge of how colors age.

Restoring a major work is a huge and painstaking undertaking, and many of the less eminent pictures hanging on gallery walls will never find their way to the front of the queue. For every painting like Hans Holbein's *Ambassadors* in London's National Gallery, recently restored to its original

glory, there will be half a dozen lesser canvases consigned forever to brownness.

To appreciate what can befall a famous painting and how that affects our perception of it, consider Cosimo Tura's splendid *Allegorical Figure* (c. 1459–1463) (Plate 52). It is one of the earliest Italian works to be painted primarily in oils. The colors are ravishing, produced by a glazing technique that bears the unmistakable mark of the Netherlands. It is generally thought that this picture is a response by the Italian painter to the works of Rogier van der Weyden, who may have met Tura during a visit to Italy in 1450.

No one knows what the subject matter is—it is a deeply inscrutable image, and all the more striking for that. Tura's seated figure gazes out with a mysterious, almost quizzical serenity. But can we recognize her in the description of a commentator in the 1950s as "a coldblooded demon"? Such, it seems, was her appearance before cleaning and restoration in the 1980s. Cracks in the paintwork, along with some discolored and insensitive retouchings, had left the figure with a fierce expression. Moreover, her face, which is delicately modeled with highlights and shadow, was apparently reduced at that time to a flat, "masklike, smooth" visage. Clearly, the vicissitudes of time had altered the whole tone of the painting.

When the conservators at the Gallery looked into the picture's history to uncover the origins of the damage, they found a sad tale. The painting had originally been owned by George Somes Layard, who bequeathed it to the National Gallery on his death in 1916. In 1866 Layard decided it needed renovating and sent it with several other works to the Milanese restorer Giuseppe Molteni. It was not a cheap undertaking: Layard complained that the work would cost him as much as he'd paid for the paintings in the first place.

Molteni took the attitude, not atypical for the time, that works that came to him would benefit from alterations to "improve" them, bringing them more in line with nineteenth-century tastes. This could involve rather extensive repainting. Mercifully, the Tura escaped lightly, perhaps suffering only from Molteni's attempts to reduce the contrasts in the deep shadows of the pink drapery. Yet Molteni seems to have coated the glowing colors with a layer of brown varnish. The brownness was not the result of any shortcomings of varnish manufacture; it was quite intentional. Molteni tinted his varnishes with blackish and red-brown pigments such as Cassel earth. Thus "tastefully" modified, the picture was returned to its owner.

In 1921 the National Gallery sent the picture across London to the Vic-

toria and Albert Museum for woodworm treatment of the wooden panel. Taken from indoors in the middle of winter, the panel may have warped when exposed to the change in temperature and humidity, causing the paint surface to crack. At the Victoria and Albert it was fumigated with chloroform, which, it was subsequently discovered, attacked and blistered the paint. The damage was particularly severe where green copper resinate had been used, since the organic solvent softened and swelled the resin in the paint.

An attempt to repair the flaking was made in 1939. The panel was sent to a commercial restoration firm, which tried to reattach the loose flakes by pressing them with some heavy implement. Instead, many simply shattered and collapsed, so that the paint was lost. The worst of the damage was then retouched by hand.

The first task of the conservators in the 1980s was to remove all the junk that had accumulated on the panel over the past century or so. The brown varnish and the retouchings were relatively easy to swab away with methylated spirits. Over some damaged areas, such as flaking in the pink robe, a thick black paint had been applied, and this was carefully scraped off with a scalpel.

This cleaning process revealed some previously indistinct features of the work, such as the strange puffs of cloud down the right-hand side and the differences in color between the pink robe and the paler pink marble. The woman's face was restored to its original, more tender expression. Blisters and flakes of paint were reattached using glue and a hot spatula.

Yet this cleaned image was a distressing sight, laced with a fine web of cracks so that in places the figure appeared as though seen through a mesh (Figure 11.1). The conservators decided that some of this cracking should be retained—it is, after all, an inevitable aspect of the aging process, a kind of stamp of authenticity known as craquelure. But if the picture was to be at all fit for display, some retouching of the paint was essential, especially in the area of the face. This was done using pigments matched as closely as possible to those that would have featured in Tura's workshop, bound in a modern medium. The gaps were filled until the cracks were but fine threads. Where the damage was especially bad, the retouchers worked from old photos of the painting taken when it was still in the Layard collection in Venice.

It might come as a disappointment to know that works like this are commonly covered in fine brush marks of modern origin, rather than rep-

Figure 11.1: After cleaning but before restoration, Tura's painting was covered by a mesh of cracks.

resenting the unadulterated handiwork of the Renaissance Masters. But clearly, the alternative is either a distorted and discolored version restructured to suit the anachronistic judgments of another era or a fragmented surface that offers little hint of the painting's original power and brilliance.

And we can take some comfort from the fact that today's view of gallery maintenance places the emphasis on conservation over restoration. While repainting is sometimes unavoidable, it is generally kept to a minimum,[1] and most effort goes into maintaining the original integrity of a picture rather than reconstructing it in the (vain) attempt to keep it forever as it looked when the paint first dried. That is to say, the conservator seeks not to *complete* the painting but to create a balanced whole, working creatively with damage and aging rather than disguising them. In some cases, large areas of damage are not retouched at all but are simply rendered in a blank, neutral color so that the observer can see where they are without being distracted by them. A little dirt might be left on bright areas where differential aging of the pigments would otherwise leave it discordant with more muted surroundings. As Ernst Gombrich explains of restorers, "What we want of them is not to restore individual pigments to their pristine colour,

but something infinitely more tricky and delicate—to preserve [tonal] relationships."[2]

The restoration of Tura's painting had an unforeseen bonus. To identify areas of repainting, the panel was photographed with X-rays. This highlights pigments that absorb X-rays strongly, such as those that contain lead. The X-rays showed the outlines of a throne backed with a row of tall columns resembling organ pipes, revealing that the artist initially had a wholly different program. The painting was utterly transformed during its execution, something extremely unusual for the fifteenth century. We will probably never know what transpired to change Tura's plans.

UNDER THE SKIN

Dirty varnishes and cracks are physical impediments to our appreciation of a painting, and as such their effects can usually be more or less eliminated. But chemistry is less relenting. Just as iron rusts, copper corrodes, and silver tarnishes, so the chemical compounds that impart color to paints are liable to react with substances in the air or with light. These chemical reactions can alter their appearance, sometimes drastically. Whereas an iron railing or a copper roof can be scraped clean of a discolored surface film, a thin layer of pigment on wood or canvas can become transformed throughout by such reactions, and in general there is no easy way to restore it to its original state. To the painter who wishes to create a work that will speak for centuries, the discoloration of pigments is perhaps the most invidious of dangers.

It has always been thus. The progress of chemistry has enabled a better understanding of the processes that can degrade a color but not necessarily better means to prevent them. And as chemistry has supplied ever more colors, so too has it created more possibilities for their deterioration. Moreover, artists are liable to experiment with their materials, but they are no longer chemists and can seldom foresee the consequences of their explorations. Paint companies will now routinely test the permanence of their colors (which until the twentieth century they were by no means sure to do), but they cannot always anticipate the ways in which artists will use them.

And so the unreliability of artists' materials has been a constant complaint throughout the ages. We have seen some examples already in earlier chapters. It has been said of Joshua Reynolds, who was particularly given

to poorly informed experimentation, that many of his paintings were
"wrecked almost as soon as they left the studio." The American painter Au-
gustus Wall Callcott described in 1805 how the British artist John Opie
"observed that Painters were as much governed by their tools as their tools
were by them, seeming to consider that most of the art was dependent on
the materials." Most probably Opie had Reynolds very much in mind.

Yet how may we know that what now resembles yellow ocher was once
the seductively brilliant lemon yellow? That this patch of pale pink left the
painter's brush as rosy carmine lake? Knowing how a painting has aged pre-
supposes an ability to identify the pigments used. How is this done?

This question pertains not only to the decay of paintings but to the en-
tire theme of this book, for one might very reasonably ask on what author-
ity I state that Dürer used azurite where Titian would use ultramarine. An
expert can get a very long way indeed with an eye attuned to the differ-
ences in hue between greenish azurite and purplish ultramarine. But no
historian or conservator will give that much credence without a scientific
analysis of the pigments' identities.

Chemists have an impressive battery of methods for detecting the pres-
ence of this or that element or ion. Lead compounds dissolved in water re-
lease a heavy black deposit of lead sulfide on exposure to hydrogen sulfide
gas; soluble sulfate salts precipitate white barium sulfate when mixed with
barium chloride. Such tests are all very well if you are analyzing a heap of
powder. But no one is going to let you scrape away all the yellow from a
Monet so that you can determine what it consists of. Pigment analysts must
generally make do with the tiniest fragment of material, removed, for
instance, with the head of a sawed-off hypodermic needle. Occasionally,
"wet" chemical tests can be applied even for work on this scale, sometimes
conducted under a microscope. But commonly, more sophisticated meth-
ods are needed for definitive identification of a pigment.

Of the many methods now available, it is possible to make a few gen-
eralizations. Spectroscopic techniques are those in which the chemical
components of the sample absorb radiation of some characteristic wave-
length—an elaborate way of saying that one measures the pigment's color.
But it is a far more precise and quantitative assessment of "color" (and thus
of chemical identity) than a mere description such as "reddish orange" or
"bright green"; one determines how much light is absorbed at each wave-
length. And the "color" in question might fall outside the visible range—the
absorbed radiation might consist of X-rays or infrared rays, for example.

One of the best spectroscopic techniques for detecting particular ele-

ments is called energy-dispersive X-ray analysis (EDX), a method that mea-sures the characteristic wavelengths *emitted* rather than absorbed by the sam-ple. In effect the sample glows with X-rays of a certain color (that is, a certain wavelength) when stimulated by a beam of electrons (like that pro-duced inside a television set). Much the same is true of the technique called laser microspectral analysis, in which a laser pulse is used to heat a sample suddenly and vaporize it. The vapor then passes between two charged elec-trodes, triggering a spark. The spark acts rather like an electron beam, but of lower energy than that used in EDX, stimulating emission of radiation that is typically in the visible range and is diagnostic of the elements present.

Absorption rather than emission of radiation provides the basis of Fourier-transform infrared (FTIR) spectroscopy, which basically involves looking at the color of the sample in the infrared range, at wavelengths longer than those of visible light. Compounds absorb infrared radiation when the bonds between atoms are excited into resonant vibration by the radiation. The resonant frequencies are characteristic of the particular chemical bonds present in the compound.

Looking at small samples under a microscope can provide insights that spectroscopy cannot. For example, how can one tell if a nineteenth-century sample of ultramarine is natural or synthetic when both are more or less chemically identical? The shape of the microscopic pigment particles can tell a lot about the way the material was prepared. Grinding of lapis lazuli typically produces particles with a broad range of sizes, whereas the artifi-cial pigment tends to consist of rounder, more regular, and smaller parti-cles. Synthetic modern vermilion prepared by the dry process (see page 78) and then ground has a wide range of particle sizes, whereas wet-process vermilion, which is precipitated from solution as a fine powder, has uniformly sized particles.

Some pigments may be prepared in forms that are identical in chemical composition but slightly different in the way that the atoms are arranged in the crystal. Realgar, the orange sulfide of arsenic, is an example: in addition to the normal crystal form, there exists a different form called pararealgar, which is also orange. To tell them apart, one needs to know where the atoms are. This can be deduced from the pattern of X-rays scattered off the pigment particles. The regular stacks of atoms in the crystals reflect the X-rays more strongly at some angles than others, a phenomenon called dif-fraction. For a jumble of grains in different orientations, this gives rise to a series of concentric rings of reflected X-rays that can be recorded on pho-tographic film. The position and brightness of the rings constitute a record

of where the atoms are located in space. By such means, it has been possible to deduce that Paolo Veronese made use (doubtless unwittingly) of both realgar and pararealgar in the orange hues of his *Allegories* (c. 1570s).

The organic dyes that give lake pigments their colors are harder to identify with certainty. It is no good knowing that the dyes contain carbon, hydrogen, and oxygen, since that is true of most natural products and will not help us distinguish madder lake (colored by alizarin and purpurin) from kermes carmine lake or cochineal carmine lake (both colored by carminic and kermesic acids). There are, however, some wet chemical methods that can be used to distinguish them, even to the extent of differentiating kermes carmine from cochineal carmine. And infrared spectroscopy reveals the distinctive vibrations of the different organic molecules, provided that the sample is big enough to offer measurable spectra.

The technique of thin-layer chromatography allows the various molecular components in an organic dye to be separated. The components are carried in a solvent through a thin layer of a gel-like substance and travel at a speed that depends on their size and chemical structure. So gradually the different components separate out into distinct bands on the gel. Two dyes that contain the same component will, at any instant, produce bands matched at the same location. By using so-called high-performance liquid chromatography, it is even possible to distinguish between cochineal lakes in which the dyes have come from different sources: from Old World (Polish) or New World insect species, which produce different proportions of much the same coloring molecules.

Analyzing an artist's painting *technique* is generally a matter of close inspection of how the pigment has been applied to the canvas. Sometimes a great deal can be deduced simply from photographing the painting under strong light skimming across the surface at a low angle, so-called raking light. Like sunlight streaming over the fields just before sunset, this produces exaggerated shadows, highlighting the relief of the paint surface (Figure 11.2). A picture that appears under normal light to be a flat film of paint can then suddenly become a terrain of hills and valleys, showing where the brush has been wielded with long, sweeping gestures or short dabs. The energy of the brushwork leaps into view, almost alarmingly so in van Gogh's wild visions. We can see where modern Hard Edge painters have used masking tape, revealed by the raised ridges this leaves behind in the paint.

Microscopic examination of the paint surface shows us telling details

that the eye cannot easily see: where paint was applied wet-on-wet, for example, or where underpainting or drawn or ruled lines have not been fully covered up. We see the grains of sand charmingly stuck to Monet's beach scenes. But still more can be deduced from microscopic cross sections through the paint layers, which reveal how the Old Masters built up their scenes through meticulous applications of several strata. In a painting by Gerard David from the early sixteenth century, a purplish red drapery is revealed as a mixture of azurite and red lake over a red underlayer, beneath which black charcoal particles from the original drawing sit on the white ground (Plate 53). A plum-red cloak by the sixteenth-century Flemish painter Jan Gossaert is seen to consist of red lake over dark gray. We find by this means that Van Dyck in the seventeenth century sometimes applied double grounds—a brownish orange and a gray. Over this he would lay down very methodical mixtures: a sky of ultramarine and smalt over an underlayer of smalt alone or multiple applications of mixed red pigments. In these hidden layers, the full complexity of the artist's working process starts to unfold.

Figure 11.2: Illuminating a painting by oblique (raking) light reveals the pattern and style of brushwork. Shown here is *The Côte des Bœufs at L'Hermitage* (1877) by Camille Pissarro.

A HISTORY OF NEGLECT

Cennino Cennini was no stranger to the fugitive properties of his materials: "Some lake is made from the shearings of cloth," he wrote, "and it is very attractive to the eye. Beware of this type, for it . . . does not last at all, either with temperas or without temperas, and quickly loses its color."[3] He is apparently talking of the insect-based lake made from kermes, which was less stable than madder lake. But it would have been hard for the medieval artists to draw any secure generalizations about their lake pigments, since the resistance to fading depends also on the method of preparation, the inorganic particles on which the dye is bound, and the medium in which the pigment is mixed. All the same, it is broadly true that lake pigments, in which the coloring agents are delicate organic molecules, are more susceptible to fading when exposed to light than mineral-based pigments are.

Such changes can utterly subvert the artist's intentions. It was common in the fourteenth and fifteenth centuries for important figures in a religious scene, particularly Jesus or the Virgin Mary, to be depicted in sumptuous purplish robes. These would typically have been colored with ultramarine mixed or glazed with a red lake. Yet in several paintings of this era the red lake has faded away altogether, with the result that the robes are pale pink in the highlights and midtones (which contain a lot of white lead) and deep bluish purple in the shadows and folds, where they were darkened with ultramarine.

A particularly striking example is *The Virgin and Child Before a Firescreen,* painted by a follower of the French painter Robert Campin of Flémalle around 1440. The Virgin's voluminous robes fill most of the lower half of the painting, yet they are almost as pale as paper, where once they would probably have been a warm mauve (Plate 54).

Lake pigments were not alone in presenting medieval and Renaissance painters with hazards of impermanence that might have become evident even during their lifetimes. Vermilion offers a more reliable red but is not infallible. Like realgar, mercury sulfide adopts two crystalline forms: the red cinnabar that is vermilion and the black metacinnabar or "Ethiops mineral," which appears first in most methods for synthesizing vermilion. Reversion to metacinnabar may sometimes occur on the canvas, particularly if it is exposed to short-wavelength (blue) light. This process is more common in egg tempera than oil and is seen in medieval panel paintings such as Nardo di Cione's *Altarpiece: Three Saints* (c. 1365), where a saint's red-lined

gown is patched with dirty brown. The same thing is not unknown in later works in oils.

Max Doerner claims that the darkening of vermilion was "already known by the ancients," which is why the vermilion wall panels in Pompeii were covered with wax. Glazing vermilion with red lake, which became common practice during the Renaissance, also confers some protection, although whether the Old Masters knew this or were simply seeking to deepen and enrich the orange tint is not clear. But Cennino warns against the instability of unprotected vermilion, especially in fresco: "Bear in mind that it is not its nature to be exposed to air, but it stands up better on panel than on the wall; because, in the course of time, from exposure to the air, it turns black when it is used and laid on the wall."[4]

Red lead is a still more treacherous color. Lead's generosity of colors has its drawbacks, for in addition to red, white, and yellow, it readily forms a black compound, lead dioxide, when exposed to air. Without the protection of varnish, red lead will therefore darken rapidly, making it wholly unsuitable for frescoes. This deterioration has been seen on wall paintings in China, Turkestan, and Afghanistan, where the red lead has turned chocolate brown. Such darkening has happened far and wide: in fifteenth-century Indian miniatures, Japanese paintings of the seventeenth and eighteenth centuries, and Swiss wall paintings from the thirteenth to the seventeenth centuries. Blackening can also be caused by exposure to air polluted by sulfurous fumes, which leads to the formation of black lead sulfide.

Even the revered ultramarine was not immune to decay. Darkening has taken place in some medieval altarpieces, leaving robes a most inauspicious blue-black. And occasionally pictures fall prey to so-called ultramarine sickness, in which the blue becomes mottled with a grayish or yellow-gray discoloration whose cause is not yet fully understood.

In general, however, ultramarine is a wonderfully stable color whose glory has been little diminished over centuries. Azurite, too, may age gracefully, but the coarse texture with which the pigment was sometimes applied can cause problems when varnish applied on top of the gritty paint penetrates between the particles, discoloring the pigment layer as it ages and darkens. There are many examples of thick layers of azurite that have darkened almost to black over the years, possibly as a result of the deterioration of the surrounding medium. This is apparent, for example, in the Madonna's robes of Dieric Bouts's *Virgin and Child* (c. 1465) and Gerard David's *Virgin and Child with Saints and a Donor* (c. 1510). The pigment itself is relatively stable unless exposed to acids (such as sulfurous pollution),

which wreck the color by decomposing the copper carbonate to black copper oxide.

Azurite is almost identical in composition to the green mineral malachite and can become transformed to it over the years. This is especially common in fresco works: medieval Italian churches are full of examples of blues turning to green. Malachite itself, however, is generally very stable and has lasted well in these murals.

The same cannot be said of the green copper pigment verdigris. Its tendency to darken with age became notorious: Cennino notes that "it is beautiful to the eye, but it does not last." Max Doerner says:

> Verdigris and other blue and green copper colors . . . had to be used by the old masters because of a lack of other pigments. They were well aware of the dangerous nature and incompatibility of these pigments and took the precaution of placing them between coats of varnish. Verdigris was the cause of the blackening of the shadows in the canvases of later masters, such as Ribera, who used it in oil instead of tempera and without protective varnishes.[5]

Daniel Thompson asserts straightforwardly that "the accidents of time affect no other pigment so generally or so disastrously as verdigris."

Yet this disrepute may be quite undeserved. Modern tests on verdigris in various media have revealed little sign of darkening, suggesting that there was some aspect of the overall paint formulation that caused the degradation rather than any inherent defect of verdigris itself. One clear culprit was the practice, common in the late fifteenth century, of mixing verdigris with resins to make the pigment loosely termed "copper resinate." Light-induced decomposition of the organic resins turns the paint blackish. Paintings of this era are now liberally adorned with deep brown or almost black foliage (Plate 55), giving the appearance of some Magritte-style trick of the light. Italian landscape painting of this era is awash with drab brown hills and forests, and Veronese's *Allegory of Love III (Respect)* (c. 1570) is disfigured by green draperies that have turned brown.

Any self-respecting student of fifteenth- and sixteenth-century painting will now be alert to these changes and will make the appropriate mental translation of the images on gallery walls. But Thompson, writing in the 1920s, commented that darkened verdigris (by which he must largely mean copper resinate) "misleads art historians daily," inviting them to perceive a medieval penchant for portraying "mournfully the dreariest days of autumn."

Not all discoloration is the result of the action of the environment.

Some pigments are chemically incompatible with one another, reacting to bring about a change in composition. These adverse reactions contributed to the traditional wariness about mixing pigments. Lacking any understanding of their chemical origins, early painters developed rules of thumb. Verdigris and white lead, said Cennino, are "mortal enemies in every respect," and Thompson remarks how inconvenient this must have been in the days when "white lead was so nearly indispensable to the medieval book or panel painter that he could not comfortably rely upon pigments which could not be mixed with it." But modern tests show no evidence of any harmful effects from a mixture of these two pigments—and indeed, they were often used together. Again, we are left wondering what the early artists were doing differently that caused them difficulties. In any event, warnings like Cennino's would have provided some considerable stimulus for the development of new and safer pigments.

Verdigris was also reputed to be incompatible with orpiment, with which it would otherwise offer an attractive grass green. This is more readily understood, for in a watery medium (such as egg tempera or size), the copper in verdigris can combine with the sulfur in orpiment to generate black copper sulfide. Orpiment developed a bad reputation for compatibility all around. Heraclius' tenth-century text *De coloribus et artibus Romanorum* warns that "orpiment does not agree with folium, or with green, or with *minium*." (He also takes pains to clarify that this is no reflection on the compatibility of their various colors but is a matter of the material substances—of the chemistry, had he possessed the word.) In Giovanni Paolo Lomazzo's painting manual *Trattato dell'arte de la pintura* (1584), the author cautions that "orpiment is an enemy to all save gypsum, ocher, azures, smalt, green azure, green earth, rust of iron, Spanish brown, and lake." To what extent these warnings have a sound basis is not clear, but wise artists tended to heed them: Veronese ensures that orpiment stays isolated in *The Vision of St. Helena* (c. 1570–1580).

MAKING MATTERS WORSE

The replacement of egg tempera with oil removed some problems of compatibility by isolating each pigment particle in a coat of oil. But some painters of the seventeenth and eighteenth centuries pushed their luck with elaborate palette mixtures of untested provenance. The introduction of new pigments with no history of reliability did not help. The complex

blends used by landscapists such as Claude Lorrain, Gaspard Dughet, and Nicolas Poussin could undergo unpredictable changes, particularly since they included new yellow pigments that were less stable than the traditional lead-tin yellow or Naples yellow.

Some painters' manuals sought to limit the damage by recommending a precautionary technique. Roger de Piles's influential *Éléments de peinture pratique* (1684, significantly augmented in 1776 by C. A. Jombert) advocated the use of oil and varnish layers to isolate different colors. But experimentation was on the increase during the Baroque era. The addition of resins to the oil medium to speed up the drying process, in which even the van Eycks dabbled, became common practice for painters such as Velázquez, Rembrandt, and Rubens. Resins and balsams could also increase the permanence of the colors but had a tendency to turn dark or yellow and to induce wrinkling if imprudently applied.

By the eighteenth century there was still not one of the spectral colors with which artists considered themselves adequately supplied in pigments. For blues, azurite and ultramarine were scarce, and smalt, difficult to work with in the first place, had a tendency to fade owing to leaching of cobalt from the pigment particles. (The smalt sky in Velázquez's otherwise radiant *Immaculate Conception*, produced about 1618, has turned a depressing brown.) Indigo, an organic dye, was not lightfast. The report of the discovery of Prussian blue in 1710 began by saying, "Painters who mix oil with their colors have few that represent blue, and those such that, rightly, they wish for [some] more satisfactory."

The richest reds were lakes—primarily cochineal and madder—but these might not last. In Joshua Reynolds's *Anne, Countess of Albemarle* (c. 1759–1760), the countess's pallid face was once a healthier pink; the complexion has become deathly as the color drained from the (probably cochineal) red lake.

Of pure and bright purples there were still none, and for orange, realgar had only ever been used sparingly. Greens were still a particular problem. The Italian Giovanni Angelo Canini commented in the mid-seventeenth century that mixed greens should always be made up "fresher" than they actually appeared in nature because they would darken with age. A century later Robert Dossie's *Handmaid to the Arts* proclaimed that "the greens we are forced at present to compound from blue and yellow are seldom secure from flying or changing."

This was largely the result of using fugitive yellow lakes. Foliage would

often turn a bizarre and sickly blue color as the yellow component (sometimes a glaze over blue underpaint) lost its hue under the influence of light. Pieter Lastman's *Juno Discovering Jupiter with Io* (c. 1618) has acquired dark blue-green vegetation, and Jan van Huysum's *Flowers in a Terracotta Vase* (1736) has patchy blue leaves owing to the fading of the lake pigment (Plate 56). In 1830 J.-F.-L. Mérimée commented that "in several Flemish paintings, leaves of trees have become blue, because the yellow lake, mixed with ultramarine, has disappeared."

It was hoped that Prussian blue, discovered in the early eighteenth century, would at least satisfy the desire for a blue to replace ultramarine. But already by the middle of the century, its tendency to fade had become evident. Dossie warned that the lighter, brighter, and most attractive varieties of Prussian blue (which contain white alumina) are "extremely subject to fly, or to turn to a greyish green." This propensity to fade is accentuated when the pigment is mixed with a high proportion of white, as it often was for eighteenth-century skies. The skies in several paintings by Gainsborough (such as *Gainsborough's Forest*, c. 1748), Watteau (*Récréation italienne*, c. 1715–1716), and Canaletto (*Venice: Campo San Vidal and Santa Maria della Carita*, 1726–1728) are all pearly and washed out where once they would have been a deeper blue.[6]

In 1834 the painter Franz Fernbach noticed a strange feature of this fading process. He used Prussian blue to decorate parts of an outdoor rain shelter. Returning after having left it to dry in the sun, he was dismayed to see that the color had already drained away almost completely. But when he went the next morning to review the damage, he saw that the color was restored in full strength. George Field too noted this ability of Prussian blue to partly regain its color after fading in the sun and then being removed from the light.

With the influx of new and seductively vibrant pigments in the nineteenth century, the painter's difficulties were exacerbated in proportion to the expansion of choice. Never was there a greater need for professionals like Mérimée and Field to conduct a thorough examination of the products with which paintmakers tempted the hapless artist. Many who rushed to use the new colors did so to their cost. The Pre-Raphaelite William Holman Hunt was among those who suffered acutely from hues that shifted or vanished on the canvas, and he became a crusader for proper testing. In a letter to the paint supplier Charles Roberson in 1875 he complained of the instability of a new madder lake, saying, "I feel that I may do you as well as the profession a service if I induce you to reject the colour as not fulfilling

the requirements of the artist for the delicate work for which the original madders are used." His frustration is palpable in his account of an orange vermilion that turned brown, which he says "cost me at least ten months of my life" because of the need to rework the painting. Things were much better, said Hunt, "in the days of Mr. Field."

Field warned against the chrome yellow that was later to dull van Gogh's sunflowers: "The yellow and orange chromates of lead, withstanding as they do the action of the sunbeam, become by time, foul air, and the influence of other pigments, inferior to the ochres." He cautioned artists that from a poor choice of coloring materials, there was no prospect of succor: "Without a strong constitution there is no hope for [painting]; no chemistry can strengthen the sickly frame, restore the faded colour, stop the ravages of consumption: Science stands helpless before dying Art." All the more reason, then, for the painter and the chemist to collaborate closely: "Happily there is promise of a healthier state of things. When this comes, Art will be less shy to consult her sister: in the interests of both there should be a closer union."[7]

But the changes that might overtake the new pigments were hard to anticipate. So much depended on how they were prepared and mixed and in what medium. Field warned unequivocally against iodine scarlet, yet the British painter William Mulready was able to deploy it without catastrophe in *The Widow* (1823), and Hunt's experiment with the color in his preparatory sketch for *Valentine Rescuing Sylvia from Proteus*, in which he mixed it with copal resin varnish for protection, seems to have stood the test of time. (Whether Hunt trusted it sufficiently to use it in the final painting, however, is not known.) There is a tone of bemused helplessness in the comment of the English painter Samuel Palmer that

> painting is a matter of such chemical complexity and intangible subtility that, as I have heard Mr. Mulready say more than once, two men shall paint off the same palette with the same vehicle, A's picture shall dry, B's picture shall not dry, A's picture shall stand, B's picture shall fade.[8]

The Impressionists and their successors would surely have benefited from the services of someone like Field. As it was, they tended to throw caution to the wind—and pay the price. Some of the new pigments, such as cobalt blue and lemon yellow (strontium chromate), aged very well; others did not at all. Zinc yellow (zinc chromate) goes greenish in oil, which proved disastrous for Georges Seurat's carefully judged pointillism.

Discoloration of zinc yellow is apparent in *Bathers at Asnières* (1883–1884), and the lawn of *La Grande Jatte* (1884–1885) is peppered with brown spots owing to deterioration of a chrome yellow. There can be few more emphatic examples of how the limitations of materials can undermine an artist's delicate coloristic intentions.

It was not until the twentieth century that color manufacturers began to take seriously their own responsibilities to the artist by testing their products thoroughly before selling them. Meanwhile, there was a growing recognition that the artist had some obligation to understand the materials with which he or she worked—not as a scientist, for that was by now too much to demand, but as a craftsperson who knew how to make the best use of them. As Max Doerner said:

> The artist cannot be expected to be a chemist; he would only become the victim of a dilettantism more harmful than beneficial . . . [Yet] the laws which govern the materials of the artist are the same for all artists, to whatever schools they may belong. Whoever wishes to employ his materials correctly and to the best advantage must know these laws and follow them, otherwise sooner or later he will pay dearly for his mistakes . . . *Craftsmanship must again be made the solid foundation of art.*[9]

The foundation of the Doerner Institute—officially the State Institute for Technical Tests and Research in the Field of Painting—at the State Art Academy in Munich in 1938 can be seen as a recognition of this necessity. Doerner himself served as an instructor in technical methods at the Royal Bavarian Academy from 1911 until his death in 1939, and he did much to reacquaint the art world with the techniques that left some of the works of the Old Masters in a better state of preservation than those painted in the nineteenth century.

Yet there is something stolid, formal, and stifling about the whole business that almost invites rebellion from artists, just as the Impressionists rebelled against the academic strictures of the French Academy. What artist wants to be governed by laws, even under the threat of dire consequences? Experimentation with materials, and the misfortune that often follows, abounded throughout the twentieth century. It seems that every generation of artists must learn its own lessons, just as each must find its own style and its own material means of expression.

CAPTURING COLOR

HOW ART APPEARS IN REPRODUCTION

"Even the most perfect reproduction of a work of art is lacking in one element: its presence in time and space, its unique existence at the place where it happens to be . . . The presence of the original is the prerequisite to the concept of authenticity."
—Walter Benjamin (1936), "The Work of Art in the Age of Mechanical Reproduction"

"Our modern painters can't come near it with their colours, and if they attempt a copy make us pay as many guineas as we now give shillings."
—Sir James Percival (1721), on Jacob Le Blon's printing process

"For the first time ever, images of art have become ephemeral, ubiquitous, insubstantial, available, valueless, free. They surround us in the same way as language surrounds us."
—John Berger (1972), *Ways of Seeing*

How many Monets and Picassos hang on the walls of even the most modest of suburbs? One can see great works through the windows of almost any street, displayed in framed splendor above the hearth or pinned at ragged corners to the bedroom wall. We can all be collectors now, for good reproductions may be had for the price of an indif-

ferent meal. Between the covers on our bookshelves are whole galleries' worth of masterpieces.

One can hardly complain about this democratization of art. Many artists have wished to see it plucked from the rarefied atmosphere of the gallery and brought into the mainstream. But purists may complain that a removal of context cheapens the work, that Michelangelo's outstretched fingers of man and God become stripped of their cultural significance and transformed into a parodic cartoon when edited onto a greeting card in the visual equivalent of a sound bite.

There is indeed something a little sad in the way that overexposure dilutes the impact, like a favorite song that has become tiresome from repetition. Can we really still feel the same shock on seeing the original *Guernica*, as its subject matter deserves, when it has been staring back at us for years on the cover of a Sartre novel? In his famous essay of 1936, social historian Walter Benjamin suggests that what "withers in the age of mechanical reproduction is the aura of the work of art."[1]

And yet our major galleries are as full as ever they were. If anything, the accessibility of copies serves to whet the appetite for the originals. In considerable measure, the impulse to visit the source of the glossy images in art books stems from a desire to bask in the intangible mystique not of the image but of the object: *these* very marks were made by the hand of van Gogh, of Rubens, of Masaccio. The picture becomes a historical artifact, the gallery a museum to human imagination and ingenuity. No one goes to see the Mona Lisa to inspect the beauty of the painting—those who do come away disappointed, having been jostled in a craning throng to catch a glimpse of this underlit and surprisingly diminutive work.

Benjamin claimed that mass reproduction emancipates art from a "ritual of authenticity." He imagined that color photography and film would bring this about. But it seems that we have merely substituted one ritual for another. People now go to galleries not just to become informed about what artists have done but also to worship at the feet of familiar images. An ecclesiastic solemnity presides over our halls of art—we whisper, we act with reverence, we do everything that the Parisians at the boisterous Salons of the nineteenth century did not do. "The work of art," says John Berger, "is enveloped in an atmosphere of entirely bogus religiosity. Works of art are discussed and presented as though they were holy relics."[2]

For the serious student of art, there is at least one other good reason to view the original, and if you are an eager collector of art books, you may

have noticed it already. How often does *this* Titian look like *that* Titian? In one book *The Assumption* is all golden autumnal light and deep shadow; in another it is the milky glow of spring that bathes the crowd, and the orange-red robe of the Virgin is almost pinkish. For a coloristically complex picture like *Danaë*, no two reproductions will look the same. Can there, then, be any reliable discussion of color based only on reproductions?

Yet much art criticism is necessarily conducted in this way. All written discourses on art must rely on reproductions to make their point.[3] In verbal exposition, such as college teaching, color slides might instead be the medium through which the object of discussion is displayed. I am fortunate to have on my doorstep two galleries—the Tate and the National—from which many of my examples are drawn, and so I can view the originals relatively easily. But I must rely for most of my research on the images provided by books, seeing all too clearly in perusing several texts of related topics how untrustworthy these images can be. According to John Gage, the limitations of color reproduction technology are "themselves part of the history of colour in art."

How much greater my difficulties would have been if I had been writing this book three decades ago! Even my casual acquaintance with the paintings in the Prado in Madrid tells me that my copy of *The Prado* (1966) gives only a very schematic impression of those works. The same is true of Herbert Read's *Concise History of Modern Painting*, of which I have a 1985 edition. And these are both books by one of the most committed of art publishers, who will commonly spare no expense on illustrations.

So I believe it is essential, in any survey of chemistry's influence on color in art, to ask how far chemical technology can take us in capturing the image on the page. This is not, as one might expect and hope, a linear tale of gradual improvement in quality; indeed, some fear today that standards may decline as the economics of publishing overwhelm considerations of accuracy and longevity.

Moreover, technology today is changing the way visual information is disseminated to an extent not seen since Gutenberg's time. I have done some picture research wholly electronically and am aware that such a statement is already sounding like that of the scientist who proudly says in the 1950s, "My calculations were assisted by digital computer." We now have a completely new way of accessing and displaying information, and it requires no great foresight to predict that many (if not all) of the roles of

books will be displaced by the computer in the next few decades. How these changes will affect the quality of art reproduction is in part a question of physics and electronic engineering, but this too is ultimately delimited by the chemistry behind the glowing colors of the monitor.

ART FOR THE MASSES

There was a time when the only way you could possess your own version of a painting was to have a copy painted for you—legally or otherwise. Even in the nineteenth century, many people knew the works of masters old and new via monochrome engravings. Turner's works, at the height of his fame, would be regularly transcribed in this way, and the results are somewhat like fabulous renditions of architectural wonders in matchsticks: awesomely skillful but inevitably missing the point. Re-creation of the paintings of Turner, whose language was one of color, light, and texture, in a web of black outlines and crosshatching holds a fascination in its very folly.

Printing using colored inks was possible from the moment the printing press was invented, and colored typography was indeed occasionally used in fifteenth-century manuscripts. Several colors could be laid down on the same page by running it through presses loaded with blocks cut to imprint different areas. This was obviously a cumbersome process and not to be undertaken lightly. In 1482 Erhard Ratdolt seems to have become the first to master the problem of aligning the different blocks. In the sixteenth and seventeenth centuries, pictures were crudely rendered in two or more colors in this way, and a kind of primitive chiaroscuro could be achieved by overprinting with black hatching or blocked-out shadows (Figure 12.1). Lucas Cranach was one of the first in a long tradition of great painters who have experimented with color printing technology, a tradition that later embraced Henri de Toulouse-Lautrec, Edvard Munch, and Sonia Delaunay. But as a means of *reproduction*, there could be no pretense that the chiaroscuro technique gave a much more impressive representation of a color painting than a delicate black-and-white copper-plate engraving could.

The earliest attempt at full-color printing as we now know it was made in the eighteenth century by the painter Jacob Christoph Le Blon, born to French parents in Frankfurt-am-Main in 1667. Le Blon drew on the idea (expounded by Robert Boyle) that all colors could be synthesized from three primaries, believed to be red, yellow, and blue. He therefore realized

Figure 12.1: *Saturn*, a chiaroscuro print by Ugo da Carpi made in 1604 after a drawing by Pordenone (c.1485-1539).

that in principle all colors should be accessible from these three by superimposing "separations": a different printing plate for each primary. Each plate laid down a monochrome partial version of the image, with a density of ink corresponding to the intensity of that primary in the original. For example, yellow areas would be reproduced on the yellow plate but would be left blank on the red and blue plates. Orange features would appear on both the red and the yellow plates so that the two translucent inks laid one atop the other would generate the secondary color by subtractive mixing.

How, though, might one prepare the monochrome separations? Le Blon had no choice but to do it by hand and eye. Astonishingly, he set out to hand-engrave each of the plates based on his own visual judgment of how much of each primary was in each part of the image. One might compare it to an attempt to decompose a musical note from an instrument into its separate frequencies—not only to say which frequencies are present but also to determine in what quantities. The surviving examples of Le Blon's works, such as his own composition *Narcissus* with its warm flesh tones and cool green foliage, reveal the engraver's near-miraculous ability to disassemble complex colors in this way.

Le Blon's plates were engraved using the method of mezzotinting, in-

vented in the seventeenth century by a German military officer in Amsterdam. The surface of a copper plate is roughened all over using a chisel-like tool called a rocker, whose curved end is incised with a series of parallel lines to raise burrs in the soft copper. This rough surface captures and holds the ink. Gradations in ink density are achieved by smoothing the surface back down to different degrees. A wholly blank area must be polished smooth. The technique takes its name from the fact that it reproduces middle tones of intensity more faithfully than the alternative of line engraving.

For the three-color method to work, the inks must be good primaries. If, for instance, the red is a little bluish, it will produce only a dirty brownish orange when overprinted with yellow. But such pure colors were not available in Le Blon's time, and so he was forced to grapple with how the ideal theory of color mixing propounded by scientists might be realized using the imperfect hues that chemists offered. His quandary stems from much the same considerations that had made early painters cautious about mixing pigments: because they are not "spectrally pure," their brightness suffers when they are combined.

Le Blon's efforts led him deep into color theory, and by the 1720s he believed he had discovered the "laws of color," which some considered to have been lost since the time of the Old Masters. Le Blon presented these ideas in 1725 in *Coloritto* (subtitled *The Harmony of Colouring in Painting, Reduced to Mechanical Practice Under Easy Precepts and Infallible Rules*), wherein he suggested:

> The ingenious *Painters*, who shall peruse my Rules, and perform a little in this Way, will soon judge of the knowledge, of Titian, Rubens and Van Dyck, in the *Theoretical* Part of the Coloritto, whether the Common Report or Tradition of their being possess'd of the *Secret*, may be depended upon; and whether any *Masters* besides these *Three*, have had any distinct and regular knowledge of it?[4]

His rules were basically the now-standard means of preparing the secondary colors from the primaries:

> Painting can represent all *visible* Objects with three Colours, *Yellow*, *Red*, and *Blue*; for all other Colours can be compos'd of these *Three*, which I call *Primitive* . . . and a *Mixture* of those *Three* Original Colours makes a *Black*, and all other Colours whatsoever.[5]

But here Le Blon found himself forced to confront the distinction, then still obscure, between additive and subtractive mixtures as best he could:

I am speaking of *Material* colours, or those used by *Painters*; for a *Mixture* of *all* the primitive *impalpable* Colours, that cannot be felt, will not produce *Black*, but the very contrary *White*; as the great Sir ISAAC NEWTON has demonstrated in his Opticks.[6]

Despite Le Blon's talk of the "material colours used by painters," he needed inks that were translucent, not opaque paints. Thus his colorants were mostly dyestuffs, and his printing process may have gained some inspiration from the calico-printing industry.

For primary blue, Le Blon used the new Prussian blue, which was in truth a shade too green for the job. He also seems to have experimented with indigo. His yellow was a dark yellow lake. Red was the most difficult of all, and he felt compelled to concoct a mixture of madder lake, carmine, and a little cinnabar. In principle, the ideal primaries combine to black, but in practice, simple mixtures of these (and any other) primary pigments tend more toward brown. So Le Blon found himself obliged to conduct final retouching of the image—adding black, for example—by hand.

His eagerness to stress the "easiness" and "infallibility" of his technique therefore betrays a certain desperation about its shortcomings. Perhaps even more troublesome than the lack of primary inks was the fact that the copper plates did not survive many impressions before their fine detail became blurred. Given the immense industry and patience that went into their making, this was a serious matter.

Yet what the method lacked in practicality, Le Blon made up for in bluster and enthusiasm. After exhibiting some early specimens of the process to eminent persons in Amsterdam in 1704, he began to seek a sponsor. Holland proved fruitless, and he hoped for more luck in Paris in 1705—again to no avail. Not until he came to London in about 1719 did he manage to persuade a rich dignitary, Colonel John Guise, to part with the money needed to establish a business. With Guise's backing, Le Blon was able to secure permission from George I to copy some of the pictures in Kensington Palace. The two set up a company called the Picture Office in 1720 and proceeded to generate several thousand copies of twenty-five selected paintings.

But Le Blon was no businessman, and very rapidly the company was in financial trouble. On meeting the entrepreneur, Horace Walpole (son of Sir Robert) was unimpressed, describing him as "either a dupe or a cheat, I think the former . . . As he was much of an enthusiast, perhaps, like most other enthusiasts, he was both one and t'other."[7] Guise, meanwhile, swore

at and bullied everyone on the company's staff, convinced that this was in the best interests of the business.

Matters deteriorated to the point where a committee was appointed to investigate the dealings of the Picture Office. As a result of the inquiry, Le Blon was removed as director. Yet it seemed that the quality of the prints was actually quite fair (Plate 57)—Walpole called them "very tolerable copies." In fact, some seem to have been passed off as originals, disguised under heavy layers of varnish. In a time when the public was unaccustomed to seeing full-color art outside galleries, this seemingly implausible deception becomes far less so. But whatever the merits of the copying process, it was just not profitable enough.

Undeterred, Le Blon established a new company in 1727 with the aim of applying another of his inventions—a method to reconstruct paintings in tapestry form—to the Raphael Cartoons at Hampton Court (which now reside in the Victoria and Albert Museum in London). He believed that in tapestry, too, red, yellow, and blue threads would, if artfully combined, suffice to create all hues. This venture again came to nothing, and Le Blon was finally forced to flee the country to escape his debts. He made unsuccessful attempts to revitalize the printing technique in Holland and France before dying in 1741 in impoverished circumstances.

Le Blon's method survived his death by only a few decades. In Paris, Jacques Gautier d'Agoty developed a similar process while Le Blon was still alive and argued bitterly with him over the question of priority. This notwithstanding, Gautier seems to have acquired the rights to the three-color process after Le Blon's demise and claimed to have perfected it in the ensuing years. The surviving examples of his efforts scarcely support this claim, although among his innovations was the introduction of a fourth, black plate in lieu of retouching by hand. Gautier's sons continued the trade in the 1770s and passed the method on to the Italian Carlo Lasinio in the 1780s, who practiced it with energy but no great distinction before it disappeared from sight.

BOOKS OF COLOR

Le Blon's invention was an idea ahead of its time, lacking the material means of realization. The alternative color printing techniques developed in the eighteenth century had no aspirations toward producing all colors from

just three translucent primaries. Instead, they laid on directly whichever colors the printmaker selected, making sure that areas of different color did not overlap. This meant that the color range was generally very restricted.

The simplest technique was the old chiaroscuro method in which blocks were used to imprint flat areas of color that were subsequently shaded crudely with black. Just one or two colors were typically applied, so the images were not so much color prints as we would recognize them today but merely splashes of dull shades like sepia that served mainly to give the eye some relief from the monochrome page.

The unappealing flat color fields of chiaroscuro printing could be avoided by using so-called halftone techniques, which were able to capture nuances of value or tone by varying the density of colored lines or dots against the white paper. The principle is just the same as that by which a gray scale is obtained in newspaper images: when the dots are small enough, they appear to merge into smooth tonal gradients. The mezzotinting method used by Le Blon is a halftone process and was widely used to apply graded local colors rather than Le Blon's ambitious three-color mixtures.

The basic component of halftone printing is a metal plate covered with a uniform field of dots, grooves, or ridges, which are smoothed to different degrees in different areas. In stipple engraving, the dots are created by piercing a protective film on the plate with a needle and using acid to eat into the exposed metal. The tiny cavities thus produced will retain ink or paint when the plate is coated using a roller and then wiped clean. When the plate is pressed onto paper, the ink soaks into the paper. Like engraving, this is a so-called intaglio printing method: the ink is applied to paper only where material is removed from the surface of the plate to leave an indentation.

Stipple engraving was invented in the seventeenth century by a Dutch goldsmith named Jean Lutma and was developed into a practical printing method by the Frenchman Jean-Charles François, whose efforts were supported in the 1750s by the Académie des Beaux-Arts—a reminder that printing was desired as much for fine art as for commercial purposes. Because a separate plate was usually required for each color used, most printers could only be bothered (or more probably, could only afford) to use two or three colors. The Englishman William Wynne Ryland, who opened a print shop in London in the 1770s, preferred to employ just one plate, hand-brushed with different colors in different areas.

The method was crude, sure enough, but for a public unaccustomed to seeing any color at all in art reproductions, the stipple prints were things of beauty. Demand for them boomed, and Ryland would have become rich had he not run up huge bills indulging his fashionable tastes and the extravagant demands of his mistress. So great were these expenses that they forced Ryland to the desperate extreme of forging a banknote—a capital offense that cost the printer his life in 1783.

Another halftone technique introduced in the late eighteenth century was aquatinting. The invention is commonly attributed to the French painter and engraver Jean-Baptiste Le Prince (1733–1781), although he may have acquired the knowledge from elsewhere. The metal plate is covered with specks of resin, which act as a protective mask against acid etching. The grain is very fine so that the prints can look almost like wash drawings. Aquatints produced by hand-inking a single plate were widely used for book illustrations in the early nineteenth century.

Lithography—literally, "drawing from stone"—was invented in 1796 by John Aloysius Senefelder in Munich, who used it to reproduce colored drawings by Dürer. A polished slab of a stone such as marble is marked with a greasy crayon and then dampened with a water-charged roller and loaded with an oil-based paint or ink from another roller. Insoluble in water, the ink is repelled by the damp stone but adheres to the marks left by the crayon. The image is then imprinted on paper.

This technique was generally used in the chiaroscuro fashion of woodblock printing, although unsuccessful experiments were made in the 1830s to develop it as a three-color process (suitably transparent inks were still not available). But in 1837 the Parisian lithographer Godefroy Engelmann adapted the method into a multiplate process that became known as chromolithography, which was capable of an impressive range and subtlety of color. For this work Engelmann was awarded a prize by the ever-supportive Société d'Encouragement de l'Industrie Nationale.

In England the lithographic technique had humble beginnings: Thomas De La Rue in London patented a lithographic process in 1832 for printing playing cards. But some had larger ambitions. The architectural designer Owen Jones teamed up with the printing firm of William Day in 1836 to produce a color book illustrating the Alhambra palace in Granada, resplendent in gold inks. Jones's illustrated *Grammar of Ornament* (1856) later became a standard text for British designers.

At the Great Exhibition of 1851, at which Jones, Engelmann, and others displayed their works of chromolithography, the jurors declared (rather

optimistically) that it was capable of results equal to a good painting. Automated lithographic machines began to replace hand presses in the 1850s, using metal rollers of zinc. In 1852 Day's firm ventured to produce a chromolithographic reproduction of Turner's *Vessel Burning Blue Lights*, a highly ambitious project at which they apparently acquitted themselves well. Turner's hazy, fluid style demanded that the printers for the first time abandon the convention of outlining in black, depicting the image instead in pure color.

The desire to apply these new techniques to fine art was shared by the Arundel Society, founded in 1849 by John Ruskin and others. The society set out to reproduce early Italian frescoes for explicitly pedagogical reasons: it wished to stimulate public awareness of the revitalization of art during the Renaissance. Chromolithography was used to reproduce such works as Perugino's *Martyrdom of St. Sebastian* and Bellini's *Madonna and Child*. It was a formidable undertaking: each of the chosen paintings had first to be hand-copied by a commissioned artist before being translated onto separate lithographic plates. Efforts like these gave many people their first inkling of the splendor of the original works, and for the wealthy there was the opportunity to own one's personal version.

Less elevated, perhaps, but equally impressive was the famous chromolithographic reproduction of a painting by John Everett Millais in the "Bubbles" advertisement for Pears soap—a feat that gained the artist's somewhat grudging admiration.

Among the books illustrated in color at that time were those of William Blake, who was himself a printer and engraver as well as a poet and painter. He sometimes painted in the color by hand—a supremely laborsome task. But by all accounts he was none too careful, or perhaps he had little concern for the conventions of neatness expected at the time. One later commentator reported that Blake's paints were

> applied over all the outline illustrations, and also in smeary patches at the sides of, or across the text, much in the same style as one would expect a child, in possession of a box of paints, to spoil a book, and tending to strengthen the idea that Blake was mentally afflicted.[8]

So important was color printing by the end of the eighteenth century that when the Royal Institution was founded in London in 1799 by the scientist Count Rumford, it set up a department to study the scientific needs of the craft. The departmental head was a Yorkshireman named William

Savage, who set out to remedy the shortage of colored inks. These new materials appeared in Savage's masterpiece, an illustrated book titled *Practical Hints on Decorative Printing* (1823), which took him eight years to complete. He used nothing more sophisticated than the chiaroscuro method with wooden printing blocks, but they were prepared with such care and profusion that the results were sometimes exquisite. Some of the images in this book required up to twenty-nine separate blocks.

The art of wood-block printing was brought to its zenith by George Baxter (1804–1867). He used oil paints rather than inks and achieved an unprecedented brilliance and permanence of hue (Plate 58). His *Pictorial Album, or Cabinet of Paintings* (1836–1837) was the first full-color popular book in England—the first coffee-table book, you might say. It demonstrated just how much could be achieved with the methods of the time if they were applied with sufficient diligence, and as a result of Baxter's work, color printing began to flourish.

The first color illustrations to appear in a periodical were published in 1855 in the *Illustrated London News*. Combining wood-block and etching techniques, they were of no great merit but were sufficiently popular that the newspaper continued regularly producing color supplements. And in 1861 the renowned wood engraver Edmund Evans in London published the *Art Album*, an attempt to offer works of fine art in color to a broad public. Wood-block printing was still deemed adequate for such endeavors in the early twentieth century, when the Knofler brothers in Vienna used it to create fine-art prints. The blunt, uncompromising outlines offered by this method suited the stylistic aims of the German Expressionist painters such as Ernst Ludwig Kirchner and Karl Schmidt-Rottluff, who produced many woodcuts in the prewar years.

There can be no question now that many of the color reproductions of the eighteenth and nineteenth centuries, printed from blocks, plates, and rollers painstakingly produced by a skillful hand, are works of art in their own right. Yet even by the 1850s an alternative to this hand-tooling was starting to appear. For technologists had discovered how to let light paint its own pictures.

THE ALL-SEEING LENS

Many technologies blossom not when the technical means are available but when a conceptual advance unlocks their potential. The necessary materials

and methods for photography existed for a hundred years before they were put to work.

It was in 1725 that the German anatomist Johann Heinrich Schulze deduced that the darkening of certain silver salts was due to exposure to sunlight. He produced images in this way by covering a glass bottle, containing chalk and silver nitrate solution, with letters cut out from paper. The liquid darkened where exposed to the sun's rays, owing to the formation of silver metal from the soluble silver salt. The tiny particles of silver absorb visible light and so appear dark.[9]

The optical technology behind the camera is even older. The camera obscura, a darkened room within which an outside view is projected onto a screen through a small hole, was described by the Moorish scholar Alhazen around the end of the tenth century A.D. Portable, box-sized versions of the camera obscura fitted with a lens were introduced toward the end of the sixteenth century and soon became standard items for the natural scientist.

But not until the nineteenth century did anyone think to combine the image-creating properties of the camera with the image-recording potential of light-sensitive silver salts. In 1800 Thomas Wedgwood attempted to imprint images from a camera obscura onto paper coated with silver nitrate. He was able to create negative images of "masks" such as leaves, insect wings, and even paintings but could not devise a way to preserve the image by avoiding further darkening of the paper when exposed to light. The process interested the chemist Humphry Davy at the Royal Institution, who collaborated with Wedgwood on this primitive form of photography.

The first "fixed" negative photograph was taken in 1816 by the Frenchman Joseph-Nicéphore Niepce, who imprinted the view from his window near Chalon-sur-Saône onto paper coated with silver chloride, which he then partially "fixed" (rendered insensitive to further alteration) with nitric acid. In 1826 he created a true positive photograph by using a camera to expose a thin film of oily bitumen spread on a metal plate. The bitumen hardened where illuminated, and the rest could be washed away with oil and petroleum. As the bitumen protects the metal from attack by acids, this process could be used to make an etched metal plate for printing. This is a primitive form of the technique known as photogravure. Thus photography was allied with printing from the outset.

Four years before his death, Niepce went into partnership with Louis-Jacques-Mandé Daguerre, a Parisian theater designer. By 1837 Daguerre was able to make permanent photographs on silvered copper plate with an

exposure time of about thirty minutes. The slow darkening of the silver salts prohibited the capture of moving objects: Daguerre's street scenes have a ghostly, deserted quality because the strolling pedestrians are smeared out of view. Samuel Morse, an American painter and inventor whom Daguerre invited to view his images, described them thus:

> The Boulevard, so constantly filled with the moving throng of pedestrians and carriages, was perfectly solitary, except for an individual who was having his boots brushed. His feet were compelled, of course, to be stationary for some time . . . Consequently his boots and legs were well defined, but he is without body and head, because these were in motion.[10]

In Daguerre's process, the silvered plate was exposed to iodine vapor, which formed a thin layer of silver iodide. This was then exposed to light in the camera in the presence of mercury vapor. The mercury settled on the light-exposed regions as tiny droplets that formed an amalgam with the silver. The iodide was then dissolved away in a fixing agent (sodium thiosulfate, at the time called hyposulfite, or "hypo"). The mercury corresponded to the light parts of the image, while the shadows were reproduced in the silver beneath. The developed plate had to be protected with glass to prevent the mercury from being wiped off.

The French government bought the rights to this process from Daguerre and unveiled it in 1839 at a joint meeting of the Académie des Sciences and the Académie des Beaux-Arts. Seeing the results, the artist Paul Delaroche was moved to exclaim, "From today on, painting is dead." (It is reassuring to hear that this claim, still common today, has a history of falsity.) Photography, in the form of these "daguerreotypes," was regarded not as a means of documenting life but as a new medium for art.

By the early 1840s, photographic portrait studios had begun to appear in London and New York. Several innovations shortened the exposure times, and new kinds of photographic media replaced Daguerre's cumbersome and fragile silver-mercury plates. In 1840 the English inventor William Henry Fox Talbot introduced the calotype process, in which gallic acid was used to develop silver iodide soaked into paper. (The developer promotes the transformation of a light-exposed silver salt into particles of silver metal; the fixer makes the image lightfast by removing unexposed silver salt.) The calotype process produced a negative image, from which positive prints could be generated. In 1844 Fox Talbot published the first

photographically illustrated book, *The Pencil of Nature*, with the photos individually pasted in place. It advised the reader that "the plates in the present work are impressed by the agency of light alone, without any aid whatever from the artist's pencil."

Like the calotype, Frederick Scott Archer's collodion process, introduced in 1851, was a "wet" technique in which the photographic paper was prepared on the spot and exposed while wet. Nitrocellulose (the first synthetic polymer) dissolved in ether was mixed with potassium iodide, poured onto a glass plate, and sensitized to light with silver nitrate. Once exposed, the plate was developed with gallic acid or iron sulfate and fixed with hypo or potassium cyanide. Thus the photographer was required to carry with him a small chemical laboratory, not to mention a portable darkroom (Figure 12.2). Photography could never emerge as a mass-market hobby until there was a photographic medium that was portable, robust, and easy to develop.

In the mid-1850s Richard Hill Norris found that liquid gelatin could be used to preserve the prepared collodion mixture as an emulsion, which could then be prepared in advance on dry plates. The gelatin softened when wet so that the developer could do its work. By 1867 the Liverpool Dry Plate and Photographic Company was selling dry plates of a collodion–silver bromide emulsion preserved with tannin.

Fox Talbot introduced a second crucial innovation in 1852. He devised a variant of Niepce's primitive photogravure method in which a light-sensitized gelatin film, hardened in proportion to its exposure to light, was used as a mask to make printing plates by acid etching. By exposing the plates through a mesh of black cloth, the photographer could produce stippled images that captured halftones, rather than consisting of uniformly black and white (exposed and unexposed) areas. This halftone photogravure was improved in the 1880s by replacing the cloth mesh with two sheets of glass engraved with parallel lines that crossed at right angles.

Fox Talbot's gelatin films were adopted in 1853 by Paul Pretsch of Vienna for his "collotype" method of photographic printing. As the gelatin hardens, it loses its ability to absorb water. This allows the film to be used in a manner related to lithography: greasy lithographic inks are repelled from the soft regions of the film, which absorb water, and are drawn to the hardened regions. But rather than a sharp division between the two, there is a gradation related to the intensity of exposure and thus the degree of hardening. So collotype printing can capture halftones without the need for

Figure 12.2: The photographer of the mid-nineteenth century had to carry with him a small chemical laboratory. The engraving on the left shows a landscape photographer of around 1859; above is the equipment needed to make daguerreotypes.

a mesh screen and hence without the graininess characteristic of the latter. It therefore reproduces images with excellent fidelity and is still used today for making high-quality prints. The collotype plates wear out after only a few hundred impressions, however, so the technique is expensive and suitable only for short print runs.

Amateur photography began to bloom in the 1890s. George Eastman's photographic company in New York acquired a patent for flexible celluloid-based photographic film in 1889. The film could be neatly packaged in rolls, and Eastman introduced a compact camera, the Kodak, that housed it. The developing could be done only by the Eastman Company, and so the entire camera, with exposed film, had to be sent back to the company for making prints. It was returned loaded with a new film. "You press the button—we do the rest," the advertisements proclaimed.

Was photography an art in itself or simply a means of reproduction and documentation? Many early photographers were also painters, though often more distinguished behind the lens than the easel. During the 1840s the Scottish landscape painter David Octavius Hill and his technical collaborator Robert Adamson used the calotype process to capture striking portraits that, although intended as reference works for Hill's paintings, brought critical acclaim in their own right. In the 1850s the French artist Gustave Le Gray formed the Société Française de Photographie to promote the new technology as an art form. By the start of the twentieth century, similar societies existed in London and New York.

Because of the stark tonal contrasts produced in early photographs, painters using them as a reference source found a new way of depicting the world—one quite at odds with the formalized chiaroscuro practices of the academies. Manet and Degas studied photography in the 1860s, and the immediacy of Manet's *Olympia* (1863), which so outraged traditional sensibilities, exploits a photographic style of lighting. For the painter and art historian Eugène Fromentin, this bold directness threatened a moral decline in painting: "so clear, so explicit, so formal, so crude."

In the 1920s artists such as the surrealist Man Ray and the Hungarian constructivist painter Laszlo Moholy-Nagy showed that by manipulating the photographic process one could produce images every bit as imaginative and striking as those that came from brushwork. Yet it was the veracity of "straight" photography that lent the medium much of its artistic force. In the right hands, it could produce visions that not only were breathtaking, beautiful, disturbing, or shocking but had *actually existed* at a point in time. The documentary-style photographs of Henri Cartier-Bresson and Robert Capa straddled this compelling boundary between reportage and art, where photography seemed to possess a force for social change that no painting could ever muster. Walter Benjamin suggests that art in which the authentic no longer has meaning inevitably becomes political. For photography and film, this was surely the case.

My purpose here is not, however, to trace the artistic history of photography but to look at its influence on the reproduction of paintings. Entrepreneurs wasted no time in using it for that purpose. The brothers Leopoldo, Giuseppe, and Romualdo Alinari in Florence, for example, established a photographic workshop in 1852 devoted not only to portraits but also to monochrome reproductions of works of art and architecture. Yet it was hard to see how photography could ever satisfy the art lover when all it could offer were tonal sketches in sepia and gray.

MAXWELL'S TARTAN RIBBON

Color photography was a surprisingly early invention. Seeing the first photographic images trapped under the glass of daguerreotypes or picked out in dark silver on Fox Talbot's calotype paper, viewers longed for color to re-create the world their eyes registered. And so painters would hand-tint these early photos. In 1859 the printmaker George Baxter patented the idea of coloring photos using his intricate wood-block technique.

Yet this was simply a more efficient way of adding "false color" after the image was developed. How much better it would be to create color printing plates directly from the photographic exposure. In the late 1850s one Mr. Burnett of the Edinburgh Photographic Society made the suggestion, obvious in retrospect, that photogravure or other photographic etching methods could achieve this by the simple expedient of blanking out by hand areas on the printing plate where color was not wanted. Multicolored prints could be constructed from the accumulation of separately colored patches, in the same way as hand-engraved polychrome prints were then being made. The collotype process became popular for preparing plates for this purpose.

Making plates photographically was certainly easier than engraving them manually. But one still needed a separate plate for every color in the image. A three-color method that generated a full-color image from just the three primary colors would represent a great economy. To achieve this, one needed first of all a way of exposing photographic plates in a color-sensitive manner to obtain color separations in the primary colors.

The physicist James Clerk Maxwell's work on color optics and additive primaries, along with his knowledge of Thomas Young's three-color theory of vision, gave him a clear notion of how a color image might be built up in this way from monochrome separations. In 1857 he wrote:

> These three elementary effects, according to [Young's] view, correspond to the three sensations of red, green and violet, and would separately convey to the sensorium the sensation of a red, a green and a violet picture, so that by the superposition of these pictures, the actual variegated world is represented.[11]

Maxwell set about making experiments to this end in the late 1850s. In natural outdoor light, he and his assistant Thomas Sutton exposed collodion photographic plates before a bow made of tartan ribbon striped with various colors, pinned to black velvet. By placing color filters between the object and the plate, they obtained negatives that registered light of each of the additive primaries individually. For example, red parts of the ribbon, which absorb blue and green light, would not appear in the exposures taken through blue and green filters.

These filters were glass vessels containing colored solutions. Someone connected to the world of color manufacturing would surely have used standard dyes, but as a scientist, Maxwell was more familiar with the colors

of the academic chemical laboratory: the royal blue of ammoniacal copper sulfate, the green of copper chloride, the red of iron thiosulfate.

To reconstruct the full-color image from the negative separations, Maxwell projected colored light through each of them and superimposed the projected images on a screen. He revealed his results in a lecture demonstration in 1861 at the Royal Institution. Despite the resounding success of his demonstration,[12] Maxwell was conscious of its limitations. He knew that the standard photographic emulsion he employed was much less sensitive to red and green light than to blue, so that the reconstructed image lacked veracity:

> If the red and green images had been as fully photographed as the blue, [the result] would have been a truly coloured photograph of the riband. By finding photographic material more sensitive to the less refrangible [long-wavelength] rays, the presentation of the colours of objects might be greatly improved.[13]

In fact, the emulsion responded so weakly to red light that it should barely have registered the red separation at all. But modern studies have revealed that to Maxwell's good fortune, ultraviolet light was also reflected from the red parts of his tartan ribbon, and this instead was able to convert the silver salt to silver metal.

The need to take three separate images of the same scene was naturally a great inconvenience to nineteenth-century color photographers. In 1893 the enterprising American inventor Frederick Eugene Ives made matters easier with his Kromogram, which could take all three negatives in close succession through red, green, and blue-violet filters. By 1900 he had worked out how to do this in a single shot. The color picture was then reconstructed by viewing through a special projection device of his own invention, called the Kromscop.

More commercially successful as a means of reconstructing the color image were the Autochrome plates developed by the brothers Auguste and Louis Lumière, the inventors of cinematography, in 1907. These plates were coated with tiny grains of potato starch dyed red, green, and blue, over which lay the light-sensitive emulsion. Exposures were taken through the dyed layer, which acted as a color filter. After development, a positive transparency was prepared from this negative in which small specks of light in the primary colors, transmitted through the starch grains, combined optically to produce a color image like the pixels of a television screen.

The Lumière brothers devised the principles of the Autochrome system several years before they could put them into practice. They were hindered by the problem Maxwell had identified: the available emulsions were not "panchromatic," equally sensitive to all wavelengths of visible light. It was not until the invention of new red-sensitive dyes by chemists at the IG Farben dyeworks in 1905–1906 that the absorption of red light by photographic emulsions could be enhanced to produce truly panchromatic plates.

The Autochrome system is, from a historical perspective, an idiosyncratic one. It represents a means of selectively sensitizing the photographic emulsion to light of particular colors by installing a kind of pointillistic screen of colored filters in front of the film. But in 1873 the German scientist Hermann Wilhelm Vogel had already proposed a better way of eliminating the need for Maxwell's liquid light filters. He devised photographic emulsions that were themselves darkened by only one of the three primaries, by adding dyes to the emulsions that absorbed only red, green, or blue light. The color of each dye must be *complementary* to the color to which it sensitizes the plate: a red dye sensitizes a plate not to red light (which it reflects or transmits) but to green (which it absorbs).

In fact, the ideal sensitizer for green would reflect both red *and* blue light and so would appear purplish—the color known as magenta—rather than pure red. Likewise for the blue sensitizer: it reflects red and green light, which combine additively to yellow. And the red sensitizer reflects green and blue, thus having a turquoise appearance that printers call cyan. The ideal sensitizers would, in other words, absorb about one-third of the white-light spectrum and reflect two-thirds: cyan (white minus red), yellow (white minus blue), and magenta (white minus green).

Vogel employed the compounds naphthol blue or cyanin for the red-sensitive plate and pinkish eosin for the green plate. Initially, he did not consider it essential to add a (yellow-colored) sensitizer for the blue separation, as the silver bromide in the emulsion is primarily sensitive to blue light anyway. But he later made use of yellow-green fluorescein as a blue sensitizer. All of these, you might notice, are coal-tar dyes, of very recent origin in the 1870s.

Vogel was interested in using these separations for preparing three-color printing plates—which is, after all, the way in which color photography ultimately supplies reproductions to a mass audience. But his approach of sensitizing emulsions to particular colors using dyes was also adopted for

making color transparencies and positive color prints, which ultimately led to the huge market for amateur color photography in the 1960s.

The next step in this direction was the invention in 1911 by the German chemist Rudolf Fischer of a film that eliminated the awkward need for three color separations. In Fischer's film the three dye-sensitized emulsions are not divided among separate plates but are superimposed in layers on a single substrate (Figure 12.3). All modern photographic film is based on this design. The way in which the film is converted to a true color negative, from which positive prints may be prepared, is somewhat different today from how Fischer did it, but the principles are much the same.

The objective is to convert an area of darkened emulsion, where silver grains have precipitated, into an area of translucent color of the appropriate hue. So-called coupling agents are used to deposit in these regions dyes that are complementary to the colors to which the layers are sensitized. For example, where the blue-sensitized layer has darkened, the coupling agent deposits a yellow dye on the silver particles. The precipitated silver particles and unexposed silver salt are then chemically removed from the emulsion, creating a negative transparency.

Photographic companies such as Agfa and Kodak grew rapidly in the early part of the century, benefiting from the demand for color photography from advertising firms, art galleries, and industries. (Agfa, you may recall, began as a Berlin-based dye manufacturer.) In the 1930s the companies introduced Agfacolor and Kodachrome color film, and in the next decade they commercialized methods for making positive color prints from the negative transparencies.

To alleviate the most egregious shortcomings of the materials, modern photographic film is something of a patchwork. Because conversion of the silver salt to silver is particularly sensitive to high-frequency radiation (that is, to blue light), the red- and green-sensitive layers, which lie beneath the blue, have to be protected from any extraneous blue light passing through the blue layer by an intervening yellow-dyed filter.

More problematic is the fact that the dyes are inevitably imperfect primaries: the cyan dye absorbs a little green and blue, and the magenta absorbs some blue. This means that the cyan in the negative potentially imparts a pinkish tinge to the positive, and the magenta is corrupted with yellow. To counteract this, additional pale dyes are added to the cyan and magenta layers in the negative to correct the color balance.

Ideally, the dyes should have a sharp band of absorption within their re-

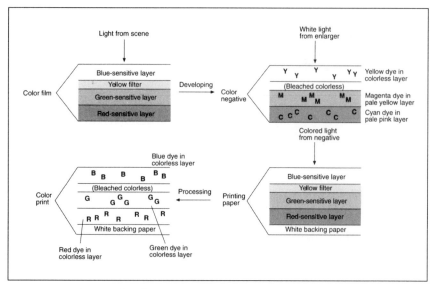

Figure 12.3: Photographic film contains three light-sensitive layers, each sensitized by dyes to one of the three additive primary colors. A yellow filter protects the green- and red-sensitized layers from stray blue light. To form the negative, colored dyes in yellow, magenta, and cyan are substituted for the silver particles formed by the action of light. To make a print, a three-layer film is exposed through the negative, and blue, green, and red dyes are added in the exposed areas.

spective wavelength ranges, with no overlap between them. In that way, for example, green light would not contaminate the blue separation. But the physics of light absorption does not work this way: there is always a more or less smooth rise and fall in absorption as the wavelength is altered (see Figure 12.4 on page 293). Considerable effort has gone into crafting dyes that have characteristics as close as possible to the ideal; those used in the textile industry aren't designed to meet such narrow constraints. Efforts toward a rational synthesis of color, initiated by Otto Witt in the nineteenth century, have therefore become of central importance to the veracity of color photography.

FAITH IN INK

Although James Clerk Maxwell confined himself to additive reconstruction of his three-color images by projection, it did not take great genius to ap-

preciate that his photographic separations might be used to prepare plates for three-color printing via the existing techniques of photogravure or photolithography. The idea occurred to several individuals in the early 1860s, making priority a contentious matter. In 1862 the Frenchman Louis Ducos du Hauron proposed that printing plates might be made from photographs exposed through colored glass. And in 1865 an Englishman named Henry Collen outlined a similar concept in a letter to the *British Journal of Photography*, albeit in ignorance of Maxwell's work. This compelled him to begin with a reinvention of color photography:

> It occurred to me . . . this morning that if substances were discovered sensitive only to the primary colours . . . it would be possible to obtain photographs with the tints as in nature by some such means as the following:
> - Obtain a negative sensitive to the blue rays only . . .[14]

But the credit for putting these ideas into practice must go to Baron Ransonnet in Vienna, who in 1865 set out to use the three-color principle for photolithography. He collaborated with the Viennese lithographer Johann Haupt to make prints of a Chinese temple, which Ransonnet photographed as a member of the Austrian Imperial East Asia expedition. Haupt found it necessary to add two extra plates, for black and brown, to achieve satisfactory results.

Vogel's dye-sensitized photographic emulsions made the preparation of the color separation printing plates more direct by eliminating the color filters. Each plate is then inked in the same color as the respective sensitizing dye—in general, yellow, magenta, and cyan, plus a black separation for emphasis. The plate prepared from the green-sensitive emulsion, for example, is coated with magenta ink.

The key consideration, as Vogel appreciated, is that the inks should absorb light in *precisely* the same way as the dye sensitizers. Unless this is so, the recombination of colors cannot hope to capture faithfully the hues of the original scene. For example, if a reddish ink is used instead of magenta, it absorbs blue light where, in the final print, it ought to be reflecting it.

Ideally, said Vogel, the colorants in the inks should be the very same dyes as those in the sensitizers. It was an implicit injunction to chemical and photographic manufacturers to match their products one to the other. But this was not feasible, since not all dyes make viable inks, both for chemical and for economic reasons. In other words, in the era of photogra-

phy just as in the period of hand engraving, the success of three-color printing hung on a question of materials.

The outcome was inevitably a compromise: one had to make do with whatever inks were available. Frederick Ives (who introduced Fox Talbot's halftone method to three-color photographic printing in the late 1870s) proposed in 1888 that Prussian blue (which is greenish), eosin red (which is bluish), and an unspecified "brilliant yellow" should be used. But photographer E. J. Wall, writing in 1925, commented that "printing inks that more nearly conform to the strict theoretical requirements . . . would appear to [represent] the field of greatest advance . . . Theoretically perfect inks are still a desideratum."[15]

Actually, "theoretically perfect" inks are an impossibility. Just as with the sensitizing dyes in photographic film, the ideal three-color printing inks would each absorb a third of the visible spectrum in nonoverlapping chunks (Figure 12.4). But the physics of the light-absorption process doesn't permit this: real inks have smooth-edged absorption bands that encroach into one another's territory. This limits their ability to capture colors accurately when superimposed.

You can judge for yourself from any color prints in old books how effectively (or otherwise) printing inks edged their way toward "theoretical perfection." For those too young to have firsthand recollection, it is hard to escape the notion that the events of the world in the post–World War II years took place in an overcharged Technicolor glow of ruby-red lips and phthalocyanine-blue skies, just as World War I was conducted in monochrome.

The extent to which a print is true to the original is always going to be determined by the quality of the inks. They are the chromatic building blocks from which one must try to re-create every color under the sun, and this can never amount to more than an approximation. Vermilion, for instance, has its own unique hue, its characteristic plucking of the spectrum's many strings. To emulate it using cyan, yellow, and magenta—each of which plucks its own blend of harmonics—is analogous to an attempt to reproduce a trumpet sound by mixing, in different proportions, the notes sounded on a piano, a flute, and a tuba. One might aim for the same result with a different trio of instruments and obtain an approximation more or less faithful. Thus one's impression of the rich vermilion of a medieval triptych, as viewed in an illustrated book, is utterly dependent on the printer's choice of inks (among other things). The one thing we can say for sure is

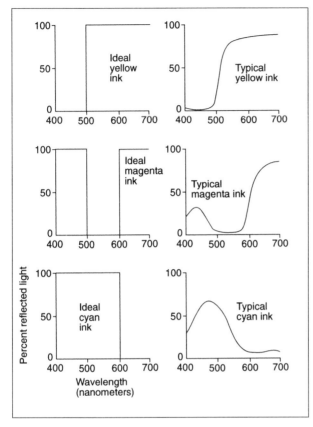

Figure 12.4: The inks used for color printing should ideally absorb light in crisply defined wavelength bands, with no overlap. In practice, this ideal can never be achieved, and the absorption bands overlap somewhat, compromising the fidelity of the color reproduction.

that this impression will never be identical to the one you would have from standing before the painting itself.

Eager to dispel such concerns, in 1920 the English art magazine *Colour* bore testimonials from several "great artists" to the accuracy of their prints. Nonetheless, art historians remained reluctant to accept color photography—even photographic prints, let alone printed copies in books—as a valid means of recording images until at least the 1950s.

By the 1960s, according to art historian Edgar Wind, color photographic reproduction of paintings was still so primitive that it was better to rely on black-and-white images:

> Since the ordinary photographic plate is sensitive to a larger range of shades than can be recorded in color, the best black-and-white reproduction of a Titian, Veronese or Renoir is comparable to a conscientious piano transcription of an orchestral score, whereas the color print, with some exceptions, is like a reduced orchestra with all the instruments out of tune.[16]

To judge from some books of that time, he had a fair point. John Gage comments that the use of color slides in art lectures at Cambridge was then the exception rather than the norm.

DIGITAL COLOR

Principles remain but technologies change. Modern color printing is almost invariably conducted from an electronic image. There need be no "copy" that one can hold in the hand and inspect visually between the stage of electronically scanning the original and printing the reproduction in colored inks—no lithographed plates, no photographic negatives. Even if "photography" is used, it can be of a kind that converts the reflected light directly into a matrix of magnetically recorded data in a digital camera, rather than leaving an imprint on photographic emulsion. And yet in the end, the reproduction is still created as Le Blon did it: by subtractive and optical mixing of three colored inks, with black added for emphasis. The computer software has to conduct careful deliberations to convert the scanned image data into output instructions that re-create color values by the halftone method, mimicking with digital electronics what Fox Talbot did with a sheet of black tulle. The three-color method, stippled into halftones, remains the most efficient way of putting accurate color on the page.

Electronic systems allow a great deal of control over color reproduction, but this is not the same as saying that they permit perfect accuracy. They *can* be very accurate but are not routinely so, and digital processing introduces complications of its own.

To convert a colored image—be it an original painting or a photograph of it—into electronic form, a scanner contains devices that produce an electric current in proportion to the amount of light that falls on them. Colored filters separate out the light falling onto these devices into the red, blue, and green components.

To store the image digitally, it is broken down into a grid of tiny patches, each of which is assigned a single color. The fineness of this grid ultimately determines the resolution—the degree of detail—that may be recovered in a printed version of the electronically stored image. The finer the grid, the better the resolution—but also the more memory space needed to store the image. In general, the image will be stored on a finer

grid than that corresponding to the "grain size" of the final halftone print. It is not uncommon, for example, for the scanned image to be broken down into several thousand patches per inch, whereas printing at a resolution of 300 dots per inch is sufficient for all but the highest-quality work.

Before printing, a judgment about the fidelity and balance of the color in a scanned image will be made by inspecting it on the monitor screen. The electronically stored image is painted in the colors of glowing phosphor dots of the computer screen.

Each grid point or pixel on the screen contains specks of three different phosphor materials. When they are struck by the beam of electrons fired at the screen from the back of the monitor, the phosphors emit light of a particular color: one of them glows red, one blue, and one green. The electron beam is swept back and forth across the screen so rapidly that the eye registers each shining phosphor dot continuously.

The phosphors therefore embody another system of primaries, which may be slightly different from that of the color filters of the scanner as well as differing from the yellow-cyan-magenta of the printing inks. The computer must know how to shift its color reference frame between these different systems. But any method for constructing colors from three primaries, whether additive or subtractive, must inevitably lose some colors. The color space accessible by additive mixing of three colors can be represented by a triangular field on the CIE diagram (see Plate 4) that has those three colors at its corners (Figure 12.5a). (But remember that this does not show differing brightnesses, so that a brown is equivalent to a yellow.) Because the full color space is bounded not by straight borders but by curves, no triangle of primaries can encompass it all. The range of colors that it is possible to obtain from the mixing of a certain set of primaries is called the color gamut.

So what should one do with a combination of red, blue, and green light recorded by the scanner that the system of primaries in the "reproduction"—whether the screen phosphors or the printing inks—is not equipped to reproduce? There are two common ways for the computer to handle colors that fall outside the gamut. The simplest is to move them to the nearest boundary of the gamut: to approximate any color one cannot capture with the nearest color that one can. This means that two areas of color that are visually distinct in the original image might become identical in the reproduction. Another alternative that avoids this consequence is to compress the entire color range of the image evenly until all the grid points

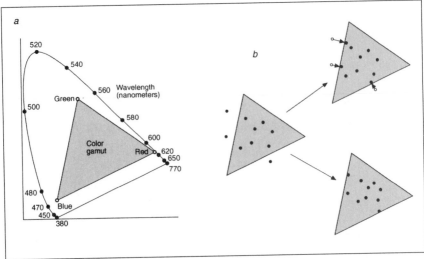

Figure 12.5: (a) The color gamut of phosphors on television screens, displayed on the CIE diagram. (b) If scanned colors fall outside the gamut, either the outliers can be shifted to the nearest edge of the gamut or the entire "palette" can be compressed. The latter preserves color relationships but shifts all the colors across the board. In practice, adjustments made to fit all measured points within the gamut can take these points along quite complex trajectories in color space.

fit within the gamut (Figure 12.5b). This shifts all the color slightly throughout the image but maintains a balance that closely approximates that in the original.

The color gamut of screen phosphors is determined by the materials from which they are made. One might imagine that the ideal phosphors for a full-color screen would correspond to colors located as far as possible in the corners of the tongue-shaped CIE diagram, to encompass as much color space as possible. But in fact it is better not to venture too far into these fully saturated corners, because that would entail using red and blue phosphors that emit at the edges of the visible range. At these extremes, very high light intensity is needed to produce a sensation of appreciable brightness. It is technologically difficult to extract such brightness from phosphors. So for this and other reasons, the phosphors considered ideal have a more restricted gamut. All the same, it is hard to find materials that satisfy this ideal: the canonical green phosphor (zinc cadmium sulfide) cannot reproduce strongly saturated greens.

So even on computer screens, where art is increasingly viewed, manip-

ulated, and even created, limitations in materials restrict the coloristic pos-
sibilities. As new screen technologies become available, in particular flat-
screen systems based on liquid crystal displays or on light-emitting diodes,
new layers of complexity will be added to these limitations. It is by no
means obvious at this point that the new technologies will enhance the
color range of on-screen images—possibly quite the opposite.

In general, the red, green, and blue phosphors of a monitor screen offer
something like seventeen million different color combinations. But typi-
cally the palette of a stored image will be much more restricted, so that the
image can be stored using only a modest amount of memory. The palette
generally contains 256 colors, each composed of a specific combination of
red, green, and blue to which the hues of the scanned image will be
matched via a "color look-up table," or "clut." The stored image is therefore
likely to have a narrower range of color than the original: one is essentially
repainting the picture with a palette of 256 colors that may not be mixed.
But if the clut (which is to say, the digital palette) is well chosen to match
the colors of the original, there should be sufficient diversity for the eye to
be scarcely able to detect a difference. A poorly matched clut, however, can
generate an image with a shifted tonality (Plate 59).

Optimizing the clut is a crucial aspect of color matching. This may be
done in different ways on different computer systems, which is one reason
why an image's color range might be altered if it is scanned on one system
and viewed or printed on another. Differences between monitors can also
alter the balance owing to variations in brightness of the phosphors. For
these reasons, an image may be brightened or darkened if transferred be-
tween machines: those scanned on IBM PCs tend to look too bright when
displayed on Apple Macintosh and Unix systems, whereas the reverse
transfer gives darker, muddy images.

To print the scanned image, the computer must convert a grid encoding
different intensities of red, blue, and green light into instructions for de-
positing the four (yellow, magenta, cyan, black) inks in a given area in the
correct proportions and overlaps to generate the same visual effect as the
reflected red, green, and blue light from that area of the original. The cal-
culation is complicated by several factors—for example, the properties of
the paper, such as its whiteness and graininess, will affect the appearance of
any given combination of inks. In practice these calculations would be too
time-consuming to perform on the spot, as it were, and so they are pre-
determined for a whole range of different red-blue-green combinations,

taking into account the qualities of the printing inks and paper. Then all the computer has to do is look up in a stored table the answers for each patch of the gridded image.

For printing on a large scale, such as for this book, electronically stored images will be physically embodied on printing plates or rollers so that they may then be run off mechanically. To apply ink to paper, most of the processes developed in the nineteenth century are still used. Lithography with rollers patterned into ink-attracting and ink-repelling areas is the most common of these, conducted via the offset technique in which the ink is first transferred from the plates to a rubber blanket that is then pressed against the paper. Intaglio and relief methods (where the inks are respectively held in depressions or carried on raised areas of the plates) continue to find their niches. And rather than using printing plates, it can be cheaper and more convenient for small-scale printing jobs to be conducted by "direct imaging printing," whereby the reproduction is created straight from the electronic data using ink-jet systems.

But how good, in the end, are the copies? The gamut on the printed page is still delimited by the extent to which the inks are good primaries, and theoretically perfect inks are still "a desideratum." Because the magentas absorb rather too much blue and the cyans too much blue and green, it can be hard to reproduce accurately low-saturation (dirty-looking) blues, greens, cyan, and magenta. And only in the red-to-yellow range can a three-color reproduction successfully capture high-saturation colors. The gamut may be further restricted by the paper substrate—newspaper, for example, deadens high-saturation colors, which is why newspapers resort to higher-quality paper for their glossy magazine supplements. The gamut can be extended by using supplementary inks such as strong blues, greens, and reds. This adds to the printing costs and can be contemplated only for the most demanding assignments.

THE COMPUTER IN ART

Just as printing methods such as wood-block and linocut have been used as vehicles for artistic expression in their own right, so too the digital age offers a new way for artists to manipulate line and color. Computer art is still so new a medium that one cannot yet be sure whether to dismiss it as a fad or hail it as the future of visual art. Yet I cannot imagine that digital tech-

nology will fail to be valorized as a means of creative expression once there exists a generation of artists more accustomed to holding a mouse than a paintbrush. No great digital painter has emerged so far to rival those who deal in messy stuff squeezed from tubes, but the electronic visionaries have, after all, had their paint boxes for barely twenty years.

The use of computers in art began in the 1960s, when digital technology was still so new and mysterious that the graphic art it generated gained kudos by mere association. Monochrome works made by computer were displayed in art galleries; and even if they had no more merit than the tortuous computer music that reached concert halls, it was a start. American painter Robert Rauschenberg was one of the high-profile artists who saw the shape of things to come, and in 1967 he teamed up with physicist Billy Kluver of Bell Laboratories to create an initiative called Experiments in Art and Technology.

Given the absence of color in these early efforts, it is hardly surprising that the computer art of the 1960s and 1970s focused on line and volume—on the construction of space. These preoccupations are apparent in the computer-generated works of early pioneers Frieder Nake and Manfred Mohr. But the danger of an algorithmic approach to art is apparent in the quest of the German philosopher Max Bense in the 1960s to identify exact laws that the computer can explore and use to produce "aesthetically correct" images. One is reminded of scientists' attempts to impose strict rules of color on painting and to "correct" works that contravene them.

For computer art to broaden and flourish, the three most vital ingredients were low cost, interactive interfacing, and color. All arrived in the 1980s when Apple introduced the affordable Macintosh personal computer with its MacPaint interactive graphics software. (Despite the enticing name, however, this was initially capable of handling only black-and-white images.) As color graphics became more sophisticated, painters stirred themselves to investigate the new technology. David Hockney took to using computers for photocollage works, and Andy Warhol bought an Amiga computer to experiment with color combinations for his silk-screen prints.

Because computer technology is now such a fast-moving target, a snapshot will capture little of lasting relevance. The artist now has a virtual canvas on which marks can be made that resemble brush strokes, pencil or pastel lines, spray-can swaths, and so forth—each in something like seventeen million different colors. Canvases can be revised in an instant and initiated or discarded at no cost. But it is an open question whether mimicry

of manual painting is the best way to exploit the new medium when the possibilities for interaction, animation, collage, and cross-referencing are so great. The computer's biggest problem right now is its versatility: too great a range of options smothers art, as Renaissance colorists knew.

And there are no agreed notions of authenticity and originality for a work of art that has been created digitally. Is each hard-copy print an original? If not, where exactly *is* the original? Some computer artists deal with this problem by making limited-edition prints—Manfred Mohr made only a single print of his works. Of course, in a sense those who create fine art by photography face this same dilemma, but at least there is always an original negative. As the Internet makes dissemination of digital images ever easier, and since it comes imbued with its culture of free access to all, the issue of authenticity in computer art—and its ramifications for commerce—is likely to become ever more complex.

The liberation of art from ritual that Walter Benjamin foresaw has not yet happened, in part because photography has never really acquired the same artistic status as painting or sculpture. Perhaps it will be the computer, not the camera, that truly provides this emancipation.

DOES IT MATTER?

No doubt the majority of artists, living or dead, would be (and often have been) mortified to see what has sometimes become of their work in reproduction. But we should not take it for granted that this will be so. There is a sense in which a carefully wrought reproduction becomes a work of art in itself, its colors chosen so that even if they do not precisely mimic the original, they harmonize effectively. This is certainly evident in Le Blon's three-color prints, hand-engraved with truly remarkable skill and sensitivity. A case can be made for the intrinsic artistic validity of the monochrome engravings that in the nineteenth century strove to convey the essence of a great painting. Technology takes out much of the hard work, but it needs guidance from the human eye to do justice to an image.

Perhaps this is how the American painter Georgia O'Keeffe felt when some of her works were being prepared for printing by Viking Press in 1976. An artist with a particularly strong feeling for nuances of color, she nevertheless indicated to the printers that "it doesn't really matter if the color isn't absolutely right, if the picture feels right when you finish the print."[17]

MIND OVER MATTER

COLOR AS FORM IN MODERNISM

"The new art will really begin when we understand that colour has an existence of its own, that the infinite combinations of colours have a poetry and a poetic language much more expressive than anything before."
—Sonia Delaunay

"Colors win you over more and more. A certain blue enters your soul. A certain red has an effect on your blood pressure. A certain color tones you up. It's the concentration of timbres. A new era is opening."
—Henri Matisse (1952)

E ver since the Middle Ages, painters have been constantly reminded of how inadequate their palette was for capturing the true glory of the natural world. The colormaker George Field remarked in the 1840s that the Old Masters had been forced to "harmonize much below nature" because their pigments were not bright enough. Hermann von Helmholtz concurred: "The representation which the painter has to give of the light and colours of his object . . . cannot give a copy true in all its details. The altered scale of brightness which the artist must apply in many cases is opposed to this."[1]

Even with his modern palette, Cézanne recognized this with palpable anguish: "I cannot attain the intensity that is unfolded before my senses. I

do not have the magnificent richness of coloring that animates Nature." Van Gogh seems to have reconciled himself to this limitation: "A painter had better start from the colors on his palette than from the colors in nature."

Yet ever since Turner began to use the bright new pigments, painting was moving inexorably toward a consensus that the task of the painter was no longer the representation of nature at all. The road to abstraction was prefigured by a liberation from "naturalistic" color, heralded by van Gogh, Cézanne, and Henri Matisse (1869–1954). "The truth of the matter," said Matisse, "was that we kept at the farthest remove from imitative colors."

The result was an explosion of solid color and strong primaries. "I use the simplest colors," averred Matisse. "I don't transform them myself; it is the relationships that take charge of them." The red interiors of *La Desserte* (1908) and *Red Studio* (1911) are almost overwhelming in their uncompromising two-dimensionality, denying the illusion of pictorial volume. The art critic John Russell says of *Red Studio*, "It is a crucial moment in the history of painting: color is on top, and making the most of it."

THE WILD BEASTS

All use of color in the twentieth century must be considered in relation to Matisse, just as all use of form relates to Cézanne. Picasso said as much: "If all the great colorist painters of this century could have composed a banner that comprised each one's favorite colors, the result would certainly have been a Matisse."[2]

And what are these colors but those of pure joy and pleasure, delighting in the cobalt, chomium, and cadmium hues of nineteenth-century chemistry? In 1897 Matisse discarded his previously somber palette for one that danced with the bright blues, greens, and reds of newly invented pigments—a palette much like that of the Impressionists, although he did not exclude earths such as yellow ocher and the sienna pigments. He used cobalt violet, which features only occasionally in Impressionism, and he adopted the new cadmium reds, in light and purplish shades.

Remarkably, cadmium red was essentially the first major material innovation in red pigments since the introduction of carmine lake made from cochineal in the sixteenth century. Mars red (synthetic iron oxide) was a refinement of the red ocher known since antiquity; red lake manufacture

was improved in the early nineteenth century but involved no truly new colorants; the aniline reds were never really successful as artists' colors; and synthetic alizarin was the same compound that the Egyptians drew from madder root. Every other primary and secondary color was given an influential new embodiment in the nineteenth century except red.

Cadmium red is basically cadmium yellow (cadmium sulfide) with some selenium added in place of sulfur. The element selenium, delightfully named for the moon, was discovered in 1817—the same year as cadmium—by the Swedish chemist Jöns Jacob Berzelius. It has properties similar to sulfur and often occurs naturally in association with it.

It is not easy to trace the genesis of the pigment, for cadmium sulfide orange can itself approach red closely enough to blur the boundaries. George Field speaks approvingly of a pigment he calls cadmium red in his (posthumous) 1869 edition of *Chromatography*. But since no known technical document specifies the sulfide-selenide before a German patent from 1892, we have to suppose that Field's color, which he describes as "orange-scarlet," is merely a particularly deep variant of cadmium orange. In any event, the compound that now goes under the name of cadmium red was not available as a commercial product until 1910. The Bayer chemical company developed a more reliable and economical means of producing it in 1919. By altering the amount of selenium, the color can be adjusted from orange to dark maroon.

Matisse was much taken with this strong new red, which has excellent stability. He recounts that he attempted, unsuccessfully, to persuade Renoir to adopt a "cadmium red" in place of the traditional vermilion. Since this was in 1904, however, he was presumably speaking of whatever pigment it was that Field had investigated, whose orange tint would have resembled vermilion more closely than the deeper modern variety.

Matisse felt, like Cézanne, that it is the relationship between the colors and not the forms of a painting that gives it its structure: "Composition is the art of arranging in a decorative manner the various elements at the painter's disposal for the expression of his feelings . . . The chief aim of color should be to serve expression as well as possible."[3] This expressiveness, he believed, could not be planned from "theories" of color use but must flow directly from the sensitivity of the artist: "My choice of colors does not rest on any scientific theory; it is based on observation, on feeling, on the very nature of each experience . . . I merely try to find a color that will fit my sensation."[4]

Yet when instinctive colorists speak about their use of color, we are not wise to look for consistency. Matisse confessed on one occasion that he was "a good half a scientist," and he had a reputation among his colleagues for adhering to theory. At his art school in Paris, he exposed his pupils to Chevreul, Helmholtz, and their interpreter Ogden Rood, through whom Matisse may have developed some interest in materials. Certainly Matisse derived from Rood an understanding that red, blue, and green alone could "create the equivalent of the spectrum"—which of course they can in the additive mixtures that Rood investigated but not as pigments. Here, nonetheless, may be the seed of Matisse's *Dance* and *Music*, both painted in 1910, in which these three colors appear in flat juxtaposition, each with a quasi-Aristotelian elemental assignation: blue sky, green earth, red flesh.

At the turn of the twentieth century, with Impressionism threatening to become the new establishment, Neo-Impressionism moribund, and van Gogh dead, there was plenty of room for a new avant-garde. It appeared first in the movement known as Fauvism, with Matisse as the figure-head. The Dutch Fauvist painter Kees van Dongen said of this group, "One can talk about the Impressionist school because [those artists] held certain principles. For us there was nothing like that; we merely thought their colors were a bit dull." Set Monet's water lilies against Courbet, and you can scarcely credit the accusation. Set them against André Derain's *Pool of London* (1906) (Plate 60), and all becomes clear. Here is color at full throttle, and it speaks as eloquently of the centrality of bright new pigments as if they had been simply squeezed in sequence from the tubes (which in truth they often were).

Like every other major movement in early-twentieth-century painting, Fauvism was a direct descendant of Impressionism. Matisse received a classical but open-minded training in Paris under Gustave Moreau in the 1890s but came under the spell of Impressionism in 1896. The young painter was fortunate to be recognized by that most generous and perceptive of Impressionists, Camille Pissarro, who also fostered Gauguin and Cézanne and advocated the genius of van Gogh.

But Matisse's enthusiasms led him in a different direction. In the works of Cézanne he found not only a resurrection of the idea—buried since the Venetian Old Masters—of color as constructive medium but also an emphasis on the importance of harmony and balance of tones, to which some other Fauves paid little heed. From Gauguin, meanwhile, Matisse took an understanding of the impact and emotional force of "primitive" art, as

well as an appreciation of the use of flat rather than modeled color. (Like van Gogh and Gauguin, he was strongly influenced by the Japanese prints in vogue in France at the end of the nineteenth century.) He laid out his influences plainly enough:

> To say that colour has once again become expressive is to sum up its history . . . From Delacroix to van Gogh and chiefly to Gauguin, by way of the Impressionists, who cleared the ground, and Cézanne, who gave the final impulse and introduced coloured volumes, we can follow this rehabilitation of colour's function, this restoration of its emotive power.[5]

But whereas for Gauguin color had mystical and symbolic implications, for Matisse it was purely the stuff from which pictures are made. Many of his paintings abolish depth from the canvas, building up a two-dimensional tiling of colored spaces almost like a tapestry. "What prevents Gauguin from being assimilated to the Fauves," he said, "is his failure to use colour for constructing space and his use of it as a means of expressing sentiment."

In 1899 André Derain (1880–1954) became acquainted with Matisse, to whom he introduced Maurice de Vlaminck (1876–1958) in 1901 at a van Gogh retrospective exhibition in Paris. These three were the core of the loosely knit Fauve group, and the van Gogh exhibition was the catalyst that ignited their incendiary colors. Vlaminck went away exclaiming that he loved the Dutchman more than his own father. Matisse remembers Vlaminck from this occasion as "a young giant who was voicing his enthusiasm in dictatorial tones and declaring that one must paint with pure cobalt, pure vermilion, and pure Veronese green [emerald green]." Derain said of his association with Vlaminck in those days in the Parisian suburb of Chatou, "We were always drunk with color, with words that describe color, and the sun that gives life to color."

Derain's palette was even broader than Matisse's, with barely a primary or secondary pigment omitted: all the cadmium colors are there, with barium chromate (lemon yellow) and Mars yellow. The impetuous and egotistic Vlaminck used the modern colors in unmixed form, producing high-keyed and strident works such as Landscape with Red Trees (1906–1907) that dazzled but ultimately left him unable to develop a mature voice (by 1910 he could do little but emulate Cézanne). Raoul Dufy (1877–1953), also associated with the group, is said to have eschewed all browns and used the full range of Mars colors (from yellow to violet) as well as the new

cerulean blue. There is a strong case to be made that Fauvism, not Impressionism, represents the most glorious fruit of the nineteenth-century advances in pigment technology, the final emancipation of color from tradition.

Fauvism burst into public view in 1905, when the movement found its name. At the Salon des Indépendants (which the Neo-Impressionists had initiated) in the spring of that year, Matisse exhibited *Luxe, calme et volupté*, fresh from his excursion with Paul Signac in Saint-Tropez. It excited much discussion and inspired others of the Fauves toward the "Divisionism" into which Seurat's pointillist style had evolved.

But Signac insisted that this style remain bound by rules of color contrast and complementarity, which ultimately frustrated and alienated the instinctive Matisse. In *Luxe, calme et volupté* he is little concerned with scientific exactitude—his stippled color patches are far too large to work by optical mixing in the way Seurat had intended. Much of the Divisionism practiced by Matisse, Derain, Georges Braque, and others was simply a separation of color into unblended dabs (*taches*). Matisse frequently evinces an almost medieval determination to preserve the integrity of pure color, and he criticized the Neo-Impressionists for undermining it with their optical mixtures.

That summer Matisse returned with Derain to the south of France, to the small town of Collioure, and here they developed the style that came to be seen as definitive of Fauvism. On seeing a collection of Gauguin's paintings, they realized that the way forward lay not with Divisionism but with flat color, "a harmony of intensely colored surfaces." Together with the other Fauve painters, they exhibited the results of this excursion at the Salon d'Automne in late 1905. This exhibition was founded in 1903 as a more discriminating alternative to the Salon des Indépendants, whose openness to all comers meant that the good tended to be buried among the bad.

The autumn Salon caused an uproar comparable to that of the first Impressionist exhibition in 1874, prompting scorn of a similar flavor. "A pot of colors flung in the face of the public," exclaimed the critic Camille Mauclair, lamely repeating the accusation that Ruskin leveled at Whistler in 1877. Others went further, driven almost to a frenzy by this lack of good taste. "Why put all these maniacs together and show their work to the public," wrote J.-B. Hall, "if it has no aesthetic value? What is the meaning of this new farce? Who is protecting them?" and so on until the final snooty punchline: "What have the daubs of Messrs Matisse, Vlaminck and Derain got to do with art?"

On seeing these dazzling works exhibited in the same room as some traditional Florentine-inspired sculptures, Louis Vauxcelles, the eminent critic of *Gil Blas*, remarked to Matisse, "Look! Donatello in a cage of wild beasts *(dans la cage aux fauves)*!" And so, like Impressionism before it and Cubism after (again courtesy of the witty Vauxcelles), Fauvism was branded by a derisive joke.

Others were more perceptive. Maurice Denis, a painter with the innovative Nabi group, remarked that "this is painting above and beyond contingencies, painting for its own sake, the pure act of painting." It was almost as if he could foresee the inevitable next step into abstraction.

But Fauvism had more shoots than that. Matisse's *Portrait with a Green Stripe*, a portrait of his wife painted in late 1905, seems to show the way to Expressionism, as well as announcing the redundancy of the color theories of Impressionism. Here complementaries are sacrificed, and instead there is dissonance: vermilion against violet, green against pink and ocher. With *Blue Nude* (1907), Matisse appears in retrospect to be preparing us for Picasso's astonishing nude figures.

Perhaps it was because Fauvism was simply too fertile that it was so short-lived: by 1908 it had ceased to exist as a coherent movement. In just four years it briefly claimed both Kandinsky and Braque, Picasso's collaborator in the inception of Cubism. Fauvism can perhaps be seen as a kind of catching-up period, an assimilation of the possibilities of the new colors that the Impressionists had only partly glimpsed. After Matisse, there was no looking back.

EXPERIMENTS IN COLOR

Some early-twentieth-century artists clung to the hope that science, not intuition, would help them navigate the treacherous waters of nonrepresentational color. In 1906 the Italian artist Gaetano Previati published *Scientific Principles of Divisionism,* which expanded on some of the Neo-Impressionistic views of contrast and optical mixing. It was highly influential on the Italian Futurist painters such as Giacomo Balla and Umberto Boccioni. Boccioni's painting *The City Rises* (1910) is an image surging with chromatic life, yet giving the impression of a more systematic use of color than Seurat's. "I want the new, the expressive, the formidable," Boccioni explained, implicitly summarizing the Futurist manifesto.

It may have been a translation of Previati's book that induced the

Frenchman Robert Delaunay (1885–1941) to dabble in Divisionism. Delaunay strove to achieve a luminous effect akin to stained glass, which he studied in French churches between 1907 and 1912: a series of paintings executed between 1911 and 1913 was called *Windows*. "Color alone," he said, "is both form and subject," but it was really colored light that he was trying to emulate, at first by attempting to suggest transparency through the luster that Divisionism seemed to promise. Delaunay subsequently abandoned the dots for flat color patches inspired by Cézanne and the geometric designs of the Cubists. Glowing with fully saturated, vibrant color, these paintings have been called "fragmented rainbows," although one might better regard them as mutations of the Newtonian color wheel. The poet and critic Guillaume Apollinaire called this style Orphism.

Orphism has been dismissed by some as nothing more than Fauvism turned abstract (and Delaunay indeed passed through a Fauvist stage early in his career). But it appears that Delaunay was searching for a color syntax, whereas the Fauves showed little interest in formulas. He professed, however, to have little patience for scientific principles:

> I am mad about the forms of colors, but I do not look for a scholastic explanation of them . . . None of the finite sciences has anything to do with my technique of moving toward light. My only science is choosing among the impressions which light in the universe offers to my craftsmanly awareness and which I try to group together by giving them an order.[6]

Yet Delaunay studied Chevreul and was probably familiar with the color theory of Rood (on which Previati had drawn). He made use of complementaries to develop his ideas of "colour movement." By seemingly paradoxical reasoning, he claimed that complementaries side by side produce "slow" movements whereas colors close together on the color wheel, such as orange and yellow or blue and green, produce "fast" movements. On the basis of these rather vague notions, Delaunay insisted that his works were not truly abstract but grounded in natural rules.

In the United States, Orphism fostered the movement known as Synchromism, whose key proponents were the painters Morgan Russell and Stanton MacDonald Wright. The intersecting planes of the Synchromists were, if anything, even brighter than Delaunay's. And in the "aesthetic of purity" sought by the Frenchman and his Russian wife, Sonia, herself an accomplished painter and poet, one can see the beginnings of the minimalism

that was to develop into Color Field painting in the United States. But Delaunay's weakness was inclusiveness. By embracing the entire spectrum, by failing to make the selection that is essential to all great art, he ran the risk of simply charting the colors of the rainbow rather than constructing them into a convincing work. There are dangers in falling too deeply for the gorgeous modern pigments.

THE SCHOOL WITHOUT THEORY

No one can deny that Paul Klee (1879–1940) was a superb and inventive colorist. Jean-Paul Sartre went further: "Klee is an angel who re-creates the miracles of this world." Yet it is by no means easy to reduce a Klee composition to any principles of color theory. He is a conjurer in color, at one moment working in luminous pastel shades (*Highways and Byways*, 1929), at another in lustrous, subtly modulated reds (*Landscape at Sunset*, 1923), then bright primaries on a dreamlike black background (*Landscape with Yellow Birds*, 1923; *Black Prince*, 1927). *Child with Aunt* (1937) is all shades of autumn; the rose, orange, green, and blue of *Glass Façade* (1940) glows as if genuinely backlit. *The Light and So Much Else* (1931) advertises its real subject in the title: light, given a superficially Divisionist treatment but otherwise indebted not one jot to the rigid codes of Neo-Impressionism.

Nothing better captures the sheer exuberance that color instills than Klee's recollections of the fantastic chromatic visions he found in the Arabic culture of Tunisia in 1914, which inspired him to joyous epiphany: "Colour has taken hold of me; no longer do I have to chase after it. I know that it has hold of me for ever. That is the significance of this blessed moment. Colour and I are one."[7]

It is no surprise that with Klee and Kandinsky among the teachers, the Bauhaus school of art, architecture, and design in Weimar, Germany, accorded much emphasis to color in the 1920s. Founded in 1919, the Bauhaus set itself the task—quixotic in retrospect—of both fostering creativity in artists and designers and reconciling their crafts with the demands of the industries that would use them. To some tastes, the school now represents all that is soulless and functional in modern design, with its geometrical forms and its rejection of pure ornament. To others, it symbolizes an avant-garde stripped of pretension and is one of the central foundations of Modernism. To the Nazis it was simply a center of "degenerate" art, and they closed the school in 1933.

The Bauhaus arose from an amalgamation of the Weimar Academy of Art and the Weimar School of Applied Arts. Its first director was the architect and designer Walter Gropius, whose vision was to reawaken the manufacturing industries to the importance of art. In the past, the craftsman who made useful artifacts was an artist as well as a technician, trained to make items that were aesthetically pleasing (which is not the same as pointlessly fanciful) as well as functional. With the rise of industrialization, this link had been lost, and mass production resulted in products that were devoid of any artistic value. "The artist," said Gropius, "possesses the ability to breathe soul into the lifeless product of the machine."

To this end, Gropius set about recruiting skilled and imaginative proponents of both the pure and applied arts to teach in the Bauhaus workshops and foster a new breed of creative craftspeople. Klee joined in 1921; Kandinsky followed the next year. With these two luminaries on the staff, the school did not find it hard to attract students but discovered that many wanted to become modern painters and had little interest in a training in the practical crafts.

But that was only one of Gropius's problems. On the staff in the school's first years was Johannes Itten, a teacher of painting and a student of the abstract painter and art academic Adolf Hölzel. Color theory was a strong preoccupation for Hölzel, and he conducted research into the relationship between color and sound. Itten acquired from his mentor this passion for color, as well as a penchant for unconventional teaching methods.

Meister Itten was a mystic, a follower of the Mazdaznan belief, rooted in ancient Zoroastrianism. He shaved his head, wore priestly robes, and encouraged the students to do likewise. Itten's outlook drew on the emotional excesses of the nineteenth-century German Romantics and their heirs, the Expressionist painters of the group called Die Brücke. He had little time for formal methods but instead considered "self-discovery" and experience the raw material of artistic creativity. His students were taught breathing and concentration exercises and were encouraged to empathize with their subject. Before drawing circles they would describe circles with swinging arms; to analyze Grünewald's painting of the Crucifixion, they had to weep as Mary Magdalene was weeping.

All of this made Itten a charismatic, controversial, and difficult *Meister*. According to one of his students, Paul Citroen, "There was something demonic about Itten. As a master he was either ardently admired, or just as ardently hated by his opponents, of whom there were many. At all events, it was impossible to ignore him."[8]

One has a sense that the Bauhaus operated in the early 1920s under conditions of barely controlled anarchy, despite the best efforts of Gropius. This was by no means an inhospitable environment for such ingenious figures as Klee and Kandinsky, but it hardly made for a coherent theoretical foundation. In no aspect is this more evident than in the Bauhaus attitude toward color.

The Bauhaus inherited from the Weimar School of Applied Arts a tradition of rational experimentation in color inspired by Neo-Impressionism. Itten himself aspired to a "grammar of color" but had no clear idea of how to establish such a thing. Kandinsky was responsible for most of the teachings on color, and the Bauhaus ethos professed that it should be studied from a physical, chemical, and psychological point of view. Kandinsky's attempts to conduct "scientific" consensus experiments in color psychology were a manifestation of this ethos that ultimately proved only to undermine his rather dogmatic ideas about the emotional language of color.

In fact, it seems clear that neither Klee nor Kandinsky nor Itten had a strong grasp of contemporary scientific ideas about color. Klee's lectures made reference to Goethe's views and the use of complementary colors by artists such as Otto Runge and Eugène Delacroix. But Klee regarded the value of these theories as limited, as far as the artist was concerned, not least because the colors of the scientist were not the same as the pigments of the artist: "Of course we may use it for a bit, but we hardly have any need for a theory of colors. All the infinite mixtures possible will never produce a Schweinfurt green [emerald green], a Saturn red, a cobalt violet."[9]

And there is no real sign that anyone at the Bauhaus possessed any knowledge of the chemical basis of color. Itten's *Elements of Color* contains much of interest, but nothing of any note about pigments, the very stuff of color.

Evidently, none of this is any bar to being a truly great painter or an imaginative colorist, but one can only wonder what the students made of it all. One could find fragments of all manner of color theories floating around the Bauhaus, no matter that some stood in stark contradiction to others. It is no surprise that Josef Albers, a Bauhaus alumnus who later became one of its tutors, sought refuge in a purely empirical approach. He called color "the most relative medium in art," liable to change with its context. After the Bauhaus was closed, Albers emigrated to the United States, where he taught painting at Black Mountain College in North Carolina. He began his series of paintings called *Homage to the Square* in the

1950s and pursued them until his death in 1976, by which time his flat-colored superimposed squares had become emblematic of American minimalism. These images, midway between art and experiment, formed the basis of his influential book *Interaction of Color* (1963), in which he suggests, with echoes of Kandinsky, that certain combinations of primary, secondary, and tertiary colors hold particular emotional significance.

It is hardly surprising, given Itten's iconoclasm, that he was not destined to last long at the Bauhaus. His fundamental dispute with Gropius's vision was with the idea of compromise with the world of commerce. He was convinced that true creativity must stem from self-knowledge unfettered by the crude practical demands of industry, and he structured his courses accordingly. He demanded that Gropius settle for one or the other: for pure art or for pure practicality. But Gropius insisted, "I seek unity in the *fusion*, not in the separation of these ways of life." In 1922 Gropius expressed concern that "the Bauhaus could become a haven for eccentrics if it were to lose contact with the work and working methods of the outside world." Itten took the hint and departed under a cloud with the avowed intention to "cling to his romantic island."

Significantly, in 1923 Gropius proposed to replace him with a teacher in chemistry in order to promote a return to the study of color as a material. (The Bauhaus manifesto of 1923 explicitly classed it as such, alongside wood, metal, glass, and other substances.) The school reopened the workshop in dyeing techniques that had previously been a part of the Weimar School of Applied Arts. After relocating to Dessau in 1925, the Bauhaus reestablished its mission as a place of practical training. Klee and Kandinsky continued to teach painting, but more in the spirit of resident artists instilling a sense of aesthetics in the institution than as star teachers of a new breed of modernists.

"THANKS BUT NO THANKS"

The apparent rejection, in the Bauhaus of the early 1920s, of the material aspects of color may have had its origins in something more concrete than the mystical leanings of its *Meister*. Itten's teacher Hölzel was an outspoken opponent of the color theory of the German chemist Friedrich Wilhelm Ostwald (1853–1932). In 1909 Ostwald was awarded the Nobel Prize for his work in physical chemistry, a discipline that he and a handful of others all but invented. An amateur painter who had made his own pigments since

childhood, Ostwald developed an intense interest in color in all its aspects.

Ostwald is scarcely alone among Nobel laureates in acquiring the conviction that his prize conferred invulnerability on any of his subsequent ideas. But few have displayed such single-minded assertiveness and arrogance in propagating them. His espousal of the belief that there were absolute color principles (his own, of course) in art, violation of which led to art that was "wrong" and in need of correction, can hardly have endeared him to those of a more instinctive temperament. Coupled with a strong socialist conviction that art should serve the people and not the individual, this was guaranteed to set him on more than one collision course. Max Doerner no doubt spoke for many when he said, "It seemed somewhat amusing to painters when Professor Ostwald, in analyzing Titian, announced that the blue of a mantle was two tones too high or too deep! It was simply Titian's own blue."[10]

At the Bauhaus, Itten's opposition to Ostwald's theories was shared with equal vigor by Klee. Although the young Klee was one of the few artists to express enthusiasm for Ostwald's handbook *Malerbriefe* (*Letters to a Painter*) in 1904, calling it "an excellent scientific handling of all technical matters," his later views were scathing:

> That which most artists have in common, an aversion to color as a science, became understandable to me when a short time ago I read Ostwald's theory of colors. I gave myself a little time to see if I could succeed in getting something of value from it but instead was only able to get a few interesting thoughts . . . Scientists often find art to be childish, but in this case the position is inverted . . . To hold [as Ostwald did] that the possibility of creating harmony using a tone of equal value should become a general rule means renouncing the wealth of the soul. Thanks but no thanks.[11]

But Kandinsky was ambivalent and came to favor Ostwald's views by 1925; Gropius and the more technologically inclined of the designers had viewed them sympathetically all along.

One feature of Ostwald's theory, seemingly odd for a scientist, was to instate green as a primary along with red, yellow, and blue. The color wheel shown in Ostwald's book *The Colour Primer* (1916) awards greens no fewer than nine of its twenty-four divisions. But Ostwald had no quarrel with the notion of green as a secondary mixture of blue and yellow. Rather, he considered green to be *perceptually* autonomous, an acknowledgment of the psychological dimension of color that owes much to Goethe. Ostwald's

scheme was derived from the theories of the Viennese psychologist Ewald Hering, who posited three sets of "opponent colors" that have a strong resonance with the dualisms of Goethe's theory: black and white, red and green, yellow and blue.

The most important aspect of Ostwald's color theory, however, was the role that he assigned to the gray component of colors: he introduced the dimension of gray-scale *value* (or brightness) into color space. Otto Runge's color sphere had attempted to extend the one-dimensional color wheel by progressing from black at one pole to white at the other, but it did not find any place for gray as such. Albert Munsell's three-dimensional color space (see Plate 5) went further, and Ostwald was much influenced by it when he met Munsell at Harvard in 1905. Ostwald wished to translate this abstract space into a set of principles relevant to the artist, a means of achieving harmonious color composition.

He did so by first establishing a gray scale of evenly varying perceptual steps. According to Ostwald, these steps obeyed a mathematical relationship between the progressive ratios of black and white. He then applied this gray scale to each of the hues on his twenty-four-part color circle and asserted that color harmony resulted from the use of colors whose values—their gray components—are balanced. This was the central idea laid out in *The Colour Primer*, which Klee condemned so dismissively. The upshot for painters was a recommendation to temper and harmonize colors with white.

This much would have been a solid enough contribution to color theory, but Ostwald turned it into the basis for a crusade. His chemical expertise gave him an unusual ability to translate theory into terms relevant to the pigments from which colors were actually made—and his consultancy role in the German paint industry meant that Ostwald was able to impress the theory onto commercial color products. In 1914 he arranged a "color show" of industrial paints and dyes at Cologne on behalf of the Deutsche Werkbund, the German association for art and design, and in 1919 he initiated a series of technical conferences on the topic of color at Stuttgart that still runs today. His children described their father in his later years as working away in his laboratory with an unkempt beard so full of pigment particles that it shone with all the colors of the rainbow.

In the 1920s Ostwald's vigorous promotion of his ideas made them preeminent among European artists of the time, whether as a basis for practice or an object of vilification. He is said to have become something of a cult

figure among the Dutch De Stijl painters such as Piet Mondrian, Theo van Doesburg, and J.P.P. Oud. But Mondrian, who was much concerned with the question of primaries, seems to have struggled to comprehend what Ostwald's theory should imply for his own use of color: Should one include green or not? Perhaps there is something to be learned from the prospect of the Dutchman fretting over how to fill his grids according to ill-grasped theoretical principles while Klee sets his own grids ablaze with unfettered intuition.

ART FOR ART'S SAKE

NEW MATERIALS, NEW HORIZONS

"I think a picture is more like the real world when it's made out of the real world." —Robert Rauschenberg

"This was an entirely new conception of colour, and it was put into words, tentatively, by Stella . . . when he said: . . . 'I tried to keep the paint as good as it was in the can.' . . . That Stella sought to 'keep' the paint that 'good' suggests that he knew it might be hard to improve on the materials in their raw state, that once the paint had been put to use in art, it might well be less interesting than when it was 'in the can.' " —David Batchelor (2000), *Chromophobia*

For the twentieth-century artist, the medium carries its own message. Collage, explored by the Cubists and brought to a delicious refinement by the surrealist Max Ernst, injected the fabric of the real world into the composition. It spoke directly of the artist's social environment: the newspapers, the cigarette packets, the imitation caning pattern of café furniture, all lending the work an urbanity and immediacy that paint on canvas could only imitate. Georges Braque let sand and sawdust emphasize the solidity, the materiality, of his paints. In the "ready-mades" of Marcel Duchamp, the media do all the work; the artist simply selects. It is not what one sees that matters but the question posed by its identity as a workshop product or its placement in a gallery: What is art?

What is art? We have just lived through the first century in history in which that question has lost its boundaries. The nineteenth-century critic had only to distinguish the good from the bad, the object of attention unambiguously framed, varnished, and hung ready for inspection. Today we can pass in the street a billboard, a pile of detritus, a person behaving bizarrely, a graffito, and wonder to ourselves: Was that art, or just life?

In letting the medium carry so much of the message, twentieth-century artists were in some respects returning to a secular version of the medieval attitude: materials possess their own intrinsic values and symbolic significance. The substance of art is no longer the passive tool that it became in the intervening centuries, to be arranged and worked until it ceased to be visible beneath the image itself. The very choice of materials may carry a message that is political, subversive, spiritual, shocking. Art is made from animal carcasses, human body fluids, excrement.

And yet few, if any, modern painters have understood their materials in the way that the painters of the Middle Ages or the Renaissance did. And few have seemed to care or have shown much curiosity about what was actually in their cans (the preferred receptacle for postwar paint). In any case, colors appeared in such bewildering profusion—spurred by the development of new synthetic colorants—that no artist could be expected to keep pace with the march of materials. As a result, painters would mostly take the colors they were given and hope for the best. Even Mark Rothko, one of the foremost of modern colorists and a rare devotee of technical knowledge, occasionally used pigments that did not withstand the ravages of time so that already some of his paintings have lost their impact.

Such was the fissiparity of art in the twentieth century that few traditional categories survived it. Michelangelo was of course both painter and sculptor, and Alberti painter and architect. But they did these things one at a time. By the late twentieth century, the boundaries were gone: painting is no longer about the flat canvas, and installation may merge image and space, light and tactile experience. The artist's medium is the world: trees and ice, the city and its appurtenances, mountains and sky. So we can hardly be surprised that modern color too is a multifaceted gem, no longer uniquely defined by the paint box nor even by the rainbow or the Munsell atlas. The question of how artists get their colors thus becomes a matter as much for the philosophy of art as for its related technologies. Color itself is being reinvented.

INDUSTRIAL COLOR

The context of Marshall McLuhan's statement that "the medium is the message" was the Pop Art of the 1960s, which insisted that there could be no other message *but* the medium. The medium was garish, crude, and gloppy in Claes Oldenburg's hamburger sculptures because that was the nature of the fast food it depicted. Andy Warhol's work was repetitive because the advertising it quoted relied on repetition. Art was mass-produced and disposable because the culture in which it was embedded was just the same. In a sense, this art does nothing more than mirror the culture that produces it—"says" nothing that has not already been said.

Yet this is worlds away from Yves Klein, Mark Rothko, or Jackson Pollock, let alone Matisse and Kandinsky. The pivotal point for the late twentieth century's archcolorists is that color itself—which is to say, its material substance—ferries the message to the viewer. The message might be psychological, emotional, spiritual; certainly it is not, for these artists, as stark and blunt as that of Pop Art. But it is conveyed not through the careful depiction of Christ's agonies on the cross or the watery eyes of a tired old man or the fragmented, contradictory planes of a woman's face—not, that is to say, through *disegno*. *Colore* speaks for itself and represents nothing but itself.

This is a radical idea, although we can find its roots at least as far back as Goethe's *Theory of Colors*. Its modern incarnation is often attributed to Kandinsky, who has (rather meaninglessly) been described as the first abstract painter. The tale is told of Kandinsky's epiphany when, on returning from a walk, he glimpsed one of his own early figurative works standing on its side. The removal of all referential objects allowed the full impact of pure color to work on his senses. He realized that objects—"signs"—serve only to obstruct this direct communion with color, preventing access to a deeper layer of reality beneath the physical form of things. "Modern art can only be born when signs become symbols," he said.

Could such a conclusion have been reached by a painter less extraordinarily (and neurologically) sensitive to color than Kandinsky? Was this profound insight or naive theosophy? It matters little. Abstraction was inevitable; anyone who now looks at the work of Cézanne or Gauguin can see that. Of course, all artists create their own ancestors, as Borges said of Kafka. But it is hard to imagine how abstract art could have become so pervasive so quickly if the world of Western art was not already primed for it

as the twentieth century dawned—in part because of its new immersion in powerful color. "The need for color, the meaning of that," says American artist Donald Judd, "more than anything destroyed the earlier representational painting."

Yet for the artist who wishes to paint nonrepresentationally, color is a treacherous ally. For real things are colored too, and we cannot readily let go of that association. According to art historian Philip Leider, "If you are going to make abstract pictures you have to be sure that your colours don't suggest or take on the quality of non-abstract things, like sky or grass or air or shadow (try black, or if that's too poetic, copper or aluminium)."[1] Thus abstraction makes new demands on color. In the second half of the twentieth century, some artists did as Leider recommends, making use of paints that were not strictly "colored" at all and not intended for fine art in the first place.

One of them was Frank Stella, who is said to have used industrial paints "in an industrial way"—applied, that is, as if to a building or a railing. Here the medium of color comes with its ready-made aesthetic, and it is the one most appropriate to the modern age: anonymous, devoid of charm, mass-produced. Today everything gets assigned a color, whether it be an office corridor, a battleship, or a computer terminal. Colors are no longer signifiers of worth: an approximation of ultramarine can be bought by the gallon, purple-dyed cloth by the yard.

The work of many of the major artists of the twentieth century's second half, from the American Abstract Expressionists to the Pop Artists and the British school that includes David Hockney and Peter Blake, can therefore be understood only with reference to the technological and economic context of their materials. This again harks back to the constraints imposed by guilds, contracts, and trade patterns in the Middle Ages and the Renaissance, in the sense that the artist's *work*, and not just the artist's *practice*, bears an imprint of mundane considerations about cost, availability, and properties of materials. The Pre-Raphaelites used the brilliant products of the new chemical technology to depict a world that science had never "tainted." But for Jackson Pollock, new types of paint not only demanded new techniques but were essential for the task the painter now faced: "It seems to me that the modern painter cannot express this age, the airplane, the atom bomb, the radio, in the old forms of the Renaissance or of any other past culture."[2]

Yet for Pollock and many of his contemporaries, the new material

forms that enabled innovations in painting style were not so much about color as about the binding medium for the pigment. Color was to become subservient not to line or form but to texture and consistency.

NEW MEDIA

From the beginning of the century, synthetic binders were used to create paints with unprecedented qualities. "Most of the paint I use is a liquid, flowing kind of paint," said Pollock, whose spattering techniques would not have been possible with anything else.[3] He used enamel gloss paints mass-produced for household and industrial purposes, which were cheap enough to allow him to cover huge canvases and to experiment in ways that would have been prohibited by more costly materials.

American artist Kenneth Noland confesses that financial considerations played a major role in the choice of these mass-market paints by him and his peers. In the 1940s, he said, there was "no money coming in from painting . . . They couldn't get good art materials, and there was a necessity almost to go out and start using house paint, enamel paint."

Yet cost was not the only factor. The Mexican mural artist David Alfaro Siqueiros, at whose New York workshops in the 1930s Pollock and Morris Louis began experimenting with commercial paints, appreciated the durability of these materials. When Peter Blake began using enamel gloss paints in the 1950s, it was partly because of their association with fairground painting, in which he was intensely interested. British painter Patrick Caulfield was also drawn to household paints because of the impersonal sign-painting style they encouraged, with their flat surface unmarked by brush strokes (Plate 61).

For these and other young painters of the 1950s and 1960s, there was also a desire to escape from the academic "painterliness" associated with oils. American painter Helen Frankenthaler took to acrylic emulsions because of their "lack of sentiment." British artist John Hoyland says that in those days, "oil paint smacked of garrets and starving artists." In contrast, new paint media like acrylics "seemed exciting in the way people got excited about the use of plastics, aluminium . . . and other industrial materials." It was much the same impulse that led the progressive French painters of the late nineteenth century to abandon the practice of varnishing their works: a rejection of the codified norms of academic painterly practice. Even in the early years of the twentieth century, the matte finish so charac-

teristic of the painting of the 1950s was valued by Expressionists such as Ernst Ludwig Kirchner because of its ability to create "a more intense expression."

As the transition from egg tempera to oils shows, a new paint binder shifts the boundaries of color and its application. It alters the optical properties of a pigment, for instance, and also the drying time—with implications for color blending. Perhaps even more dramatically, those postwar painters who, like Peter Blake, used their commercial paints straight from the can were essentially having their palette determined by the manufacturers, who were producing for a very different market and were at the time often barely aware that artists were using their materials. Frank Stella admits that in his early days his color range had a kind of inverse relation with the whims of fashion—he used house paints that were sold at a discount because their color had gone out of style. "I just took what the regular paint stores had to offer," he says. In much the same way, the bright impact of graffiti art owes everything to the range of fluorescent colors produced in spray cans. Few artists, however, have placed their palette so far at the mercy of the paint industry as Robert Rauschenberg, widely personified as the "father of Pop Art." He once bought some cheap, unlabeled cans of household paint and painted with whatever colors they happened to contain.

These new types of paint were an obvious product of the "age of plastic," but it is sobering to be reminded that this age began in the first half of the nineteenth century. In 1832 the German-Swiss chemist Christian Friedrich Schönbein discovered that cellulose, a natural polymer that is the main component of plant fibers, can be converted to a semisynthetic material by reacting cotton fibers with nitric acid. Schönbein's product, which could be molded and hardened, is commonly called cellulose nitrate or nitrocellulose.

In the late 1860s the brothers John and Isaiah Hyatt in Newark, New Jersey, found that a "plasticizer" such as camphor makes nitrocellulose flexible; their new material, called celluloid, made them rich. But the property of nitrocellulose that elicited the greatest interest was its explosive nature, for which reason it also became known as guncotton. During the First World War it was manufactured in huge quantities.

After the war there was suddenly a huge surplus of the now superfluous substance, so new uses were sought for it. Dissolved in an organic solvent and supplemented with a resin, nitrocellulose provides a varnish, a kind of

synthetic lacquer. Colored with pigments, it is a tough, glossy, and quick-drying paint that became known as enamel.[4] These characteristics of enamel paints endeared them to the expanding automobile industry, and the Du Pont chemical company began providing enamels to General Motors. As a result, the time needed to paint a car dropped from as long as ten days in the early 1900s to about thirty minutes in the 1920s—a great boost for mass production.

Siqueiros began using the Du Pont enamels, called the Duco range, in the 1930s. In the 1950s the British artist Richard Hamilton used nitrocellulose spray paints, notably for *Hers Is a Lush Situation* (1958), whose subject is the automobile. Though he admits to some (unwarranted) suspicion at the time that these industrial paints must be better than artists' paints because so much more money had been lavished on them, the primary reason for his choice was symbolic: "I wanted the work to have as close a connection with the source as possible . . . Everything was directed not as representing the object but as symbolizing it . . . It's meant to be a car, so I thought it was appropriate to use car colour."[5]

Much the same considerations inform Hamilton's use of nitrocellulose enamel paints in other works concerned with technological artifacts, such as the household appliances in his painting titled *$he* (1958–1961). The Independent Group in Britain, of which Hamilton was a leading light, explicitly advocated an art that embraced modern developments in science and technology.

Among artists, perhaps the most famous brand name for enamel paints is Ripolin, made by a French company for household use since the early years of the century. Linseed oil was initially used as the binder, toughened and given a high-gloss finish by addition of resins. Ripolin's reputation is due single-handedly to Picasso, who used the paints extensively from at least 1912, apparently because of their durability. His endorsement of the Ripolin range lent it a certain mystique, motivating several later artists to use the same materials. (There is some suggestion, however, that Picasso tended to use "Ripolin" as a generic term for commercial paint, much as Americans might call any facial tissue "Kleenex"—so he may not in fact have used the Ripolin brand exclusively.)

Nitrocellulose has now been replaced as the binder in most industrial and household paints by a new class of synthetic resins called alkyds. These are polyester polymers that are mixed with oils to make a fast-drying paint medium. The first alkyd resin was produced in 1927, and alkyds were used

as binders in commercial paints from the late 1930s in the United States and from the 1950s in Europe. These resins can accept a greater loading of pigment than nitrocellulose and so can give more intense, opaque colors. Du Pont began to use alkyd resins in place of nitrocellulose in the Duco range starting in the 1940s, and Ripolin also switched from oils to alkyds. Manufacturers of artists' paints, however, have been slow to respond to the enthusiasm for alkyds: Winsor and Newton is one of the few companies to offer alkyd paints for artists, and these were introduced only in the 1980s.

An inconvenience of these synthetic resin-based paints is that, like oils, they must be thinned with organic solvents such as white spirit—a messy and noxious business. It was inevitable that sooner or later someone would devise a paint medium that handled like oils but could be thinned with water. Enter acrylic emulsions in 1953.

Acrylic plastics, which include hard plastics such as Plexiglas, have been commercially available since the 1930s. Liquid acrylic polymers do not dissolve in water; but in acrylic emulsions, tiny pigment-laden droplets of the polymer are dispersed in water and prevented from coalescing by a soap-like substance called an emulsifier. As the film of paint dries, the water evaporates, and the acrylic becomes transformed into a tough but flexible coating. Once it has set, the paint is impervious to water.

The first acrylic emulsions were house paints, but the American paint company Permanent Pigments adopted the same formulation to make a range of artists' paints called Liquitex. Artists such as Andy Warhol and Helen Frankenthaler experimented with them in the 1950s, but the runny consistency did not suit most tastes. Only when Liquitex was reformulated in 1963 with a thicker consistency, more like oil paint, did artists take to it. George Rowney & Sons provided a British version, the Cryla range, in the early 1960s.

As well as being water-thinned, one of the big attractions of acrylic emulsions was the fast drying time: fresh layers can usually be laid on within an hour. This was what prompted David Hockney to switch from oils to acrylics in 1963: "When I worked with oil paints I always had to work on at least three or four pictures at the same time because then you could keep working every day You had to wait for things to dry. Whereas now it's possible to work on one all the time."[6]

Acrylics usually give a very different paint surface from oils: flat and opaque, without brush marks, the ideal finish for a painter striving for the stark, impersonal style characteristic of the 1960s. And, says Hockney, the

paint serves color well: "When you use simple and bold colours, acrylic is a fine medium: the colours are very intense and they stay intense, they don't alter much."[7] Yet acrylics, thinned to translucency with water, can be glazed like oils, with the advantage that the glaze is dry in minutes. Hockney used this traditional technique for *Mr. and Mrs. Clark and Percy* (1970–1971). Yet interestingly, he later felt compelled to revert to oils when he began to work in a more naturalistic style. The medium must suit the message, it seems.

Acrylics were in fact first introduced as a paint medium not as water-dispersed emulsions but as resins, immiscible with water, in which the polymer is dissolved in an organic solvent. In the late 1940s the American paintmakers Leonard Bocour and Sam Golden collaborated with a manufacturer of acrylic resins to devise the Magna range of acrylic "solution" paints for artists, which they advertised as "the first new painting medium in 500 years." Magna paints came in tubes with a consistency similar to oil paints and could be thinned with turpentine. They could even be mixed with oil colors. The paints had a high loading of pigment and so could be diluted considerably without losing their intensity of color, whereas thinned oil paints become translucent. This property was attractive to the American Color Field artists such as Mark Rothko, Barnett Newman, and Kenneth Noland, as well as to Pop Artists like Roy Lichtenstein. Bocour was happy to deal directly with the artists: he collaborated with the painter Morris Louis to develop a customized version of the Magna paints suited to Louis's very individualistic style. Bocour would sometimes test new Magna products by giving them free to his circle of loyal American painters—to the envy of British painters like John Hoyland, who, before 1963, had no local access to acrylics.

Roy Lichtenstein has never really used any medium other than acrylic solution paints, which meant that for many years his color range of bright primaries was delimited by the (rather small) Magna catalogue. When the Magna range was discontinued in the 1980s, Lichtenstein bought up all the remaining stocks he could find. But Sam Golden's son Mark, now head of Golden Artist Colors, created a similar range of acrylic paints in the late 1980s with a wider range of colors. He, too, was willing to tailor his products to the specifications requested by Lichtenstein, who commented appreciatively, "Now I have maybe four different light yellows instead of one."

One drawback of acrylic solution paints is that the dried paint will redissolve in turpentine and so tends to become mobile when overpainted

unless each layer is varnished. Lichtenstein was prepared to go to this trouble ("It gets very sticky if you don't"), but the requirement would scarcely accommodate artists who do not use flat, blocked-out fields of color.

Acrylics are expensive materials, however, and most household emulsion paints (that is, those that can be thinned with water) are now based instead on polyvinyl acetate (PVA). The principle is the same: PVA is itself a water-insoluble polymer that can be used to form tough plastics and resins, but in emulsions it is dispersed as liquid droplets in water. PVA paints, first marketed in the 1950s, also had the attraction of fast drying times. That, along with their ease of handling, was what induced British painter Bridget Riley to use them in the 1960s. The flat finish of PVA complements her precise, illusionistic compositions. Toward the late 1960s, when Riley began to paint her Op Art works increasingly in color rather than in black, white, and gray, she began to seek materials that would give her strong color intensities. She was not enthusiastic about Rowney's Cryla range of acrylics, considering them too "pale" and "grayish," and so found herself compelled to mix her own colors from hand-ground pigment added to PVA. This was an arduous and difficult process and could result in an uneven paint surface. In the 1970s Riley finally switched to acrylics, which she sometimes later glazed with oils to gain still greater color density.

For Kenneth Noland, meanwhile, the attraction of PVA was financial: "You could buy [Elmer's glue, a PVA glue] by the gallon. I used to put dry pigment in it." And surely only an age that offers affordable paint "by the gallon," coupled with a cultural philosophy in which size and space are iconic, could have produced works on the vast scale of the American Abstract Expressionists.

FIELD AND VISION

For Mark Rothko (1903–1970), immense scale was a way of immersing the viewer in the picture: "However you paint the larger picture, you are in it. It isn't something you command."

This is not sheer hubris. Rothko wanted to make works that wrought a transcendent effect, that dealt with spiritual concerns: "Paintings must be like miracles," he once said. With Barnett Newman and Clyfford Still, Rothko represents, in the words of art critic Robert Hughes, the "theological side" of Abstract Expressionism.

Rothko and Newman worked with vast fields of unbroken color, without any figurative reference points at all. In principle at least, there was nothing in these works for the viewer to respond to except raw visual impression, the hue and luminosity of the paint itself. This was Kandinsky's vision taken to its logical extreme: the object had disappeared entirely, and the only thing left was color. As the strength of the effect was considered proportional to the size of the image, these painters found it necessary to work on a large scale. They have become known as the Color Field group.

Yet something of the figurative remains if the canvas is not simply monochrome. The eye and brain seem to demand it; they conspire to construct forms from the juxtaposed fields of color, just as Leider warns. Rothko's *Two Openings in Black over Wine* (1958) becomes a window in a dark room through which one sees the last glimmering of a burgundy dusk. *Ochre and Red on Red* (1954) (Plate 62) has echoes of landscape simply by virtue of the horizontal format of the color fields: we are looking out into the shimmering heat haze of a desert.

According to Rothko, however, these rectangles of luminous color are not infinite sky or sea, or even abstractions of them, but "things." Typically they do not fill the canvas as if framed by a window; they stop short of the edge with clear boundaries. This forces the question of whether they are really "color fields" at all. In Newman's work the field is more explicit, characteristically disrupted by a vertical line that he called a "zip." The narrow bands of yellow and blue that frame an almost wholly vermilion-colored canvas in Newman's *Who's Afraid of Red, Yellow, and Blue III* (1966–1967) undoubtedly suggest some kind of depth, the red behind the other colors, so that we are seeing not just a blank color but a scene.[8]

One can theorize endlessly about what drove these painters to seek expression in the anguished minimalism of raw, nonfigurative color. One senses a response to the extremity of the midcentury: to Hiroshima, the Holocaust, the threat of nuclear war, and, in the United States in particular, an increasingly reactionary postwar pressure to conform. Pollock's response was that of the wild, virile, self-destructive rebel so compellingly portrayed in the American cinema of the 1950s. Barnett Newman courted later derision with the outrageous, if apparently sincere, claim that his paintings, if seen properly, would spell the end of global capitalism.

Speculation is all the more encouraged, if not indeed required, by the fact that the artists' own pronouncements had this resolutely gnomic quality. Rothko was reluctant to dissect his works with words—"A painting

doesn't need anybody to explain what it is about. If it is any good, it speaks for itself"—and that may be just as well: here is Rothko, for example, on his departure from figurative representation in the mid-1940s: "It was not that the figure had been removed . . . but the symbols for the figures, and in turn the shapes in the later canvases were substitutes for the figures."[9]

Perhaps this is not so very different from Kandinsky's statement of the challenge of abstraction. Yet Rothko's solution was quite different. Whereas Kandinsky sought a visual language in color, for the Color Field painters color was (curiously enough) simply a means to an end. Rothko himself disclaimed any strong interest in color per se but explained that he had no option but to use it as his vehicle: "Since there is no line, what is there left to paint with?" The idea of arranging colors in some aesthetically or theoretically satisfying way, as "colorists" would do, horrified Rothko, who destroyed canvases of his own on which he saw this happening. "If you . . . are moved only by their color relationships," he exclaimed angrily to one reporter, "then you miss the point." And the point was that "I'm not interested in the relationship of color or form or anything else. I'm interested only in expressing basic human emotions—tragedy, ecstasy, doom and so on . . . The people who weep before my pictures are having the same religious experience as I had when I painted them."[10] It is probably for this reason that Rothko toned down the bright palette of his early Color Field paintings, preferring to work instead in blacks, browns, grays, and deep maroons to avoid the pictures' being appreciated simply for their decorative qualities.

The goal of the Color Field group had nothing to do with a sumptuous display of color but was connected to the idea of the sublime, so treasured by the nineteenth-century Romantics. How to describe it? Perhaps as a sense of vastness, of solitude, silence, and infinity—which is precisely why the Color Field painters found it necessary to expand their works to awesome proportions. Rothko stressed that this huge scale was not an attempt to be "grandiose and pompous" but quite the opposite: "because I want to be very intimate and human." Only through such extremes could the painting act directly on the viewer. One can find the same thing in the high-keyed abstract color compositions of Sol LeWitt, painted directly onto entire gallery walls so as to merge with the architecture in an all-encompassing experience.

Yet this almost religious intensity of feeling in the Color Field group did not make for very practical men. Rothko shows little sign of any system for

organizing color, for all that he is working with nothing else, and Newman and Still display nothing more theoretical than an occasional play of primaries. Fortunately, Rothko had an innate sensitivity for color, but Still has been accused (and I will not deny it) of being a rather poor colorist, something of a drawback for a Color Field painter. Here indeed is, as John Gage puts it, an art of "color without theory." There is nothing so terrible in that, yet I cannot help but suspect that it is again something of a precondition for a distancing from materials. Rothko himself confessed that he was "divorced from the conventions of a thousand years of painting"—with consequences that were, in at least one notable instance, disastrous.

Rothko's relationship with his materials is ambivalent. On the one hand, his studio techniques have something of the medieval about them: here he is, halfway up a ladder, employing assistants to help with the brushwork on monumental religious works (such as those commissioned for the Rothko Chapel in Houston), mixing up buckets of paints from dry pigment, size obtained from boiled rabbit skin, and egg. His experiments in materials seem to have been partly guided by the practical manuals of Max Doerner and Cennino Cennini. And yet he evinces a wish to escape from the constraints of the paint's physicality: he thinned them so much that the unprimed canvases were as much stained as painted, and according to Dore Ashton, a close associate, "Rothko was always aware that his means fell short of his vision because his means were material." Nowhere was that vision more compromised than in the huge mural canvases painted as a gift to Harvard University.

The Harvard murals are perhaps one of the starkest reminders of what can happen when untested modern materials find their way to painters with a reckless disregard for technical matters. Rothko gave them to the university in 1962. Within five years they were deteriorating fast; by 1979 they were ruined and were removed from view. Their worth was estimated at around $100,000 at the time of completion; today one suspects Rothko would have sanctioned their destruction. This was partly the result of poor planning and maintenance by the university, but one cannot overlook, in conservator Marjorie Cohn's words, "Rothko's complete ignorance of, or indifference to, the most basic requirements for permanent painting."

As ever he did, Rothko chose the colors for the Harvard murals (two panels and a triptych) with great care: he said that they reenact Christ's passion, with the dark tones representing His suffering on the cross and the lighter tones His resurrection. The predominant colors are dark pink and crimson. But you would never know that now: they have turned light blue.

Rothko made his crimsons from mixtures of synthetic ultramarine, cerulean blue, titanium white, and two modern organic colors, Naphthol red and Lithol red. The former, an azo color, has lasted well; the latter is dreadfully fugitive in light and has faded like the worst of medieval red lakes. It is now not accepted in artists' materials but was probably widespread in cheap paints of the 1960s. In all probability, Rothko did not even know what the colorants were in his reds. His indifference to materials is often illustrated by his remarks to conservator Elizabeth Jones, who says that, while painting the murals, "when he ran out of paint he had gone downstairs to the Woolworth's and bought more paint—he didn't know what kind it was."[11] Rothko's son suggests this was merely a mischievous quip, and there seems to be no evidence of household paints in the works. But there is a deeper truth in the jest, if that is all it was.

This is not to imply, however, that Rothko was ignorant of the risks of light-induced fading—he voiced this concern when he learned that the room in which the murals were stationed, a function room of the Holyoke Center at Harvard, received full sunlight. But in general Rothko's insistence on subdued lighting for displaying his works (as is used for the "Seagram" murals at Tate Modern in London) was due more to his view that overbright light washed out the intensity of colors and prevented them from displaying their subtle vibrations. The Harvard authorities, meanwhile, assumed that they could treat the murals as no different from the oil paintings of past presidents that hung on the walls. The Holyoke room was used for meals and social events, adding food stains, rips, and graffiti to the damage wrought by the years.

Rothko's experimental technique of applying thinned distemper paints, worked over with thinly brushed oils, raw egg, and synthetic paints, has also left its mark on the Rothko Chapel murals (1965), which are disfigured with whitish streaks and cracking (perhaps due to the swelling of undissolved resin crystals). But at least the synthetic alizarin-based reds used in these dark maroon monochromes have retained their intensity. Elsewhere Rothko uses reliable inorganic reds—cadmium red and iron oxide—and his works executed in acrylics on paper and board have lost little of their glory. That, it seems, may be as much a matter of good fortune as anything else: when Rothko wanted a red, he looked at the hue and not at the composition.

He might have done better to heed the advice of Robert Motherwell (1915–1991), in some sense the intellectual leader of the Abstract Expressionists: "The pure red of which certain abstractionists speak," he said in

1944, "does not exist. . . Any red is rooted in blood, glass, wine, hunters' caps, and a thousand other concrete phenomena." Motherwell thus speaks for the "dirty" side of the movement, for the sensualists rather than the transcendentalists. He saw that the "search for the subject," which all abstractionists must confront, can be conducted through the physical process of painting itself, which entails an appreciation of materials: their liquidity or solidity, their crystallinity and translucency. Commenting on an exhibition of Pollock's, Motherwell said, "Since painting is his thought's medium, the resolution [of the search for the true subject] must grow out of the process of painting itself." This is precisely what Pollock believed: that the work has a life of its own that would reveal itself through his handling of materials.

The paintings of Willem de Kooning (1904–1997) share with Pollock's an unmistakable physicality that speaks of the artist's sensitivity to materials. He used a variety of paint media, including oils and cheap enamels intended for sign painting, and sometimes enhanced the texture with the addition of plaster of Paris and ground glass. Some of his works are bright and high-keyed; others have colors dirty with rubbed charcoal. His predilection for modifying and reworking the paint surface led him during the 1950s to abandon alkyd-based paints for the same reason that others favored them: their quick drying times.

THE GOLDEN VEIL

Kenneth Noland (b. 1924) and Morris Louis (1912–1972) were part of the group that in the 1950s inherited the mantle of the Abstract Expressionists Pollock, Rothko, and Motherwell under the cumbersome label of Post-Painterly Abstractionism. Noland and Louis, like Rothko, were interested in making color both luminous and numinous by achieving a stainlike effect with thin washes. Together they visited Helen Frankenthaler's studio in 1953, which the forty-one-year-old Louis appears to have found something of a revelation. In Frankenthaler's very thin layers of highly diluted oil paint, which produce a watercolorlike finish in *Mountains and Sea* (1952), Louis perceived a staining effect that galvanized his art. But he and Noland were wary of saturating unprimed canvas with diluted oils, fearing that the paint medium would rot the fibers. So they both welcomed Bocour's acrylic solution paints in the 1940s because of the way that the Magna

paints would hold their color intensity even when thinned to the consistency of water.

Louis created his series of "Veil" paintings in the late 1950s by pouring highly thinned paint down the canvas. Repeated applications in a range of bright colors created the appearance of translucent, gauzy curtains in which all the colors mixed to a kind of warm golden brown (Plate 63). In these compositions Louis is using paint but is not really painting: the color impregnates the cloth as if in a dyeing process.

In his "Unfurled" series of the 1960s, Louis retained the pouring technique but used it with greater control and without superimposing and mixing colors. He combined pouring with a swabbing method to guide the paint into diagonal bands of color, leaving much of the canvas blank. Now that the colors were on display individually, Louis became more concerned about their quality. His palette of some twenty or so colors was provided directly by Bocour, whom Louis entreated to make the colors fresh each time and to clean the machines carefully before preparation of each color. The extreme dilution of the acrylic binder meant, however, that it could be difficult to obtain an even paint surface; there is evidence of clumping of pigment particles in some of these works.

Whereas the images of Rothko and Newman, and to some extent Louis's Veils, exude a certain mystery and atmospheric effect, Kenneth Noland and Frank Stella wanted painting to be more straightforward, free of these "extra" qualities. No miracles, they insist; what you see is what you get. Theirs came to be called the Hard Edge school, exemplified by the stark "Target" paintings of Noland (Plate 64).

In 1969 Noland said, "I wanted to have color be the origin of the painting. I was trying to neutralize the layout, the shape, the composition, in order to get at the color . . . I wanted to make color the generating force."[12] There would, in other words, be no *disegno* at all, or any "meaning" as such, simply paint for paint's sake. This is a distinctly North American idea (and draw from it what cultural conclusions you will). Painters from the Old World could never assimilate the idea, which is maybe why John Hoyland found his own approach to the Hard Edge style ill-received by the Americans he admired. Whereas the minimalism evident in the works of Stella and Noland has some kind of precedent in Kasimir Malevich's white monochrome "Suprematist" paintings from the 1910s or Yves Klein's blue monochromes in the 1950s, Malevich and Klein insisted on a philosophical interpretation: paint as idea. For the American minimalists, it was just paint.

To Noland, tutored by color empiricist Josef Albers, even the paint was to some extent an unfortunate necessity, a cumbersome layer that represented the only way he knew to get the color onto the surface. "The thing is to get that color down on the thinnest conceivable surface, a surface sliced into the air as if by a razor. It's all color and surface. That's all." No wonder he so appreciated the flatness and high covering strength of the new acrylics.

Yet despite his insistence on the elimination of structure, Noland was forced to employ some kind of design. His was a minimalism not of the monochrome but of color interactions, and with more than one color in the picture, there had to be borders. His solution was to use "neutral" forms devoid (or so he intended) of emotional content: first the concentric circles of his Target series, then nested chevrons and parallel stripes. This was nothing new—Albers's textbook was full of images based on nested squares, and he articulated the intention that motivated Noland: "For me, color is the means of my idiom. It's automatic. I'm not paying 'homage to a square.' It's only the dish I serve my craziness about color in."[13] In these dishes, marked out with masking tape, Noland served up chromatic meals of quiet restraint. The colors might be in full saturation, but the relationships had none of the glory of, say, Orphism. Often only related colors would be juxtaposed—blue against green, orange against red and pink, dissonances punctuated only here and there with a sudden contrast.

Frank Stella's early work in the 1950s was a quite different affair. It was typically monochrome, a single color threaded with a linear, repetitive design (Plate 65). He is credited with a materialistic approach, with placing special emphasis on the materials, yet he did so simply by cleaving to the idea that the painter does not *need* anything special in the way of materials. As we saw earlier, color for Stella was, at least initially, at the mercy of commerce: "I just took what the regular paint stores had to offer."

On one occasion what they had to offer was a metallic copper paint used to prevent barnacle growth on boat hulls. Another time it was silvery aluminum paint used for radiators. These metallic paints were, one might say, beyond color—they had been manufactured not because of their visual effect but because of the other properties that the suspended metal flakes conveyed. By renouncing color, Stella took it somewhere new.

But by the 1970s, Stella's work had altered radically. He was still as insouciant as ever toward materials and took to using alkyd household or industrial paints in place of acrylic emulsions, which he saw as "too

sophisticated or something." These alkyds were manufactured by the Benjamin Moore company, and Stella generally used the primaries and secondaries straight from the can, making no attempt to alter the color. It was, he explained, "just a mechanical use" of the manufacturer's colors.

Yet he began to combine these colors in works that were half painting, half sculpture—"relief paintings" with the appearance of graffiti-daubed found objects, decorated in strong pinks, reds, and greens (Plate 66). He designed his shapes on paper and then had them cut by a metalworking company from aluminum alloy honeycomb used in the aircraft industry. He covered these objects not only with paint but also with a magpie assortment of substances: sequins, glitter, ground glass.

What prompted this change? Curiously, Stella's increasing eclecticism of materials was stimulated by a sense that his previous minimalist style was too "material"—too much enslaved by pure paint. This, he suggested, was the legacy of Kandinsky, who never quite succeeded in converting paint to space and so ended up "filling up the landscape with pigment." Picasso, said Stella,

> saw the danger . . . of materiality—the danger that the new, open, atmospheric space of abstraction would be clogged up and weighed down by the mass of its only real ingredient: pigment. Picasso's concern articulated the fear that abstraction, instead of giving us pure painting, would merely give us pure paint—something we could find on store shelves as well as on museum walls."[14]

The problem with Kandinsky, Stella suggests, is a consequence of his failure to accept that he was working not with pure color (as he might have preferred) but with a physical material that needs to be understood and manipulated to one's will. "He never seems to push the paint as hard" as Picasso, Stella laments; "he never seems to penetrate the surface as successfully." It is a charge all too plausible when one considers the mystical, antimaterialistic atmosphere at the Bauhaus in the 1920s. Picasso and Malevich, by contrast, "in their acceptance of materiality . . . both came to terms with the surface of painting . . . They troweled pigment onto a self-sustaining surface which they had willed into being."[15] For Stella, then, paint is something that must be overcome.

Many modern colorists have sought to do that by moving beyond paint, and a thorough survey of contemporary artistic color would have to do the same. The works of Donald Judd and Anish Kapoor, for example, might be

properly regarded as sculpture. But Judd deems himself a painter and traces his roots back to Delacroix, to the painterly color theorists Chevreul and Rood, and most of all to the De Stijl painters. Enamel paint covers some of his minimalist structures of wood and aluminum, but his palette also embraces colored plastics, metals, and the light of colored reflections. Kapoor brings a mirrored metal sheen into the domain of color. The American artist James Turrell composes from a play of colored light, including the pure blue of day and the spangled firmament of night that show through the openings in his installation works. Other artists work with the gaudy glare of colored fluorescent lights or the translucent glow of light boxes or the precise rainbow of light-emitting diodes (to which chemists added a blue glow only in the 1990s), making scenes more genuinely radiant than the Impressionists could ever have dreamed of. Each of these media has, of course, its own associated technology with its own histories, stories, and limitations. Each replays the dance of cause and effect between scientific innovation and artistic expression.

NEW COLORS

But it is time nevertheless to come back finally to pure paint, for innovation in color did not cease throughout the twentieth century. There was still plenty of room for improvement.

In the mid-nineteenth century, George Field was able to test virtually all of the materials that brought color to the painter's palette. Today the list of colorants manufactured industrially covers nine thousand pages in nine volumes of the *Colour Index International*, the bible of dyers and colorists. Here these bright, synthetic earths have no fanciful names but are catalogued uncompromisingly by hue, use, and a number denoting the chemical composition: CI Vat Red 13 CI No. 70320, CI Food Yellow 4 CI No. 19140. The ambiguities of older terminology are banished, and undoubtedly some of the magic goes with them. About six hundred of these materials are pigments, and over nine thousand are dyes, attesting to the might of organic chemistry for tailoring color to precise ends.

Yet a sociologist might draw some interesting conclusion from the fact that the pigment now produced in far and away the greatest quantities is white. A glance at any street or commercial building interior will remind us that this "noncolor" is the most widely preferred veneer for our synthetic environment. (Of course, white is also used extensively for moder-

ating the saturation of other pigments to a tone considered, these days, gentler on the eye.) David Batchelor has much fun at the expense of the fashionable minimalist's taste for blank white interiors:

> The host was an Anglo-American art collector, and the party was in the collector's house . . . Inside this house was a whole world, a very particular kind of world, a very clean, clear and orderly universe . . . There is a kind of white that is more than white, and this was that kind of white. There is a kind of white that repels everything that is inferior to it, and that is almost everything . . . This white was aggressively white. It did its work on everything around it, and nothing escaped.[16]

Yet this kind of white, the foremost of today's pigments, did not exist before the twentieth century. Lead white was a major preindustrial product, and despite the emergence of zinc white as an artist's color in the nineteenth century, the lead pigment remained preeminent in an industrial context because it was so much cheaper and, in oils, more opaque and quicker-drying. In 1900 lead white still commanded virtually all of the market for white pigment. But between 1916 and 1918, chemical companies in Norway and North America discovered how to manufacture and purify an opaque white oxide of the metal titanium, an element identified in 1796 by the German chemist Martin Klaproth.

Titanium dioxide, or titania, has twice the covering power of lead white and is extremely stable. Once the manufacturing difficulties were resolved, titania quickly became the dominant white pigment; by 1945 it accounted for 80 percent of the market. As a result, the incidence of fatal lead poisoning from preparation of lead white fell. Today most white paint of any sort is titanium white.

But twentieth-century color made up in variety for what it lacked in the breadth of its application. In the 1950s a completely new class of pigments was introduced, the richly colored and highly stable organic compounds called quinacridones. These are true organic pigments, powdered solids resembling ground minerals but composed solely of organic molecules.

The first true organic pigments, based on salts of azo dyes, in fact date back to the 1880s. Because these colored organic compounds did not have to be attached to inorganic particles to make lake pigments, it became possible to apply to pigment manufacture the increasingly rational "synthesis of color" that evolved from the synthetic dye industry. The first azo pigment, tartrazine yellow, was patented in 1884.

Discovered in 1896, quinacridones took much longer to emerge as

pigments. In 1935 a German chemist named H. Liebermann (not the Lieberman of alizarin synthesis, who died in 1914) synthesized the first quinacridone suitable for use as a pigment. Yet it was not until two decades later that chemists at Du Pont began to look for ways to make these pigments on a commercial basis. Quinacridone pigments were marketed from 1958, offering colors from orange-red to violet. They were quickly adopted by the New York Abstract Expressionists, who welcomed the strong hues. Many artists' paints are now colored with quinacridones.

Were it not for these organic pigments, one might reasonably fear for the future of red. Cadmium red has become the canonical rich scarlet of the modern age, a color unmatched by any lake pigments for covering power and lightfastness. Cadmium is a toxic heavy metal, but only mildly so, and the cadmium colors present no great hazard to the painter. All the same, concerns about the health effects of heavy metals in the environment generally, highlighted by the problems caused by lead and mercury pollution, are leading to tighter restrictions on products that incorporate these elements. The complete prohibition of cadmium in paints has been extensively debated. It is not yet clear whether this will happen, but if it does, quinacridones will be the most promising replacements. Indeed, paints labeled as cadmium red or cadmium orange are now often pigmented with these organic molecules—the name, like others through the centuries, has been transformed from a signifier of composition to one of hue.

We can be confident that new alternatives will continue to appear.[17] In 1983 the first patent was taken out on another class of organic pigments, called diketopyrrolopyrroles, or DPPs. The light-absorbing organic molecule from which DPPs are derived was discovered in 1974. Initially a very minor reaction product, it was developed into a commercially viable compound by chemist Abdul Iqbal at Ciba-Geigy in Switzerland. The DPP pigments, which range between red and orange, are still costly; Ciba-Geigy manufactures them primarily for use in the automobile industry. No doubt this larger industrial concern will, according to the age-old pattern, eventually bring the colors to the artists' market. Painters will get their colors for the same reason as always: chemistry has many other consumers besides artists.

A TRADITION OF REVOLUTION

But will anyone still be painting in ten or twenty years' time? It is not a fashionable art. Painters have become a relative novelty among the candi-

dates for the much hyped Turner Prize, awarded annually in Britain for young artists. The names of no new young painters are on everyone's lips (at least, not for longer than a few weeks). We are still blessed with our Frank Auerbachs, our Howard Hodgkins, our Lucian Freuds; but do we have our Klees, our Goyas, our Raphaels?

I must take care that I do not begin to sound like Pliny, lamenting the passing of the Golden Age when Apelles held his brushes. Or perhaps a Pliny in reverse, bemoaning that few now know how best to use strong, brilliant color rather than the grayish mud, not even Rembrandt brown, that is spread over many a contemporary canvas. The truth is that we had more than enough greatness in twentieth-century painting, and what does it matter that the final years lost their sparkle? Who now complains, for example, about the fallow time at the end of the seventeenth century when Vermeer, Velázquez, Rubens, and Rembrandt had passed on and no one had stepped up to take their place?

And so where will the next great colorists take us, and what will be on their palette? Perhaps conventional pigmentation will indeed take second place as the metallic flakes and fluorescent splashes of Stella and the Pop Artists become supplemented with new possibilities: pearlescent colors (John Hoyland has used them already) or pigments that change hue as we change our viewing angle. Both are manufactured as automobile pigments. Perhaps artists will use liquid crystals that change color with temperature or that offer an iridescent rainbow all at once.

Well, maybe. Certainly, all these media will be used—because that is the way of art, to find ways to take advantage of what technology offers. That, I hope, is the one central message of this book: technology opens new doors for artists. And of course technologists cannot then prescribe which portals the artists will go through or what they will do on the other side. "The painter of the future," said van Gogh, "is a colorist such as has never been seen before." I do hope so. The delicious irony is that paint manufacturers, color theorists, and colormakers, practically inclined craftspeople, have traditionally been conventionally minded folk, offering up gleaming new tools into the hands of visionaries who go and do something crazy with them, break the mold, create a revolution. Long may it last.

NOTES

PREFACE

1. L. Dittmann, *Farbgestaltung und Farbtheorie in der abendländischen Malerei*, 1987, *X*, p. 290.

1: THE EYE OF THE BEHOLDER

EPIGRAPHS:

W. Kandinsky (1912), *Über das Geistige in der Kunst* (*Concerning the Spiritual in Art*), transl. M.T.H. Sadler. New York: Dover, 1977.
Brassaï (1964), *Conversations avec Picasso* (*Picasso and Company*), transl. F. Price. Garden City, N.Y.: Doubleday, 1966.

1. E. H. Gombrich, *Art and Illusion*, 5th ed. London: Phaidon, 1977, p. 30.
2. A. Callen, *Techniques of the Impressionists*. London: New Burlington Books, 1987, p. 6.
3. He presumably means to refer to cobalt-containing smalt, an inferior blue that he thereby fails to distinguish from the utterly different "cobalt blue" in the palettes of the Impressionists.
4. B. Riley, quoted in *Colour: Art and Science*, ed. T. Lamb & J. Bourriau. Cambridge: Cambridge University Press, 1995, pp. 31–32. (Minor alterations at the request of the author.)
5. Leonardo da Vinci, quoted in A. Blunt, *Artistic Theory in Italy, 1450–1600*. Oxford: Oxford University Press, 1962, p. 28.
6. L. B. Alberti (1435), *Della pittura* (*On Painting*), transl. C. Grayson. Harmondsworth, England: Penguin, 1991, p. 63.
7. Here Leonardo is indulging in a favorite sport of Renaissance humanists: arguing for the superiority of one art over another. Leonardo's contemporary Bellini can be found, for example, praising painting over poetry. Renaissance scholars found such

debates, called *paragones* by the Italians, in classical texts, and because everything classical was good, they sought to mimic them.

8. Alberti, *On Painting*, p. 61.

9. L. M. Principe, *The Aspiring Adept: Robert Boyle and His Alchemical Quest*. Princeton, N.J.: Princeton University Press, 1998, p. 33.

10. Le Corbusier & A. Ozenfant (1920), "Purism," in *Modern Artists on Art: Ten Unabridged Essays*, ed. R. L. Herbert. Englewood Cliffs, N.J.: Prentice-Hall, 1964.

11. Others have made an elegant case for these connections, notably Martin Kemp in his splendid book *The Science of Art*. But Kemp openly acknowledges that he leaves precisely the gap that I hope to fill: he omits "any sustained discussion of the way in which the chemistry and manufacture of new pigments affected the parameters of illusionistic imitation in painting" while highlighting the importance of this consideration.

12. J. Kristeva, "Giotto's Joy," in *Desire in Language*, transl. T. Gora, A. Jardine & L. S. Roudiez. Oxford: Oxford University Press, 1982.

13. Le Corbusier, "The Decorative Art of Today," in *Essential Le Corbusier: L'Esprit Nouveau Articles*, trans. J. Dunnett. Oxford: Oxford University Press, 1998, p. 135.

14. C. Blanc, quoted in C. A. Riley II, *Color Codes*. Hanover, N.H.: University Press of New England, 1995, p. 6.

15. D. Batchelor, *Chromophobia*. London: Reaktion Books, 2000.

16. Y. Klein, quoted in S. Stich, *Yves Klein*, exhibition catalogue, Hayward Gallery, London, 1995.

17. O. Sacks, *Uncle Tungsten: Memories of a Chemical Boyhood*. New York: Knopf, 2001.

18. P. Levi & T. Regge, *Conversations*. London: Tauris, 1989.

19. M. Platnauer, "Greek Colour Perception," *Classical Quarterly*, 1921, *15*.

20. Alberti, *On Painting*, p. 85.

21. Ibid., p. 84.

22. Kandinsky (1913), *Reminiscences*, in K. C. Lindsay and P. Vargo (eds.), *Kandinsky: Complete Writings on Art*. Boston: Hall, 1982, Vol. 1, pp. 369–370.

23. Kandinsky, *Concerning the Spiritual in Art*.

24. Ibid., pp. 38–41.

25. B. Riley, quoted in *Colour: Art and Science*, p. 63.

2: PLUCKING THE RAINBOW

EPIGRAPHS:

J. Dubuffet (1973), "L'Homme du commun à l'ouvrage" ("The Common Man at Work"), quoted in *Colour Since Matisse*, an exhibition of French painting, Edinburgh International Festival. London: Trefoil Books, 1985.

C. Blanc (1867), *Grammaire des arts du dessin* (*Grammar of Painting and Engraving*).

P. Guston, quoted in B. Clearwater, *Mark Rothko: Works on Paper*. New York: Hudson Hills Press, 1984, p. 11.

1. I. Newton (1706), *Opticks*. New York: Dover, 1952.

2. Ibid.

3. W. von Goethe (1810), *Die Farbenlehre* (*Theory of Colours*), transl. C. L. Eastlake, 1840.

4. Quoted in H. Maguire, *Earth and Ocean: The Terrestrial World in Byzantine Art*. N. p., 1987, p. 30.

5. Why a change in *speed* instigates a change in *direction* is subtle. Basically, the light rays take the quickest route from A to B, and the kinked route is, given the speed difference, more rapidly traversed than the straight route.

6. I. Newton, *Opticks*.

7. Aristotle, *De coloribus* (*On Colours*), transl. Hett, 793b. See note 14 for Chapter 3.

8. Pigments on a painted disk absorb light too, so it may not be clear why Maxwell's spinning disks gave additive rather than subtractive mixing. The answer is that the colored segments of the disk are not all absorbing at the same place and time. At any location on the disk, just one segment is absorbing at each instant. The part of the white-light spectrum that it removes is replaced a moment later when a differently colored segment covers that spot. The entire spectrum is thus delivered to the eye not instantaneously but in such rapid succession that it makes no difference.

9. G. Field, *Chromatography*. London: Winsor and Newton, 1869.

10. Leonardo da Vinci, quoted in F. Birren, *History of Color in Painting*. New York: Van Nostrand Reinhold, 1965.

11. In 1685 the mathematician and painter Philippe de la Hire commented that "painters know hues whose brilliance is much greater by candlelight than by daylight; there are also a number of hues which are very bright by daylight but lose their beauty entirely by candlelight." P. de la Hire, *Dissertation sur les differens accidens de la vue*, 1685.

12. It is not, however, always a straightforward matter to deduce from this spectrum what response the reflected light will induce in the eye and brain.

13. M. Sahlins, "Colors and Cultures," *Semiotica*, 1976, *16*: 12.

3: THE FORGE OF VULCAN

EPIGRAPHS:

Pliny, *Natural History*, quoted in V. J. Bruno, *Form and Colour in Greek Painting*. London: Thames and Hudson, 1977, p. 68.

R. Davies, *What's Bred in the Bone*. London, England: Penguin, 1986, p. 292.

T. Bardwell, *The Practice of Painting*, 1756.

1. O. Jones, *Athenaeum*, December 21, 1850, p. 1348.

2. Nonetheless, it had its admirers; the *Illustrated London News* said approvingly that "the whole produces an effect which is to architectural display what the vista of the grove and the glade of the forest is to the views presented by natural scenery."

3. The British biologist and science popularizer Lewis Wolpert is not the first to state that "technology is not science." But his book *The Unnatural Nature of Science*, in which this claim appears, contains a useful idea, which makes it all the more important that this fallacy should not hitch a ride on the coattails of a truth. Says Wolpert, "The final product of science is an idea . . . The final product of technology is an artifact." This alone excludes most of chemistry (old and new) from science. Wolpert's argument, however, makes essentially no reference to chemistry—whether through ignorance or for the sake of a tidy thesis, I do not know. Why the "wrong" ideas of the Greek

philosophers (who used them to make nothing useful) should be seen as intrinsically more scientific than the "wrong" ideas of, say, the medieval alchemists (who were abundant and effective manufacturers) is unexplained.

4. A modern tube of Naples yellow is likely to contain a mixture of more recent pigments, particularly cadmium yellow.

5. A recent illustration of this is the discovery of synthetic laurionite and phosgenite, complex compounds of lead and chlorine, in cosmetic powders from ancient Egypt dating from between 2000 and 1200 B.C. They were probably made by reacting lead monoxide with sodium chloride (common salt). See P. Walter et al., "Making Make-Up in Ancient Egypt," *Nature*, 1999, *397*: 483–484.

6. Pliny, *Natural History*, 36, xvi: 191.

7. Quoted in W. S. Ellis, *Glass*. New York: Avon Books, 1998, pp. 4–5.

8. A sixteenth-century innovation, made possible by the discovery of nitric acid, was the use of gold to make the finest red glass. A mixture of nitric and hydrochloric acids, made by adding sal ammoniac (ammonium chloride) to nitric acid, will dissolve gold: it is the potent *aqua regia* of the alchemists. The metal forms a soluble chloride salt but can be recovered by evaporating the liquid and heating the residue. In glassmaking, gold was precipitated from gold chloride solution as tiny particles, which scatter light strongly to impart a translucent red hue. This kind of chemical processing required considerable knowledge and practical skill, both derived from the use of *aqua regia* to dissolve gold in the refining process of gold mining, where it had to be separated from silver. It is not surprising, in view of the alchemical association of gold with the color red, that this process acquired considerable significance for alchemists.

9. Pliny, *Natural History*, 35: 42.

10. By the Middle Ages any whitish mineral mordant tended to be called alum, regardless of its chemical composition. The Greeks and Romans used primarily a potassium-containing alum mineral found in volcanic regions.

11. Isaiah 1:18.

12. To zoologists the scale insects of the kermes family were previously (and in some cases still are) denoted by the genus *Coccus*.

13. Theophrastus (transl. Hill), quoted in G. Agricola (1556), *De re metallica*, transl. H. C. Hoover & L. H. Hoover. New York: Dover, 1950, p. 440. Vitruvius, Dioscorides, and Pliny also describe the process.

14. This volume (*De coloribus*) is traditionally attributed to Aristotle, but it is now widely believed that its true author was his disciple Theophrastus. In any event, we can be sure that it gives a fair picture of Aristotle's thought.

15. Quoted in D. V. Thompson, *The Materials and Techniques of Medieval Painting*. New York: Dover, 1956, p. 125.

4: SECRET RECIPES

EPIGRAPHS:

Theophilus (c. 1122), *De diversis artibus* (*On Divers Arts*), transl. J. G. Hawthorne & C. S. Smith. New York: Dover, 1979, pp. 12–13.

G. Duthuit, *The Fauvist Painters*. New York: Wittenborn, Schultz, 1950.

1. Later revisionist historians of science have portrayed *The Sceptical Chymist* as an anti-alchemical tract. It is now clear that Boyle was instead attempting to separate what he regarded as "good" alchemy from "bad."

2. Paracelsus, "The Treasure of Treasures for Alchemists," in *The Water-Stone of the Wise Men: Describing the Matter of and Manner How to Attain the Universal Tincture.* London: J. H. Oxon, 1659, "to be sold at the Black Spred Eagle, at the West end of St Pauls."

3. Albertus Magnus (c. 1270), *Book of Minerals*, transl. D. Wyckoff. Oxford: Clarendon Press, 1967, pp. 207–208.

4. Thompson, *The Materials and Techniques of Medieval Painting*, p. 106.

5. Theophilus, *On Divers Arts*, p. 119.

6. Boyle says the process was related to him by a Dutch or Belgian refiner; the discovery must surely have stemmed from the mining practice of separating silver from copper.

7. C. S. Smith & J. G. Hawthorne (eds. & transl.), *Mappae clavicula: A Little Key to the World of Medieval Techniques.* In *Transactions of the American Philosophical Society*, 1974, 64(4): 28.

8. Heraclius (10th century A.D.), *De coloribus et artibus Romanorum*, ed. & transl. M. P. Merrifield (1849), in *Original Treatises on the Arts of Painting.* New York: Dover, 1967. Heraclius' tract was among those unearthed and translated into English in the 1840s by Mary Merrifield, who was commissioned by the British government to collect Italian manuscripts relating to the early history of the technical aspects of painting. Merrifield was one of those rare Victorian women who succeeded in overcoming the chauvinism of her age to win the respect of the prevailing patriarchy, and her contribution to the technical history of painting is profound. An artist, a scholar of distinction, the mother of at least three children, and reputedly "a forceful character with an agreeable sense of humor," she was the first to translate Cennino's book into English and brought a number of other important compilations of medieval recipes to a wide audience.

9. Theophilus, *On Divers Arts*, pp. 11–12.

10. Cennino Cennini, *Il libro dell'arte* (*The Craftsman's Handbook*), transl. D. V. Thompson. New York: Dover, 1960, p. 3.

11. G. B. Armenini (1587), *De veri precetti della pittura*, quoted in W. G. Constable, *The Painter's Workshop*. London: Oxford University Press, 1954, p. 66.

12. K. Scheit (1552), *Die frohliche Heimfahrt* (*The Joyous Journey Home*), quoted in A. Burmester & C. Krekel, "The Relationship Between Albrecht Dürer's Palette and Fifteenth/Sixteenth-Century Pharmacy Price Lists: The Use of Azurite and Ultramarine," in *Contributions to the IIC Dublin Congress, 7–11 September 1998: Painting Techniques: History, Materials and Studio Practice*, ed. A. Roy & P. Smith. London: International Institute for Conservation of Historic and Artistic Works, 1998, p. 101.

13. Cennino Cennini, *The Craftsman's Handbook*, pp. 84–85.

14. Ibid., pp. 101–102.

15. Heraclius, *De coloribus et artibus Romanorum*.

5: MASTERS OF LIGHT AND SHADOW

EPIGRAPHS:

Alberti, *On Painting*, p. 85.

1. Alberti, *On Painting*, p. 87.
2. G. Vasari (1568), *Lives of the Artists*, transl. G. Bull. Harmondsworth, England: Penguin, 1965, p. 284.
3. Ibid., p. 360.
4. Theophilus, *On Divers Arts*, pp. 27–28, 32.
5. G. Vasari, introduction to *Lives of the Artists* (1550). Published as *Vasari on Technique*, transl. L. S. Maclehose. New York: Dover, 1960, pp. 226, 230.
6. G. Birelli, *Opera*. Florence, 1601, book 2, pp. 369–370.
7. C. Merret (1662), *The Art of Glass*. Translation of A. Neri (1612), *L'arte vetraria*.
8. J. Mathesius (1562), *Sarepta oder Bergpostill*. In G. Agricola, *De re metallica*, p. 214, n. 21.
9. Alberti, *On Painting*, p. 85.
10. A. Dürer, quoted in M. Doerner, *The Materials of the Artist*. Orlando, Fla.: Harcourt Brace, 1949, p. 342.
11. One should be wary, however, of casting Venice and Florence as sixteenth-century rivals. This seems to be largely a nineteenth-century fiction that does not reflect the perceptions of the time. Nonetheless, Vasari is partly to blame. It is ironic that he places the least theoretically inclined of the Florentine masters, Michelangelo, at odds with the Venetian Titian, who shared his intuitive approach to painting. In Vasari's *Lives of the Artists*, Titian receives grudging praise laced with veiled criticisms of those who have not learned to draw well, while Vasari's compatriot Michelangelo is the embodiment of all that is desirable in art.
12. L. Lazzarini, "Indagini preliminari di laboratorio," in *Il polittico Averoldi di Tiziano restaurato*, ed. E. L. Ragni & G. Agosti. Brescia, 1991, p. 176.
13. The modern painter Frank Auerbach commonly covers his canvases with thick, sculpted impastos of earth colors. But for his version of *Bacchus and Ariadne*, commissioned in 1971 in response to Titian's picture, he was forced to take up an uncharacteristic palette of primary hues. The inspiration for Auerbach's translation is recognizable mainly from its colors rather than its figures. Titian's realgar is reproduced with a strong modern orange.

6: OLD GOLD

EPIGRAPHS:

Quoted in Doerner, *The Materials of the Artist*, p. 354, as "after Descamps," who attributes the remark to Rubens.
Doerner, *The Materials of the Artist*, p. 371.

1. F. Zuccaro (1607), *Idea de'pittori, scultori e architetti*, bk. ii, ch. 6, quoted in A. Blunt, *Artistic Theory in Italy, 1450–1600*. Oxford: Oxford University Press, 1962.

2. E. Norgate (1627–1628), *Miniatura, or The Art of Limning*, quoted in R. D. Harley, *Artists' Pigments, c. 1600–1835*, 2nd ed. London: Butterworths, 1982.

3. Ibid.

4. Leonardo da Vinci, *Treatise on Painting*, ed. & transl. A. P. McMahon. Princeton, N. J.: Princeton University Press, 1956.

5. C. S. Wood, *Albrecht Altdorfer and the Origins of Landscape*. Chicago: Chicago University Press, 1993, p. 63.

6. R. de Piles (1699), *Dialogue sur le coloris*, quoted in Gombrich, *Art and Illusion*, p. 265.

7. S. van Hoogstraten, quoted in J. Kirby & D. Saunders, "Sixteenth- to Eighteenth-Century Green Colours in Landscape and Flower Paintings: Composition and Deterioration," in *Contributions to the IIC Dublin Congress*, p. 155.

8. H. Peacham, *The Compleat Gentleman*. London, 1622.

9. There has been a recent claim that the colors in this painting are in fact too garish for it to be a work of Rubens at all. The National Gallery emphatically denies this suggestion.

7: THE PRISMATIC METALS

EPIGRAPHS:

W. Cullen (c. 1766), quoted in A. L. Donovan, *Philosophical Chemistry in the Scottish Enlightenment*. Edinburgh: Edinburgh University Press, 1975, p. 98.

J.-K. Huysmans, "Turner and Goya," in *Certains*. Paris, 1889.

1. R. Boyle (1661), *The Sceptical Chymist*, quoted in W. H. Brock, *The Fontana History of Chemistry*. London: Fontana, 1992, p. 57.

2. Ibid., p. 61.

3. A. Wurtz (1869), *Dictionnaire de chimie pure et appliquée*, quoted in *The Fontana History of Chemistry*, p. 87. The color chemist Jocelyn Field Thorpe retaliated seven decades later with the claim that "chemistry is an English science; its founder was Cavendish of immortal memory."

4. Although Lavoisier's new systematic chemistry became dominant in France, its acceptance elsewhere depended on committed advocates. In Germany no one was more enthusiastic than the apothecarist Martin Henrich Klaproth, one of the finest analytical chemists of his era and an expert element hunter. Klaproth was an avid investigator of minerals, and his tally of new metallic substances is impressive: cerium, tellurium, and titanium were among his discoveries, and his studies of pitchblende led him to the bright yellow compounds of a new heavy element that Klaproth named in honor of William Herschel's discovery of the planet Uranus: uranium. Uranium salts were subsequently to enjoy a brief career as pigments, primarily in orange ceramic glazes. They had been used intermittently in this context since at least the first century A.D.

5. P. Vernatti, *Philosophical Transactions of the Royal Society*, 1678, *12*(137).

6. Some texts suggest this was Bernard Courtois, the discoverer of iodine (p. 164). But as Bernard Courtois was born in 1777, the idea that he discovered zinc white in 1781 is rather hard to sustain.

7. The origin of the name *zinc* is obscure. Some attribute it to Paracelsus, who had a proclivity for strange lexicological inventions.

8. Because of impurities in the ore, the product is less pure than that made by the French process, so high-grade zinc white had to be imported to the States. Indeed, nineteenth-century zinc white came in a number of grades; the best, Zinc White No. 1, was the finest white pigment, while "stone gray" and "gray zinc oxide" were poor-quality materials used for primers or industrial paints.

9. F. Stromeyer, "New Details Respecting Cadmium," *Annals of Philosophy*, transl. from *Annalen der Physik*, 1819, *14*: 269–274.

10. A Viennese chemist named Ignaz Mitis is also credited with the discovery. He may have made copper aceto-arsenite sometime between 1798 and 1814 and manufactured it as Mitis green or Vienna green by the later date, if not earlier. It is possible, however, that the discoveries of Mitis and Sattler were more or less simultaneous.

11. Quoted in S. Garfield, *Mauve*. London: Faber & Faber, 2000, p. 105.

12. This surprisingly early date is supported by analysis conducted at the Doerner Institute in Munich; see R. L. Feller (ed.), *Artists' Pigments*. Washington, D.C.: National Gallery of Art, Vol. 1, p. 213.

13. Chromium oxide has been tentatively identified in Turner's *Somer Hill* (1812), a remarkably early usage that would certainly support Turner's reputation as an avid experimenter with new pigments. See E. West Fitzhugh (ed.), *Artists' Pigments*. Washington, D.C.: National Gallery of Art, Vol. 3, p. 275.

14. Chaptal was himself an industrial chemist and author of *Chimie appliquée aux arts* (1807), a major influence on the later generations of industrial chemists in the paints and dyes industry.

15. J.-F.-L. Mérimée (1830), *De la peinture à l'huile*, p. ix.

16. G. D. Leslie, *Inner Life of the Royal Academy*, quoted in K. E. Sullivan, *Turner*. London: Brockhampton Press, 1996.

17. There are exceptions. Hunt stated that the lemon yellow used by Turner in *Approach to Venice* (1844) was Field's, yet Ruskin lamented in 1857 that the picture had become "a miserable wreck of dead colours." J. Gage, *George Field and His Circle*. Cambridge: Fitzwilliam Museum, 1989, p. 42.

18. Joyce Townsend (private communication) says that iodine scarlet has been found in Turner's *Téméraire* in the National Gallery, London. If applied without varnish, it is apt to disappear through sublimation.

8: THE REIGN OF LIGHT

EPIGRAPHS:

C. Monet, quoted in L. C. Perry, "Reminiscences of Claude Monet from 1889–1909," *American Magazine of Art*, 1927, *19*.

E. Cardon, "Avant le Salon—l'exposition des révoltés," *La Presse*, April 29, 1874, quoted in J. Rewald, *The History of Impressionism*, 4th ed. London: Secker & Warburg, 1973, pp. 330–331.

1. E. Delacroix, quoted in Birren, *History of Color in Painting*, p. 13.

2. Ibid., p. 57.

3. H. von Helmholtz, "Recent Progress in the Theory of Vision," *Popular Lectures on Scientific Subjects*, 1901, *2*: 121–122.

4. J. Ruskin, *The Art of England*, in *The Works of John Ruskin*, ed. E. Cook & A. Wedderburn. London, 1908, pp. 272–273.

5. J. Laforgue, *L'Impressionnisme* (review of an exhibition at the Gurlitt Gallery, Berlin, 1883), first published in *Mélanges posthumes: Œuvres completes*, Vol. 3, Paris, 1903; reprinted in *Les ecrivains devant l'Impressionnisme*, 1989. For a translation, see L. Nochlin, *Impressionism and Post-Impressionism, 1874–1904: Sources and Documents*. Englewood Cliffs, N.J.: Prentice-Hall, 1966, pp. 14–20.

6. In his *Leçons de chimie appliquée à la teinture* (1829–1830), Chevreul was one of the first scientists to call for a systematic approach to dye chemistry.

7. M.-E. Chevreul (1839), *De la loi du contraste simultané des couleurs* (*On the Laws of Simultaneous Contrast of Colors*).

8. Underscoring the chemical origins of his interest in color, he dedicated the book to his friend and colleague, the famous Swedish chemist Jöns Jacob Berzelius.

9. H. von Helmholtz, "Über die Theorie der zusammengesetzten Farben," *Poggendorffs Annalen der Physik und Chemie*, 1852, *87*: 45–66; transl. as "Sur la théorie des couleurs composées," *Cosmos*, 1852–1853, *2*: 112–120. Helmholtz elaborated his findings in his *Treatise on Optics* (1867).

10. All the same, earth pigments do appear in Pissarro's paintings from the 1870s. And Delacroix himself had already called for earth colors to be banished in 1857.

11. Quoted in H. A. Roberts, *Records of the Amicable Society of Blues*. Cambridge: Cambridge University Press, 1924, pp. 53–54.

12. A. Renoir, from an interview in 1910, quoted in Rewald, *The History of Impressionism*.

13. Putting this to the test is a disturbing thought. But the American artist Sherry Levine has done almost precisely that. Her *Melt-Down* paintings (1990) are monochromes in the colors obtained by averaging those in famous works, using a computer. *Melt-Down (After Monet I)* is a darkish silver-gray. As a kind of subtractive mixture, this veers toward black rather than white. But the achromaticity of the averaged hue testifies to the spectral inclusiveness of Monet's work.

14. Sunlight is, of course, white, not yellow, but the Impressionists perceived it as golden.

15. C. Monet, quoted in J. Claretie, *La Vie à Paris, 1881*. Paris, 1881, p. 266. One commentator, Alfred de Lostalot, suggested that Monet actually had an unusually extended visual range and was able to perceive ultraviolet light.

16. O. Rood, *Modern Chromatics*. N. p., 1879, pp. 279–280, 139–140.

17. J. Ruskin, *Elements*, in *The Works of John Ruskin*, p. 152.

18. Indeed, it is not clear that Seurat ever studied Rood's text deeply. His knowledge of optical mixing seems to have come largely from Charles Blanc's popularization of Chevreul's theory. See J. Gage, *Colour and Meaning*. London: Thames & Hudson, 1999, p. 213 and note 10.

19. F. Fénéon, "Les Impressionistes," *La Vogue*, June 13–20, 1886.

20. Ibid.

21. P. Signac, quoted in R. L. Herbert, *Neo-Impressionism*. New York, 1968, p. 108. See also Gage, *Colour and Meaning*, p. 217.

22. C. Pissarro, letter to P. Durand-Ruel, November 6, 1886, in L. Venturi, *Les Archives de l'Impressionnisme*. Paris, 1939, Vol. 2, p. 24.

23. P. Gauguin, quoted in L. Bolton, *The History and Techniques of the Great Masters: Gauguin*. London: Tiger Books International, p. 13. In the same letter to Vollard, written from La Dominique in 1902, Gauguin prefigures the U.S. artists of the 1950s by demanding "decorators' colors." "They cost a third as much," he writes, "and they are much better."

24. J.-P. Crespelle, *The Fauves*. London: Oldbourne Press, 1962.

25. V. van Gogh, letter to his brother Theo, June 1888, in *The Letters of Vincent van Gogh*, ed. M. Roskill. Flamingo, 2000, p. 268.

26. This carmine lake was probably of the new synthetic variety, made from artificial alizarin.

27. *The Letters of Vincent van Gogh*, p. 252.

9: A PASSION FOR PURPLE

EPIGRAPHS:

R. Browning, "Popularity," 1855.
All the Year Round, September 1859, quoted in Garfield, *Mauve*, p. 66.

1. Pliny, *Natural History*, 9: 36.

2. Aristotle, *Historia animalium*, bk. 5, transl. D. W. Thompson. Oxford: Clarendon Press, 1910.

3. Pliny, *Natural History*, 9: 28.

4. Ibid., 35: 46.

5. Julius Caesar, *De bello gallico*, bk. 5.

6. R. Hakluyt (1589), *The Principal Navigations Voiages and Discoveries of the English Nation*. Reprinted in facsimile, Cambridge: Cambridge University Press, 1965, Vol. 2, p. 454.

7. W. Cullen (c. 1766), quoted in L.A.L. Donovan, *Philosophical Chemistry in the Scottish Enlightenment*. Edinburgh: Edinburgh University Press, 1975, p. 107.

8. Benzene was nitrated (given a nitro group, consisting of nitrogen and oxygen) by treatment with concentrated nitric acid. Then the product, nitrobenzene, was "reduced," which involves replacing the oxygen atoms in the nitro group with hydrogens to make the amino group. The molecular structures of these compounds, for those who do not scare easily at chemistry's symbolic formalism, are as follows. The pictures are easier than the words, once you are used to the system. The letters denote atoms of carbon, hydrogen, and nitrogen; the lines indicate the bonds joining them.

Benzene Nitrobenzene Aniline

9. *All the Year Round*, September 1859, quoted in Garfield, *Mauve*, p. 67.

10. There are probably good reasons why the date is somewhat fluid in contemporary ac-counts, for whether or not Verguin was still employed by Raffard or by his subsequent employers the Renard Brothers or by neither when he made his discovery had some importance for subsequent patent disputes. Industrial espionage was not unknown in this increasingly competitive business.

11. A. W. Hofmann, "On Aniline-Blue," *Proceedings of the Royal Society*, 1863, *13*: 14.

12. The Scottish chemist Archibald Scott Couper proposed the idea of a carbon chain in-dependently of Kekulé, and more explicitly, in 1858. But the publication of his paper was delayed until after Kekulé's had appeared, and Couper lost the claim to priority. His ensuing struggles for recognition left him so disenchanted that he eventually gave up chemistry altogether. *Plus ça change . . .*

13. The astute reader will notice that this connects each carbon atom to just three other atoms, not four. The deficit is made up by the ability of carbon to form *multiple* bonds to the same atom. This is illustrated in the diagram in note 8, where two parallel lines de-note double bonds. It is not, as it might appear, a cop-out. Double bonds really are stronger and shorter than single bonds, and one of the two bonds can be broken open, al-lowing additional atoms to attach themselves to the carbons without severing the other bond. I must add for completeness that in benzene and other aromatic hydrocarbons, the single and double bonds do not really alternate around the rings. Instead, the multiple bonding becomes "smeared out" among all the carbon-carbon links so that all these links are equal and can be regarded as though composed of "one and a half bonds" each.

14. M. Brusatin, *A History of Colors*. Boston: Shambhala, 1991, p. 99.

15. The molecular structures look like this:

Anthracene Alizarin

16. The *modus operandi* in Baeyer's lab was to apply reagents that broke down the organic compounds into fragments or simpler molecules and to use the resulting information to guide the reverse process of synthesis. To make complex organic molecules, chemists now routinely conduct an analogous "thought experiment" called retrosyn-thetic analysis.

17. Quoted in *Perkin Centenary London: 100 Years of Synthetic Dyestuffs*. London: Pergamon, 1958, p. 23.

18. The structure of indigo is as follows:

Indigo

19. C. Rawson, "The Cultivation and Manufacture of Indigo in Bengal," *Journal of the Society of Dyers and Colourists*, July 1899, p. 174.
20. Madder has long been a yardstick for the quality of dyes, to the extent that the word *guarantee* stems from the Italian word for madder, *garanza*.
21. Doerner, *The Materials of the Artist*, p. 91.

10: SHADES OF MIDNIGHT

EPIGRAPHS:

V. Nabokov, *Laughter in the Dark*. New York: Random House, 1989.
P. Cézanne, quoted in D. Jarman, *Chroma*. London: Vintage, 1994.

1. Kandinsky, *Concerning the Spiritual in Art*, p. 38.
2. R. Boyle, *Experiments and Considerations Touching Colours*. London, 1664.
3. M. Polo, *Il milione*, ed. D. Ponchiroli. Turin: Einaudi, 1954, ch. 35, p. 40.
4. Cennino Cennini, *The Craftsman's Handbook*, pp. 37–38.
5. Ibid., p. 36.
6. J. Itten, *The Elements of Color*. New York: Van Nostrand Reinhold, 1970, p. 88.
7. P. Hills, *Venetian Color*. New Haven, Conn.: Yale University Press, 1999, p. 136.
8. Y. Klein, "Par la couleur . . .", in *Mon livre*, written in 1957 and unpublished (Yves Klein Archives).
9. Ibid.

11: TIME AS PAINTER

EPIGRAPHS:

Field, *Chromatography*.
Cennino Cennini, *The Craftsman's Handbook*, p. 25.
Doerner, *The Materials of the Artist*, p. 375.

1. Some specialist paint manufacturers now make "retouching" paints for conservators, which are coloristically stable, chemically distinguishable from the paints used in the restored works, and capable of being removed with organic solvents. In 2000 the Gamblin Artists Color Company in the United States launched a new range of retouching paints with excellent optical and handling properties, bound in a nontoxic urea-aldehyde resin made by BASF. See L. R. Ember, *Chemical and Engineering News 79* (30 July 2001), pp. 51–59.
2. Gombrich, *Art and Illusion*, p. 49.
3. Cennino Cennini, *The Craftsman's Handbook*, p. 26.
4. Ibid., p. 24.
5. Doerner, *The Materials of the Artist*, p. 83.
6. It should be said in defense of the pigment that modern methods of preparation seem to protect it from impermanence. But this was of no help to the eighteenth-century painter.

7. Field, *Chromatography*, p. 412.

8. G. Field citing Samuel Palmer, quoted in Gage, *George Field and His Circle*, p. 70.

9. Doerner, *The Materials of the Artist*, pp. v–vi.

12: CAPTURING COLOR

EPIGRAPHS:

W. Benjamin, "The Work of Art in the Age of Mechanical Reproduction," in *Art in Modern Culture*, ed. F. Frascina & J. Harris. Oxford: Phaidon, 1992.

J. Percival, quoted by F. Birren in J. C. Le Blon, *Coloritto*, 1725. Facsimile reprint, New York: Van Nostrand Reinhold, 1980.

J. Berger, *Ways of Seeing*. Harmondsworth, England: Penguin, 1972, p. 32.

1. Benjamin, "The Work of Art."

2. Berger, *Ways of Seeing*, p. 21.

3. Jonathan Brown and Carmen Garrido point out that one of the most discussed works of the Western canon, Velázquez's *Las Meninas*, has been interpreted mainly from reproductions. They say, "No one seems to have been interested in the materiality, or physical structure, of the work, or appreciated it as a pictorial performance . . . However, the [1984] cleaning of the painting . . . allows us to appreciate it as one of the most remarkable artistic tours-de-force in the history of Western culture." The message (apart from "Get thee to the Prado") is that by insisting on the conceptual and ignoring the material, we may miss the true beauty of works like this. J. Brown & C. Garrido, *Velázquez: The Technique of Genius*. New Haven, Conn.: Yale University Press, 1998.

4. J. C. Le Blon (1725), *Coloritto*, epistle, p. xx. Facsimile reprint, New York: Van Nostrand Reinhold, 1980.

5. Ibid., p. 28.

6. Ibid., p. 30.

7. Presumably, Le Blon did not know of this remark when he dedicated *Coloritto* to Walpole.

8. R. M. Burch, *Colour Printing and Colour Printers*. London: Pitman, 1910, p. 112.

9. When Schulze published his findings, he titled them *Scotophorus pro phosphoro inventus*, a joke on the fact that the experiments had been intended to make phosphorus, inflammable "bringer of light," but instead produced "Scotophorus," "bringer of darkness."

10. S.F.B. Morse in the *New York Observer*, quoted in J. Carey (ed.), *The Faber Book of Science*. London: Faber & Faber, 1996, p. 83.

11. J. C. Maxwell, *Transactions of the Royal Society of Edinburgh*, 1857, 21: 275.

12. I am reliably informed that the lecture itself was grim, Maxwell being a notoriously poor speaker.

13. J. C. Maxwell, *British Journal of Photography*, 1861, 9: 270.

14. H. Collen, *British Journal of Photography*, 1865, 12: 547. Collen proposed that the color separations be taken according to the subtractive primaries red, blue, and yellow, rather than (more properly) the additive primaries used by Maxwell.

15. E. J. Wall, *History of Three-Color Photography*. Boston: American Photographic Publishing Co., 1925, p. 9.
16. E. Wind, *Art and Anarchy*. New York: Knopf, 1965.
17. G. O'Keeffe, quoted in Riley, *Color Codes*, p. 169.

13: MIND OVER MATTER

EPIGRAPHS:

S. Delaunay, quoted in *Colour Since Matisse*.
H. Matisse (1952), quoted in Riley, *Color Codes*.

1. H. von Helmholtz, "Recent Progress in the Theory of Colour Vision," *Popular Lectures on Scientific Subjects*, 1901, 2: 121–122.
2. P. Picasso, quoted in J. Flam (ed.), *Matisse: A Retrospective*. New York: Levin, 1988, p. 153.
3. H. Matisse, quoted in A. H. Barr Jr., *Matisse: His Art and His Public*. New York: 1951, p. 119.
4. H. Matisse, quoted in Riley, *Color Codes*, p. 134.
5. H. Matisse, quoted in J. Leymarie, *Fauves and Fauvism*. Geneva: Skira, 1995.
6. R. Delaunay, *Du Cubisme à l'Art Abstrait*, ed. P. Francastel. N. p., 1957, pp. 182–183.
7. P. Klee, quoted in H. Read, *A Concise History of Modern Painting*. London: Thames & Hudson, 1974, p. 180.
8. P. Citroen, quoted in E. Neumann (ed.), *Bauhaus and Bauhaus People*. New York: Van Nostrand Reinhold, 1970, p. 45.
9. P. Klee, quoted in P. Cherchi, *Paul Klee teorico (Paul Klee, Theoretician)*. Bari, Italy: De Donato, 1978, pp. 160–161.
10. Doerner, *The Materials of the Artist*, pp. 169–170.
11. P. Klee, quoted in Cherchi, *Paul Klee teorico*, pp. 160–161.

14: ART FOR ART'S SAKE

EPIGRAPHS:

R. Rauschenberg, quoted in R. Hughes, *The Shock of the New*. London: BBC Books, 1991.
D. Batchelor, *Chromophobia*, pp. 98, 100.

1. P. Leider (1970), "Literalism and Abstraction: Frank Stella's Retrospective at the Modern," in *Art in Modern Culture*, ed. F. Rascina and J. Harris. London: Phaidon, 1992, p. 319.
2. J. Pollock (1950), interview with W. Wright, in H. Namuth, *Pollock Painting*. New York: Agrinde Publications, 1980.
3. There is a danger, however, of attributing a little too much to Pollock's nontraditional materials. He did sometimes use oil paints even in his distinctive drip paintings, albeit apparently squeezed straight from the tube. See S. Lake, "The Challenge of Preserving Modern Art: A Technical Investigation of Paints Used in Selected Works by Willem de Kooning and Jackson Pollock," *MRS Bulletin*, 2001, 26(1): 56.

4. Enamel paints are not invariably bound in nitrocellulose; the term simply denotes a tough, high-gloss finish. Some early enamel paints used linseed oil as the main binding medium, toughened with resins. Later, alkyd resins provided the binder.

5. R. Hamilton, quoted in J. Crook & T. Learner, *The Impact of Modern Paints*. London: Tate Gallery Publishing, 2000, p. 71.

6. *David Hockney: Paintings, Prints and Drawings 1960–1970*, exhibition catalogue, Whitechapel Art Gallery, London, 1970, pp. 11–12.

7. D. Hockney, quoted in Crook & Learner, *The Impact of Modern Paints*, p. 97.

8. I have seen this work, and some of Rothko's, reproduced upside down: the hazard of abstraction. I don't suppose there are many paintings that give you two scenic views for the price of one. But publishers can be forgiven some confusion when we bear in mind that Rothko himself did not always know which way up a work should go until he had finished it, and even then he sometimes changed his mind.

9. M. Rothko, quoted in D. Anfam, *Abstract Expressionism*. London: Thames & Hudson, 1990, p. 142.

10. S. Rodman, *Conversations with Artists*. New York, 1957, p. 93.

11. E. Jones, memorandum to A. Morgan, acting director of the Fogg Museum, November 3, 1970, quoted in *Mark Rothko's Harvard Murals*, ed. M. B. Cohn. Cambridge, Mass.: Harvard University Art Museums, 1988.

12. K. Noland, quoted in Hughes, *The Shock of the New*.

13. K. Noland, quoted in N. Welliver, "Albers on Albers," *Art News*, 1966, *64*: 68–69.

14. F. Stella, *Working Space*. Cambridge, Mass.: Harvard University Press, 1986, p. 71.

15. Ibid., p. 89.

16. Batchelor, *Chromophobia*, p. 10.

17. In 2000 a new class of red and yellow inorganic materials devoid of toxic heavy metals was reported by German chemists M. Jansen and H. P. Letschert (see "Inorganic Yellow-Red Pigments Without Toxic Metals," *Nature*, 2000, *404*: 980–982). These are complex compounds containing calcium, lanthanum, tantalum, oxygen, and nitrogen. It remains to be seen whether they can be commercialized.

BIBLIOGRAPHY

Agricola, G. (1556). *De re metallica*, transl. H. C. Hoover & L. H. Hoover. New York: Dover, 1950.

Alberti, L. B. (1435). *Della pittura (On Painting)*, transl. C. Grayson. Harmondsworth, England: Penguin, 1991.

Aldred, C. *Egyptian Art*. London: Thames & Hudson, 1980.

Anfam, D. *Abstract Expressionism*. London: Thames & Hudson, 1990.

Anfam, D. *Mark Rothko*. Washington, D.C.: National Gallery of Art, 1998.

Ashton, D. *About Rothko*. New York: Oxford University Press, 1983.

Ayers, J. *The Artist's Craft*. Oxford: Phaidon, 1985.

Balfour-Paul, J. *Indigo*. London: British Museum Press, 1998.

Barnes, S. J. *The Rothko Chapel: An Act of Faith*. Austin: University of Texas Press, 1989.

Batchelor, D. *Chromophobia*. London: Reaktion Books, 2000.

Benjamin, W. (1936). "The Work of Art in the Age of Mechanical Reproduction," in *Art in Modern Culture*, ed. F. Frascina & J. Harris. London: Phaidon, 1992.

Berger, J. *Ways of Seeing*. Harmondsworth, England: Penguin, 1972.

Berlin, B., & P. Kay. *Basic Color Terms*. Berkeley: University of California Press, 1969.

Berns, R. S. *Principles of Color Technology*. New York: Wiley, 2000.

Binski, P. *Medieval Craftsmen: Painters*. London: British Museum Press, 1991.

Birren, F. *History of Color in Painting*. New York: Van Nostrand Reinhold, 1965.

Blunt, A. *Artistic Theory in Italy, 1450–1600*. Oxford: Oxford University Press, 1962.

Bolton, L. *The History and Techniques of the Great Masters: Gauguin*. London: Tiger Books International, 1988.

Bomford, D., C. Brown & A. Roy. *Art in the Making: Rembrandt*. London: National Gallery Publications, 1988.

Bomford, D., J. Dunkerton, D. Gordon & A. Roy. *Art in the Making: Italian Painting Before 1400*. London: National Gallery Publications, 1989.

Bomford, D., J. Kirby, J. Leighton & A. Roy. *Art in the Making: Impressionism.* London: National Gallery Publications, 1990.

Bomford, D., & A. Roy. *Colour.* London: National Gallery Publications, 2000.

Brock, W. H. *The Fontana History of Chemistry.* London: Fontana, 1992.

Brown, J., & C. Garrido. *Velázquez: The Technique of Genius.* New Haven, Conn.: Yale University Press, 1998.

Bruno, V. J. *Form and Colour in Greek Painting.* London: Thames & Hudson, 1977.

Brusatin, M. *A History of Colors.* Boston: Shambhala, 1991.

Büchner, W., R. Schliebs, G. Winter & K. H. Buchel, *Industrial Inorganic Chemistry.* Weinheim, Germany: VCH, 1989.

Bucklow, S. "Paradigms and Pigment Recipes: Vermilion, Synthetic Yellows and the Nature of the Egg." *Zeitschrift für Kunsttechnologie*, 1999, *13*(1): 140.

Burch, R. M. *Colour Printing and Colour Printers.* London: Pitman, 1910.

Burmester, A., & C. Krekel. "The Relationship Between Albrecht Dürer's Palette and Fifteenth/Sixteenth-Century Pharmacy Price Lists: The Use of Azurite and Ultramarine." In *Contributions to the IIC Dublin Congress, 7–11 September 1998: Painting Techniques: History, Materials and Studio Practice*, ed. A. Roy & P. Smith. London: International Institute for Conservation of Historic and Artistic Works, 1998.

Callen, A. *Techniques of the Impressionists.* London: New Burlington Books, 1987.

Cennino Cennini (c. 1390). *Il libro dell'arte (The Craftsman's Handbook)*, transl. D. V. Thompson. New York: Dover, 1960.

Charlet, N. *Yves Klein.* Paris: Vilo International, 2000.

Chevreul, M.-E. (1839) *De la loi du contraste simultané des couleurs (The Principles of Harmony and Contrast of Colors).* New York: Van Nostrand Reinhold, 1981.

Church, A. H. *The Chemistry of Paints and Painting.* London: Seeley & Co., 1890.

Clearwater, B. *Mark Rothko: Works on Paper.* New York: Hudson Hills Press, 1984.

Cobb, C., & H. Goldwhite. *Creations of Fire.* New York: Plenum, 1995.

Cohn, M. B. (ed.). *Mark Rothko's Harvard Murals.* Cambridge, Mass.: Harvard University Art Museums, 1988.

Cole, B. *The Renaissance Artist at Work.* London: Murray, 1983.

Constable, W. G. *The Painter's Workshop.* London: Oxford University Press, 1954.

Cranmer, D. "Ephemeral Paintings on 'Permanent View': The Accelerated Aging of Mark Rothko's Paintings." *Proceedings of ICOM Committee for Conservation, 8th Triennial Meeting, Sydney.*

Crespelle, J.-P. *The Fauves.* London: Oldbourne Press, 1962.

Crook, J., & T. Learner. *The Impact of Modern Paints.* London: Tate Gallery Publishing, 2000.

Cumming, E., & W. Kaplan. *The Arts and Crafts Movement.* London: Thames & Hudson, 1991.

de Keijzer, M. "Microchemical Identification of Modern Organic Pigments in Cross-Sections of Artists' Paintings." *Proceedings of ICOM Committee for Conservation, 8th Triennial Meeting, Sydney.*

Dickson Gill, I. *The History and Techniques of the Great Masters: Titian.* London: Tiger Books International, 1989.

Doerner, M. *The Materials of the Artist.* Orlando, Fla.: Harcourt Brace, [1949] 1984.

Dunkerton, J., A. Roy & A. Smith. "The Unmasking of Tura's *Allegorical Figure*: A Painting and Its Concealed Image." *National Gallery Technical Bulletin*, 1987, *11*: 5.

Duthuit, G. *The Fauvist Painters*. New York: Wittenborn, Schultz, 1950.

Eamon, W. *Science and the Secrets of Nature*. Princeton, N.J.: Princeton University Press, 1994.

Elger, D. (ed.). *Donald Judd, Colorist*. Ostfildern-Ruit, Germany: Hatje Cantz, 2000.

Ellis, W. S. *Glass*. New York: Avon Books, 1998.

Feller, R. L. (ed.). *Artists' Pigments: A Handbook of Their History and Characteristics*, Vol. 1. Oxford: Oxford University Press, 1986.

Field, G. *Chromatography*. London: Winsor and Newton, 1869.

Fitzhugh, E. W. (ed.). *Artists' Pigments: A Handbook of Their History and Characteristics*, Vol. 3. Oxford: Oxford University Press, 1997.

Fortini Brown, P. *The Renaissance in Venice*. London: Weidenfeld & Nicolson, 1997.

Fox, R., & A. Nieto-Galan (eds.). *Natural Dyestuffs and Industrial Culture in Europe, 1750–1880*. Canton, Mass.: Watson Academic, 1999.

Gage, J. *Colour in Turner: Poetry and Truth*. London: Studio Vista, 1969.

Gage, J. *George Field and His Circle*. Cambridge: Fitzwilliam Museum, 1989.

Gage, J. *Colour and Culture*. London: Thames & Hudson, 1993.

Gage, J. Review of *Farbe am Bauhaus: Synthese und Synasthesie*. *Kunst Chronik*, February 1998, p. 78.

Gage, J. *Colour and Meaning*. London: Thames & Hudson, 1999.

Garfield, S. *Mauve*. London: Faber & Faber, 2000.

Gaugh, H. F. *De Kooning*. New York: Abbeville, 1983.

Gernsheim, H. *A Concise History of Photography*. New York: Dover, 1986.

Gettens, R. J., & G. L. Stout. *Painting Materials: A Short Encyclopedia*. New York: Dover, 1966.

Gombrich, E. H. *Art and Illusion*, 5th ed. London: Phaidon, 1977.

Gombrich, E. H. *The Story of Art*, 15th ed. London: Phaidon, 1989.

Goodwin, M. *Artist and Colourman*. Wealdstone, Harrow, England: Reeves, 1966.

Grohmann, W. *Klee*. New York: Abrams, 1985.

Hackney, S., R. Jones & J. Townsend. *Paint and Purpose*. London: National Gallery Publications, 1999.

Hall, M. *Colour and Meaning: Practice and Theory in Renaissance Painting*. Cambridge: Cambridge University Press, 1992.

Harley, R. D. *Artists' Pigments, c. 1600–1836*, 2nd ed. London: Butterworths, 1982.

Heaton, A. (ed.). *The Chemical Industry*. Glasgow, Scotland: Blackie Academic, 1994.

Helmholtz, H. von. "On the Relation of Optics to Painting," transl. E. Atkinson. *Popular Lectures on Scientific Subjects*, 1900, *2*: 118.

Hills, P. *Venetian Color*. New Haven, Conn.: Yale University Press, 1999.

Hodges, H. *Technology in the Ancient World*. London: O'Mara, 1996.

Hughes, R. *The Shock of the New*. London: BBC Books, 1991.

Itten, J. *The Elements of Color*. New York: Van Nostrand Reinhold, 1970.

Jarman, D. *Chroma*. London: Vintage, 1994.

Jirat-Wasiutynski, V., & H. T. Newton Jr. "Absorbent Grounds and the Matt Aesthetic in

Post-Impressionist Painting." In *Contributions to the IIC Dublin Congress, 7–11 September 1998: Painting Techniques: History, Materials and Studio Practice*, ed. A. Roy & P. Smith. London: International Institute for Conservation of Historic and Artistic Works, 1998.

Jonson, B. (c. 1610). *The Alchemist*. In *Three Comedies*. Harmondsworth, England: Penguin, 1966.

Kandinsky, W. (1912). *Über das Geistige in der Kunst (Concerning the Spiritual in Art)*, transl. M.T.H. Sadler. New York: Dover, 1977.

Kemp, M. *The Science of Art*. New Haven, Conn.: Yale University Press, 1990.

Kirby, J. "Fading and Colour Change of Prussian Blue: Occurrences and Early Reports." *National Gallery Technical Bulletin*, 1993, *14*: 63.

Kirby, J. "The Painter's Trade in the Seventeenth Century: Theory and Practice." *National Gallery Technical Bulletin*, 1999, *20*: 5.

Kirby, J. "The Price of Quality: Factors Influencing the Cost of Pigments During the Renaissance." In *Values in Renaissance Art*, ed. G. Neher & R. Shepherd. London: Ashgate, 2000.

Kirby, J., & D. Saunders. "Sixteenth- to Eighteenth-Century Green Colours in Landscape and Flower Paintings: Composition and Deterioration." In *Contributions to the IIC Dublin Congress, 7–11 September 1998: Painting Techniques: History, Materials and Studio Practice*, ed. A. Roy & P. Smith. London: International Institute for Conservation of Historic and Artistic Works, 1998.

Kirby, J., & R. White. "The Identification of Red Lake Pigment Dyestuffs and a Discussion of Their Use." *National Gallery Technical Bulletin*, 1996, *17*: 56.

Lamb, T., & J. Bourriau (eds.). *Colour: Art and Science*. Cambridge: Cambridge University Press, 1995.

Laurie, A. P. *The Pigments and Mediums of the Old Masters*. London: Macmillan, 1914.

Laurie, A. P. *The Painter's Methods and Materials*. London: Seeley Service, 1960.

Le Blon, J. C. (1725). *Coloritto*. Facsimile reprint. New York: Van Nostrand Reinhold, 1980.

Leicester, H. M. *The Historical Background of Chemistry*. New York: Dover, 1971.

Leymarie, J. *Fauves and Fauvism*. Geneva: Skira, 1995.

Lucas, A. *Ancient Egyptian Materials and Industries*, 3rd ed. London: Arnold, 1948.

Lucie-Smith, E. *Movements in Art Since 1945*. London: Thames & Hudson, 1984.

Mascheroni, A. M. (ed.). *Vlaminck*. London: Park Lane, 1993.

Menu, M. "Cave Paintings: Structure and Analysis." *MRS Bulletin*, 1996, *21*(12): 48.

Merrifield, M. P. (1849). *Original Treatises on the Arts of Painting*. New York: Dover, 1967.

Morrall, A. *The History and Techniques of the Great Masters: Rembrandt*. London: Tiger Books International, 1988.

Morrall, A. *The History and Techniques of the Great Masters: Rubens*. London: Tiger Books International, 1988.

Multhauf, R. P. *The Origins of Chemistry*. Langhorne, Pa.: Gordon & Breach, 1993.

Nassau, K. (ed.). *Color for Science, Art, and Technology*. Amsterdam: Elsevier, 1997.

Naylor, G. *The Bauhaus Reassessed*. London: Herbert Press, 1985.

O'Donoghue, E., R. Romero & J. Dik. "French Eighteenth-Century Painting Techniques."

In *Contributions to the IIC Dublin Congress, 7–11 September 1998: Painting Techniques: History, Materials and Studio Practice*, ed. A. Roy & P. Smith. London: International Institute for Conservation of Historic and Artistic Works, 1998.

Osborne, J. *Light and Pigments*. London: Murray, 1980.

Penny, N., A. Roy & M. Spring. "Veronese's Paintings in the National Gallery: Technique and Materials, Part II." *National Gallery Technical Bulletin*, 1996, *17*: 33.

Penny, N., & M. Spring. "Veronese's Paintings in the National Gallery: Technique and Materials, Part I." *National Gallery Technical Bulletin*, 1995, *16*: 5.

Perkin Centenary London: 100 Years of Synthetic Dyestuffs. London: Pergamon, 1958.

Powell, A. *The Origins of Western Art*. London: Thames & Hudson, 1973.

Principe, L. M. *The Aspiring Adept: Robert Boyle and His Alchemical Quest*. Princeton, N.J.: Princeton University Press, 1998.

Ratliff, F. *Paul Signac and Color in Neo-Impressionism*. New York: Rockefeller University Press, 1992.

Rewald, J. *The History of Impressionism*, 4th ed. London: Secker & Warburg, 1973.

Read, H. *A Concise History of Modern Painting*. London: Thames & Hudson, 1974.

Read, J. "Alchemy and Art." *Transactions of the Royal Institution*, 1952, *30*: 286.

Read, J. *Through Alchemy to Chemistry*. London: Bell, 1957. (Reprinted as *From Alchemy to Chemistry*. New York: Dover, 1995.)

Rhodes, D. *Clay and Glazes for the Potter*. Radnor, Pa.: Chilton, 1973.

Riley, B. *Mondrian: Nature to Abstraction*. London: Tate Gallery Publications, 1997.

Riley, C. A., II. *Color Codes*. Hanover, N.H.: University Press of New England, 1995.

Rosenblum, R. *Ingres*. London: Thames & Hudson, 1990.

Rossotti, H. *Color*. Princeton, N.J.: Princeton University Press, 1983.

Roy, A. "The Materials of van Gogh's *Cornfield with Cypresses*." *National Gallery Technical Bulletin*, 1987, *11*: 50.

Roy, A. (ed.). *Artists' Pigments: A Handbook of Their History and Characteristics*, Vol. 2. Oxford: Oxford University Press, 1993.

Roy, A., & P. Smith (eds.). *Contributions to the IIC Dublin Congress, 7–11 September 1998: Painting Techniques: History, Materials and Studio Practice*. London: International Institute for Conservation of Historic and Artistic Works, 1998.

Sandars, N. K. *Prehistoric Art in Europe*. Harmondsworth, England: Penguin, 1968.

Sass, S. *The Substance of Civilization*. New York: Arcade, 1998.

Saunders, D., & J. Kirby. "Light-Induced Colour Changes in Red and Yellow Lake Pigments." *National Gallery Technical Bulletin*, 1994, *15*: 79.

Sheldon, L. "Methods and Materials of the Pre-Raphaelite Circle in the 1850s." In *Contributions to the IIC Dublin Congress, 7–11 September 1998: Painting Techniques: History, Materials and Studio Practice*, ed. A. Roy & P. Smith. London: International Institute for Conservation of Historic and Artistic Works, 1998.

Singer, C., E. J. Holmyard, A. R. Hall & T. I. Williams (eds.). *A History of Technology*, Vols. 1–4. Oxford: Clarendon Press, 1954–1958.

Skelton, H. "A Colour Chemist's History of Art." *Review of Progress in Coloration*, 1999.

Spalter, A. M. *The Computer in the Visual Arts*. Reading, Mass.: Addison-Wesley, 1999.

Steer, J. *Venetian Painting*. London: Thames & Hudson, 1970.

Sullivan, K. E. *Turner*. London: Brockhampton Press, 1996.

Taylor, F. S. *A History of Industrial Chemistry*. London: Heinemann, 1957.

Theophilus (c. 1122). *De diversis artibus* (*On Divers Arts*), transl. J. G. Hawthorne & C. S. Smith. New York: Dover, 1979.

Theroux, A. *The Primary Colors*. New York: Holt, 1994.

Theroux, A. *The Secondary Colors*. New York: Holt, 1996.

Thomas, A. *The Painter's Practice in Renaissance Tuscany*. Cambridge: Cambridge University Press, 1995.

Thompson, D. V. *The Materials and Techniques of Medieval Painting*. New York: Dover, 1956.

Townsend, J. H. "The Materials of J.M.W. Turner: Pigments." *Studies in Conservation*, 1993, *38*: 231.

Travis, A. S. *The Rainbow Makers*. Cranbury, N.J.: Associated University Presses, 1993.

Varley, H. (ed.). *Colour*. London: Marshall Editions, 1980.

Vasari, G. (1550). Introduction to *Lives of the Artists*, published as *Vasari on Technique*, transl. L. S. Maclehose. New York: Dover, 1960.

Wall, E. J. *History of Three-Color Photography*. Boston: American Photographic Publishing Co., 1925.

Weiss, J. *Mark Rothko* (Tate Gallery exhibition catalogue). Washington, D.C.: National Gallery of Art, 1998.

Weitemeier, H. *Yves Klein*. Cologne, Germany: Taschen, 1995.

White, R., & J. Kirby. "Rembrandt and His Circle: Seventeenth-Century Dutch Paint Media Re-Examined." *National Gallery Technical Bulletin*, 1994, *15*: 64.

Whitford, F. *Bauhaus*. London: Thames & Hudson, 1984.

Williams, T. I. (ed.). *A History of Technology*, Vols. 5 and 6. Oxford: Clarendon Press, 1958.

Wood, C. S. *Albrecht Altdorfer and the Origins of Landscape*. Chicago: University of Chicago Press, 1993.

Zollinger, H. *Color: A Multidisciplinary Approach*. Zürich, Switzerland: VCH, 1999.

INDEX

Page numbers in italics refer to figures.

PERMISSION
ACKNOWLEDGMENTS

Grateful acknowledgment is made to the following institutions for their kind permission to reproduce paintings and other material in their possession: *As If to Celebrate, I Discovered a Mountain Blooming with Red Flowers* and *A Wing at the Heart of Things* by Anish Kapoor; *Our English Coasts* ("Strayed Sheep") by William Holman Hunt; *April Love* by Arthur Hughes; *IKB 79* by Yves Klein; *Pottery* by Patrick Caulfield; *VAV* by Morris Louis; *Drought* by Kenneth Noland; and *Six Mile Bottom* and *Guadalupe Island* by Frank Stella © Tate Gallery, London. *Valentine Rescuing Sylvia from Proteus* by William Holman Hunt courtesy of Birmingham Museums and Art Gallery. Illustration of Le Blon's three-color printing process; *Hollyhocks* by George Baxter; *Saturn* by Ugo da Carpi; and page from Albert Munsell's *Colour Atlas* courtesy of Victoria and Albert Museum, London. Photos of mauve-dyed silk dress and bottle of aniline dye courtesy of Science Museum and Science & Society Picture Library, London. Photo of lapis lazuli courtesy of Natural History Museum, London. Photos of shabti figure from tomb of Sety I and Egyptian wall painting © British Museum, London. *Saints Jerome and John the Baptist*, attributed to Masaccio and Masolino; *Saints Peter and Dorothy* by the Master of Saint Bartholomew; *The Ascension of St. John the Evangelist* by Giovanni del Ponte; *St. John the Baptist with St. John the Evangelist (?) and St. James* by Nardo di Cione; *The Virgin of the Rocks* by Leonardo da Vinci; *The Portrait of Giovanni Arnolfini and His Wife (The Arnolfini Marriage)* by Jan van Eyck; *Annunciation, with St. Emidius* by Carlo Crivelli; *Bacchus and Ariadne*, *Portrait of a Man*, and *Madonna and Child with Saints John the Baptist and Catherine of Alexandria* by Titian; *Equestrian Portrait of Charles* and *Charity* by Anthony Van Dyck; *Adoration of the Kings* by Paolo Veronese; *St. George and the Dragon* by Tintoretto; *Samson and Delilah* by Peter Paul Rubens; *Portrait of Hendrickje Stoffels* by Rembrandt; *Ulysses Deriding Polyphemus* by J.M.W. Turner; photos of materials typically used in Impressionist paintings; *Boating on the Seine* by Auguste Renoir; *Lavacourt Under Snow* by Claude Monet; *Hillside in Provence* by Paul Cézanne; *The Virgin and Child with Saints* by Duccio; *The Côte des Boeufs at L'Hermitage* by Camille Pissarro; *Canon Bernadinus de Salviatis and Three Saints* by Gerard David; *Allegorical Figure* by Cosimo Tura; *The Virgin and Child Before a Firescreen* by a follower of Campin; *Apollo and Daphne* by Antonio del Pollaiuolo; *Flowers in a Terracotta Vase* by Jan van Huysum; and *The Pool of London* by André Derain © National Gallery, London. Illustration of painter working on an image of the Virgin Mary courtesy of Patrimonio Nacional, Madrid. Alexander mosaic from the House of the Faun, Pompeii, courtesy of the Museo Archeologica Nazionale, Naples. *Algerian Women in Their Apartment* by Eugène Delacroix (Photo: RMN) and *The Virgin with Chancellor Rolin* by Jan van Eyck (Photo: RMN/H. Lewandowski) courtesy of the Louvre, Paris. *The Talisman* by Paul Serusier (Photo: RMN/Jean Schormans) and *Regatta at Argenteuil* by Claude Monet (Photo: RMN/H. Lewandowski, S. Hubert) (quoted in © ADAGP, Paris, and DACS, London) courtesy of Musée d'Orsay, Paris. *Yellow Accompaniment* by Wassily Kandinsky © Guggenheim Museum, New York. Illustrations of cave art from Altamira, Spain; depiction of Thamar and assistant (from an illuminated manuscript of 1403, ms. 12.420, folio 86, Bib-